Shared W

Shared Walls

Seattle Apartment Buildings, 1900–1939

DIANA E. JAMES

Diana James
January 28, 2012

McFarland & Company, Inc., Publishers
Jefferson, North Carolina, and London

LIBRARY OF CONGRESS CATALOGUING-IN-PUBLICATION DATA

James, Diana E., 1941–
Shared walls : Seattle apartment buildings,
1900–1939 / Diana E. James.
p. cm.
Includes bibliographical references and index.

ISBN 978-0-7864-6596-5

softcover : acid free paper ∞

1. Apartment houses—Washington (State)—Seattle—History—20th century.
2. Apartments—Washington (State)—Seattle—History—20th century. I. Title.
NA7862.S43J36 2012 728'.314097977209041—dc23 2011039638

BRITISH LIBRARY CATALOGUING DATA ARE AVAILABLE

On the cover: (top) Franklin and Charlesgate apartment buildings,
1930 (Seattle Municipal Archives); (bottom) The present-day
Glencoe Apartments, originally built in 1907

Front cover design by Bernadette Skok (bskok@ptd.net)

Manufactured in the United States of America

McFarland & Company, Inc., Publishers
Box 611, Jefferson, North Carolina 28640
www.mcfarlandpub.com

In memory of my favorite architect
Patrick T. James
1940–1992

Table of Contents

Acknowledgments ix

Preface 1

1. Shared Walls: A Beginning 5
2. All the Modern Conveniences: Electricity, Radios, and Ice Cube Trays 20
3. Behind the Scenes: Architects and Builders 35
4. Apartment Fundamentals: Styles, a Seattle Form, Classes, and Building Materials 64
5. Downtown Apartments: Between the Water and Hills 86
6. First Hill and Renton Hill Apartments 115
7. Capitol Hill Apartments West of Broadway 144
8. Capitol Hill Apartments East of Broadway 181
9. Apartments All Around the Town 219

Chapter Notes 239
Bibliography 259
Index 267

Acknowledgments

Jacqueline B. Williams and I worked together on *Shared Walls* for more than half its long brooding period. The title of the book was her inspiration. She is knowledgeable, a published author, connected to people and organizations, and blessed with a droll sense of humor that saw us through the down times. She made a huge contribution to the book before wisely deciding she had more to do with her life. I owe her my deepest thanks.

I thank my family for their patience and understanding and practical help over the last seven years: my two daughters who patiently offered advice; my techie son-in-law who did everything from finding "lost" files to keeping my computer(s) in good working order and all my work safely saved; and my grandchildren, Zack and Julia, who thrilled me when they were thrilled that I had "become an author."

Librarians, without whom the world would not turn, have been resourceful and encouraging. To John LaMont in the History/Genealogy Department and Jodee Fenton in the Seattle Room, as well as my cheering squad of other librarians at the downtown Seattle Public Library, I say thank you. My appreciation to Chris Burns in Special Collections at the University of Vermont; research assistance at the Multnomah Public Library in downtown Portland, Oregon; Carolyn Conklin, reference assistant at the Peoria (Illinois) Public Library; and a library volunteer in Fort Smith, Arkansas, all of whom went the extra mile to provide me with otherwise unobtainable information. Director Eleanor Boba kindly made the contents of the library of Seattle's Rainier Valley Historical Society available to me.

Those who facilitated the acquisition of the photos for *Shared Walls* include Anne Frantilla, Seattle Municipal Archives; Greg Lange, Washington State Archives/Puget Sound Regional Branch; Nicolette Bromberg, Visual Materials Curator, Special Collections, University of Washington Libraries; Kris Kinsey, Special Collections, University of Washington Libraries; Carolyn Marr, Museum of History and Industry librarian; and Jacqueline Lawson, Black Heritage Society of Washington State. Because of their efforts, *Shared Walls* will be a pictorial pleasure. And just for the record, all photos not otherwise credited are products of my faithful digital camera.

Had I not been able to see the insides of apartment buildings, I never would have known what a unique creation each is. For their contributions toward this end, I especially thank Susan Bradford, Dotty DeCoster, Debby Gibby, Dag Randolph, and Georgeanne Seabeck, who showed me their buildings—often more than once—and enticed other residents into letting me see additional units within the building.

Many kind and trusting people invited me to view their building and/or apartment unit: Eric Kochis, Phyllis Kirkpatrick, Brian Postle, Steve Olans, Rob Femur, Lauren Smith, John McKenna, Ginger Curry, G. Altman, Tanya Flanagin and Eden Bossum, Shannon

Moore, Florence Lentz, Malory Graham and Jonathan Lilly, Elise Mebel, Jim Morrison, Lee Serrano, Mara Benedict and David Shannon, Anna Haas, Chance Koener, Tim Horton, Marty Lund, Cynthia Marsh and Lucy, Dustin Ziegelman, Judy Amster, Pat Siggs and Joan Trunk, and Zachary Morrison. Amelia Middleton, who had moved into the Gables when it became a condominium, allowed me free rein in asking questions and nosing around; she was the first person to demonstrate a wall bed for me. Warren Munsell, Dick Barclay, and Beverly Strain talked to me about apartments, past and present. In absentia, Jennifer Robinson and Sky Lanigan let me view their apartment.

Some special people who no longer live in an apartment were anxious to share their memories of bygone years. Florence Lundquist was my best resource, happily and humorously providing me with many good stories as she recalled her years at the St. Johns. Eloise Knapp sketched the layout of the apartment she lived in as a girl and related her memories of the building. D'Arcy Larson drew plans of the apartment she had lived in and mailed them, and some of her recollections, to me. Aleda Carter, who still stays in touch with some early apartment friends, told me, "We had so much fun living there!"

A number of people sent e-mails or talked with Jacqueline Williams regarding their memories of life in an early apartment building. They include Buzz Anderson, Sarah Benezra, Meta Buttnick, Bernice Ovadia, and Al Wilding, and I am grateful to them for sharing.

I am fortunate to have friends, most of whom managed not to roll their eyes when I got off on "my subject," who have stayed the course even though I was often busy "working on the book." These include my walking friends, who became accustomed to the detours and pauses for photographs of one apartment building or another: Joyce and Roy Ostergren, Connie Phelps, and Beth Gibson. I am grateful to friends Ruth and Peter Van Voast, who conveniently moved into several buildings featured in the book and then let me view them. Carol Jean Hendrickson shared photos of family members who had lived in a Capitol Hill apartment building. Sterling Morris, my indefatigable friend, literally and figuratively, opened the doors to several apartment buildings for me. Sincere thanks to Renna Pierce who on two occasions saved the day by assisting with tedious tasks prior to the send-off of Shared Walls. I thank my newfound friend Kathy Bradley, as much for her encouraging words and enthusiasm for the topic as for her excellent editorial skills.

Different people read parts of the book as it worked itself into the product it is today. Thanks go to Karen Link, Mimi Sheridan, Dennis Andersen, Rich Erickson, and Chuck LeWarne for their suggestions and comments. In the final throes of editing, scanning photos, and burning everything onto discs, I am grateful to Sarah Weeks for her able assistance.

A 2008 Heritage Special Projects grant from 4Culture, King County, Washington's, cultural service agency, helped defray editing expenses and assisted the purchase of photographs. In addition to the financial help, the confidence it implied in the importance of Shared Walls to King County's history was most rewarding, so that I am doubly grateful.

Preface

Ten years ago I moved into a 1928 apartment building that had just been converted to a condominium. A desire to learn more about my own building, and a fascination with the multitude of apartments in my new neighborhood, awakened an interest that soon became a passion. In 1900 *Polk's Seattle City Directory* listed four addresses under the brand new heading of apartments. By the beginning of World War II that number had multiplied to nearly 1,400. Nearly one-fifth of all Seattle households—rich and poor, single men and extended families—lived in apartments. *Shared Walls: Seattle Apartment Buildings, 1900–1939* chronicles their growth up through 1939, after which apartment construction, curtailed by the Great Depression and World War II, never returned to its glory days of ornate terra cotta trim, marble entryways, and leaded-glass doors, features present on even the most modest apartment buildings.

As I pondered writing the book, I knew I had to limit the number of apartments I would write about. Initially my intent was to document extant, and some significant nonextant, apartments located downtown, and on First Hill and Capitol Hill. My reasoning was that by limiting the study to those large urban neighborhoods, rather than the whole city, I could expand on the rich concentration of apartments within them. I could be more thorough in my accounting of a smaller number, knowing that they were representative of those found throughout Seattle. Nevertheless, despite the ongoing destruction of apartment buildings in those areas—on several occasions I watched the dust settle after they were razed—too many remained not to impose further limits. After more thought, I decided to focus on some concentrations of apartments within smaller neighborhoods and along the streets of downtown, First Hill, and Capitol Hill. With this approach, I found I could describe the apartments in their natural setting and in relationship to one another. Even though *Shared Walls* discusses more than a hundred apartments, I anguished over the many omitted.

With the selection process settled, there was the quandary of what information to include about each building. For some, there was very little to draw on, but they were still worthy of mention. For others, there was more than enough, usually because the investor/owner had the means to be sure his or her building received attention. For most every apartment, I was able to include a certain amount of factual information: the architect or builder when known, who built it, the materials used in construction, and the number of units. But whenever possible, *Shared Wall* attempts to inject a human element into the story of the building.

It has been my steadfast goal for *Shared Walls* to be inclusive—to include the wide range of apartments that exist in Seattle. You will find accounts of apartment buildings designed to attract the wealthy, and you will read about those that housed laborers and salesmen and young working women.

1

Why write a book about early apartment buildings in Seattle? They were a significant source of housing in the early decades of Seattle's rise as an important West Coast city. An in-depth study of apartments reveals a city's history on a different level, so when an apartment building disappears, a bit of Seattle's history disappears. Ideally *Shared Walls* will inspire an appreciation for their history and architectural variety, and for their preservation as an integral part of Seattle's urban landscape.

Because so little has been written about apartment buildings, *Shared Walls* will add to the general knowledge of this overlooked building type. In my effort to find applicable material for my research, I discovered that the words of John Hancock, author of "The Apartment House in Urban America," an essay in *Buildings and Society*, rang true. He wrote that neither its architectural nor its social significance has been much analyzed in scholarly literature: most studies of American architecture and urbanism rarely mention apartments. Perhaps *Shared Walls* will inspire others to write about the apartments in their own towns and cities, regardless of size, and make a contribution toward reversing the dearth of material.

My research has taken many forms, but my initial research began on foot. I walked through neighborhoods and along arterials and downtown streets looking for apartments built between 1900 and 1939. I studied and photographed exteriors, and, as often as possible, cajoled an invitation to see inside. Some of my most enlightening and enjoyable research was the result of being inside an apartment building. Enthusiastic managers and caring residents frequently invited me to look around, proudly showing me the view from their roof as well as the storage units in the basement. Strangers became friends as I listened to their stories related to living in an apartment building. Nowhere was this pride more evident than on a tour of early apartment buildings that a colleague and I conducted on a snowy Sunday morning. As our group looked at a small but charming apartment building while I discoursed on its features, a resident opened a window and asked what we were doing. I shouted up to him that we were admiring his building. He asked if we would like to come inside. In we tromped, and en route to his top-floor unit, another resident came into the hall and asked if we wanted to see hers, too. Of course we did!

The resources at Historic Seattle, the City of Seattle's Historic Preservation Program, Special Collections at the University of Washington, Seattle's Museum of History and Industry, and the Seattle Room and other departments of the Seattle Central Library were the mainstays of my research. I conducted research, both in person and by correspondence, with the Washington State Archives–Puget Sound Regional Branch, where all my requests were quickly honored. The Seattle Municipal Archives was my resource for codebooks, street information, and photographs. The Washington State History Museum in Olympia opened up additional photographic possibilities.

The recent addition of the online archives of the *Seattle Times* newspaper, accessible through the Seattle Public Library, brought to light previously unknown or tedious-to-access information. Precise opening dates, builders and architects, interior features, and even social events related to the buildings' residents, can now be found online. Trolling other local newspapers also provided much useful information. Information gleaned from newspapers served a dual purpose. Preconstruction, work-in-progress, and opening-day information told of an apartment's economic and physical aspects, but the social pages, with their comments on the card parties, luncheons, and entertainment of visiting guests, told of life within the building. Classified advertisements, in their very brevity, conveyed much (although the modern reader might wonder what "overstuffed" meant, or what "five

minutes walk" implied). There is a selection of classified advertisements at the beginning of each chapter, chosen for their aptness to the area under discussion.

From the City of Seattle Department of Planning and Development I obtained copies of plans for more than fifty apartment buildings. While I may have to look up the meaning of *muntins* every time I come across the word, I *can* read plans. Building plans also proved helpful on more than one level. While they showed the layout of the lobby and corridor and units, they often also included detailed drawings for kitchen and bathroom built-ins and stipulations for interior materials. The quality of the latter indirectly implied to whom the apartment building was meant to appeal.

Some books proved so useful that I finally bought them rather than monopolize the libraries' copies: *Street Railway Era of Seattle* by Leslie Blanchard, *A Narrative History of Public Works in Seattle* by Myra Phelps, *Building the West* edited by Dennis Luxton, and *Greenscapes: Olmsted's Pacific Northwest* by Joan Hockaday. Two indispensable references, *The Hill with a Future: Seattle's Capitol Hill 1900–1946* by Jacqueline Williams and *Shaping Seattle Architecture: A Historical Guide to the Architects* edited by Jeffrey Ochsner, were extremely helpful. From a practical standpoint, I consulted the *Penguin Dictionary of Architecture and Landscape Architecture* to help me with building terms. Also helpful were Blumenson's *Identifying American Architecture*; Poppeliers, Chambers, and Schwartz's *What Style Is It?*; and Tunick's *Field Guide to Apartment Building Architecture.*

For research regarding architects and builders, U.S. Census information either provided new information or confirmed (or not) previous sources. The *Architect's Files* in Special Collections at the University of Washington were helpful. Early trade journals, such as *Hotel News of the West* and *Washington State Architect*, and specialized newspapers, such as *Pacific Builder and Engineer* and the *Seattle Daily Bulletin,* offered tantalizing bits of information about the architects and their projects. A trip to the Multnomah County Library in Portland, Oregon, yielded information on several architects who lived and practiced in Portland but designed buildings in Seattle. Librarians in other cities were responsive to telephone calls when I requested information on Seattle-based architects who once lived and/or practiced in their towns. The Internet frequently provided leads or filled in blanks about the architects.

Information about tenants gathered from census data, newspaper accounts, and other sources such as Seattle's *Social Blue Book* helped to fill out the story of each building. The rarest of all research were my conversations with people who had lived in one of the apartment buildings during the early time frame; each had fond memories.

More than just descriptions, *Shared Walls* is a history of when and why apartment buildings began to change Seattle's skyline. Thus, chapters 1 through 4 are dedicated to providing the context for the discussions of apartment buildings that occur in chapters 5 through 9.

Chapter 1 sets the stage with some early Seattle history and describes options for multifamily dwelling prior to the onset of apartment construction. It discusses issues that paved the way for the steady development of apartments: the regrading of Seattle's unfriendly terrain; the Bogue Plan, Seattle's response to the City Beautiful movement; the growth of an apartment-building real estate industry, which surprisingly included many women, a fact frequently pointed out in chapters 5 through 9; an improved transportation system; and Seattle's hosting of the 1909 Alaska-Yukon-Pacific Exposition. Chapter 1 ends with a discussion of the opposition to apartments that existed at the local and national level.

Chapter 2 describes advancements and changes in America's material culture and their

impact on the amenities and modern conveniences found early on in apartment buildings. It touches on the city's moves to expand its waterworks and provide electricity, which enabled apartment owners to offer hot and cold running water, flush toilets, electric stoves, and laundry facilities. It describes period features such as package closets, cooler boxes, and variations on hidden beds, the latter a necessary feature in every efficiency apartment and a bonus in larger units.

Chapter 3 discusses the relationship between client and architect. It recounts the use of pattern books by builders and architects and describes options for training (apprenticeships and university education), and why architects gravitated to the Pacific Northwest. The chapter touches on the professional relationships of architects and firms. Biographical accounts of all architects and builders whose apartments appear in *Shared Walls* follow.

Chapter 4 describes building styles, or the lack thereof, of Seattle apartments. It discusses one building form that I describe as Seattle-centric, which, although it appears in other cities, is a predominant form in Seattle. The chapter elaborates on the three classes of apartment buildings — efficiency, intermediate, and luxury — that evolved in Seattle and expands on an example of each. It discusses the mundane but important subject of building materials for the apartments, used both structurally and decoratively, and their local production.

Chapters 5 through 8 get to the heart of *Shared Walls*: the discussion of apartments in small neighborhoods within the broader context of Downtown, First Hill, and Capitol Hill, the latter divided into two chapters for ease of discussing the very large area. Chapter 9, just to clear any doubts about apartments being located all around the town, discusses one apartment from each of ten widely scattered Seattle neighborhoods. As with chapters 5 through 8, a brief background and history of the neighborhood of each of the ten is presented prior to the discussion.

That move in 2001 to an apartment-turned-condominium that became my new home coincided with the beginning of graduate school for me, and ultimately an MA in Historic Preservation from Goucher College. After graduation, there was time to think seriously about creating a history of Seattle's apartments, from Anhalts to the Zindorf. I wanted to give the buildings the recognition they deserved! I wrote *Shared Walls* with the heart of a preservationist, hoping to convey the essence of the apartment buildings as well as their physical attributes. It is the untold story of why and how apartments came to be built in Seattle and of the people who lived in them. After a friend read an early version of the downtown chapter, he commented, "Belltown will never be the same for me now." If so, my mission has been accomplished.

1

Shared Walls: A Beginning

To Let: Several furnished rooms in house formerly known as Transient House.
Wanted: Rooms in Family House.
For Rent: Strictly first-class family hotel. 200 rooms, 100 with private bath.
Rates to permanent guests.

In the Pacific Northwest, the practice of residing in dwellings that accommodated multiple numbers of people has a long history. Living together in one structure offered protection and companionship, and encouraged a sharing of resources.

In Seattle, the Duwamish Indians had lived in communal dwellings for several hundred years before the arrival of Euro-Americans. Permanent longhouses accommodating extended families were part of their native winter villages. The houses were built from local red cedar, a wood that easily split into wide straight planks. Families might separate their individual spaces with "shared walls" of cattail mats.[1] According to ethnographic historian David Buerge, eight of these Duwamish longhouses, which together sheltered upwards of two hundred people, stood not far from the intersection of First Avenue and Yesler Way in today's Pioneer Square neighborhood.[2]

When pioneers Arthur Denny, Carson Boren, and William Bell explored the same area in 1852, they located an isthmus that connected a small island in Elliott Bay to forested land farther north.[3] Originally called "Little Crossing-Over Place" by the natives, Denny named it Denny's Island.[4] The site would become the center of Seattle's first commercial and residential area.[5] Historians say the land measured approximately a quarter mile long and 1,300 feet wide. A saltwater lagoon, located roughly at Occidental and Fourth avenues, bordered the island on the east; green forests of Douglas fir, and western red cedar and white cedar, covered the bluffs to the north. Tidal flats, which extended to the Duwamish River delta, lay to the south.

In 1853 pioneer Henry Yesler opened a steam sawmill at the water's edge, at what would become Yesler Way and First Avenue South.[6] Within a few months of the mill's opening, twenty frame buildings made with rough-hewn logs dotted the landscape.[7] Timber, sent tumbling down rutted Yesler Way into the bay, was to become an important export.

Also in 1853, the Felker House, Seattle's first hotel and the earliest example of multifamily housing, opened. A map of Seattle dated 1855–56 places the building just a few blocks south of the Duwamish longhouses.[8] Mary Ann Conklin, also known as "Mother Damnable" for her temper and language, managed the Felker House.[9] Conklin supplied clean sheets and food to her lodgers, mostly bachelors who had come to work in the burgeoning city.[10] Two of those early lodgers, Bailey Gatzert and John Leary, became Seattle mayors.[11]

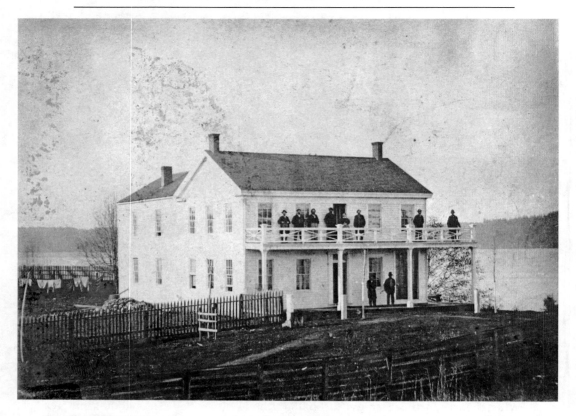

Captain Leonard Felker transported the milled board sides, pine floors, and lath-and-plaster walls for the Felker House. *University of Washington Libraries, Special Collections, UW 28263z.*

Seattle on the Cusp of Becoming a Great City

THE ECONOMY

Other than a successful sawmill and a handful of buildings, there were few signs of progress in the far northwest corner of Washington Territory, still nearly four decades shy of statehood. Indian wars, the nation's involvement in the Civil War, Seattle's remote location, and the absence of railroad service hindered Seattle's growth in the 1850s and 1860s.

Businessmen and city fathers, alert to the possibility that the transcontinental Northern Pacific Railroad would choose Seattle for its western terminus, were optimistic. In 1873, however, when the railroad instead selected Tacoma, Seattle's neighbor thirty miles to the south, townspeople turned to their own resources. Using volunteer labor, construction began on the Seattle and Walla Walla Railroad. Although the workers put down less than twenty miles of track in three years, the railroad managed to reach the lucrative coalfields south and east of Lake Washington. By the end of the decade, coal rivaled lumber as a major export.[12]

Equally important, Seattle took action to make its port the hub for steamships transporting goods and people up and down Puget Sound. To accomplish this task, leading citizens made contact with investors and shipbuilders throughout the country, informing them of the city's superior location near a deepwater harbor.

Near the end of the century, following some tenuous years, Seattle could boast diverse and robust industries and a complex, urban economy. A number of dramatic events contributed to this outstanding progress. A scorching fire on June 6, 1889, set whole streets aflame and destroyed 116 acres of the business district. Rather than being a hindrance to Seattle's progress and momentum, the fire was viewed as an opportunity to build a finer, more permanent, and more modern city.[13] In the fall of 1889 President Benjamin Harrison declared Washington the forty-second state. Transcontinental railroad service, via the Great Northern Railroad, finally reached Seattle in 1893, providing access between Elliott Bay and the rest of the nation.[14] In 1897 the Klondike gold rush spiked the city's recovery when it became a point of departure for would-be miners going to the Alaskan goldfields. Despite the city's previous ups and downs, "Seattle's commerce experienced an eight-fold expansion between 1895 and the beginning of the twentieth century," observed Seattle historian Richard Berner.[15]

Several of the preceding events would have an impact on the future development and construction of apartment buildings in Seattle. Ease of travel via railway meant more people traveled to the Pacific Northwest. Many who came liked what they saw and put down roots. Local stores, precursors of Seattle business interests, grew as they outfitted the thousands of hopeful gold prospectors, and ships did a brisk business delivering the men to and from Alaska. Local producers, such as the Carnation Milk Company, whose cans of evaporated

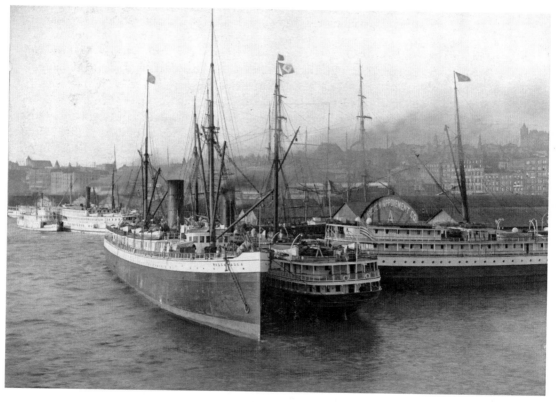

Even prior to this 1898 Seattle waterfront scene, the city could claim more steamboats than all the vessels in other Puget Sound ports combined. *University of Washington Libraries, Special Collections, La Roche 2125.*

milk were in demand by gold prospectors heading to Alaska, created new industries and jobs. In the aftermath of Seattle's Great Fire, those involved in all aspects of the building trades, including architects, flooded into Seattle. A growing population increased the demand for housing.

As the Seattle economy shifted into overdrive, real estate transactions and construction activity, fueled by both local and eastern investors, made headlines. Seattle newspapers peppered their pages with tales of profits made in the buying and selling of property. "Big Blocks of Brick Buildings in the City" headlined a story in the *Seattle Post-Intelligencer*, October 17, 1889. "The marvelous growth of Seattle during the past thirty years cannot be better judged than from a glance at the increase in the values of real estate now forming," boasted a local newspaper at the beginning of 1903.[16] Erecting housing for the ambitious men and women, laborers and professionals, skilled and unskilled, who swarmed in to take advantage of Seattle's strong economy became a priority. Between 1880 and 1900, Seattle experienced phenomenal growth, changing from a small settlement of 3,500 in 1880 to a dynamic city of over 80,000 in 1900.

BUILDING ORDINANCES

In 1869 Seattle received a charter enabling it to tax its citizens and establish laws, as promulgated by the Territorial Legislature. The enactment of ordinances by the city government played an important role during Seattle's growth from a hinterland into a modern city. As might be expected, an increase in construction led to a proliferation of ordinances, the earliest targeting fire safety and building regulations. After Seattle's commercial core burned in the Great Fire of 1889, the city passed two significant ordinances. The first concerned regulations for constructing, altering and repairing buildings and specified that new construction within the commercial area be of brick or stone.[17] The second ordinance created the Office of Superintendent of Buildings, headed by an inspector of buildings, who had to be an "able and experienced architect."[18] The inspector's duties included the examination of applications for permits to determine if the proposed work conformed to building ordinances, the prosecution of those who did not obtain a permit, and the written notification of owners when buildings became unsafe.[19]

As time passed, the city repeatedly amended and refined ordinances. For example, the first ordinance, passed in 1895, that mentioned sleeping rooms merely stated that the regulation was for the "preservation of good health." Two years later the ordinance was amended and read "to prevent the overcrowding of sleeping apartments in lodging and tenement houses and other buildings for the preservation of health." In 1901 it required that "sleeping rooms" have at least one window, but still did not clarify what constituted "sleeping apartments in lodging and tenement houses" or "sleeping rooms."[20]

After 1901 more specific housing-related ordinances appeared in building code handbooks, which were compilations of the ordinances used by architects, contractors, builders, plumbers and others involved in the building trades.[21] Seattle based its housing code on the New York Tenement House Law of 1901, also known as the New Law.[22]

MULTIFAMILY HOUSING IN SEATTLE

The *Building Inspector's Handbook of the City of Seattle, 1902* defined all multiple-housing structures "occupied as a dwelling by more than two families, living independently of one another, and doing their cooking upon the premises" as tenement houses.[23] The broad-

ness of the 1902 definition, and possibly the use of the pejorative term "tenement house" for all multiple-dwelling structures, led to the issuance of the following terms in 1907: *Boarding house*: "A building used for boarding and lodging purposes, and containing not less than five (5) nor more than twenty (20) sleeping rooms for guests"; *Lodging house*: "A building or part thereof intended, designed or used for lodging purposes and having not less than five (5) nor more than twenty (20) sleeping rooms for guests;" *Hotel*: "A building or part thereof intended, designed or used for lodging purposes and having more than twenty (20) sleeping rooms for guests"; *Apartment*: "A building containing separate house-keeping apartments for three (3) or more families, and having a street entrance common to all."[24]

BOARDING HOUSES

In a boarding house, paying guests rented rooms and the proprietor provided meals in a family-style setting. Paul Groth, author of *Living Downtown: The History of Residential Hotels in the United States*, writes that "throughout the nineteenth and early twentieth century ... one-third to one-half of all urban Americans either boarded or took boarders at some time in their lives."[25] Boarding houses played important roles: as a fixture in the country's housing market, as a boost to the local economy from money spent on upkeep and food and supplies, and as income in the proprietor's pocket from rents received.

Some boarding houses advertised for a certain type of tenant. Teachers, gentlemen, couples and families headed the list of desirable renters. A Mrs. Andrews advertised that "none but persons of respectability solicited."[26] In an 1893 advertisement, the proprietress of the Sarah B. Yesler Home announced: "Home Boarding for Women Only — Unexcelled for Cheapness and Comfort."[27] During Seattle's "expansion and growth, transient, single males and poorly paid blue-collar workers of many nationalities continued to occupy the seedy hotels and rooming and boarding houses."[28] But, conversely, "the boarding house owner acted as family," recounted Meta Buttnick, whose father arrived in Seattle in 1904 and lived in a house operated by the Karnofsky family, with whom he remained friends throughout his life.[29]

LODGING HOUSES

Lodging houses provided a place to sleep, but no food. This usually low-cost form of housing was prominent in Seattle's Chinatown, where accommodations catered to the Chinese and Japanese.[30] The first Chinese immigrants to Seattle came to work on the railroads, as laborers and as street workers, often migrating betweens jobs and towns. A Chinese lodging house planned by Chin Gee Hee, a Chinese pioneer, had seventy-two rooms.[31] The Japanese came as construction workers on the Great Northern Railway; many lived in the first Japanese-managed hotel, the Cosmos House, which, similar to other Japanese-operated hotels and rooming houses, were "inexpensive sleeping quarters, typically large rooms with up to seventy beds."[32] Jewish people rented rooms in the Cherry Street/Yesler Way neighborhood. Many Sephardic families, despite the small size of their dwellings, took in one or two lodgers from the old country, who would eat their meals in a nearby Sephardic restaurant.[33]

The owner of a boarding or lodging house usually handled the renting, but agencies such as the Seattle Rental Bureau might be hired to supervise transactions. Many women were managers, a respectable occupation that made economic sense. If single, the job meant

free rent for her and possibly a salary. If married or widowed, the rentals added to the family income. During the Alaskan gold rush, Mrs. Elizabeth Anderson, an African American who owned a lucrative lodging house, earned sufficient income to send her daughter to a private school.[34]

HOTELS

Hotels offered lodging not only to travelers but permanent residents as well. The first hotels were built to house men brought in to build Seattle's infrastructure during the construction boom of the 1870s.[35] The men rented their furnished rooms by the day, week, or month. While some of the smaller inexpensive lodgings catered exclusively to day laborers, the clientele in many of the hotels commonly included a mixture of low- and middle-income residents, both transient and permanent, a practice prevailing throughout the United States.[36]

There were also more luxurious accommodations, such as the Hotel Rainier, which opened in 1889 and was considered to be the "finest hotel on the North Pacific Coast." Designed by Charles Saunders, it filled a city block.[37] Its public rooms, among them a large reading room, ladies' reception room, several dining rooms, billiard room and bar, were resplendent. Guest rooms featured the latest styles of carpet and oak furniture. Most shared communal toilets and bathtubs, although a few front rooms had their own "separate water closets and baths."[38] A first-floor veranda and balconies on the upper floors allowed guests to enjoy the view. In September of 1910, "the huge frame structure of picturesque architecture" was torn down to accommodate the Fifth Avenue regrade.[39]

More modest hotel accommodations were the Guiry, built in 1904, and the Schillestad, built in 1907, adjacent buildings on the southwest corner of First Avenue and Stewart Street. The word HOTEL, patterned in the floor tile of the entry of the Guiry, is still visible. The fifty-four hotel rooms, arranged around a light well, occupied the upper two floors. Non-permanent guests paid fifty cents and up per day, or $2.50 per week, for a room with hot and cold water and the opportunity to use the building's free baths. The street-level space, originally occupied by a saloon, has always been commercial. The Schillestad, a fine brick building adorned with ironwork, had thirty-six rooms, also arranged around an internal light well. Architects Charles N. Elliott and Thomas L. West designed the Guiry Hotel, and Andrew McBean designed the Schillestad. Both are listed on the National Register.[40]

APARTMENTS: ANOTHER CHOICE

By 1900, boarding houses, lodging houses, and hotels could no longer accommodate the burgeoning population. Seattle, similar to many other growing cities, including West Coast neighbors Portland, Oregon, and Vancouver, British Columbia, began to embrace apartments as a way of solving its housing deficit.

Various definitions for apartment buildings persisted. According to Elizabeth Collins Cromley, architectural historian and author of *Alone Together: A History of New York's Early Apartments*, in the mid-nineteenth century the term "'apartments' meant any set of rooms: a suite in a hotel or a set of rented rooms in a private house ... or a family unit in an apartment building."[41] Jeffrey Ochsner and Dennis Andersen, authors of *Distant Corner: Seattle Architects and the Legacy of H. H. Richardson*, write that "the difference between a residential hotel or rooming house and an apartment building in late-nineteenth-century Seattle was primarily a matter of name and not of planning and design."[42]

Influences on Apartment Construction in Seattle

In the early 1900s, a number of disparate, but intertwined, issues helped pave the way for the development and growth of apartments in Seattle.

LAND DEVELOPMENT: THE DENNY REGRADE
AND THE BOGUE PLAN

In downtown Seattle, land well located and suitable for apartment construction came about by two unrelated means: the leveling, or regrading, of its hills, and the failure of the brilliantly conceived Bogue Plan.

Seattle's original commercial core occupied a narrow strip of level land confined between the waters of Puget Sound to the west and steep hills to the east. Denny Hill, considered the most egregious of the downtown hills, covered sixty-two city blocks. Stationed at the northern edge of the downtown business district, city fathers viewed the hill as an impediment to Seattle's development and began its removal in 1902.[43] This area, known even today as the Denny Regrade, became a suitable location for apartment development due to, first of all, its availability, but its level streets and proximity to downtown and the waterfront were also key.[44] Northwest historian Carlos Schwantes said the regrade projects were "one of the most ambitious civil engineering programs in American history, one that literally moved mountains to reshape the downtown area and gave a new dimension to the Seattle Spirit."[45]

The Bogue Plan was Seattle's response to the City Beautiful movement, which flourished in America between 1900 and 1912. Proponents of the movement believed that a beautiful and functional city would inspire and improve the lives of the urban poor, thus bringing about social change, and they encouraged cities to develop beautiful buildings, parks, libraries, art museums, and drives. In 1910, Seattle's Municipal Plans Commission hired Virgil Bogue to create such a plan.[46] In addition to many improvements for port and harbor facilities, railroads, streetcar lines, and roads, Bogue proposed a large civic center, replete with a City Beautiful grouping of public buildings. The location of the center was in the heart of the Denny Regrade area, where property was available and reasonably priced.

In March of 1912 voters rejected the Bogue Plan.[47] Its discussion, planning, and eventual defeat tied up a substantial plot of land that later became the site of extensive apartment development.

APARTMENTS AS INVESTMENTS:
PRE- AND POST-DEPRESSION

Between 1900 and 1910 Seattle shifted from a "gold rush boom to a real estate boom."[48] The buying and selling of apartment houses offered lucrative financial opportunities. As a consequence, an entrepreneurial throng of investors, realtors, developers, contractors and builders arose to take advantage of this market. Based on transactions reported in local newspapers and trade journals, a surprisingly large number of women were involved in the business.[49] Upon completion of the Charlesgate Apartments in 1923, Margaret Dudley bought the building from the Investors Corporation. In 1924, another woman, Marion Plank, bought the Charlesgate from Dudley. Plank and Nellie Jones, who had recently purchased the furniture and lease of the Sherwood Apartments for "a consideration of over $100,000," were partners in several Seattle apartment buildings.[50]

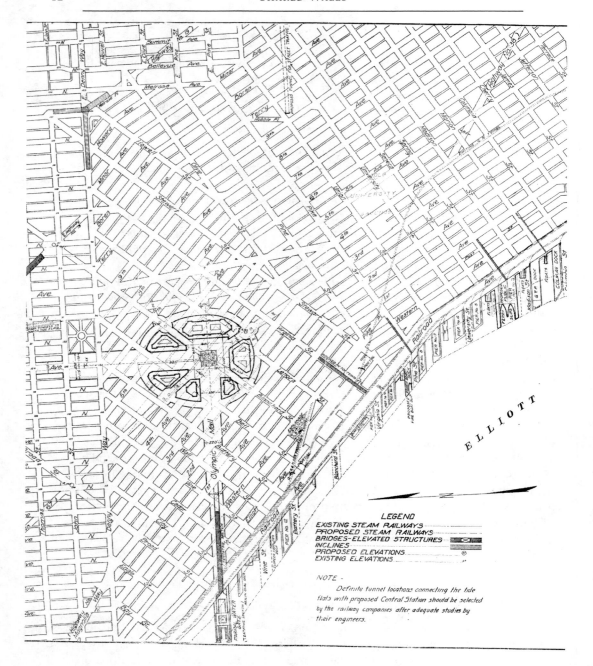

Virgil Bogue's plan for a civic center (inset) envisioned all public buildings grouped together in a comprehensive setting. *Seattle Municipal Archives 619.*

As permits for new structures increased, returns on investment in real estate soared. Newspapers were rife with examples of individuals and companies making large profits. Apartment buildings were routinely sold within a year of construction as some people, such as Margaret Dudley, "played" the real estate market much as they did the stock market.

Typical is the selling of the San Marco Apartments on First Hill. The three-story building opened in October 1905 and within a few months became investment property for Senator Frank Clapp. "The buy [$70,000] is regarded as a splendid one," said realtor John Davis and Company.[51]

"Investment expectations have often chased unusual stars, and in the 1920s the apartment building was one of these," observed Michael Doucet.[52] Investors, such as the Marion Investment Company, replaced older frame dwellings with brick apartment buildings "modern in every respect" in order to reap higher profits.[53] L. N. Rosenbaum, who represented a syndicate of eastern investors, regularly bought apartments for investments.[54] The coffers of city government also profited from the buying and selling of apartments, since completed transactions provided a source of capital to municipalities in the form of property taxes, adding more to the city treasury than did single-family homes.[55]

On September 30, 1923, the real estate industry reported to the *Seattle Times* that in the first eight months of the year, fifty-two hotels, flats, lodging houses and apartments had been erected, begun, or announced, and were valued conservatively at $6.5 million. Of the total, thirty-seven were apartment houses containing 1400 units, ranging from one to eight rooms. Seattle's population grew from 315,000 in 1920 to more than 365,000 in 1930, and although the increase was smaller than in previous decades, it was enough to buoy the building, buying and selling of apartments. In 1928 apartment buildings in Seattle represented an aggregate investment of $9.5 million.[56] When asked if the city had overbuilt, realtors said apartment house vacancies for the entire city did not exceed 10 or 12 percent, considered a normal vacancy rate.[57]

The same frantic investments in apartments occurred in other cities. Between 1921 and 1928, there was a "significant increase in apartments in every section of the United States."[58] Portland, Oregon, constructed 553 new apartments between 1920 and 1930, with the highest number, 243, built between 1925 and 1928.[59] Nationwide, by 1930 investors, including conservative banking and lending institutions, had poured "$9 billion into apartment construction.... In one estimation, [it] had become 'America's fifth largest industry.'"[60]

In 1929 an optimistic contributor to the *Apartment Operators Journal* wrote that though they did not consider Seattle overbuilt, "we do feel that the time is opportune NOW to place a warning ... there is nothing for our industry to lose by being conservative."[61] Despite all the optimism, the rosy glow did not continue. Once the effects of the Depression settled in, the number of building permits in Seattle dropped to the point that not a single permit for apartment houses was issued in 1933 or 1934, followed in 1935 by only one, two in 1936, and one in 1937.[62] The same free fall occurred across the country. From

Advertisements similar to this one, which appeared in the *Seattle Times* on March 8, 1925, appeared frequently, beckoning people to invest in apartment buildings.

1925, the peak year of apartment construction in the United States, to 1932, the figures dropped by 97.1 percent.[63]

The Depression sorely affected Seattle's construction trade, exemplified by Fred Anhalt, a local developer and builder of numerous apartments. "We tried to hold onto the apartment houses as long as we could, but pretty soon we were running them with less than half the units filled, and those didn't pay their rent." For two years Anhalt managed the buildings for the mortgage company in an effort to keep things going, "but finally the times caught up to us and the banks started to foreclose. It got so we couldn't even keep up payments on the interest and taxes. Once one was foreclosed, the rest went like dominoes."[64]

TRANSPORTATION: CHANGES AND IMPROVEMENTS

Prior to public transportation, Seattle was a walking city. Businesses of all sorts congregated near one another, and most urban dwellers, both workers and owners, lived within two miles of their work. As modes of transportation developed, some people moved away from the downtown area, but many remained: doctors, lawyers, real estate and investment brokers, teachers, and office workers.[65] Regardless of where people lived, public transportation unified the urban space by linking home, place of work, shopping and entertainment, and imbued the city with a "functional unity."[66]

As early as 1884 the Seattle Street Railway operated downtown, using horse-drawn carriages, which, though limited on Seattle's hilly terrain, established fixed transit routes along the city's most heavily traveled streets.[67] Budd Hebert, author of "Urban Morphology," an article that appeared in the *Traffic Quarterly*, wrote that transit systems developed between 1890 and 1900 became the framework for future networks, and all routes that survive from that period are transit lines today.

> The urban development process is tempered by the old. New transport technology spirits the imagination and may have some benefits, but the old city structure and form have a lasting influence. Location of the first path has an impact on growth that reverberates throughout each new transportation network. Old ideas and habits are comfortable and are often difficult to change.[68]

Hebert's statement resonates today along Seattle streets. A cursory study of early street maps reveals that current Metro bus routes in downtown, First Hill, and Capitol Hill neighborhoods follow early trolley routes. From the inception of the trolley lines, businesses and apartments flourished along the routes.

Technological advances led to mechanically powered vehicles. In 1873 the first cable car in America went into service, not surprisingly, in San Francisco. Seattle's first cable car began operating in 1888. Attractive to cities with steep grades, cable cars carried more passengers and were smoother and faster than horse-drawn vehicles. They were not without their price, however, as they required extensive infrastructure and were expensive to maintain.[69] Seattle followed the national move toward electric streetcars, or trolleys, considered the most immediately accepted technological innovation in history. Electrification of Seattle streetcars occurred on March 30, 1889, and within one week all horses on the network had been withdrawn and replaced by trolleys.

The rapid growth of the city led to a proliferation of railway companies, with chaotic results: too many franchises, insufficient funds to buy and maintain equipment, absence of transferable fares, and underpaid and overworked employees.[70] This unmanageable transportation system improved when the Seattle Electric Company received a franchise from

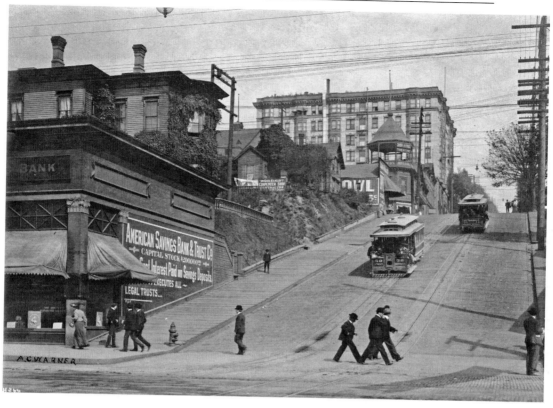

Cable cars worked well on Seattle's steep streets, such as these two on Madison Street in this undated photograph. *University of Washington Libraries, Special Collections, Warner 48x.*

the city. The company consolidated independent lines and, in short order, rebuilt narrow-gauge tracks to conform to standard gauge, purchased new cars, and installed new trolley wires. Leslie Blanchard, author of *The Street Railway Era in Seattle*, referred to 1900 to 1912 as the "golden years."[71]

George Smerk, who traced the impact of transportation on neighborhood development, contends that at first the street railway was a public service that followed the people. Over time, however, streetcar companies went into the real estate business, and it was a commonly accepted fact that when a streetcar line entered new territory, housing followed.[72] The concept was not lost on Seattle real estate developers and apartment house entrepreneurs, who had free rein in building without restrictions until 1923, when the city adopted a comprehensive zoning ordinance that regulated land use. Owners and managers of apartments appreciated the effect that public transportation had on their buildings. An apartment's proximity to streetcar lines added value, and owners frequently advertised, "Best location in Seattle; on three car lines."

ALASKA-YUKON-PACIFIC EXPOSITION

On June 1, 1909, the Alaska-Yukon-Pacific Exposition (AYP) opened with great fanfare on the grounds of the University of Washington. Fairs and expositions held during the last

half of the nineteenth century had served as "arenas in which nations vied with each other to display cultural and economic superiority ... [and] were showcases in which technological innovation could be disseminated worldwide."[73] Chicago's hugely successful World's Columbian Exposition of 1893 may have been an inspiration for Seattle, but more likely it was a response to being upstaged in 1905 by Portland, Oregon's, Lewis and Clark Exposition. Seattle hoped to "call attention to the wealth of resources in Alaska, to focus on Seattle as its major port of entry, and to celebrate the city's achievements."[74]

Similar to other fairs, some civic improvements, created expressly for Seattle's exposition, remained afterward. The Olmsted Brothers landscape firm was hired to develop the University of Washington grounds for the exposition. John Charles Olmsted made numerous trips to Seattle to advise and oversee the work. At closing, the landscaped site and several buildings, "adapted to serve educational purposes," were turned over to the university.[75] "The Olmsted Brothers legacy still shapes much of the campus of the University of Washington," recognized today as one of America's most beautiful.[76]

Although some credit the exposition for a surge in Seattle apartment building, Groth declares that "no one purposely built a sixty-year structure for only one year of business."[77] But some were constructed in time to accommodate guests attending the exposition before being turned into full-fledged apartments. Existing apartment buildings also took advantage of the visitors who poured into the city. A March 1909 advertisement for the sale of an

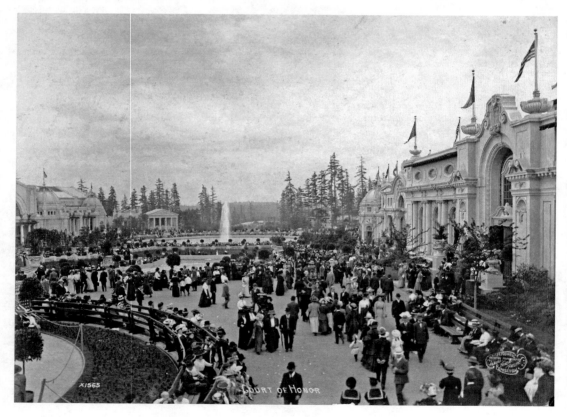

The crowds of people that daily thronged the grounds of the Alaska-Yukon-Pacific Exposition eventually totaled 3.7 million. *University of Washington Libraries, Special Collections, Nowell x1565.*

apartment house of eighty-five rooms mentioned that folding doors in its two-room apartments would allow them to be turned into single rooms during the fair.[78] After traveling great distances, many visitors stayed for an extended time in Seattle, and an apartment was a convenient, and usually less expensive, lodging option than a hotel.

Fairs promoted tourism, and those in real estate anticipated that the true results of the fair would occur later. It was hoped that many of the 3.7 million AYP visitors would decide to move permanently to Seattle as a result of their exposure to the city during the exposition. According to early Seattle historian Clarence Bagley, "The city's guests left the fair with the knowledge that Alaska was a golden possession and Seattle a growing metropolis," good news indeed for those in the building trade.[79]

Opposition to Construction of Apartments

It seemed that the stage was set for Seattle to move forward with building apartments: more buildable space in the downtown area, recognition of apartments as good investments, an improved and expanded transportation system, and the Alaska-Yukon-Pacific Exposition, which served as a magnet for newcomers. Despite these encouraging factors, a degree of negativity toward apartments persisted, manifested locally through restrictive zoning and neighborhood covenants, and nationally through opposition by the National Housing Association and resistance by authorities. While Seattle apartment owners, investors, realtors, construction workers, contractors, builders, and architects were happy when the real estate section of area newspapers proclaimed APARTMENT BLOCKS ARE IN BIG DEMAND, not everyone shared the sentiment.

LOCAL ZONING

Between the time New York City adopted the first comprehensive zoning ordinance in 1916 and the end of the 1920s, almost a thousand cities and towns had implemented zoning.[80] In 1922 Seattle established a City Zoning Commission. Prior to its creation, the city's approach toward zoning had been one of laissez-faire: there were no minimum lot sizes, setback requirements, or bulk regulations that prevented a building from covering an entire private lot. Other than the attraction of like businesses to congregate near one another, any number of different uses could exist in close proximity to one another.[81]

In 1923 the commission introduced its first zoning ordinance, which by definition is a technique for managing land use. The ordinance divided the city into a series of three overlaying districts: use, area, and height. Each district had control over certain aspects of how individual parcels of land could be developed, and each either controlled or impinged upon apartment construction.[82] There was the argument that assumed zoning could prevent losses to home owners "due to encroachment of apartments or stores upon home districts."[83] Provisions in the 1923 zoning ordinance were not retroactive. As a result, some older neighborhoods in Seattle may now contain a rich mixture of apartments and homes and businesses, while newer residential areas are primarily neighborhoods of single-family homes. The ordinance did, however, provide that existing uses which did not conform were to be eliminated over time. In other words, if a pre–1923 apartment building, located in an area now zoned for single-family residences, were destroyed by a fire, the owner would not be permitted to rebuild.[84]

Neighborhood covenants, also known as snob zoning, were another form of discrim-
ination against apartment construction. Most often aimed at excluding racial groups from
living in certain neighborhoods, covenants were tucked into the bylaws of subdivisions or
attached to the deeds of homes by developers, real estate agents, or the landowner, while
cities and zoning authorities often looked the other way. Some lending institutions occa-
sionally made covenants a requirement for a loan.[85] Neighborhood improvement clubs that
appeared in the early 1900s initially stirred public interest for sidewalks and streetlights for
their neighborhoods. Over time, their concerns expanded to restricting property uses, par-
ticularly the building of apartments, in their locales. Seattle's Renton Hill Improvement
Club, organized in 1901, gradually sank into a period of inactivity. But in the 1920s, when
home owners became concerned about the nearby proliferation of apartment buildings and
worriedly pointed out that "to the north is the Capitol Hill section, which is rapidly becom-
ing an apartment house district," the Club was reinvigorated and reorganized.[86]

NATIONAL HOUSING ASSOCIATION

On a larger scale, the National Housing Association (NHA) was established in 1909.
According to Kenneth Baar, author of "The National Movement to Halt the Spread of Mul-
tifamily Housing, 1890–1926," which appeared in the *Journal of the American Planning
Association*, the NHA was formed largely to combat the spread of multifamily housing.
Gradually, leaders of the NHA and prominent city planners, who "played a critical role in
developing the original legislative and judicial justifications for apartment exclusions,"
united.[87] Together they promoted the ills of apartments, "without any empirical support,"
because of their purportedly harmful effect on single-family homes.[88] The NHA felt that all
multifamily housing should be prohibited so that families could buy single-family homes
without the worry of their investment being destroyed by "an invasion of multifamily build-
ings."[89] Since the profits from building a neighborhood of single-family homes outweighed
the profit of building one apartment building that would house the same number of resi-
dents, it was not surprising that the powerful housing industry, which stood to benefit,
would promote issues that discouraged, and even prohibited, the construction of multi-
family housing.

THE FEDERAL LEVEL:
SUPREME COURT DECISIONS

As early as 1909, the case of *Welch v. Swasey*, decided in the United States Supreme
Court, found that communities could regulate the development of private land before such
development became a threat to public health, safety, morals, or welfare. At the time, apart-
ments were commonly blamed for the decline of single-family homes in the same neigh-
borhood because of "associated ills": diseases spread because of close living conditions
(health), tenants made poor neighbors (safety), they led dissolute lives (morals), and they
were unstable. *Welch v. Swasey* established the constitutional right of cities to limit the
height of buildings and to vary these limits by geographic districts, or zones.[90] Limiting the
height of a building was a direct attack on apartment construction.

As late as 1920 an article in the *American Architect* entitled "Are Apartments Necessary?"
conceded that apartments were a desirable convenience for some, even a necessity, but it
seemed "eminently fair" to restrict the apartment builder, via zoning, "to a limited area,
where his use of his property will do the least damage to others and to the community."[91]

In 1926 the Supreme Court of the United States upheld the constitutionality of zoning, and thus the rights of local governments to control land use, in the case of *Euclid v. Ambler*.[92]

Defining "Apartments"

What exactly were these apartment buildings that Seattle had begun to adopt, and how did they differ from the other forms of shared housing?[93] Although it is safe to say that the definitive definition of an apartment may never be found, a good start is one written in 1901, which defined an apartment as a complete dwelling.[94] In other words, one could sleep, cook, eat, and bathe inside one's unit. The *Encyclopedia of Urban Architecture*'s definition further qualifies it as having "several households" of independent dwelling units within a building that share common facilities, such as entrance, lobby, and roof.[95] And in 1907 Seattle defined an apartment as a building containing separate housekeeping apartments for three or more families, having a street entrance common to all. Borrowing from the varied definitions, the present work will adhere to the following: *an apartment is a self-contained unit that includes a kitchen and bathroom within a building of more than four such units*. And, as far as can be determined, all apartments but one discussed in *Shared Walls* began as a purpose-built (built for an intended use) apartment, rather than being the result of a conversion from some other building type, residential or otherwise.

Over time, building codes, exclusionary zoning, bias on the part of lending institutions, and promotion of single-family-only zoning at the federal level contributed to the move to discourage multifamily housing.[96] But the efforts put forth by planners, officials, and so-called reformers were unable to stem the proliferation of apartment house construction, and they were built all across America.[97] Seattle, in comparison to the East Coast, was a relative latecomer to apartment living, but the stage was set for a confident city to move into the next century. And it was fitting that a new type of shared housing, the apartment, would become a prime option. After the St. Paul, Seattle's first apartment building, opened on Seattle's prestigious First Hill in 1901, there was no stopping the groundswell of enthusiasm for this new building type.

2

All the Modern Conveniences:
Electricity, Radios, and
Ice Cube Trays

New, modern ... with bath, steam heat, gas range, sink, hot and cold water, china and clothes closets.

Electrically equipped kitchenette with electric refrigeration in which you can make your own ice.

Living room with built in radio, Tiffany walls ... telephone niches and ventilating fans.

When apartment buildings first began fronting Seattle streets in the early 1900s, enticements to rent included hot and cold running water, electric lights, telephones, laundry facilities, and gas ranges. In 1907, when W. P. White, one of many Seattle architects who designed apartments, urged builders to include "all of the modern conveniences," it was advice that most builders and owners of apartments had already adopted.[1] "There is no limit to the invention of mechanical conveniences," enthused a writer in *The Brickbuilder*, a magazine for architects and builders.[2] Scientific advances resulted in gleaming new electric stoves and porcelain-lined refrigerators that made ice cubes—pinnacles of convenience in early twentieth century American kitchens.[3]

Basic Utilities

The city's introduction of home services, such as clean water, gas, and electricity, made it possible for apartment builders to offer these up-to-date amenities. Widespread availability of these essential utilities, coinciding with the rise in industrialization that began in the early 1880s and Seattle's population growth, and abetted by the switch from privately owned water and power systems to municipally owned, moved Seattle toward becoming a metropolitan area.

WATER: CLEAN AND OTHERWISE

The earliest settlers found water in the numerous springs that flowed into the city from the hills surrounding Seattle. Later, pipes made from twelve-inch fir logs with a two-inch hole bored through the center went underground in Seattle's early attempt to supply homes with clean water. Though these pipes did work, they were not reliable, and a more expedient method of conveying water to homes and business became necessary. In 1881, John Leary, one of a group of prominent citizens, organized the Spring Hill Water Company, Seattle's first integrated distribution system.[4] Using water from Lake Washington, the

20

company placed hollowed log pipes beneath the business district's principal streets as conduits for bringing in water, but within a few years the system again proved unreliable and inadequate. As signs of pollution began to appear in Lake Washington, it became apparent that the city needed an improved system.[5]

Credit goes to city engineer Reginald H. Thomson for giving Seattle a workable municipal water system. By 1901, using water from the Cedar River, approximately thirty-five miles southeast of Seattle, Thomson had built a public system capable of delivering clean water to reservoirs in Seattle.[6] Thus, when the earliest apartment houses began to be built in Seattle, there was hot and cold running water in the kitchen and bathroom sinks, in the bathtub, and in a sink located in a basement laundry room. Describing the St. Paul Apartments in 1901, the *Seattle Daily Bulletin* said, "The building will have its own steam heating plant, which besides heating the building will distribute hot water for baths and kitchen use."[7]

Bringing in water solved only half the problem. A system for disposal was also needed. In 1891, 65 percent of the city drained naturally into Puget Sound, Lake Union, and, indirectly, Lake Washington.[8] Cesspools were no longer able to handle the drainage, and this resulted in outbreaks of typhoid and diphtheria. A plan was needed for a *combined* system for carrying both sewage and storm water. Despite lack of money and public indifference, the pollution resulting from flooding and backups eventually led City Engineer Thomson to recommend the construction of about fifty more miles of sewers.[9] In 1893 voters approved sewer construction bonds, but the improved system required constant upgrading in order to handle increasing volumes of wastewater and to accommodate city ordinances.

ELECTRICITY: BRIGHT LIGHTS
AND ELECTRIC PLUGS

With the construction of a coal-gas plant in 1873, gas lights illuminated Seattle streets; ten years later gas lights were illuminating homes of the wealthy. When electricity arrived in 1886, it very quickly surpassed gas for lighting streets, businesses, and eventually residences. Desiring more electricity and better service, in 1902 voters approved the building of a hydroelectric plant on the Cedar River, the first municipal power plant in the country. By the beginning of 1905 the City Light Cedar River Power Plant was providing power to Seattle's streetlights, and eight months later it had the capacity to service private individuals. Within two years, however, the municipal lighting plant had almost reached the limit of its capacity, resulting in the city expanding the system in order to supply the demand.

Apartments, as well as most houses, were not wired with electrical outlets until after 1914. Kitchens were a "nightmare of 'octopus wiring,'" with several electrical cords accommodated by multiple-socket adapters screwed into a drop-cord light socket hanging from the middle of the room."[10] By the 1920s, when they had become more common, apartment owners made certain to mention that the units had "ample electrical outlets," or "base plugs for plenty of electrical equipment."

Innovations in the Kitchen, Bathroom, and Laundry Room

THE KITCHEN: BUILT-INS, RANGES, REFRIGERATORS

A kitchen is the room that sets apart an apartment from other forms of multihousing. Unlike a boarding house, rooming house, or hotel, units in an apartment building always

contained a kitchen. Early codes specified that a kitchen had to be at least "eight-feet in height from floor to ceiling" and include one window for each three-hundred cubic feet of air space.[11] In 1914, ordinances required apartments to contain "not less than two rooms ... including the room where cooking is done," one of which had to be at least 120 square feet. A skylight could substitute for the required window, if it had "the light area and ventilating capacity required of windows."[12] The city continued to refine the requirements, largely related to size and ventilation, for apartment kitchens. To allay concerns about the latter, a wall fan in a kitchen or dinette provided ventilation and eliminated objectionable cooking odors, or as one advertisement asserted, the fan drew impurities out of the apartment and then brought in fresh air.

Responding to an increasing array of large and small appliances, architects and builders set about arranging the kitchen to appeal to women tenants. They listened to home economists who advocated following scientific principles in arranging appliances, cabinets, and sinks within easy reach of the cook and designed compact, efficient kitchens with little wasted space. They paid attention to reformers who stressed scrupulously clean, sanitary surfaces to ensure good health. And they emphasized that the kitchen could also be an attractive room, as an advertisement for the Buckley Apartments so glibly described:

> Not so many years ago the kitchen was thought a place of drudgery, that no beauty nor taste could be connected with, but today this room must be as presentable as any other part of the home. Therefore the floor is covered with inlaid linoleum in attractive design. The walls enameled in a color scheme composed by a capable decorator. The range in white enamel is the latest electric model. Cabinets, drawers and accessories, even to the china closet are in keeping.[13]

BUILT-INS

When the Buena Vista Apartments opened in 1907 on Seattle's Capitol Hill, it featured a Hoosier kitchen cabinet, the best known of the freestanding kitchen cabinets.[14] But built-in wood cabinets, often made from local sources, soon replaced the freestanding ones.[15] Once kitchenettes, defined as "a small, compact kitchen not designed to be used, nor used as a dining room, and having a floor area not exceeding 50 square feet between walls," began appearing in Seattle apartments, space-saving built-ins were necessary to make them workable.[16] Those in the Charlesgate Apartments had cutlery drawers, bins for flour and sugar, and a pull-out dough board. A shallow door on one wall of the kitchen concealed a built-in ironing board.[17] A by-product of the kitchenette, writes Thomas Schlereth, author of *Victorian America*, was that it "epitomized a new trend toward simplified cooking and a reliance on packaged foods."[18]

In Seattle, architects frequently designed the kitchenettes in combination with a dinette. "It appears that the latest style in kitchenettes is to plan them in combination with a new variety of room, which for lack of a better term is called a Dinette."[19] This was in line with keeping the eating area as small as efficiently possible, paired with the equally small kitchen. In many apartment buildings, a set of matching floor cabinets with leaded glass doors separated the kitchenette from the dinette. In addition to delineating the two areas, dishes stored there were convenient for setting the table.

RANGES

Ranges, both gas and electric, meant the end of bringing in coal or wood to fuel a stove that was difficult to regulate and hard to keep clean.

Gas Ranges

The gas lighting companies, worried about competition from the electric companies, joined with gas appliance manufacturers to promote the use of gas for cooking by developing new products, training their salespeople, and demonstrating the products in showroom displays.[20] Hoping to increase their share of the gas appliance business, the Seattle Lighting Company ran a series of advertisements extolling the virtues of gas, although women did not need to be convinced to use a product that, in addition to producing a quicker source of heat, required neither bulky fuel nor excessive elbow grease to keep clean.

Seattle furniture stores also made a pitch for gas ranges. The Century Furniture Company trumpeted the popular Jewel gas range, which had "one giant burner, a simmer burner, and three single burners" that "suffice for every necessity and contingency."[21] To further ensure purchases, the store promised to connect the gas range for free and take the old range or stove as part payment for the new Jewel.

The gas company recommended lighting "your gas oven in your apartment late in the evening, when the furnace heat is off.... Times when additional warmth is welcome ... light the oven burners of your gas range and enjoy its cozy comfort."[22]

Electric Ranges

Seattle City Light's 1912 annual report noted that the year "has brought forward another important field for the use of electrical energy, that of heating and cooking with electricity."[23] But customers did not rush out to purchase electric ranges; the big boon for electric cooking came after the war when an improved range came on the market, and appliance companies and Seattle City Light collaborated in its promoting. Between 1924 and 1927 the number of ranges in Seattle homes jumped from fewer than 3,000 to more than 11,000.[24] The De Selm Apartments could boast that each unit had a Monarch range with an "automatic safety service switch ... which permits the complete shutting off of electricity ... while the dweller in the apartment happens to be out."[25]

KEEPING FOOD COLD

Coolers

Coolers, also referred to as cooler boxes or cooling closets, can best be described as a cupboard placed in the kitchen or dining area with its back to an outside wall. Small openings in the wall allowed outside air to ventilate the cooler box. Perforated tin, copper mesh, or wire screen kept insects from coming through the openings and into the box. These former openings are visible on an outside wall of nearly every early apartment building in Seattle.

An Electric Range
-in every apartment!

Puget Sound Power & Light Company

Promoting electric ranges was good business for Puget Sound Power and Light Company, which placed this advertisement in the *Seattle Post-Intelligencer* on August 26, 1923.

The boxes came in a variety of sizes and usually had at least one shelf. An extant cooler in the Maxmillian Apartments has metal shelves and two hooks, which might have held an additional shelf. In cheaper apartments that might not have had a cooler box, tenants could

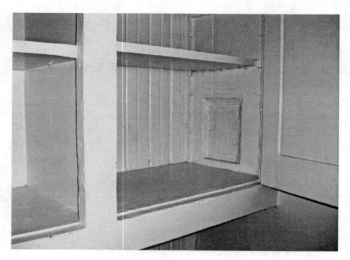

fabricate a cooler by tacking an orange crate or wood box to the windowsill. A housekeeping book advised placing a covered box, with a slanted roof to keep out snow or rain, outside a window.[26] Cooler boxes worked well in Seattle's cool climate. The boxes, not cold enough to keep perishable food, such as meat, from spoiling, worked well for short-time storage of fruits and vegetables, jars of jam and preserves, and cheeses. Owners and tenants considered them an important apartment amenity.

At the Park/Nash/Chalmers Apartments, a cupboard on the kitchen wall, which on the outside faced the building's courtyard, served as the cooler box. The ventilation holes, once no longer needed, were filled and patched on the inside of the cupboard.

Iceboxes

Promotional material indicates that in addition to, or in lieu of a cooler, many apartments included a refrigerator, a euphemism for an icebox. Generally constructed from oak, pine, or ash, iceboxes came in a variety of sizes and shapes. They were lined with zinc, slate, porcelain, galvanized metal, or wood, which acted as insulation. The door, or doors, opened to reveal adjustable shelves and a separate compartment for ice.

"Refrigerators," such as the Gurney or Alaska, emphasized the concept of free circulation of air in their advertisements. They boasted how it would aid in the preservation of food and cut down on the amount of ice needed.[27] Tenants eagerly awaited the weekly delivery of ice. The "iceman" would get orders from tenants and then break up the large blocks into sections, which he packed up the stairs to the waiting iceboxes. "Neighborhood kids would gather around the wagon to get an ice sliver to suck on," recalled Al Wilding, who lived in several Seattle apartments during the 1930s.[28]

A pan, set in the bottom of the icebox to catch and hold the melting ice water, required frequent emptying. With the icebox often placed on a back porch or against an outside wall near the door, the mess stayed outside, and the home owner did not have to be at home when the ice man delivered. Not everyone was so lucky. Some who had iceboxes located in the entry hall of their units recall having to get up at night to empty the water from the melting ice. In 1924 an announcement of the upcoming construction of the Roy Vue described how an outside porch directly off the kitchen would be the site for each unit's large refrigerator.[29]

Refrigerators

Most everyone rejoiced when true refrigerators became the norm. "No more must we arrange for porches, hallways, entries, cellars, [or] cellar landings for the refrigerator's exclu-

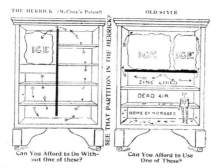
Advertisements for Herrick "refrigerators," which actually were iceboxes, frequently appeared in Seattle newspapers. *University of Washington Libraries, Special Collection, UW 29472z.*

sive reception! Nor do we have to scar beautiful partitions with openings for ice deliveries," said architect Clarence S. Stein in 1926. "We know that the place for the refrigerator is in the kitchen!"[30] Thus the electric refrigerator marked the demise of the back porch.

The ability to make ice cubes and freeze food became two of the more important selling points of the new refrigerators. Promotional material advised prospective tenants that each apartment had its own refrigerator, enabling them to make "their own ice and frozen dainties."[31] Ice cube trays of the 1920s and 1930s were made of tin or nickel-plated copper with plated brass dividers and required dunking under warm water to remove the ice.[32]

By the late 1920s, science and technology, aided by the increased use of electricity, had developed almost foolproof household refrigerators. Along the way, companies tested many improvements. One, Electro-Kold, employed a single machine, located in a basement or other out-of-way place, to operate twenty kitchen refrigerators in individual apartments. "In apartments just building a special type of installation ... affords the greatest possible economy," said the company. In 1923, at least twenty apartment buildings had purchased the Electro-Kold.[33] In the mid-1930s, after engineers solved the choice-of-coolants and design dilemmas, the refrigerator was well on its way to becoming an indispensable machine.

Dishwashers

The precursor of the modern dishwasher was a hand-powered machine designed by Josephine Cochran in 1886. Not until the late 1920s did they occasionally appear in apart-

ments, and only in those that appealed to a higher economic level of renters. Ruth Schwartz Cowan, author of *More Work for Mother*, writes that although dishwashers were available by the time the United States entered World War I, they "were little more than toys for the very rich."[34]

THE BATHROOM AND BATHROOM INNOVATIONS: TOILETS AND NEEDLE BATHS

As sinks, toilets, and bathtubs became more common, they called for a special room inside apartment units. Earlier, when a water closet, or toilet, on each floor sufficed, there was no need for individual bathrooms.[35] But once they were required to be inside individual units, bathrooms fostered a new industry.[36] Soon manufacturers had eliminated the bulky furniture surrounds of the early bathtubs, sinks, and water closets and replaced them with trim and compact enameled fixtures.[37] Advertisements for apartments frequently described the attractiveness of their bathrooms, as in the Gables, which had white enamel woodwork, bronze fixtures, terrazzo floors, and walls tinted in blue, tan and ivory.

Bathrooms' popularity, aided by technology, made it practical for companies, such as American Standard, to produce inexpensive stock products. "The white trio of tubs, toilet, and sink (freestanding or wall hanging), each aligned along a wall ... became a distinct architectural form," notes Schlereth.[38] Sanitary baths, a term used to describe an all-white tile bathroom, which people believed led to cleanliness and thus to better health, received mention in advertisements. But color tile and porcelain began to usurp white in the 1920s. To aid the transformation, tile manufacturers offered consumers an array of patterns and finishes. Commenting on this trend, New York architect William L. Rouse wrote that "the use of color in the bathroom ... gets away from the monotonous white which has become a national habit, based perhaps on its sanitary appeal and possibly on the fact that in years past it was not easy to get good tile in colored glazes for this purpose."[39] Within a few years, full-colored bathroom fixtures became common in apartments.

Flush toilets naturally ranked high on the list of desirable apartment fixtures but were seldom praised in advertisements. The Waldorf Apartments proudly mentioned an unusual feature in their building, where "the plumbing has been made a special feature ... a number of the apartments have been fitted with shower and needle baths."[40]

Needle baths, according to the 1889 J. L. Mott Iron Works catalog, had numerous showerheads delivering sprays of water that felt like needles. Also called ribcage showers for their design, the jets of water were forcibly shot from spigots on the freestanding pipework that almost surrounded the body. Generally used for therapeutic purposes, they were often a feature in gymnasiums. Gordon Bock writes that cage showers and needle baths were more an "invigorating health treatment ... than mere daily cleansing."[41]

LAUNDRY ROOM INNOVATIONS

Normally "doing the laundry" was a necessary task, definitely not something to look forward to. But in the Monmouth Apartments, laundry day was special. The laundry equipment was in only one of the three buildings of the large complex. To facilitate matters, each family was assigned a laundry day. To reach the laundry, the women had to lug their laundry up a hill. They then turned drudgery to fun. "The women brought their lunch and spent the day there, and in between turning the old wringer washing machines and hanging up the clothes outside, would gossip and sing and generally have a good time," said Naomi

The Waldorf Apartments installed spray showers in some of their units, probably similar to this one that appeared in the *New York Times* on August 5, 1894.

Israel, whose family lived in the Monmouth in the 1930s.[42] "I well remember how much my mother enjoyed her assigned day in the laundry room. Those groups of ladies laughed and joked and made it [doing the laundry] fun.... It was the best place to get to know each other," recalled Meta Buttnick. She also admitted that "as a bride, who knew from nothing about domesticity," she received "valuable instructions from the other launderers" in her apartment building.[43]

Later laundry rooms were equipped with electric washers, irons, and dryers. Owners and management would update the "appliances" as more efficient and up-to-date equipment became available in order to attract and retain tenants. In 1924, the laundry room of the newly built Jensen Apartments was furnished "with gas plates and boilers for boiling clothes, in addition to other laundry equipment ... a large steam drying room."[44] Clothes dryers, a metal case enclosing a series of racks, came in various sizes. They were either free standing or built into the wall. If the latter, the racks could be pulled out when hanging clothes, then pushed back to absorb the heat generated by the laundry stoves or, in some cases, heated racks. When Margaret Reed's family moved into the Castle Crag Apartments, they were pleased that the building's laundry room had "mangles for ironing."[45]

Laundry equipment was in the basement, where it shared space with boilers, furnaces and tenant locker rooms. The elegant 1223 Spring apartment building had four rooms with electric washers, irons, and dryers, "permitting each tenant to have an individual laundry room for one day of each week."[46] Since each of the large apartments in this building had one or two maid's rooms, it is likely that it was the maids, not the tenants, who laughed and gossiped in the laundry rooms.

Hidden Beds

Concealed beds have been available since the mid-nineteenth century. In 1908 the *Pacific Builder and Engineer* advised that to solve the problem of too many people for too few housing units, builders should "combine rooms, using them in the daytime for one

thing and at night for bedrooms.... Beds to resemble some serviceable piece of furniture aided in adjusting matters, and the old-style folding bed ... was created for something safe and useful."[47] The article then described two types: the folding bed, which is hung on pivots, hinges or shafts and swings up into the wall or a piece of furniture and then is pulled out at bedtime, and the disappearing bed, which occupies a recess behind a piece of furniture, or beneath the floor, remaining in a horizontal position when not in use.[48] Both the folding and disappearing beds, according to the magazine, addressed the problems of ventilation, safety, sanitation, appearance and convenience, but the disappearing bed was deemed superior.

To maximize space in an apartment unit, architects and builders devised spaces to include an extra bed or two, which during the day would be out of sight, but at night would magically appear. They might be used on an everyday basis, or they might only come into service when company arrived. Many apartments had at least one, and sometimes two, but a hidden bed was a necessity in smaller, efficiency apartments.

When visiting early apartments today, it is a challenge to discover where the bed was originally housed. Some were simply placed behind what appeared to be closet doors; others were more ingeniously hidden. Although most have been removed, there are still telltale signs: a shallow closet, a built-in cabinet with large doors below, or an unusually high bathroom floor. "Our Pike Street apartment had a bed that would slide under the bathroom floor! You'd go up three steps to get into the bathroom," recalls Margaret Reed.[49]

A folding bed was frequently stored inside a small room, referred to as a dressing closet or dressing room, which often also contained a built-in chest and vanity table. At

The Rip Van Winkle wall bed operates differently from a Murphy bed. Jim Morrison, former manager of the St. Florence, demonstrates how the overly wide door pivots open to reveal a bed frame attached to the back of the door.

night, the dressing-room door opened into the adjacent room so that the bed could fold down. Units at the Cambridge Apartments featured a Marshall-Stearns wall bed that when closed "is the dressing room with plenty of space for hanging clothes.... [And] joy to the woman's heart, a full-length mirror is mounted on the sides of the dressing room door."[50] A hidden bed in some apartments was in a "bed alcove," "shielded from view by French doors."[51]

These were commonly referred to as "Murphy beds," named for the founder of the Murphy Bed Company, but there were other choices.[52] The Douglas wall bed claimed to be a northwestern product because 80 percent of its beds used Douglas fir. Easily installed in old or new buildings, its only requirement was the framing of a door opening into a closet, "one wall of which it occupies, taking up the width of the regulation bed, a height corresponding to the door, and a depth of but 15 inches."[53] Many apartments featured the Marshall and Stearns Clos-A-Dor wall bed or the Murphy In-A-Door bed. The St. Florence Apartments opted for the Rip Van Winkle wall bed.

Longtime Capitol Hill resident Al Wilding says he would have loved to sleep on a wall bed. "I longed to have a bedroom with a real bed rather than sleeping on a couch with no sheets and covered with a blanket. Even a Murphy bed would have been nice, but these luxuries were reserved for my parents." Florence Lundquist recalls sleeping on a Murphy bed that was in the living room of her family's unit in the St. Johns Apartments. From the time Florence entered Summit Elementary School until she graduated from Broadway High School, each night it would be made out for her, and each morning after Florence left for school, her mother would make up the bed and return it to its hiding place.[54]

The bed is pulled down and locked into place. A mattress would have been stored inside the frame.

All the Extras

In the early 1900s Americans had begun to spend more on a comfortable lifestyle. "More people (middle class and working class) had more money and more time to purchase more goods, mass-produced more cheaply and advertised more widely."[55] By the 1920s most Americans had made the transition to a modern consumer society. Coupled with the rise in stock prices and the fall in prices for goods and services, more Americans purchased automobiles, radios, home appliances, and other commercial goods. This rise in consumer spending and the notion that "new comforts ... were not so extravagant after all" were reflected in apartment buildings, particularly the interiors.[56]

To appeal to Seattle's growing professional and salaried middle class, apartment owners embellished their interiors with distinctive accoutrements and furnishings. They covered the walls with fashionable Tiffany-designed wallpaper, added fountains in the lobbies and wainscoting along corridor walls, and installed fireplaces, radio aerials, and telephones in individual units. Standard and Knox-Lewis, a Seattle furniture company that prided itself as specializing in furnishing "High Class Apartments and Hotels," reminded apartment owners that "beautiful interiors assure genuine contentment to occupants of apartment homes."[57]

LOBBIES

Well-designed lobbies received special attention since these spaces were the first to greet potential renters or guests of residents, upon whom initial impressions were important. "Grandeur in public lobbies was a point of pride in some apartment buildings, where elaborate decorative schemes in the entrance, lobby, and main staircase could stun a first time visitor or entice the not yet well-to-do with promises of luxury," says architectural historian Elizabeth Collins Cromley.[58]

Many Seattle architects and builders labored to capture a certain ambiance for their apartment lobbies. With a measure of pride they designed tiled walls, specified terrazzo and marble floors, called for onyx wainscoting, and suggested ordering stylish furniture from interior decorators. "One of Seattle's most discriminating colorists has been engaged to take charge of the lobby.... The soft tones of the marble floor, the rich folds of the draperies and the especially designed furniture all have been selected to blend harmoniously," claimed the luxurious Gainsborough Apartments.[59] Not to be outdone, the Buckley hired local artist Waldemar Bach to hand paint the lobby walls. One of the most elaborate lobbies was in the Northcliffe, which featured Neoclassical detailing in the painted plaster walls, fluted pilasters, mirrored French-door panels, and a decorative iron balustrade with wood handrail. Polished terrazzo arranged in a two-tone diamond pattern, edged with dark green marble, covered the floor.[60]

Wall Treatment: The Tiffany Finish

Some lobbies were given a very special treatment: a Tiffany finish, which was a blended effect from the walls being colored with a layer of paint and then dots of glazing, after which the latter were hand blended and some areas even wiped clean, resulting in a finish that resembled richly colored fabric.[61] The finish was named for Louis Comfort Tiffany, one of the most creative designers of the late nineteenth century, who was best known for his design and manufacture of stained glass. Paint companies, such as Dutch Boy, told con-

Rugs and coffered ceilings enhanced the Camlin's lobby. *Hotel News of the West*, August 14, 1926.

sumers that the richly painted Tiffany wall paints made the "walls appear as though light were shining on them through a stained glass window."[62] No doubt this was what the Fleur de Lis apartments hoped to achieve when they applied a "Tiffanized brocaded texture finish" to its double-coved ceilings, and the Sovereign when it used Tiffany-designed wallpaper in "patterns both beautiful and harmonious."[63]

Lobbies, small or large, simply painted or elaborately decorated, served as the crossroads of each apartment building. Here were located the stairways, the elevator, the mailboxes, and, early on, the telephone, as well as an area where guests could wait for a friend to arrive or to linger afterward.

Elevators

The first steam-driven passenger elevator, perfected by Elisha Otis, was installed in 1857.[64] The elevator allowed architects and builders to ignore building heights. At the same time, the elevator hastened the increase in apartment construction since taller buildings on a piece of property meant greater returns for investors, who were quick to seize this advantage.

Most apartment buildings in Seattle over three stories tall have an elevator. Large buildings might have both a passenger and a freight elevator, as does the Biltmore Apartments. In larger, more upscale buildings, such as the Gainsborough and the 1223 Spring, an attendant operated the elevator.

Not quite the same, but accomplishing the same purpose as a freight elevator, an exposed platform at the rear of the Hillcrest Apartments, with the help of a pulley, raised items to the upper floors. This circumvented the inside stairs, which made tight turns.

Telephones

Telephones attracted potential apartment renters. The earliest apartments, such as the St. Paul, did not have telephones, as "telecommunications technology ... was pretty basic ... and service was unpredictable."[65] The St. Paul featured call bells and speaking tubes, a precursor of the intercom. Conveniently located outside the vestibule door, speaking tubes allowed residents to communicate with callers at the front door. A speaker would remove a stopper and blow into the tube. This produced a whistle-like sound at the other end. The person upstairs would remove their stopper, put their ear over the tube and listen for the voice from below. The tenant would then communicate via a speaking tube with the caller at the front door. "Each end of the tube had a trumpet." Speaking tubes were "a network of tin pipes leading from a central panel at the front door into each apartment," operating not unlike the playground equipment children use to talk with one another.[66]

In 1907, when an apartment advertisement mentioned "both phones" among its attractions, it was referring to an odd arrangement that was the result of two competing telephone companies in Seattle. The Sunset Telephone and Telegraph Company began operating in 1884. Five years later, Seattle's Great Fire destroyed all its equipment and lines, but the company was soon back in business with newer equipment and telephone poles with glass insulators. Around the same time, the Seattle Automatic Telephone Exchange began operating. "Both companies kept their facilities and customers separated," forcing customers to subscribe to both services and use two phones.[67] By 1909, telephone service was regulated, and in 1913 the Sunset Telephone Company bought out the Independent Telephone Company, the former Seattle Automatic Telephone Exchange. The company was renamed the Pacific Telephone and Telegraph Company.[68]

In the days before each apartment had its own telephone, house telephones occupied a place of honor in the lobby. Lifelong Seattle resident Florence Lundquist remembers the telephone in her aunt and uncle's apartment, whose door had the sign "Manager" on it. Calls to residents came through their phone. Florence remembers she or her aunt answering the phone and going to tell a resident they had a call, which

Intercommunicating Telephone Systems

For Factories, Residences Apartments, Hotels, Clubs Hospitals, Etc.

Wiring Repairs
Dynamos & Motors
General Electrical
Construction

Electrical Engineering Co.
112 MARION ST. Phones Main 1428, Ind. 38 SEATTLE

A telephone on a wall in the Arcadia's lobby is very similar to the type featured in this advertisement for "intercommunicating telephone systems." *Pacific Builder and Engineer*, October 5, 1907.

they would take at an extension in the hall. Once telephones became more commonplace and every unit one, builders and architects wrestled with the problem of satisfactorily placing it, obviously not always successfully, as D'Arcy Larson recalls their telephone was placed on the wall, "too low to stand comfortably and too high when sitting down."[69] One solution was a prefabricated niche that could be recessed, usually in a hallway. During a recent conversion to condominiums, the niches in the Sheffield Apartments were retained, a touching reminder of the building's history.

Package Closets

A walk through the corridors of many Seattle apartment buildings might arouse curiosity about the small doors that are usually outside a unit's entry door, close to the floor. These doors, about one by three feet in size, open up to a package or service closet. In addition to the door in the hall, there was another that opened into the apartment. They served several purposes. Residents could place their trash on an inside shelf, which would be picked up by an apartment employee who retrieved it via the outside door. Residents could also receive packages or groceries left inside their package closet by simply opening the door inside their unit. In a time when transportation options were fewer, home delivery was a popular service provided by a range of businesses. Owners of the La Vanch Apartments must have installed the latest "technology" if they could promise that their service cabinets were burglar proof, making it impossible for prowlers to enter the apartment through the opening.[70]

Radios

In the 1920s, placing a radio aerial and setting up a radio room in a Seattle apartment building was equivalent to wiring for high-speed Internet or cable television in a contemporary apartment building. Listening to the radio had become a favorite inexpensive home entertainment, especially during the years of the Great Depression. The *Seattle Times* and other newspapers devoted many pages to describing the radio's virtues, listing the programs and reporting the latest engineering feats, such as automatic volume control and the elimination of static.

Radios quickly became best sellers. Everyone wanted this technological wonder. Apartment owners, hoping to keep up with modern times, had to make it possible for their tenants to hear orchestral music, educational programs, and weekly favorites. Phrases such as "an especially fine radio installation providing unit control in every apartment" soon became standard in advertisements.

Roof Gardens

Another extra was the roof garden, an attraction atop many apartment buildings. From the street, a projecting pergola might be the only hint of its presence. Roof gardens not only gave the building another place to offer distinctive facilities; it satisfied Seattle's building code requirement pertaining to yards, which said that the ground yard "may be omitted provided the roof is constructed as a good, safe, convenient and healthful place for play and recreation for the occupants."[71] A number of roof gardens were quite elegant, showing off fountains, paths, formal gardens, attractive and comfortable garden furniture, and lighting. "We have put in a roof garden with a lovely fountain and convenient benches and

chairs," announced Charles Arensberg, builder and owner of the Buckley.[72] Roof gardens were also the place for enjoying unobstructed views of the mountains and water that sur-round Seattle.

In surveying the amenities found in Seattle apartment houses, it is clear they afforded an ease of housekeeping that benefited from the rise in technologies: hot and cold running water, electrical outlets, and refrigerators. Apartment architects, builders, and owners vied with each other in providing up-to-the-minute kitchens, bathrooms, and stylish living areas, "so highly prized by investors," for middle-class tenants.[73] While some may have worried about consumer spending habits, tenants reveled in the comforts and conveniences that their newly-rented apartments afforded them.

3

Behind the Scenes:
Architects and Builders

Constructed to conform with most advanced ideas of apartment building. Wide corridors, enormous living rooms, spacious closets, unusual refinements in bath, kitchen and dinette.

Well arranged 4 and 5-room corner apartments in this close-in modern brick building.

Capitol Hill's newest and most ultra-modern apartment, now open. You will find your highest expectations realized.

Much credit for the success of apartments built in Seattle between 1900 and 1939 goes to the architects and builders who were responsible for their design and construction. Seattle attracted a diverse and talented group of men for whom the opportunity to design apartments was more than just a job — although steady employment was a prime consideration. Architects used their imagination and skills to ensure that the buildings fit the parcel of land and stayed within budget. Architects produced plans for buildings designed so that the units were comfortable enough that renters stayed, since maintaining full occupancy meant a more profitable business operation for the owner. Attractive on the outside meant that initially prospective renters would be drawn to the building, and over the long run their building and living quarters would favorably impress their guests. Architects specified building materials and construction methods that guaranteed a safe environment for residents and low-cost maintenance for the owner. Successfully satisfying all these requirements was a tall order for the architects, who probably never imagined their apartment buildings would still be gracing the Seattle landscape a hundred years later.

In 1908 the Seattle firm of Dose, West and Reinoehl, "Contracting Architects: Builders and Designers of Artistic Homes, Flat, Store and Apartment Buildings," assembled a booklet to introduce potential clients to their business. Not limited to designing buildings, the firm made a specialty of improving vacant property, provided appropriate contractors, furnished plans and specifications via their own plan book or an individual design, and with close connections to the "money market" could assist in obtaining loans. With all these advantages, the company still offered the following argument for the question, "Why hire an architect?":

A building is a mass of details, carefully figured out, each in its relation to another and to secure all the benefits necessitates the services of a trained and skilled Architect, whose experience and study can make the result one of complete utility, harmonious, distinctive and characteristic, and not the haphazard creation of a carpenter, who, no matter how proficient in his trade, has not the training nor has he devoted the time to studying the combination of all the features that go so far to make the successful whole.[1]

Architectural Training

The 1900 *Polk's Seattle City Directory* listed Henderson Ryan as a contractor. In 1901, and each year through 1923, he was listed as an architect. Did Ryan, one of Seattle's more prolific designers of apartment buildings, misrepresent himself? Not in the least. In the early years of the twentieth century, "architects" gained their credentials in a number of ways.

In the introduction to *Building Together: A Memoir of Our Lives in Seattle*, Peter Staten remarks that local architect William J. Bain was in the minority when he returned home with an architectural degree from the University of Pennsylvania. Staten notes that until the turn of the century,

> Most Seattle architects were strays from other parts of the world. Their training was as various as they were: some had learned their craft in correspondence schools, some evolved from engineers ... a few arrived with degrees ... others had little academic training but qualified as architects by having worked for years in eastern architectural offices ... still others developed their styles by avid reading in the many architectural pattern books.[2]

APPRENTICESHIPS

One of the most common ways to receive instruction was by means of an apprenticeship, a time-honored form of training. The Hotel Pelham, built in Boston in 1857 and considered America's first true apartment house, was designed by Alfred Stone, who had earned his credentials by serving four apprenticeships in the space of five years. "Apprenticeships such as these were the standard method of training in the mid-nineteenth century for architects who did not come directly from the building trades."[3] Architect Max Umbrecht, known for his design of downtown Seattle hotels and at least one apartment building, was the grandson of a bridge builder and son of a building contractor. A graduate of the University of Syracuse, he was initially grounded in his architectural training via the apprentice system. For many aspiring architects, apprenticeships allowed them to become accustomed to the ways and means of the profession as well as opening up opportunities for future contacts.[4] The same was true for potential contractors and builders.

PLANS AND PATTERN BOOKS

Books of building plans have long played an important role in the training of architects, builders and contractors. The result of inexpensive printing and improved mail service, the popularity of pattern books reached its zenith around the turn of the twentieth century.[5] Architecturally designed plans enabled contractors and builders to use details or even entire building plans for clients. Donald Luxton, author of *Building the West: Early Architects of British Columbia*, says that prior to the regulation of the architectural practice, "anyone with a pattern book in their hands could, and often did, call themselves an architect."[6]

When New York City built its first apartment building in 1869, Seattle was a fledgling town of about 1,000 residents. The simple structures being built here at that time, writes Jeffrey Ochsner in *Shaping Seattle Architecture*, were constructed by local contractors or by itinerant contractor-builders.[7] "[T]he reality is that in city and rural America, common buildings built by land speculators, novice would-be homeowners, carpenters, and unskilled workers, account for the vast majority of housing. Much of that was inspired by pattern

and plan books," and goes far in accounting for the sameness of buildings which stretch across the United States.[8] The earliest catalog of the Territorial Library in Olympia, Washington, included plan and pattern books.[9]

In 1907 Seattle architect Victor Voorhees advertised, "Build an Apartment House" for $65.00. For that amount he would provide complete plans, specifications, and details for a six-unit apartment building, "complete in every respect."[10] Between 1907 and 1911, Voorhees also published a fully illustrated plan book, *Western Home Builder*.

In 1907 Seattle contractor C. F. Borton advertised in a local newspaper, "Improve Your Property with One of Our Apartment Houses" and encouraged readers to "call and see the designs we have, embodying a similarity of interior arrangement, with a distinctly different exterior."[11] Local architect Elmer Ellsworth Green published his *Practical Plan Book* around 1912. Although it was limited to house plans, Green is known to have designed a number of Seattle apartments.

Fred Anhalt, a builder of some of Seattle's most recognizable apartments in the 1920s, favored English, Norman, and Spanish Mission–style architecture, for which he consulted a variety of books. Seattle architectural historian Larry Kreisman says that "Anhalt never imitated entire buildings because he never found any one that he was sufficiently pleased with in all its aspects to duplicate."[12] Referring to his stock of architectural reference books, Anhalt himself said he would select "a window I liked here, a door there, and something else over there."[13] Anhalt relied on the talents of gifted draftsmen to execute his plans.

The ultimate purveyor of house plans, Sears, Roebuck and Company, produced the

The sixth edition of Victor Voorhees' popular *Western Home Builder*, an illustrated plan book, did not include plans for apartment buildings, but it did have a page of drawings for a variety of them, for which his firm would furnish plans.

Book of Modern Homes: Containing 110 Designs with Plans and Total Cost of Building Material.
Unlike Voorhees' pattern book, Sears did not charge for the plans that, in addition to homes,
included flats and apartment buildings. Since Sears shipped all the materials necessary—
from millwork and gutters to medicine cases and mantels—to complete the building, the
company made its money with the implementation of the plans.[14]

ARCHITECTURAL EDUCATION

What options were available to those who wished to pursue an architectural education?
Due to the technological changes occurring as early as 1861, colleges began to develop cur-
ricula concentrating on the sciences. Schools then added architectural drafting, design, and
structural methods to their engineering programs: Massachusetts Institute of Technology
in 1868, the University of Illinois in 1870, Cornell in 1871, Syracuse University in 1873, the
University of Pennsylvania in 1874, and Columbia University in 1881.[15]

In 1907, the *American Architect and Building News* published a half-page list of schools
that offered architectural programs. Listed were the University of Pennsylvania, which
offered a number of options, including a four-year degree program, a graduate year, and
a two-year certificate program. The University of Illinois had a four-year professional pro-
gram as well as special courses for draftsmen and "constructors." The Department of Archi-
tecture at the Massachusetts Institute of Technology, which admitted college graduates and
draughtsmen as special students, offered options in architectural engineering and landscape
architecture. Harvard University's Graduate School of Applied Science and the Lawrence
Scientific School included graduate and undergraduate courses in architecture. The depart-
ments of architecture at both Washington University of St. Louis, Missouri, and the Uni-
versity of Michigan offered four-year courses. At both of the latter, draughtsmen were
admitted as special students.[16]

Nearer to home, architectural programs were initiated in 1914 at both the University
of Washington and the University of Oregon. Carl F. Gould, respected Seattle architect,
founded the Department of Architecture at the University of Washington. His impeccable
educational credentials included graduation from Harvard and an additional five years at
the École des Beaux-Arts in Paris. He also interned with the prestigious New York firm of
McKim, Mead and White before settling in Seattle. During his tenure at the University of
Washington, the Department of Architecture was granted membership in the National
Association of Collegiate Schools of Architecture, placing it among the eighteen leading
schools of architecture in the United States.[17] It was also during Gould's tenure that the first
three women were admitted to the program. Gould was chairman of the university's archi-
tecture program until 1926.

Travails of the Profession

The ups and downs of Seattle's economy affected all members of the building trades.
The architectural profession, which depended on the health of the construction industry,
keenly felt each movement of the economy. In 1883, when the Northern Pacific Railroad
reached Seattle, architects had already begun to arrive in anticipation of a building boom.
After Seattle's Great Fire of 1889, architects, contractors, and builders poured in to partic-
ipate in the rebuilding of the city. As the economic pendulum continued to swing, the Panic

of 1893 resulted in a dearth of construction activity that forced many architects either to leave Seattle or take other jobs. Speaking of this period, Dennis Andersen and Jeffrey Ochsner, coauthors of *Distant Corner: Seattle Architects and the Legacy of H. H. Richardson,* refer to the dilemma of the "volatility of architects' careers."[18] Nowhere was this more evident than the stream of architects who moved between Seattle and British Columbia to seek work in whichever area had the stronger economy at the time.

Additionally, it was not uncommon for architects to move around within their profession, working for different firms within the same city. Unlike the above conditions, this was usually a matter of choice This was certainly true in Seattle where an architect might work for one firm, or be in partnership with another colleague or two, only to move to another firm or partnership after a period of time. This activity is reflected in the multiple architectural collaborations that produced many of Seattle's early apartment buildings.

In retrospect, the hard times of the 1893 depression benefited the Washington State architectural scene in that it led to "an effort to organize the practice of architecture on a more professional basis."[19] In 1894, architects from Seattle, Tacoma, and Spokane formed the Washington Society of Architects. When the society, in the same year, was granted a charter by the national organization of the American Institute of Architects (AIA), the northwest group became the Washington State chapter of the AIA.

The genesis of the national AIA occurred in New York City in 1857, when a group of thirteen architects met "to create an architecture organization that would 'promote the scientific and practical perfection of its members' and 'elevate the standing of the profession.'"[20] In 1867 the group modified an earlier mission statement to read, "To unite in fellowship the Architects of this continent, and to combine their efforts so as to promote the artistic, scientific, and practical efficiency of the profession."[21] Behind this exemplary statement also lurked the desire to prevent nonprofessionals from infringing on their interests.[22] Prior to 1857, anyone could call himself an architect, since neither schools of architecture nor licensing laws existed.[23] In 1897 Illinois became the first state to adopt a licensing law. Nearly two decades later, in 1919, Washington State followed suit, setting standards for competence that included education and practical intern experience before being allowed to take the five-day licensing exam. The newly created state board of architect examiners, composed of AIA members, administered the exam.[24]

Contractors and Builders

Vernacular housing, at its simplest, is defined as architecture without architects.[25] Gail Dubrow and Alexa Berlow, authors of "Vernacular and Popular Architecture in Seattle," wrote that beginning in the late 1880s, architects usually were responsible for important commercial and institutional structures, but residential and commercial buildings "were not products of architectural custom design."[26]

Nevertheless, among the numerous contractors and builders of apartment buildings, there were some with prestigious reputations. Gardner Gwinn, Sam Anderson, and Fred Anhalt were merchant builders, a term that describes a person, or a company, that buys land and develops it into housing, responsible not only for construction, but the financing and marketing.[27] Some had an in-house group of designers, whereas Stephen Berg, another Seattle merchant builder, used the services of architects Stuart and Wheatley for the design of his apartment buildings. John S. Hudson was an anomaly in the profession in that he

was a trained architect but preferred the role of builder, leaving the design of buildings to his brother, Harry.

Biographies

The following biographies are limited to the architects and builders who designed or built one or more apartments mentioned in *Shared Walls*. The amount of personal information about the men varies. The lives of some are well documented, while others have many holes in their background. The information was gleaned from a wide variety of sources, from censuses and city directories for placing their physical whereabouts, feature articles and passing comments in local newspapers, architectural journals, architectural files in libraries, and helpful library staff from Vermont to Oregon. The Internet, and its easy access to U.S. Census information and the *Seattle Times* archives, opened up information previously difficult and time consuming to access.

The names of apartment building(s) designed by the architect and discussed in *Shared Walls* follows each biography. The list is in no way indicative of all the apartments each architect designed, and, conversely, many architects who did design apartments in Seattle are not included because *Shared Walls* does not discuss any of their buildings.

WILLIAM H. AITKEN

Aitken, a Glaswegian by birth and graduate of the Glasgow Technological College, emigrated from Scotland in 1915. He and his wife and two children were living in Seattle in 1920, having arrived via Vancouver, British Columbia.[28] Aitken's active career spanned the decades: in the 1920s he designed at least two apartment buildings. In the nearby communities of Sumner he designed a Masonic lodge (1924), and in Mt. Vernon he designed a theater (1926).[29] In the 1940s, he was one of five architects who worked on the innovative Yesler Terrace Housing, a large low-cost housing project in Seattle. In the 1950s he collaborated on the design of Lakeview School (1954) on Mercer Island, a growing community on the east side of Lake Washington where he lived. Aitken died in Seattle on July 22, 1961.

Harvard Crest (1926) 135 Harvard East

A. H. ALBERTSON

Albertson came to Seattle in 1907 as a representative of Howells and Stokes, a New York firm hired to develop the University of Washington's downtown property. Abraham Horace Albertson, known as A. H., was born in Hope, New Jersey, on April 14, 1872. He graduated from Columbia University in 1895 with a degree in architecture.

While acting as supervising architect for the White-Henry-Stuart Building, part of the University of Washington's metropolitan tract, Albertson generated other work for Howells and Stokes, both in Seattle and San Francisco. At some time between 1917 and 1920, Howells and Stokes segued into the partnership of Howells and Albertson. In 1924 Albertson established his own firm with his two longtime associates, Joseph Wilson and Paul Richardson. Their work focused on large buildings.[30]

In 1935 the firm became Albertson, Wilson and Richardson. With little work due to the Depression, and the death of Richardson in 1939, Albertson joined the state office of

the Federal Housing Authority and was serving as chief architect at the time of his retirement in 1949. He died on April 18, 1964, at age ninety-two.

Rivoli (1910) 2127 Second Avenue (Howells and Stokes)

FRANK P. ALLEN

Allen's name appears only in the 1910 *Polk's Seattle City Directory* listing of architects, the year he designed the Old Colony. Other works with which he is credited make it appear that he was more of a project manager than architect, which would fit with his role during the Alaska-Yukon-Pacific Exposition. A Seattle Times article said that the fair buildings themselves — the practical work of building the exposition — was the work of Frank P. Allen, Jr., director of works and president of Frank Allen, Inc., architects and engineers. The article also mentioned that Allen received his technical training at the University of Michigan and that he had been working in the Pacific Northwest since 1903.[31]

Allen's admirable work with the AYP must have reached the ears of planners for San Diego's Panama Pacific Exposition. Although it did not take place until 1915, Allen was already living in San Diego in June of 1911, "engaged in the same capacity."[32] There he was part of the "trio of exposition builders," working with Bertram Goodhue, advising architect, and John Charles Olmsted, landscape architect, both highly respected in their fields.[33] He died in Wilmington, California, from injuries incurred from an industrial accident, in July of 1943.[34]

Old Colony (1910) 615 Boren

SAMUEL ANDERSON

Master builder Samuel Anderson was born in Muskegon, Michigan, and arrived in Seattle in 1906 from Wausau, Wisconsin. In 1918 he organized the Seattle Master Builders Association and later served as regional vice president and national director of the National Home Builders Association. He practiced in Seattle for 55 years, retiring two years prior to his death in 1959. His obituary described him as "the dean of home builders."[35] When advertising, he stated that his work was the standard by which all others of its kind were judged. His numerous apartment buildings, including the Fleur de Lis, reflect that pride.

Fleur de Lis (1929) 1114 Seventeenth Avenue

FREDERICK ANHALT

Fred Anhalt arrived in Seattle, originally from North Dakota but via Portland, in the mid–1920s. With little formal education and no prior building experience, he developed a successful business through hard work, an eye for quality, the availability of pattern books, and the talented draftsmen and architects who transferred his ideas to paper. He and Jerome B. Hardcastle, Jr., who formed the Western Building and Leasing Company, initially employed outside architects and contractors. But "Anhalt increasingly made both design and construction an in-house function of the company."[36] His apartment buildings, which emphasized quality materials and workmanship and the latest amenities, appealed to the luxury market. The Ten-O-Five East Roy is a prime representative. Anhalt built about thirty apartment buildings or bungalow courts in the late 1920s and early 1930s, the majority on Capitol Hill, including the Belmont Court, one of a cluster he erected at the north end of the hill.[37]

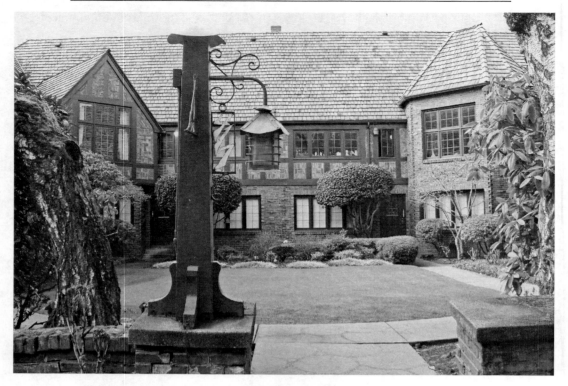

This "Anhalt," as buildings like it are popularly known, is in the heart of the Broadway district and stands out for its serene courtyard, one of Anhalt's trademarks.

His business a victim of the Depression, Anhalt turned, quite successfully, to the garden nursery business. In 1993, in recognition of his building contributions, the Seattle Chapter of the American Institute of Architects made him an honary member. Anhalt, who was born on a farm near Canby, Minnesota, on March 6, 1895, died in Seattle on July 17, 1996.

Belmont Court/750 Belmont (1929) 750 Belmont Avenue East
Ten-O-Five East Roy (1928) 1005 East Roy

WILLIAM J. BAIN, SR.

Born in New Westminster, British Columbia, on March 27, 1896, Bain moved to Seattle in 1903. Before graduating from high school, he had already worked for several Seattle architects, including W. R. B. Willcox. He also apprenticed with Marcus Priteca and Arthur Loveless. On his return from service in World War I, Bain attended the University of Pennsylvania and graduated with a degree in architecture in 1921. He spent two years in California and then returned to Seattle, opening his first office in 1924. "With his Beaux-Arts background and his engaging manner, he quickly developed a reputation for quality residential architecture."[38] Beginning in 1928, Bain and Lionel Pries, who had been classmates at the University of Pennsylvania, practiced together. They designed a number of apartments for Bain's father. Pries, born in San Francisco in 1897, was known for his illustrious thirty-year teaching career at the University of Washington. He died in 1958.

The firm dissolved in 1933 as a result of the deteriorating construction industry brought

on by the Depression. By the late 1930s, working solo, Bain's business had returned to normal. Bain was one of the founding partners of NBBJ, established in 1943 and today a global architectural firm. On the occasion of his being elected a fellow of the AIA in 1947, the *Journal of the American Institute of Architects* offered this tribute: "In community, state, and national affairs he has liberally and intelligently contributed of his training, reflecting credit to his profession and benefiting the society of which he is so vital a part."[39] He died on January 22, 1985.

Envoy (1929) 821 Ninth Avenue (Bain and Pries)
Belroy (1931) 703 Bellevue Avenue East (Bain and Pries)

Frank Lidstone Baker

Although Baker's obituary states he was a native of Ontario, Canada, census information shows him born in Germany around 1874, suggesting he immigrated to Canada at a young age. He came to the United States in 1894 and studied architecture at the University of Pennsylvania, from which he graduated.[40] He continued his studies in Paris and other European cities, and on his return he worked with firms in New York City. By 1908 he was in Seattle, and from 1911 until 1914 he practiced with James Blackwell. It was during this partnership that the two designed the mammoth Sears and Roebuck department store on Seattle's First Avenue South.[41]

In 1919 he became a member of Baker, Vogel and Roush and remained associated with them until his death on January 14, 1935. "[A]n idealist in architecture, continuously devoted to the highest ideals of his profession ... he was a lover of nature, fond of music, and deeply interested in the social welfare of the people."[42]

Dover/Amon/Highland/Laveta (1914) 901 Sixth Avenue (Blackwell and Baker)
Stratford/Nesika (1916) 2021 Fourth Avenue (Blackwell and Baker)
Laurelton (1928) 1820 Sixteenth Avenue (Baker, Vogel and Roush)

Stephen Berg

Born in Trondheim, Norway, on March 17, 1877, Berg learned the building trade at his father's knee. After immigrating to the United States in 1905 and a brief stay in Boston, Berg moved to Seattle, where he pursued his trade. He first worked for others, and then established his own business in 1909. He concentrated on the construction of residences, apartments, and hotels. Berg was not quite thirty years of age when he was described as "a typical young business man of the present age, alert and enterprising, and his career has been marked by steady progress."[43]

By 1925, Berg, now a builder, contractor, and hotel operator, oversaw a small empire. Berg's apartment credits include the downtown Claremont Apartment Hotel, which he also owned and operated, and the Biltmore, Stephensberg, and Casa Nita on Capitol Hill.[44] Berg wisely chose the architectural firm of Stuart and Wheatley, who designed elegant buildings for him, including the preceding as well as the Mayflower Park Hotel (1927), originally named the Bergonian, in downtown Seattle. Berg was living in Auburn, Washington, when he died on January 5, 1966.[45]

Henry Bittman

Bittman grew up in a suburb of New York City and received his education at Cooper Union and the Pratt Institute, where he focused on structural engineering. He came to

Seattle in 1906 and briefly worked with architect William Kingsley. Although Bittman was a licensed architect, some colleagues were dismissive of his early engineering training. It served him well, however, in his successful architectural-engineering firm, and he was known for his use of steel in design. Bittman's long association with Harold Adams, a gifted architect who studied at the University of Illinois at Champaign, "formed a powerful design collaborative."[46]

Bittman's large projects, the Terminal Sales Building, Olympic Tower, and Eagles Auditorium, continue to be mainstays of Seattle's architectural fabric and reflect his firm's skillful use of terra cotta and cast stone. Born July 15, 1882, Bittman practiced for forty-five years, until his death on November 16, 1953, in Seattle.[47]

Eagles Temple, Senator Apartments (1925) 700 Union Street

JAMES EUSTACE BLACKWELL

An architect and civil engineer, Blackwell received his education in the town of his birth, Fauquier, Virginia. He graduated from the Bethel Military Academy as a civil engineer and initially practiced engineering, working as a surveyor in his home state. Then he studied and worked in various cities on the East Coast before moving to the Northwest around 1891. From 1891 until 1910, he and Robert L. Robertson worked together in Tacoma, Washington; Portland, Oregon; and Seattle.[48] Once settled in Seattle, Blackwell actively engaged in civic life.[49] In 1901 he argued for the establishment of a new city building department, "entirely separate or distinct from the engineering department."[50] He and architect Frank Baker were in partnership from 1911 until 1914.

Blackwell was the resident engineer for the United States Shipping Board from 1918 through 1920 and two years later became Seattle superintendent of buildings; he served as city engineer from 1922 until 1926. Hs obituary mentioned that he was eighty-three years old when he died on April 5, 1939, and that the "veteran architect" designed nearly two hundred structures in Seattle.[51]

Dover/Amon/Highland/Laveta (1914) 901 Sixth Avenue (Blackwell and Baker)
Stratford/Nesika (1916) 2021 Fourth Avenue (Blackwell and Baker)

JOHN CARRIGAN

Born in New York State on March 2, 1864, Carrigan spent his early years in Buffalo and his school years in Saginaw, Michigan. He graduated from the Polytechnic School of Chicago and then worked as a draftsman for several firms in the same city. He came to the West Coast in 1906, and after spending time in Los Angeles, San Francisco, and Portland, he arrived in Seattle in 1907.[52] The 1910 census shows him living at 1202 East Pine Street in the Gordon Apartments.[53] He died on July 24, 1922.

Bamberg (1910) 416 E. Roy Street

JOHN CREUTZER

Creutzer emigrated from Sweden in 1892 and spent his growing-up years in Minnesota. As an adult, he first located in Spokane, but moved to Seattle in 1906 to supervise work for Alex Pearson, who needed a "competent superintendent of construction" for his work in Seattle.[54] Creutzer is an example of the dual roles that many architects assumed.

A prolific designer, Creutzer is responsible for many apartment buildings that still grace downtown, First and Capitol hills, and other areas of the city. Most recognized for his design of Seattle's Medical and Dental Building (1924), he was "known for his superior skill in designing beautiful and financially successful apartment houses and office buildings."[55] Born on September 22, 1873, he died in Seattle on August 23, 1929. He was "firmly respected and esteemed by all."[56]

Julie/El Rio (1929) 1924 Ninth Avenue
Lenawee (1919) 1629 Harvard
Union Arms–Union Manor (1926) 604 East Union

JULIAN F. EVERETT

Everett was born in Wisconsin on October 5, 1869.[57] He studied at the Massachusetts Institute of Technology before coming to Seattle in 1904. A tribute to him appeared in the September 21, 1912, issue of the *Town Crier*, which said Everett was the designer of "as many beautiful buildings as any architect in the Northwest" but does not advertise himself or his work.[58] Although he maintained an independent practice, he occasionally worked with W. R. B. Willcox, and the two were in practice together when they designed the Leamington Hotel and Apartments in downtown Seattle. Everett practiced in Seattle until 1922. He later moved to California and was living in Los Angeles when he died on January 13, 1955.

Pacific/Leamington (1916) 317 Marion Street (Everett and Willcox)

FRANK HOYT FOWLER

Both a practicing architect and engineer, Fowler immigrated to the United States in 1892 from Canada, where he was born on September 2, 1882.[59] In 1909 his name first appeared in the 1909 Seattle city directory. In following years, the directory variously listed his profession: in 1910 as a draftsman for the Chicago, Milwaukee, and Puget Sound Railway; in 1911 as a mechanical engineer for the same company; in 1916 as a civil engineer; and in 1917 as an architect.

A few architectural firms had engineers on their staff, but it was not the norm.[60] Fowler, presumably due to on-the-job training he acquired while working for the railway, worked in both capacities. He was thus able to design and superintend the construction of buildings, notably the Wilsonian Apartments. During his twenty-year practice in Seattle, Fowler served as president of the Seattle chapter of the American Society of Civil Engineers and was a member of the AIA. Considered an authority on masonry and timber construction, Fowler served on the 1918 Building Code Commission.[61] He died December 8, 1931.

Wilsonian (1924) 4710 University Way Northeast

JOHN GRAHAM, SR.

Born in 1873 in Liverpool and educated on the Isle of Man, Graham acquired his architectural training via an apprenticeship with an architect in his native England.[62] After extensive travel, he settled in Seattle in 1901.[63] In 1905 he began a partnership with David Myers; among their many commissions were several apartment buildings.

In 1911 Graham began his own practice. In 1914 he designed a building for local assembly of the Model T, which obviously impressed decision makers at the Ford Motor Company,

as Graham was chosen to be the company architect. The family moved to Detroit and over the course of the next three years he designed more than thirty assembly plants for the company.[64]

Graham's firm was responsible for many downtown Seattle commercial buildings, including the Bon Marche Department Store (1927–29) and the Roosevelt Hotel (1928–29). "It would not be an exaggeration to say that he was a major shaper of the early twentieth-century face of Seattle."[65] Graham died on March 15, 1955, in Hong Kong, China, while on an around-the-world pleasure trip.

John Graham placed his business advertisement in the *Seattle Times*, September 30, 1923.

Helen V/Algonquin (1907) 1321
 East Union and 1133 Fourteenth Avenue East (Graham and Myers)
Park Hill/Lagonda/Robinson (1907) 1301 East Madison/1300 East Union (Graham and Myers)
Vintage/Spring Park Apartment Hotel (1926) 1100 5th Avenue

ELMER ELLSWORTH GREEN

Green published the *Practical Plan Book* in 1912, in which he described his architectural education in the book's foreword:

> Before taking up the study of drawing I spent several years with the best and most experienced builders I could find, and learned thoroughly the mechanical end of building construction. After becoming an expert in that line I took up the study of drawing and design, and now with twenty-five years experience on high-class work, I believe I am in a position to give the very best service that money can buy.[66]

Green was born in Janesville, Minnesota, on January 8, 1861. He moved to Canada in 1895 and lived and worked near Victoria until 1903, when he moved to Seattle. He set up as draftsman and carpenter/builder. In 1907 he is listed under architects in the city directory. In 1909 he won first prize in a bungalow competition and went on to build many of that type. Building permits indicate he designed dozens of houses and apartments on Capitol Hill and other Seattle neighborhoods.[67] In 1912 he opened an office in Victoria, British Columbia, in a space that he shared with two other Seattle transplants, architects Joseph S. Cote and William Doty Van Siclen.[68] He closed that office in 1915 and by 1917

E. ELLSWORTH GREEN

Architect and Constructing Engineer

SEE ME FOR HIGH CLASS WORK

A record covering 30 years of honest dealing. Ask my patrons about me

Ellsworth Green's business advertisement appeared in the 1907 *Polk's Seattle City Directory.*

had also left Seattle. In 1927 he was living in Sierra Madre, California.[69] He died in Eureka, California, survived by his wife and nine children, in 1928.[70]

Summit Arms/Beaumont (1909) 1512 Summit (Green and Aiken)
Ben Lomond (1910) 1027 Bellevue Court East

EMIL GUENTHER

Emil Guenther von Swartzenberg was born in Germany on May 4, 1855. He studied architecture at a university and worked afterward for three years in Berlin before immigrating to the United States in 1879.[71] He established a practice in New York, and in 1886 he moved to San Antonio, Texas. One year later he deserted his wife and three children in Texas and eloped with a wealthy widow to San Diego, leaving behind not only his family, but his last name.[72] In 1888 he moved to Spokane, where he maintained a successful practice for a number of years before moving to New Westminster, British Columbia, in 1898. After moving back and forth between British Columbia and San Francisco, he settled in Seattle in 1914.[73] In 1920, at age sixty-four, he was living in Seattle with his thirty-year-old daughter and his eighty-nine-year-old father-in-law.[74] Working beyond the usual retirement age, the following year saw the completion of the North Apartments. The last mention of Guenther is in the December 14, 1930, issue of the *Settle Times*, regarding a proposed apartment building; the place and date of his death are unknown.

El Capitan/North (1925) 1617 Yale

CHARLES A. HAYNES

Born in California in 1870, Haynes was working in San Francisco in 1900, where he lived with his wife and young daughter.[75] He arrived in Seattle in 1907 and worked in numerous partnerships over the years, both in Seattle and Aberdeen, Washington. His work included homes and commercial projects. He died in Seattle in June 1940.

Roy Vue (1924) 615 Bellevue Avenue
Bonair (1925) 1806 Eighth Avenue

HENRY E. HUDSON

Hudson, usually called Harry, was born in New London, Minnesota, around 1882. He came to Seattle in 1904 and was in a partnership with James A. Gibbs for thirty years. Hudson designed many apartment buildings that his brother, John, constructed. The two of them named their buildings after New England icons, both sites and people. Hudson served as architect and chairman of the King County Parks and Recreation Department. He died in Seattle in August 1963.

Lowell (1928) 1102 Eighth Avenue
Emerson (1928) 1110 Eighth Avenue

JOHN S. HUDSON

John Hudson, licensed to practice architecture in Washington, preferred the building and business aspect and left the design to his brother Harry, although both came from a long line of builders.[76] He was born in New London, Minnesota, on March 21, 1879, and

grew up on the family farm. He came to Seattle in 1903 and started working as a builder and contractor. In 1910 Hudson began to study architecture and in 1921 received his license.[77]

He associated with local architects—quite often his brother Harry—and constructed an impressive list of apartment buildings. Hudson built, owned, and at one time lived in the Northcliffe, designed by Daniel Huntington.[78] He associated with architect H. G. Hammond on numerous First Hill apartment buildings. The 1920 census shows him living in a private home on Capitol Hill, but later he again lived in apartments and a hotel.[79] Hudson served as president of the Washington State Society of Architects and was on the King County Planning Commission.[80] He died in October 1945.[81]

DANIEL R. HUNTINGTON

Huntington, who was born in Newark, New Jersey, on December 24, 1871, grew up in New York City, except for an undetermined amount of time when he and his parents lived in Texas.[82] He attended Columbia Grammar School in New York City. With no formal architectural education, "his training was laboriously gained as an apprentice in a Denver architectural office" where he worked from 1889 until 1894.[83] He then moved to New York but after six years returned to Denver, and between 1901 and 1905 he was in partnership with William E. Fisher, a prominent Denver architect.[84] Huntington then moved to Seattle.

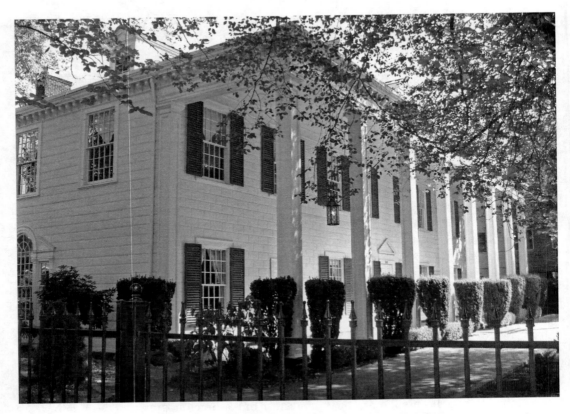

In 1925 the Rainier Chapter of the Daughters of the American Revolution asked Huntington to draw plans for a smaller but "faithful reproduction" of Mt. Vernon for their clubhouse on Capitol Hill.

In 1907, Huntington and James Schack formed a partnership, and during the two years they worked together, their firm designed the De la Mar Apartments, which are listed on the National Register of Historic Places. After he and Schack dissolved their partnership, Huntington briefly worked with Seattle architect Carl F. Gould, while at the same time maintaining an independent practice.

Huntington served as Seattle City architect from 1912 until 1921. In addition to designing municipal facilities, including two Seattle city landmarks, the Wallingford Fire and Police Station and the Lake Union Steam Plant, he maintained a private practice and briefly (1912–14) associated with architect Arthur Loveless. It was after he left civil service that he designed two large apartment buildings on Seattle's First Hill, the Northcliffe and, with partner Arch Torbitt, the Piedmont.[85]

He was twice elected president of the Seattle chapter of the American Institute of Architects.[86] He served on the faculty of the University of Washington and was a painter of some renown. Upon retirement in 1947 he moved to Oregon City, Oregon, but returned to the Seattle area in 1955, where he died on May 13, 1962.

De la Mar (1909) 115 W. Olympic Place (Schack and Huntington)
Chasselton (1925) 1017 Boren Avenue

ISHAM B. JOHNSON

Little is known of the life and career of Isham B. Johnson. A native Washingtonian, he was living in Seattle at the time of the 1910 census when he was thirty years old and listed his occupation as a building inspector.[87] At the time of the 1920 census, his occupation was architect.[88]

Arcadia Apartments (1916) 1222 Summit Avenue

TIMOTHEUS JOSENHANS

Josenhans was born near Stuttgart, Germany, on October 11, 1853, and immigrated to the United States with his family in 1855. He grew up in Michigan and studied civil engineering at the University in Ann Arbor, graduating in 1878. He moved to Chicago where he studied architecture under William Le Baron Jenney, known for designing America's first true skyscraper.[89] Josenhans then lived and worked in Iowa, New Mexico, California, and Portland, Oregon, before arriving in Seattle in 1888.

Josenhans initially worked as a draftsman for Hermann Steinman, but beginning in 1894, he worked with James Stephen for three years. Their firm designed buildings for the State Agricultural College, now Washington State University. From 1899 until 1912 Josenhans and Norris Best Allan practiced together, designing many residences as well as Parrington Hall, which opened as Science Hall in 1902 on the University of Washington campus. Allan later served in the Building Department of the city of Seattle.[90] Josenhans died in 1929. Allan died on September 24, 1932.[91]

Buena Vista (1907) 1633 Boylston Avenue.

ROBERT KNIPE

Knipe was born in Ireland in 1876 and immigrated to the United States in 1903.[92] The following year he was living in Seattle, clerking for a stationery and printing company. City

directories indicate that in 1906 Knipe was a student at the University of Washington; in 1908 he worked as a draftsman; and between 1909 and 1918 he worked as an architect. The 1913 and 1914 directories indicate that not only was he an architect, but he was also president of the Western Building and Investment Company. After 1918 Knipe's whereabouts are unknown.

Gables (1911) 403–409 Sixteenth Avenue East

GEORGE W. LAWTON

At his death, it was noted that Lawton was "as well known and popular in the entire building profession as any on the Pacific Coast."[93] For thirty-five years Lawton practiced architecture throughout the Northwest.[94] He was in partnership from 1898 until 1914 with Charles Saunders, for whom he had worked as a draftsman between 1889 and 1891. After the firm dissolved, Lawton practiced alone, although he did work with A. W. Gould when the two designed Seattle's well-known Arctic Building. In 1922 he formed a partnership with Herman Moldenhour, which lasted until 1928.[95] In addition to a number of apartment buildings, the firm also designed the Masonic Temple, constructed in 1915 in the heart of Capitol Hill's Auto Row. Lawton was born in Wisconsin on December 29, 1864, and died in Seattle on March 28, 1928.

San Marco (1905) 1207–09 Spring Street (Saunders and Lawton)
Russell (1906) 909 Ninth Avenue (Saunders and Lawton)
Castle Arms/Castle (1918) 2132 Second Avenue
Olive Crest (1926) 1510–24 Olive Way (Lawton and Moldenhour)

CARL L. LINDE

Born in Brunswick, Germany, on May 21, 1864, at age five Linde came to America with his parents. The family settled in Milwaukee, Wisconsin, where Linde attended the German-English Academy. After apprenticing with a local architect, he worked in offices in Milwaukee, Chicago, and San Francisco before moving to Portland, Oregon, in 1906. He first worked for well-known Portland architect Edgar Lazarus, then briefly practiced on his own, and then vacillated between private practice and working at various jobs. In 1921, after a five-year stint in private practice, he associated with Richard Wassell, a developer and contractor.[96]

Linde designed many of Portland's major hotels and apartment buildings, a number of which are listed on the National Register, including the Ambassador Apartments. A Portland landmark built in 1922, it is one of the "oldest continuously fashionable apartment residences in Portland's central business district."[97] Linde was familiar with many architectural styles, showing a preference for Jacobean Revival, which he later applied to the Camlin. Critics characterized his work as being "rooted somewhere in the sixteenth or seventeenth century" and wrote that when architecture headed toward a more modern idiom, he was unable to shift with the times.[98] Linde died in Portland on July 12, 1945.[99]

Camlin (1926) 1619 Ninth Avenue

ARTHUR LOVELESS

Loveless was born in Big Rapids, Michigan, in 1873, and was ninety-seven when he died in 1971. A graduate of Columbia University, he studied architecture in Europe and

worked for a New York architectural firm before coming to Seattle around 1907, when he went into partnership with Clayton Wilson.[100] Loveless also worked briefly with Daniel Huntington before opening his own practice in 1915. He was known for his eclectic designs, which he applied to residences, his primary focus. In 1940 Loveless was elected a fellow of the AIA.

Loveless Apartments (1931) 711 Broadway East

ANDREW McBEAN

Andrew McBean was born in Scotland in 1867. He immigrated to the United States in 1889. At the time of the 1900 census he was living in St. Louis, Missouri, and working as a draftsman. His name first appears in the 1905 *Polk's Seattle City Directory*, in which he listed his profession as architect. Since he is mentioned in the May 11, 1905, issue of the *Seattle Times* as the one who superintended the erection of the Alaska Building, he arrived in Seattle prior to 1905. It is probable that he worked for the St. Louis architecture firm of Eames and Young, which designed the Alaska Building, and was sent to Seattle to oversee the work, and he apparently remained. In 1906 he designed the large Westminster Apartments and in 1907 was the architect for the Schillestad Building, which is listed on the National Register. A few other newspaper references place him in Seattle up to 1909. Based on census information, McBean was living in Portland, Oregon, in 1910, but by 1920 he was back in St. Louis, again listing his profession as draftsman.

Westminster (1906) 903–5 9th Avenue

EDWARD L. MERRITT

Merritt, the son of a successful building contractor, was born in Northfield, Minnesota, on October 31, 1881. He studied architecture at the University of Minnesota and graduated in 1900. Merritt then came to Seattle and joined his father's general contracting business. The two later acquired a third partner and organized Merritt-Hall, an investment company.[101] By 1914 Merritt had become an associate of Jud Yoho, president of the Bungalow Publishing Company, head of the Craftsman Bungalow Company, and a notorious self-promoter.[102] In the mid–1920s Merritt opened the Merritt Realty Company, proving himself a well-rounded businessman. Merritt was also one of the members of the "founding triumvirate" of the Seattle Master Builders Association and served as its first president.[103] "An experienced professional with practical business knowledge, specialized technical training, and active community involvement," he was "a savvy diplomat" who worked well with all levels of the business community and heightened the credibility of the home builders' society.[104] By 1924 Merritt was practicing architecture independently and advertised that his firm not only planned homes, but financed and built them.[105] Information regarding Merritt seems to stop after 1939.

Buckley (1928) 201 Seventeenth Avenue East
Sheffield (1929) 200 Seventeenth Avenue East

WARREN H. MILNER

Described as "one of the rising young business men ... of more than ordinary skill and genius" by a hometown publication, Warren Milner was born in Bloomington, Illinois, in

1864.[106] Educating himself via an apprenticeship, he studied under one of Bloomington's leading architects, H. A. Miner. After spending eighteen months with him, Milner went to the Minneapolis–St. Paul area in 1884 and worked there for a year as a draftsman. In 1885 he returned to Bloomington and opened his own office. In 1888 he moved to Peoria, where he designed numerous impressive residences and the Woolner Block, the city's first large-scale office building. The 1889 Peoria city directory indicated that Milner practiced with Oscar McMurray, who had studied at Cornell, and George Davis, who had studied at Princeton. By 1894 Milner had left Peoria and moved to Chicago, where he worked until 1907.[107]

Milner moved to Seattle and was listed as an architect in the 1908 city directory. In 1910 he also was working in Victoria where he and architect John R. Wilson formed a "local partnership of convenience" that lasted about five years.[108] It was not unusual for an architect to maintain an office in two locations at the same time, for if the job market improved in one place, an office could shift its resources to take advantage of available work. In Seattle, Milner formed a partnership with architect Edwin Ivey in 1911.

In addition to apartments, Milner designed the Trianon Ballroom in downtown Seattle in 1927, purportedly his last project.[109] Fittingly, he lived in an apartment at the Trianon until his death in 1949.[110]

Humphrey (1923) 2205 Second Avenue

HERMAN A. MOLDENHOUR

Moldenhour, a native of Yankton, South Dakota, moved with his family to Seattle in 1893 when he was thirteen years old. He completed eighth grade before dropping out of school in order to work.[111] At age twenty he became an office boy, and later draftsman, for the architectural firm of Saunders and Lawton, a partnership that dissolved in 1914. In 1922 Lawton and Moldenhour formed a partnership, which lasted until Lawton's death in 1928. A number of extant downtown and Capitol Hill apartments resulted from their partnership. Moldenhour then practiced alone, and it was during this period that he served as architect for the Port of Seattle, which led to his designing the modern administration building and passenger terminal at Seattle-Tacoma International Airport. It was dedicated in 1949, the year of his retirement. Moldenhour died on December 14, 1976, at age ninety-six.

Olive Crest (1924) 1510–24 E. Olive Way (Lawton and Moldenhour)

EARL W. MORRISON

Although born in Sibley, Iowa, Morrison grew up in Spokane, Washington. While attending high school he opened an office, and by graduation he had worked up a large practice in designing small homes.[112] He left Spokane to attend the Art Institute of Chicago, from which he graduated in 1913.[113] Afterward he resumed his practice in Spokane, designing apartments and homes. After World War I he practiced in Wenatchee, Washington, during which time he designed the town's courthouse. Morrison, who maintained an office in Spokane until 1925, practiced with Vas S. Stimson in Wenatchee from 1919 until 1926.

"Scarcely a town in the state cannot show an example of his handiwork," and in Seattle alone he designed many buildings, including a number of large and "some twenty or thirty smaller apartments [that] testify to Mr. Morrison's skill."[114] Born on December 24, 1888, Morrison died in January 1955 while vacationing in La Jolla, California.[115]

Marlborough House (1927) 1220 Boren Avenue
Olive Tower (1928) 1626 Boren Avenue
Edwards on Fifth/Le Sourd (1929) 2619 Fifth Avenue
1223 Spring (1929) 1223 Spring Street
Gainsborough (1930) 1017 Minor Avenue
La Vanch (1931) 956 Tenth Avenue East

DAVID J. MYERS

Myers was born in Glasgow, Scotland, in December 1872. He immigrated to the United States in 1889, arriving in Seattle with his family in the early 1890s.[116] He worked for different architects until 1894, when he went east to study architecture at the Massachusetts Institute of Technology. In 1900, newly married, he was living in Boston and worked there and in Pittsburgh before he returned to Seattle in 1905. He went to work as the junior partner of John Graham, Sr., with whom he remained until 1910. Myers was involved with the Bogue Plan and served on the architecture faculty at the University of Washington from 1917 until 1920.[117] The prestigious architectural and engineering firm of Schack, Young and Myers was formed in 1920. In 1929 Myers left the firm and went back into private practice. He was made a fellow of the AIA in 1934, a few years before his death on May 9, 1936.

Helen V/Algonquin (1907) 1321 East Union and 1133 Fourteenth Avenue East (Graham and Myers)
Park Hill/Alagonda/Robinson (1907) 1301 East Madison (Graham and Myers)

W. W. NOYES

William W. Noyes was born in Michigan in 1860 but in 1900 was living in Seattle, working as a carpenter. In the 1911 city directory his name appears under the listing of architects. In 1920 he was living in Riverton, "Seattle's most picturesque suburb."[118] Noyes also dealt in real estate, and based on the type of property he sold, he had a fondness for farm and ranch properties, which could explain his living in a more rural area. He was still living in the same area at the time of his death on February 23, 1932. His obituary remarked that the seventy-one-year-old architect and contractor was "active in his profession almost to the day of his death."[119]

Melrose (1916) 1520 Melrose Avenue

EDWARD THOMAS OSBORN

British born (around 1866) and educated, Osborn worked in New Zealand, California, and Canada before arriving in Seattle, where he was living as early as 1900.[120] He had a reputation as an inventor, having received patents for a folding bathtub, and was a "renowned delineator."[121]

Osborn worked actively in Seattle and the Pacific Northwest between 1910 and 1930. He was a draftsman for a number of architectural firms, including E. W. Houghton, John Graham, Marcus Priteca, and Bebb and Gould. Between 1920 and 1930 he practiced independently, and it was during this period that he designed his two known apartment buildings in Seattle. After his years in the Pacific Northwest, his whereabouts are unknown, including the date and place of his death.

Charlesgate (1922) 2230 Fourth Avenue

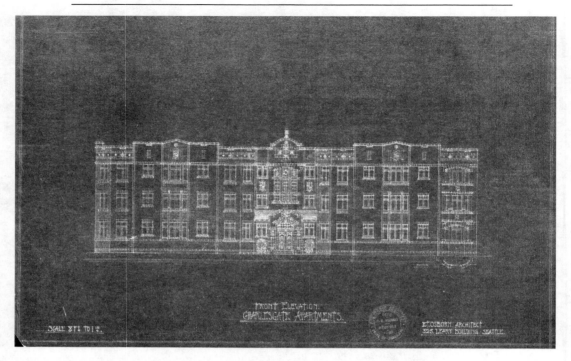

Osborn's talents are evident in this drawing of the Charlesgate Apartments' front elevation. *University of Washington Libraries, Special Collections, UW 2947lz.*

FRANK H. PERKINS

Perkins designed a large number of apartments, as well as residences, commercial buildings, hotels, and the Forest Ridge Convent and School (1910), all within Seattle.[122] The April 2, 1904, edition of the *Seattle News-Letter*, "Seattle's Society Paper," stated that "Mr. F. H. Perkins was attracted to Seattle a little more than a year ago from southern California, where for five years prior to coming here he was architect and superintendent for practically all of Senator W. A. Clark's work in California and Arizona."[123] Before arriving in Los Angeles in 1887, he had lived and worked in St. Louis for fifteen years. He was slowly making his way west from New York, where he was born February 19, 1850, had attended school, and served an apprenticeship.[124] Once in Seattle, he practiced independently for the next two decades, designing a large number of apartment buildings, principally on Capitol Hill. At the time of the 1920 census, he and his sister, both in their sixties, lived together. To the census taker, he gave his occupation as "house architect."[125] There is no record of his death.

Chardonnay/Bellevue (1907) 203 Bellevue Avenue
LaCrosse (1907) 302 Malden Avenue
Moana (1908) 1414 East Harrison

BENJAMIN MARCUS PRITECA

"Benny" was born in Glasgow, Scotland, on December 23, 1889. Apprenticed at a young age, he simultaneously took classes at Edinburgh University and the Royal College of Arts, earning a degree by the time he was twenty. With his mother and two sisters, Priteca immigrated in 1909 and came to Seattle.[126] He later reflected that if "it hadn't been for the AYP

exposition I never would have come here. Right from the beginning I determined to stay here."[127] His first job was as a draftsman for architect Edwin Houghton, but after meeting theater mogul Alexander Pantages, Priteca began his long tenure as the exclusive architect for the Pantages theater organization. The association lasted from 1910 until 1929.[128] "Lavishly outfitted with a terra cotta façade ... entertainment embodied" describes his 1916 design for the Pantages Theatre in Vancouver, British Columbia.[129] On a second Vancouver theater, the Orpheum, Frederick J. Peters was Priteca's associate architect. Licensed to practice in Washington State, Peters lived in Seattle but also practiced in Vancouver. In 1928 the two again worked together, this time as partners, on the lobby and apartment portion of Seattle's Paramount Theater. Priteca designed Seattle's Coliseum Theater, which included a large dome above the entry. [30]

Although best known for his theaters, Priteca also designed synagogues, residences, and was a consultant for Seattle's 1962 Opera House. After a "long and fruitful career that spanned six decades," Priteca died on October 1, 1971.[131]

Paramount Theater Studio Apartments (1927–28) 901 Pine Street

HOWARD H. RILEY

Riley, a native of Ohio, was born around 1888.[132] He worked in Seattle from 1914 until his death on September 24, 1950. In the 1920s, his work ran the gamut, from the large Flem-

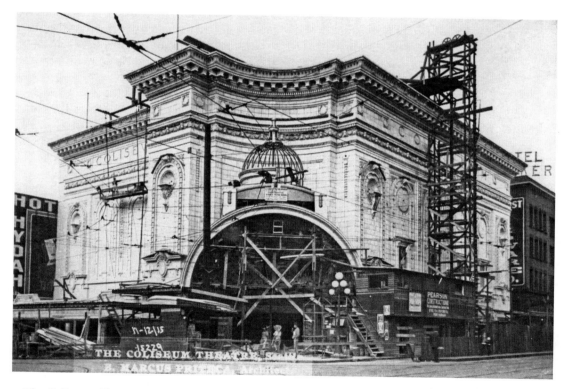

The Coliseum Theater, under construction in 1915, is in the heart of Seattle's business district. In recent years it has been sensitively adapted for use by a large clothing company. *University of Washington Libraries, Special Collections, UW 12910.*

ington Apartments building, to a French chateau-type waterfront home, to Seattle's Fremont Baptist Church. During the 1930s he "created many effective and economic designs for operative builders throughout the Pacific Northwest" for the Western Homes Foundation.[133] Except for the years 1919–1921, when he shared a practice with Edwin J. Ivey, Riley maintained his own firm.

Capitol/Flemington (1924) 906 East John Street
Lauren May/Westwood (1928) 5814 Twenty-Second Avenue Northwest

AMBROSE RUSSELL

Russell, who became a noted Tacoma, Washington, architect, was born in India on October 15, 1857, to missionary parents. Of Scottish ancestry, at a young age he returned to his homeland, where he received most of his early education. He studied architecture at the University of Glasgow and went on to spend three years at the École des Beaux-Arts in Paris. In 1884 he came to the United States, where he worked in the Boston office of Henry Hobson Richardson, one of America's most prestigious architects. Before arriving in Tacoma in 1892, he had worked in Massachusetts, Kansas City, and St. Louis, Missouri.[134] After a series of brief partnerships, Russell associated with Everett P. Babcock in about 1905.[135] Two of their Tacoma apartment buildings, the Woodstock and the Rutland, are listed on the National Register, and in 1908 their firm drew the plans for the governor's mansion in Olympia, Washington.

Russell and Babcock associated with U. Grant Fay to design Seattle's First Baptist Church (1912), located only two blocks east of the St. Paul Apartments, which Russell, with Walter Spalding, had designed in 1901. The Russell-Spalding Company was listed in the 1901 *Polk's Tacoma City Directory*; at the same time, Spalding, Russell and Heath maintained an office in downtown Seattle.[136]

Russell and Babcock closed their Tacoma office and opened the firm of Russell, Babcock and Rice in Vancouver, British Columbia, around 1912. With too few commissions, Russell returned to Tacoma in 1915, where he designed the Masonic temple, the state armory, the Tacoma Country and Golf club house, and many residences. When he died in March 1938, his obituary stated that the well-loved Tacoman had not only seen the village grow but had "designed many of the buildings and homes that have made it a city."[137]

St. Paul (1902) 1206 Summit Avenue

HENDERSON RYAN

Ryan, who designed a church, a Carnegie library, private homes, and several theaters, also designed a significant number of Seattle apartment buildings. A man of many talents, he received a patent for his invention of a ramp used in theaters that maximized convenience and seating capacity.[138] He equipped the Waldorf, the large downtown apartment building he designed, with an early central vacuuming system, an idea of Ryan's that "so far as known has never been installed in any other similar building ever constructed."[139]

Ryan was born between 1854 and 1856 in Alabama and attended the University of Kentucky.[140] In the early 1890s he and his growing family lived in Fort Smith, Arkansas, where he was a general contractor and builder.[141] His business was substantial enough that he did work in Oklahoma as well.[142] He arrived in Seattle around 1898, where he remained until 1923. Ryan's practice was at its peak of activity in the early years of 1900; in 1907 he designed

the Roycroft, one of his signature apartment buildings, about which the management was proud enough to advertise that it was "the most elegant and best appointed apartments on the Coast."[143]

At the time of the 1910 U.S. Census, Ryan and his family were living at 320 Union, in the Antlers Hotel, with Ryan the proprietor, his daughter the manager, and one of his sons a clerk.[144] The hotel may have been a sideline, since he still listed himself as an architect in the 1910 *Polk's Seattle City Directory*.

In 1926, when the *Washington State Architect* published a list of architects licensed in Washington who were living elsewhere, Ryan's residence was in Los Angeles, and it was in California that he died, date unknown.

Waldorf (1906, destroyed) 704 Pike Street
Bel Fiore/Marne/Uhlan/Josephine/Rosenbaum (1907) 1707 Bellevue Avenue
Monroe (1907) 428 Fifteenth Avenue East
Fredonia (1907) 1509 East Mercer

CHARLES W. SAUNDERS

Saunders was born in Cambridge, Massachusetts, on October 12, 1857, and raised in the Boston area. By 1886 he was living in Pasadena, California.[145] In 1889, the year of Seattle's disastrous fire, Saunders moved to Seattle and after only a few months formed a partnership with Edwin W. Houghton. By mid–1892 Saunders was practicing independently. During this period he won the design competition for Denny Hall (1895), the first building on the University of Washington's campus.[146] In 1898 he and his draftsman, George W. Lawton, formed a partnership that lasted until 1915.

After the dissolution of the partnership, Saunders maintained a much-reduced architectural practice, perhaps to devote more time to his other interests. He had an abiding concern for the environment and promoted forest fire prevention, reforestation, and conservation efforts at an early date. He served as secretary of the Seattle Board of Park Commissioners for two years. For ten years Saunders served as a Washington state representative from the Forty-fifth District, taking a leading part in the development of the state park system. And he was a baritone, who sang in his church choir for many years.[147] Saunders, a charter member of the Washington State chapter of the AIA, retired in 1929 and died March 13, 1935.[148]

Caricature of Charles W. Saunders from *Argus: Men Behind the Seattle Spirit*, H. A. Chadwick, editor. Published at Seattle, Washington, July 15, 1906, by H. A. Chadwick.

San Marco (1905) 1205 Spring Street (Saunders and Lawton)
Russell (1906) 909 Ninth Avenue (Saunders and Lawton)

F. A. SEXTON

Frederick Sexton was born in Norfolk, England, in 1852, and for his education he "studied the best masters."[149] He emigrated in 1881 and made his way west to Tacoma where he practiced from 1887 until 1891. From there he moved to Everett, where he practiced from 1891 until 1894.[150] He opened his own office in Seattle in 1900 but worked all over the state. In 1910 Sexton and his wife were residents of the Farragut, an apartment building of his own design. In 1930 he was living in Sumner, a more rural area south of Seattle, where he owned a farm and listed his profession as farmer.

Bristol (1907) 1626 Thirteenth Avenue
Pine Street Apartments/ Gordon (1907) 1202 East Pine Street
La Villa/Farragut (1907) 1629 Thirteenth Avenue

ALBAN SHAY

Judging by how often Shay's name was mentioned in the newspaper, he and his wife enjoyed a very busy social schedule. Referred to as a "well-known young architect," he and his wife attended a wide range of events and did their share of entertaining. Perhaps part of it was in the line of duty, since he worked independently from 1927 until 1935 and again from 1940 until 1975. Entertaining clients would have been good for his business, since the designing of significant homes was a mainstay of his practice.

Shay attended the University of Washington but received his architectural degree from the University of Pennsylvania in 1922. He then worked in New York for a short period before moving to Seattle and joining Bebb and Gould in 1924, where he remained for three years. After his solo practice, he and Paul Thiry formed a partnership between 1936 and 1939.[151] Thiry was a seminal figure in introducing architectural Modernism to the Northwest, and the two of them produced some strikingly modern homes.[152]

Working on his own seemed to agree with Shay, for he returned to private practice in 1940. He also returned to designing more traditional homes. He was born in 1899 in Columbus, Ohio, retired in 1975, and died in Seattle in 1984.

LaPlaya Vista/Friedlander (1927) 2250 Bonair Place
Mt. Baker Court Condominium/Mt. Baker (1939) 3601 South McClellan Street

ALBERT WALTER SPALDING

Spalding was born in Massachusetts on August 5, 1859, and graduated from the Massachusetts Agricultural College in 1881.[153] He practiced in St. Louis, Minneapolis, and Lewiston, Idaho.[154] It is uncertain where he was living in 1898 when he drew the plans, at the behest of the Department of Interior, for a hotel at the Upper Geyser Basin in Yellowstone National Park. The style of the building disappointed the new president of the Yellowstone Park Association, so Spalding did not get the job.[155]

He arrived in Tacoma in 1901 and established a business partnership with architect Ambrose Russell.[156] A year later he moved to Seattle and into a practice listed as Spalding,

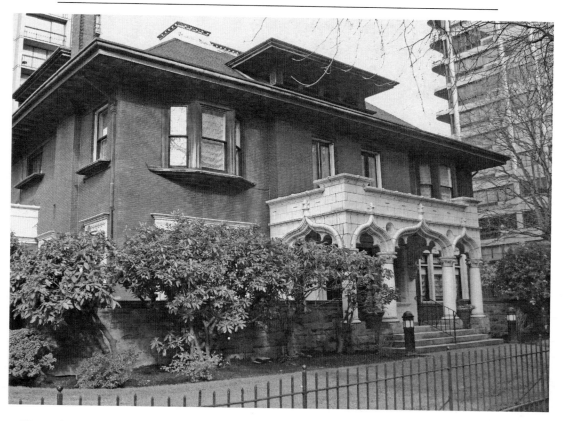

The Hofius House, designed by Spalding, is one of four early mansions that still grace the First Hill neighborhood.

Russell and Heath in the 1901 city directory. The following year he was practicing on his own, and among his many commissions was the Hofius House (1902), the design of which led to his being known for his "Moorish treatment" of residences and apartment buildings.[157] Between 1908 and 1911, he and Seattle architect Max Umbrecht worked together, but after 1912 there is no further mention of Spalding.

St. Paul (1902) 1206 Summit Avenue (Spalding and Russell)

George Wellington Stoddard

Stoddard and his father, Louis, practiced together in Seattle from 1920 until 1929 as Stoddard and Son. They were responsible for a number of apartment houses on Capitol Hill. After his father's death, Stoddard practiced alone until 1955 and then went into partnership with Francis Huggard, where he remained until his retirement in 1960.

Born in Detroit, Michigan, on September 30, 1895, Stoddard attended high school in Chicago and graduated from the University of Illinois with a degree in architectural engineering in 1917.[158] By 1920 his family had moved from Detroit to Seattle, where Stoddard played an active role in many Seattle civic organizations. He died in 1967.

Park Court (1922) 921 Eleventh Avenue East

BERTRAM DUDLEY STUART

Born in London on July 4, 1885, Stuart emigrated in the early part of the second decade of the 1900s. He practiced in Canada, first in Edmonton and then in Vancouver, where he designed Campbell Court (1914), a sophisticated brick apartment building.[159] By 1916 his name was among the Seattle city directory's listing of architects. His partnership with Arthur Wheatley from 1925 to 1930 produced a number of "well-scaled and handsomely detailed ... buildings that contribute[d] character to the urban streetscape."[160] A subsequent partnership with Robert Durham, whom Stuart had earlier employed as a draftsman, began in 1941. He continued to work until failing eyesight forced him to retire at age eighty-six. Stuart died in Seattle in October of 1977.[161]

Ragley (1922) 1608 East Republican
Biltmore (1924) 400 Loretta Place (Stuart and Wheatley)
Roundcliffe (1925) 845 Bellevue Avenue East (Stuart and Wheatley)
Andra/Claremont (1926) 2004 Fourth Avenue (Stuart and Wheatley)
Exeter (1928) 720 Seneca Street (Stuart and Wheatley)

CHARLES L. THOMPSON AND CHARLES BENNETT THOMPSON

Father Charles L. and son Charles Bennett comprised the firm of Thompson and Thompson. Perhaps impressed by their design of the large Monmouth Apartments in the 2000 block of Yesler, which opened in 1908, the firm was approached to design another apartment for a site in the 1200 block of Yesler. The *Seattle Times* reported on January 24, 1909, that Thompson and Thompson were preparing estimates for the Mosler Apartments. The younger Thompson continue to practice after the death of his father in 1927.

The elder Thompson was born in Halifax, Massachusetts, in July of 1842. A Civil War veteran, he was elected president of the King County Veterans Association in 1914 and designed a Grand Army of the Republic memorial for a Pioneer Square site in 1924.[162] Son Charles B. was born in June of 1873 in Kansas and died November 1956 in Everett, Washington.[163]

Dover/Amon/Highland/Laveta
(1904) 901 Sixth Avenue
Clairemont/Monmouth Apart-
ments (1908) 2012 E. Yesler
Way

MAX A. VAN HOUSE

The Van House family left Minnesota, where Max was born in 1887, and settled in the 1890s on Vashon Island, located in Puget Sound. His father was a pioneer farmer on the island.[164] Around 1915, Van House was practicing architecture in Butte, Montana.[165] In 1925

The elder Thompson's grave marker is in Seattle's Grand Army of the Republic (GAR) Cemetery, a burial ground for Civil War veterans.

he was working in Seattle and had his own practice. The last notice of Van House is in 1960, when he was designing, fittingly, an apartment house in Seattle.

Bering (1930) 233 Fourteenth Avenue East

Victor Voorhees

On May 4, 1876, Voorhees was born into a Dutch family in Cambria, Wisconsin. Five years later the family moved to Minneapolis, where Voorhees later studied law and did construction work. He moved to Seattle in 1904. After two brief partnership ventures, he opened his own architectural practice, moving his office to the recently constructed Eitel Building, a notable building at a prominent downtown location, and practiced there until 1926.

Voorhees was a prolific designer, whose lack of formal training did not impact his ability to get commissions. [166] In 1907 he designed Washington Hall of the Danish Brotherhood, recently restored. Judging by the drawings of apartment buildings that appeared in his pattern book *Western Home Builder*, dozens of apartments in Seattle were built according to his designs. [167] He also custom designed buildings.

Voorhees remained in Seattle for almost another three decades. In 1957 he moved to Santa Barbara, California, where he lived in a retirement home until 1965, after which he moved to the home of a niece. He had outlived four wives when he died at age ninety-four on August 10, 1970. [168]

Virginian (1917) 2014 Fourth Avenue
Washington Arms (1920) 1065 East Prospect

Arthur Wheatley

Usually associated with Bertram Dudley Stuart and their very successful practice, Wheatley had his own practice before and after his years working with Stuart. Wheatley was born in England around 1880 and emigrated in 1916. [169] He died in 1948.

Ragley (1922) 1608 East Republican Street
Biltmore (1924) 400 Loretta Place (Stuart and Wheatley)
Roundcliffe (1925) 845 Bellevue Avenue East (Stuart and Wheatley)
Andra/Claremont (1926) 2004 Fourth Avenue (Stuart and Wheatley)
Exeter (1928) 720 Seneca Street (Stuart and Wheatley)

William P. White

Details of the first three decades of White's life are missing. The date and place of his birth are inexact, and any educational experience is unknown. [170] He was living in Butte, Montana, in 1897, when he opened an architectural office, and by 1900 he had entered into a partnership with Werner Lignell. [171] White arrived in Seattle in 1902, and based on city directories, he practiced in Seattle until 1921. Between 1910 and 1912, White worked both in Seattle, in partnership with Jesse M. Warren, and in Vancouver, British Columbia. [172] During this short period he designed twenty-two apartments in the Vancouver area, some of which are extant, including the venerable Sylvia Hotel, which opened in 1912 as the Sylvia Court Apartments. [173] At some point he moved to Bremerton, Washington, and at the time of his death on April 5, 1932, his obituary stated that he had been employed in the Bremerton navy yard as an architectural draftsman since the war. [174]

Based on the output of his work, White had a very busy practice and was said to have "set the standard in gracious apartment living."[175]

Manhattan Flats (1905, demolished) 1722 Boren Avenue, 1107 Howell, 1121 Howell, 1725 Minor Avenue
Petra/Silver Bow/Cyrus (1908) 1703 Harvard Avenue
Olympian (1914) 1605 East Madison

WALTER ROSS BAUMES WILLCOX

An educator and architect, Willcox was born in Burlington, Vermont, on August 2, 1869. He received his training at Kalamazoo College in Michigan and the University of Pennsylvania.[176] He then apprenticed with firms in Chicago and later Boston, where he informally attended classes at the Massachusetts Institute of Technology.[177] Between 1895 and 1907 he practiced in Burlington, where he was one of the few professionally trained architects in the city and was responsible for some of its most significant architecture.[178] He then spent a year studying in Europe before moving to Seattle in 1907. William J. Sayward, an architect from Woodstock, Vermont, moved to Seattle at the same time, and "the new architectural firm of Willcox & Sayward ... opened offices early in February 1908."[179]

Elected a fellow of the American Institute of Architects in 1910, Willcox served on the Municipal Planning Commission and supported Virgil Bogue's 1911 Seattle Plan. Two of

Willcox created a beautiful design for a utilitarian structure, the Lake Washington footbridge, also known as the Lake Washington Sewer Bridge. The footbridge spans Lake Washington Boulevard, which winds through Seattle's Arboretum. *Seattle Municipal Archives 4378.*

Willcox's public projects, the footbridge and viaduct over Lake Washington Boulevard in the Arboretum, and the Queen Anne Boulevard retaining walls, are Seattle city landmarks.

While Willcox was president of the local AIA chapter, he was instrumental in fostering the establishment of an architectural degree program at the University of Washington in 1914. He subsequently moved to Eugene, Oregon, where he was professor of architecture and head of the Department of Architecture at the University of Oregon. During his lengthy tenure, from 1922 to 1943, he reshaped the department by moving away from "traditional methods of architectural education" to focusing on problem solving.[180] He died on April 20, 1947.

Pacific/Milner/Milner Highland/Penbrook/Pennington/Leamington (1916) 317 Marion Street (Everett and Wilcox)

Why Hire an Architect?

One can agree to some extent with architectural historian Elizabeth Collins Cromley's statement that "[f]or those who enjoy the artistic achievements of architecture, apartment buildings offer few rewards."[181] Her words could rightly describe some, perhaps even many, apartment buildings in Seattle. But for those buildings that fit a difficult site like a glove, greeted residents with a blast of colorful tiles in the entryway, sported fire escapes of ornamental iron that were works of art, displayed walls composed of inventive brick design, and still comfortably housed dozens of individuals and families within their own private space, thanks go to the talented architects and builders of early Seattle apartment buildings.

4

Apartment Fundamentals:
Styles, a Seattle Form, Classes,
and Building Materials

> Faced on the exterior with a light buff face brick trimmed with terra cotta sills, inserts and belt courses.
> Building and basement of mill construction. The exterior will be Tudor Gothic type.
> Six stories of safety and convenience. Re-enforced steel and concrete construction.

Building materials were chosen for their appropriateness to the architectural style of the building, the class of tenants to be attracted, and budget. Over time, three *classes* of apartment buildings settled into place: efficiency, intermediate, and luxury. No one particular architectural style dominated any of the classes; styles ran the gamut and frequently were an amalgamation of styles, or no style at all. Seattle, however, could claim a specific building *form*, one that suited the climate and was widely employed for the efficiency and intermediate classes of apartments. The form is easily recognized: recessed openings on the floors above the front entrance and a bay, or bays, of windows on either side. The form is not specific only to Seattle, but its ubiquity, and variations on the theme, make it a familiar sight all around the city.

Architects and builders, with their knowledge and experience and the financial support of eager investors, designed and constructed apartments that still line the streets of Seattle neighborhoods, an indication of the quality of their construction. From both economic and aesthetic perspectives, the selection of building materials played a pivotal role. The appropriate choice of structural materials ensured the building's stability and longevity. Materials selected for exterior and ornamental effects influenced an apartment's outward appeal, which played a part in its success, since a building filled with tenants meant more income for owners and the likelihood that it would survive.

Architectural Styles of Seattle Apartment Buildings

The *Oxford English Dictionary* defines *architectural style* as "a definite type of architecture, distinguished by special characteristics of structure and ornament." Most Seattle apartment buildings, to borrow from *What Style Is It?* "defy stylistic labels."[1] This was not peculiar to Seattle, however. Michael Doucet and John Weaver, authors of *Housing the American City*, contend that "[b]y the 1920s architects had already worked out schemes for achieving decorative enhancement that would hold middle-class tenants. By continent-wide conventions apartment building exteriors strove for ageless simplicity."[2]

There are certain styles that repeatedly define Seattle apartment buildings, even if only ornamentally rather than structurally. Beaux-Arts Neoclassical and Tudor describe a large number of apartment buildings featured in *Shared Walls*. Queen Anne and Colonial-Georgian Revival are also well represented. Gothic, Spanish Mission, Italian Renaissance, French, Collegiate Gothic, and Mediterranean Revival also make appearances, but Moderne/Art Deco details can be seen on a surprisingly large number of Seattle apartment buildings. A fair portion of the buildings are hybrids; that is, they have characteristics of more than one style. For instance, the styles listed for the Bering are Beaux-Arts Neoclassical and Tudor. Occasionally, stylistic labels reflect on a particular structural feature, such as the Glencoe's arched entry, which is reminiscent of the Richardsonian-Romanesque style of architecture. "Style" was most often acquired by the application — toward the end of the construction period — of ornamental terra cotta or cast stone that bespoke a particular style or, frequently, a combination of architectural styles.

The following definitions are for the four styles of apartment buildings most often represented in *Shared Walls*. The definitions transcend time periods and are subject to interpretation by builders and architects. But even cursory definitions can be useful in understanding the history of a style and helpful when identifying a building's features in an attempt to determine its style.

BEAUX-ARTS NEOCLASSICAL

Beaux-Arts Neoclassical refers both to the aesthetic principles of the Parisian École des Beaux-Arts, which "emphasized the study of Greek and Roman structures, composition, [and] symmetry," and the revival or new interpretation of those classical designs.[4] The École des Beaux-Arts, or School of Fine Arts, influenced art and architecture for 250 years, both in Europe and the United States. Seattle apartments often feature an entry surrounded by, or porch supported by, Ionic or Corinthian columns and symmetrically balanced facades, hallmarks of the style.[5]

TUDOR

Tudor-style buildings have little connection to the period and architecture from which they take their name, early sixteenth-century English housing. It is, rather, an amalgam of "late Medieval English prototypes ... freely mixed in their American Eclectic expressions."[6] Tudor style relies on one or more of the following features: steeply pitched roofs; asymmetrical gables; dormer windows; decorative half-timbering; and leaded, multipaned casement windows. On some apartments, it only required something as modest as the use of a Tudor arch — a flattened, pointed arch — to categorize it as Tudor. Seattle builder Fred Anhalt heartily embraced the Tudor style, and many of his apartment buildings employed an array of its characteristic features. Many Seattle architects adopted the style, one of several revivals (Gothic, Georgian, Spanish Colonial) popular in America up through the 1920s.

QUEEN ANNE

Similarly, buildings in the Queen Anne style do not reflect on the formal Renaissance architecture of the early 1700s; the term describes a much later period when "classical ornament was grafted onto buildings of basically medieval form."[7] Key elements are contrasting materials on different floors, gabled and hipped roofs, occasionally with turrets, and stylized relief decoration, such as decorative shingles.

The Sherwood's porch is an example of the Beaux-Arts Neoclassical style.

COLONIAL-GEORGIAN REVIVAL

It is fairly easy to recognize buildings in the Colonial-Georgian Revival style. Georgian architecture, based on interpretations of Renaissance architecture by Andrea Palladio and Christopher Wren, arrived about 1700 in the United States. It emphasizes classical detail, such as quoins, pilasters, and a centered front door decoratively capped. Dentils and other molding highlight cornices. The Colonial Revival style has its roots in Georgian architecture, and front doors are more accentuated, with fanlights and sidelights, and are often protected by extended porches that are supported by columns.

Although Seattle apartments seldom exhibit "a definite type of architecture, distinguished by special characteristics of structure and ornament," the variety of styles frequently employed by architects do add richness and distinction to a building's appearance. Seattle does have, however, a form of building that relied less on style and more on appropriateness to the climate and simplicity of construction. But even these buildings received the occasional flourish of classical columns, fanlights, or dentiled cornices.

A Seattle-Centric Building Form

Driving or walking through Seattle neighborhoods that have concentrations of apartment buildings, one is struck by the repetition of a particular form, best described as rectangular or square in shape and featuring at least one bay on either side of a centrally located

Colonial-Georgian Revival describes the columns and fanlight of the porch, the Algonquin's best feature.

and recessed opening at each floor above the entrance. Variations on this theme exist in every Seattle neighborhood.

The form makes sense in Seattle's often gray climate, because the bays, with their concentration of windows, allow more light to enter the units. The recessed areas also serve as

One bay of windows on either side of the recessed openings of the Sherbrook is the simplest and most widely used variation of the Seattle-centric form.

porches, increase ventilation to the units adjacent to them, and occasionally hold the building's fire escape, with ladders running from floor to floor through them. Over time, some recessed openings have been filled in to create more interior space.

Three Classes of Seattle Apartments: Efficiency, Intermediate, Luxury

From 1901, when Seattle's first purpose-built apartment building was erected, three classes of apartment buildings gradually evolved, which *Shared Walls* refers to as efficiency, intermediate, and luxury.[8] Definitions of the three types are helpful but cannot take into account the myriad of variables within each. In response to market demands, all three types were built simultaneously during the 1900 to 1939 time period.

EFFICIENCY APARTMENTS

Nationwide, the largest number of efficiencies were built in the period between the 1880s and the 1930s, writes John Hancock, author of "The Apartment House in Urban America," found in *Buildings and Society: Essays on the Social Development of the Built Envi-*

ronment. He defined efficiencies as "compact one- to five-room units in small walk-up buildings several stories high, covering half a block or less of land, and located in or near the city's middle- and lower-income residential areas and around commercial/industrial sub-centers."[9] The term for efficiency has segued into studio, but the concept is essentially the same. The one to five rooms that Hancock referred to included a living room, kitchen, eating alcove or dinette, bathroom, and dressing room, which was a glorified closet that functioned as a space for concealing a bed or beds. A small entry hall was almost always present.

Exteriors of the buildings were usually brick, with terra cotta or cast stone decoration, always around the entrance, and often elsewhere. On the inside, the units were compact but had the basic amenities of a stove and either a cooler box, icebox, or, later, refrigerator in the kitchen. All were furnished with heat, laundry facilities in the basement, and some form of hidden bed.[10] Compactness was achieved by careful planning that eliminated or combined rooms so that one space served two or more purposes, and by arranging the kitchen and eating area within a limited floor area.[11] The development of space-saving equipment, such as built-in cabinets, china cupboards, and tables and benches with storage beneath the seats, facilitated such arrangements. Efficiency apartments built between 1900 and 1939 are ubiquitous in present-day Seattle.

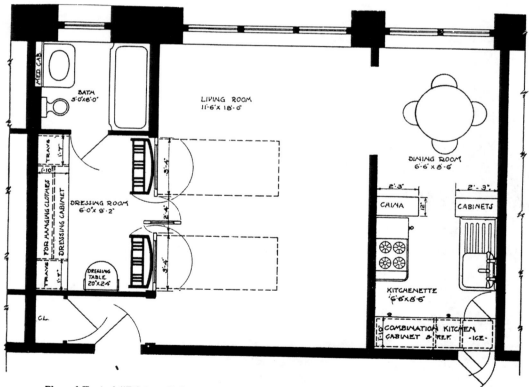

Plan of Typical "Efficiency" Apartment Showing Double Utility Space, Compact Arrangement and the Usual Equipment

253

Plan of an efficiency apartment that appeared in *Architectural Forum*, November 1924.

Quintessential Efficiency: The Charlesgate (1923) 2230 Fourth Avenue

The Charlesgate is a classic example of an efficiency apartment building: a small three-story walk-up building that covers half the block. Situated in a downtown neighborhood, it attracted people who wanted easy access to their work and to the amenities that left them spare time to enjoy the benefits of living near the heart of Seattle's entertainment and shopping venues.

Architect Edward Osborn designed the Charlesgate Apartments for Investors Corporation, which upon the building's completion sold it to Margaret Dudley. Dudley sold the building a year later. When the Charlesgate opened in 1923, a local newspaper article noted that it was "designed in the Tudor style and finished with burlap brick and beautifully planned bricks arranged to accentuate the effect of the architectural detail."[12] The Tudor style is seen in the gabled parapet at the center of the building, narrow windows in groups of three, and the not-so-subtle shields and medallions in the primary bay. Cast stone decorations, particularly around the entrance, are a nice foil to the dark red brick facade.

A stickler for detail, Osborn stipulated in his plans that not only the treads and risers of stairs leading from vestibule to lobby be marble, but that they be "highly polished."[13] The I-shaped building has a central corridor that extends from the lobby to the rear entrance; secondary corridors run perpendicular to it at both the front and rear. Units line both sides of the corridors. In all, there are sixty-two individual apartments, ranging in size between

In 1930, the Charlesgate and the Franklin Apartment buildings (the latter to the left and across the street from the Charlesgate) were not far removed from a later phase of Denny Regrade activity. *Seattle Municipal Archives 3874.*

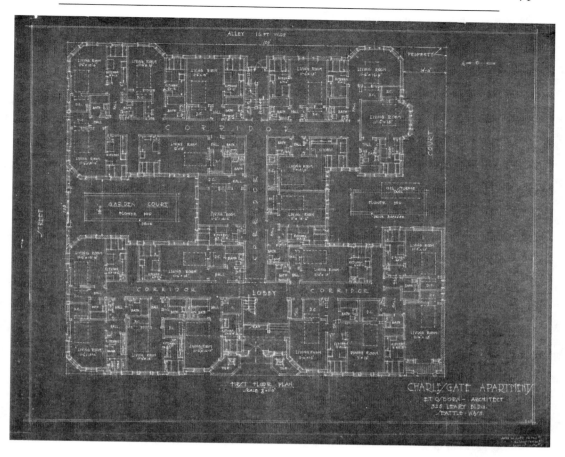

In architect Edward Osborn's first floor plan for the Charlesgate, note the garden courts on the north and south sides of the building that provided welcome green spaces. *University of Washington Libraries, Special Collections, UW 29470z.*

425 and 450 square feet. Each consists of an entry hall, living room with wall bed, kitchen with eating nook, and a bathroom.

Original kitchen plans included space-maximizing built-in wooden benches with decorative backs, placed on either side of a movable wooden table. The hinged seats of the benches opened to reveal storage bins inside. A cooler, gas range, oven, sink, icebox, and recessed ironing-board closet were in the small kitchen.[14] The basement held an apartment for the janitor, a locker for every unit, a large laundry with a ten-rack gas dryer, and five two-burner laundry gas plates for the washers.

Living in an attractive and well-conceived building, located near the downtown business district and with a streetcar line in front, outweighed any inconveniences incurred from living in a small unit at the Charlesgate.[15]

VARIATION ON A THEME: THE APARTMENT HOTEL

Beginning in the 1920s in Seattle, many multifamily buildings called themselves "apartment hotels." They were taller than the typical walk-up, boasted impressively decorated facades and elaborate lobbies, and featured attractions such as public dining rooms, pas-

senger elevators, and roof gardens, but most, and sometimes all, individual units were efficiencies. The taller buildings with their plush lobbies and public dining rooms hearkened back to the Lincoln and the Perry, Seattle residential hotels that were built downtown and on First Hill in the early part of the century. The presence of a kitchen in each unit of an apartment hotel, however, was the defining difference between them and the earlier residential, or family, hotels.

Even though an article in a 1921 issue of the *Washington State Architect* asserted that the term *apartment hotel* originated in California — the result of demands by tourists who wanted lodgings that offered hotel-like services *and* the privacy of an ordinary apartment — the term had been used in New York City in the late nineteenth century.[16] Lacking a strict definition for an apartment, the term *apartment hotel* was used interchangeably with *family hotel*, and even *apartment*. Strictly speaking, however, the New York apartment hotel could best be described as "a big bold, 20th century boarding-house."[17] In this type, units had only two rooms and a bath, and tenants took meals in their building's public dining room.[18]

In Seattle apartment hotels, tenants had their own kitchens, but in some they also had access to in-house dining rooms and some hotel services. The *Washington State Architect* believed Seattle and other larger cities would benefit from apartment hotels and promoted them as a necessity if the tourist trade to the state were not to be lost.[19] Including kitchens in units would increase the amount of time that tourists, generally from upper-income brackets, stayed in Seattle, shopping and spending money. Judging from the number of advertisements for Seattle apartment hotels, such as the Cambridge, Northcliffe, Piedmont, Rhododendron, and Olive Tower, it becomes apparent that investors, architects, and builders heeded the journal's advice.

Architectural Forum devoted its entire November 1924 issue to the topic of apartment hotels. One article promoted the use of efficiency units within apartment hotels because of their higher investment return. It advised, not so tactfully, that with careful planning, tenants could have "complete and attractive living facilities within a smaller floor area than that to which they have been accustomed in the past."[20] Squeezing more rentable units from a given space appealed to building owners, if not the tenants, because "concentration of population upon costly floor space increases tremendously the return per square foot" of apartment hotels.[21] Adhering to most of the *Forum*'s suggestions, the Spring, the Claremont and the Camlin apartment hotels opened their doors in Seattle in 1926.[22]

Quintessential Apartment Hotel: The Camlin (1926) 1619 Ninth Avenue

Now listed on the National Register, the Camlin opened in late October of 1926 as an apartment hotel. Located just north of the intersection of Ninth Avenue and Pine Street, it was in the heart of Seattle's theater district. Less than a year-and-a-half after opening, the Paramount Theater opened almost diagonally across the street from the Camlin. Business and shopping attractions were also nearby. Because it stood eleven stories tall, had a façade elaborately embellished with terra cotta, boasted a plush lobby, and its upstairs units were efficiencies, it fit the definition of an apartment hotel.

Hancock writes that apartment hotels attracted single affluent people who were drawn by the "functions and advantages of a hostelry with those of a private apartment."[23] Information from the 1930 United States Census, however, does not exactly follow suit. Among the Camlin's fifty residents, there were fifteen married couples, representing more than half the residents.[24] Many of the occupations listed in the census denoted affluence: physician,

The architecture of the Camlin, dwarfed by taller buildings and facing Seattle's downtown transit center, is in contrast to all about it.

jewelry store owner, lawyer, president of a shipping company, rancher, bottle factory owner, consulting mining engineer, consul, advertising executive, real estate broker, and investment executive. But other occupations were salesmen of coffee, sewing machines, metal, real estate, insurance, and boats and motors, as well as one teacher. Eileen and Estelle Allen, who lived together and presumably were related, listed their occupations, respectively, as "operator of a beauty salon" and "saleslady, ready to wear."[25]

Tenants, their guests, and prospective tenants would have been impressed by architect Carl Linde's imaginative finishes on the simple T-shaped building. He ornamented the Camlin's facade in a profusion of early English decoration: Tudor and ogee arches, trefoils, quoins, gargoyles, and niches.

Linde visually divided the facade of the building into three horizontal sections. Glazed terra cotta tile covers the ground floor, or base, which is punctuated by the main entrance, with its elaborate terra cotta surround. Red brick faces the eight-story central shaft. Within this space, seven bays are interspersed by windows with glazed terra cotta lintels and sills. The tenth floor, or cap, is a profusion of terra cotta decorations. The recessed eleventh floor is not visible from the street.

Originally an arched awning extended from the sidewalk to the Tudor-arched entry. Iron light fixtures and terra cotta jesters, which hold a shield incised with *1926*, flank glass double doors. Above the doors, an eagle holds a plaque incised with *The Camlin*. Inside the marble-lined vestibule, an identical set of doors opened into the lobby, replete with Italian murals, mahogany woodwork, coffered ceilings, and deep carpeting. "Vestibule and lobby design were especially important since these spaces provided potential renters and residents' guests with their first impression of a building's quality and, by extension, that of its residents."[26] Directly across from the entrance, two elevators stood ready to whisk guests and residents upstairs.

On the first floor, there were eight bachelor apartments, which consisted of a single room and bath. The remaining were efficiency units and were furnished—down to the Tudor-design glass and chinaware imported from England. The large multipurpose living space featured disappearing twin beds.

A dinette, complete with a miniature French dining table and hand-painted chairs, adjoined the living room via French doors. A tiled bathroom and a kitchenette, "the house-wife's dream come true," supplied the final touches.[27] Although the Camlin did not have an in-house dining room, it offered its residents the option of ordering "[f]rom the Camlin cuisine ... anything in reason morning, noon and night, from the simplest breakfast to the most epicurean dinner, and [could] have it delivered by uniformed waiters and served steaming hot in the apartment."[28]

INTERMEDIATE APARTMENTS

A demand for accommodations that fell between efficiency units and luxury housing was met by developers, architects, and builders who responded with a class of apartments that were a cut above efficiencies but not as costly as luxury apartments. Many renters wanted more space and amenities than the former offered but could not afford the higher rates of the latter.

The exteriors of this class of apartment generally featured more elaborate terra cotta or cast stone ornamentation, and entries were made more inviting through the addition of leaded and beveled glass in sidelights and transoms. Architects specified more interesting brickwork and windows that were paired, arched, and decoratively paned. Most often archi-

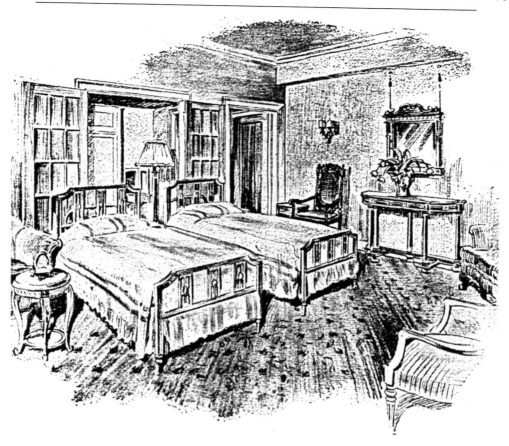

Furnishings in the Camlin's units were slightly superior to those in other apartment houses. The folding twin beds were concealed behind mirrored mahogany French doors. *Hotel News of the West*, August 14, 1926.

tecturally designed, the additional attention given to apartments in the intermediate category indicates that they were allocated more generous budgets.

Interiors often featured large and attractive lobbies, as well as areas set aside for an exclusive purpose, such as a billiards room, a roof garden, or a ping-pong room in the basement. Intermediate apartment buildings included more and larger rooms than found in efficiencies and always included at least one bedroom. Additional amenities, such as extra closets and built-in china cupboards, were common.

Some intermediate apartment buildings contained a mix of efficiency units as well as one-bedroom units. Apartment buildings of this class were so common that they could be found on several corners of the same intersection, interspersed between shops and businesses, inserted among a row of single-family homes, or lining both sides of the street.

Quintessential Intermediate Apartment: The Moana (1908)
1414 E. Harrison Street

The thirteen comfortable units in the Moana easily accommodated small families. Averaging 900 square feet, there were four units on each of the three floors and one in the

basement. According to the 1920 census, only couples, four without children, six with either one or two children, one whose daughter and son-in-law lived with them, and one who shared their unit with a sister-in-law, resided in the Moana. Based on these living arrangements, one would assume that the units had two bedrooms, but they only had one and, unlike many intermediate apartments, had no hidden wall bed lurking in the living or dining room. Families may have used the dining room as a second bedroom and used the kitchen for their meals. The janitor and his wife and two children lived in the basement apartment, implying that the building received constant attention and was well maintained.[29]

The trolley ran along the side of the Moana on Fourteenth Avenue East, and shops and Volunteer Park were nearby. It was also an easy walk to downtown. Architect F. H. Perkins designed the Moana and a number of its near neighbors, including the La Crosse and the Astor Court, also of the intermediate class. Perkins favored the Mission Style of architecture, and a description in a local newspaper initially indicated the Moana would be in that style. When built, in the typical Seattle form, it had none of the attributes of the Mission style. The multibayed facade, with recessed porches centrally located on the upper floors, was embellished with columns on the front porch, a marble vestibule, and handsome double-hung windows partially filled with diamond-shaped panes.

A skylit stairwell was at the rear of the lobby. Above the lobby on the second and third levels, an open space preceded the door out to the recessed porches. These areas probably served as a social, or hospitality, area for the residents. Due to the building's layout, none

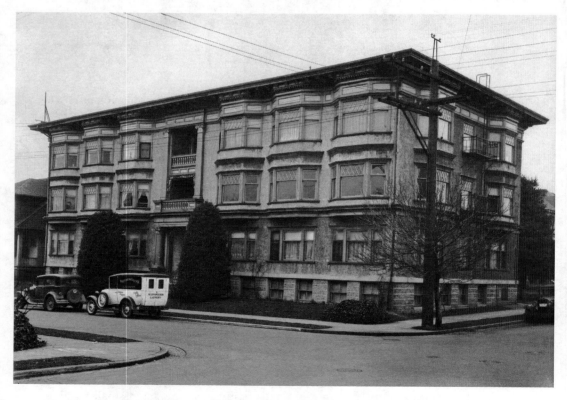

The Moana in 1935. *Museum of History and Industry, all rights reserved, unless otherwise noted.*

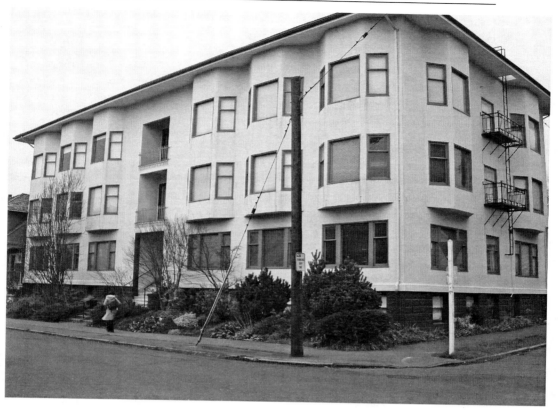

The Moana in 2006.

of the units shared a wall.[30] All units have two entrances off the corridor, one into the kitchen, and one into the living room. People making deliveries and possibly a maid used the kitchen entrance.[31] Family and guests entered through the living room and could progress into the dining room, which featured a built-in cupboard with stained-glass doors. The Moana qualifies as an apartment of the intermediate category due to its fine exterior, large lobby, the additional social space at the front of the two upper floors, and the number and size of rooms in each unit, all of which had a separate bedroom.[32]

LUXURY APARTMENTS

The demand for luxury apartments reflected on the smaller portion of the population that could afford them. Those built in Seattle, a city never prone to ostentation, may not have been on a par with luxury apartments in San Francisco, New York, or other eastern cities, but local investors and developers met the demand. Luxury apartments shared certain characteristics: they were architecturally designed; they reflected a variety of architectural styles and boasted distinctive exteriors; they did not rely only on grand lobbies to make an impression; individual units were large, usually including at least two bedrooms, a separate dining room and living room, kitchen, and bath(s), in addition to a maid's or maids' room either within the unit or located in the basement; and they were located in or near prestigious areas, both in the city and suburbs.[33] The Olympian lived up to every expectation.

Quintessential Luxury Apartment: The Olympian (1913)
1605 E. Madison

The Olympian is near the brow of Renton Hill, considered suburban at the time of the apartment's construction in 1913. The striking six-story building was at home among neighborhood mansions. Eclectic in design, some Beaux-Arts tendencies are apparent in architect W. P. White's wealth of details, such as elaborate terra cotta on either side of and above the main entrance, the prominent brackets beneath the dramatically projecting cornice, and the balustrade in the entry court.

The Olympian enjoyed views of Puget Sound and Lake Washington. The Madison Park streetcar gave easy access to the businesses, shops, and theaters of downtown and, at the line's eastern terminus, to parks and swimming on Lake Washington. The building's reinforced concrete construction, both walls and floors, which led to its claim of being fireproof throughout, further recommended it.[34] White heeded his own advice to other architects— that particular attention should be paid to the appearance of an apartment building's entrance—when he drew the plans for the Olympian's entrance. A low wall and curving balustrade, both of terra cotta, separate the courtyard from the street. Central to the facade, the deep courtyard leads to the elegant front door, where a lavish use of terra cotta embellishes the entryway.

Large terra cotta tiles face the ground-floor facade, enhancing the buff-colored brick veneer of the upper stories. Terra cotta belt courses differentiate between the first and second floors, and the fourth and fifth; brickwork and more terra cotta highlight the facade of the latter. In his plans, White detailed the black cast-iron balconettes and strategically placed them outside certain windows and in line with belt courses.[35] The dramatic projecting cornice with large dentils below and topped by a line of terra cotta anthemion, the latter a Neoclassical detail, complete the handsome building.[36]

Inside, the vestibule opens into the corridor, which is parallel to Madison Steet. According to White's plans, the wide corridor separates the staircase and elevator, located opposite the entry. On all floors, doors to each of the five units open off a central corridor, but all units also have access to service stairs at the rear of the building. The units average approximately 1,275 square feet. Two of the five units on a floor consisted of a parlor (living room), dining room, kitchen, bathroom, three bedrooms, and a maid's room with its own bathroom. The other three units had only two bedrooms and no maid's room. The larger parlors measured fourteen by twenty-seven feet, and White specified niceties such as plate rails and beamed ceilings for the dining rooms. Each apartment had a dumbwaiter, either in or near the kitchen.[37]

The basement housed a small private garage, a novel feature for the time, as well as laundry, storage spaces, and additional servants' rooms. In May of 1930, the *Washington State Architect* included the mention of an L-shaped garage, containing eighteen stalls, which would be built just to the east of the Olympian. The owner at the time must have realized the value of on-site parking for his tenants as well as future residents. Architect O. F. Nelson designed the garage.

Census information from 1920 proves that the individual units were fully occupied. Among the residents, there were seven couples, two of whom had a live-in maid. A woman and her daughter and governess occupied one suite. Extended families, such as one that included a husband and wife, a sister-in-law and her grown daughter, and a brother-in-law, lived in one unit. A more unusual, and more crowded, situation was a couple who had four

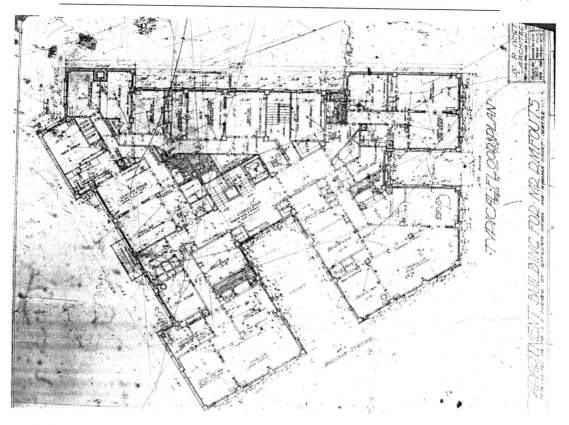

White's complex plan for the Olympian conformed to the angled shape of the site. *City of Seattle Department of Planning and Development.*

women roomers, two of whom were grade school teachers. Occupations listed on the census included two lawyers, four physicians, four managers, a purchasing agent for the city, and a leather merchant. Only one woman, an artist who painted china, listed a profession.[38]

White designed the building for Robert Fouts, for whom it was originally named. An October 19, 1913, advertisement in the *Seattle Post-Intelligencer* claimed the Fouts was for "those seeking a home of refinement." Before the name appeared in the 1914 *Polk's Seattle City Directory*, it had been renamed the Olympian. Andrew Dolkart, author of *Morningside Heights*, wrote that "the naming of apartment houses was exploited by builders to establish a unique and attractive identity for each building."[39] Evidently Fouts had second thoughts and renamed his building with one that conjured up images of grandeur and importance.

Building Materials

Prior to the construction of an apartment building, many steps and decisions had to occur. The cost of the building was predetermined by the owner or investor. After deciding on the class and style of the building, there was the important consideration of building materials, the costs of which had to stay within budget and enhance appearances while meeting structural requirements. Therefore, materials for all aspects—structural, exterior,

and decorative — would have been chosen with care. The large number of extant early Seattle apartment buildings is proof that wise choices were made.

When making choices for building materials, local builders and architects often specified local products. They were more readily available and, without added costs for transportation, were cheaper. Hometown pride also came into play, as when the owners of the Windsor Apartments told their architects to use only local materials in its construction.[40] Mrs. A. F. Denny, a principal stockholder of the Union Land Company, which owned the Windsor, and A. W. Denny, who erected it, may also have had a vested interest in promoting locally made products, as the Denny-Renton Clay and Coal Company, a large manufacturer of brick, was a family business.

STRUCTURAL MATERIALS: WOOD, MASONRY PRODUCTS, AND REINFORCED CONCRETE

The construction class for all the apartment buildings covered in *Shared Walls* falls into three categories: wood frame, masonry, or reinforced concrete. A casual observation will not reveal an apartment's structural provenance, but county building departments may provide such information.[41] Also, early newspaper and trade journals frequently reported, "The building is of solid mill construction"; "It is constructed of reinforced concrete and is four stories high"; or "The construction of a three-story masonry, fireproof structure ... is announced."

Wood

Until the early 1900s, wood was the logical and foremost choice of building material in Seattle, located in the heart of the forested Pacific Northwest. Reuben McKnight, author of "Timber!: A Brief Local History of the Building Material," writes that by 1889 there were thirty-seven mill operations listed in the Seattle city directory. These included lumber manufacturers; planning and shingle mills; and sash, door, and blinds manufacturers. As early as 1905, Washington was the leading producer of timber in the country.[42]

Masonry Products: Brick, Stone, Hollow Tile

Brick Although apartments of wood construction continued to be built after 1900, the majority were masonry, with brick the most predominant form. Because masonry was laid up unit by unit, it was labor intensive and added to the cost of construction, but its fire-resistant qualities led to widespread use. Advertisements often proudly mentioned *solid brick* construction.[43]

King County had large amounts of clay conducive to brick making. Early on, a brick-building industry developed in the Puget Sound area, so that by 1889 there were seven brick and tile manufacturers in and near Seattle.[44] One of the earliest, which incorporated in 1889, was the Pontiac Brick and Tile Company, located near Lake Washington in present-day Seattle's Sand Point neighborhood.[45] After the Seattle Fire, additional brick businesses developed to meet the demand for rebuilding. In 1900, Daniel Houlahan established Builders Brick Company at the base of Seattle's Beacon Hill, where he had found a clay deposit capable of supporting a brickworks.

Near Renton, a town immediately southeast of Seattle, the Denny-Renton Clay and Coal Company had begun operating in 1892 and at one time employed nearly a thousand people.[46]

Stone Stone, usually granite, was a second masonry option. Occasionally used as a foundation material for apartment buildings, when used above grade it was generally reserved for significant structures, such as banks, or was employed as embellishment.[47] Stone used on Seattle buildings generally came from Washington quarries. Principal sources were located near Wilkeson, midway between Seattle and Olympia; Tenino, south of Olympia; and the Chuckanut Quarry, near Bellingham.

Hollow Tile Hollow tile was a third masonry option. Also known as hollow block due to its shape, it was manufactured of concrete or burnt clay. Pacific

The Builders Brick Co. advertisement appeared in the 1911 *Seattle's Polk City Directory.*

Northwest Brick, a manufacturers association, extolled the advantages of hollow tile walls: it saved on heating bills, was economical to construct, and would "stand for centuries."[48]

The enormous Denny-Renton Clay and Coal Company's operation in 1930. *University of Washington Libraries, Special Collections, A. Curtis 19555–1.*

Reinforced Concrete

Seattle builders also used concrete — a mixture of cement, sand, water, and stone aggregate — as a structural element. Concrete's virtues as a building material were touted as early as 1904.[49] Although concrete was flexible, cheap, and extremely fire resistant, without good support, it could crack. *Reinforced* concrete meant that steel, placed within the concrete, carried all tensile loads, and the concrete did the work of compression.[50] "In other words, the steel and the concrete mutually reinforced one another."[51] In 1906 a local newspaper called the reinforced concrete construction of Seattle's Waldorf Apartments, tall for its time and place, "comparatively new here ... only recently fully recognized."[52] One of the advantages of reinforced concrete was its lower cost. Steel construction, the accepted form for large buildings, was expensive. Since steel was not locally manufactured at the time, it was shipped from East Coast points, adding large freight fees. Cement, sand, gravel, and steel rods, the necessities for reinforced concrete construction, were easily obtainable, resulting in lower costs.[53]

EXTERIOR MATERIALS: WOOD, BRICK, STUCCO, TERRA COTTA

Wood

In addition to its use as a structural element, wood was also used for exteriors. Many early apartment buildings had wood or clapboard exteriors, but few survive. Many formerly wood-clad buildings have been updated in the name of modernization and convenience and are now hidden beneath another form of cladding.

Brick

Brick's variety of sizes, colors, and textures, and the ability to create patterns, added to its popularity for exterior use, and by 1939 there were almost twice as many Seattle apartment buildings with brick exteriors as wood.[54] Carl Condit, although referring to a Chicago building, could as easily have been referring to one in Seattle when he said that "the fine quality of the walls is another example of how the craftsmanship of the brick-mason can turn commonplace construction into a work of some aesthetic distinction."[55]

The patterned brick design, although used sparingly on the Disler, still makes a statement, especially when the corners of the building are accented with fanciful metal finials.

The advantages of brick's fire resistance and illusion of permanency influenced the large number of apartment buildings that, regardless of the building's structural composition, received a brick veneer. Face brick, bonded to a back-up wall on the front, or face, of a wall, gave the appearance of a brick building. The 1908 December issue of *Pacific Builder and Engineer* discussed "Fashions in Face Brick" and concluded that in the hands of a clever architect, it produced an artistic facade.[56] The local Denny-Renton Clay and Brick Company also manufactured pressed brick.[57] Many apartments that "look like" a brick building are either wood or masonry structures with brick veneer, such as the large wood-frame Lenawee (1919).

Stucco

The occasional exteriors of painted stucco provided welcome relief from Seattle's myriad, and often dark-colored, brick apartment buildings. The terms stucco and plaster are at times used interchangeably, but plaster usually refers to an interior use of the material.[58] Stucco, made of an aggregate, binder, and water, is an ancient building material. Beginning around 1900, when Portland cement began to be used as the binder, stucco became stronger.[59] No longer limited to being a coating for more substantial materials, stucco could be applied over wood or metal lath, becoming a more integral part of the building's structure.[60] In 1910 architect William Doty Van Siclen called for stucco as the exterior of the Jensonian/Van Siclen.

In the 1930s and 1940s, stucco gained popularity all over the United States when revival styles of architecture, such as Art Deco, Art Moderne, Spanish Colonial, and Mission, which often demanded stucco exteriors, became the fashion.

Terra Cotta

Architectural terra cotta's light weight, economical production, fire resistance, and malleability made it a good choice for cladding buildings. Generally used on larger structures, it can be seen on the Coliseum Theater and the Smith Tower, just two of a plethora of downtown Seattle buildings clad in terra cotta tile. It was used in small doses on both the Olympian and the Camlin, but the Sheridan (1914) is perhaps the only early Seattle apartment building sheathed in terra cotta tile.

Terra cotta tile and ornamentation create an elegant facade for the Sheridan.

The Washington Brick, Lime and Sewer Pipe Company, near Spokane, Washington, had the capacity to produce 450 tons of fired terra cotta per month.[61] In 1925, California-based Gladding, McBean purchased the local Northern Clay Company, which had been in business since 1900, and merged with the Denny-Renton Clay and Coal Company to become "one of the largest producers of terra-cotta in the country."[62] But by 1930, rising production costs, a decline in construction due to the Depression, and a move away from the classical styles that utilized terra cotta ornamentation led to the company's decline.[63]

<div align="center">

DECORATIVE MATERIALS:
TERRA COTTA AND CAST STONE

</div>

Terra Cotta

Terra cotta, as a decorative or ornamental feature, however, was widely — and wildly — popular from the turn of the twentieth century until the advent of the Great Depression, a period that coincided with most of downtown Seattle's construction. Consequently, an abundance of decorative wreaths, swags, crests, medallions, and brackets may be seen on many downtown buildings, as well as more subdued amounts on apartment buildings all around Seattle.[64]

Terra cotta is literally baked earth. Clay is hand pressed into molds (some shapes are formed by extruding wet clay through a steel die), removed after a few hours, and placed on racks to dry. After receiving an undercoat and glaze, which is capable of being colored, and another drying period, the shapes go through an extensive firing period of several days at different temperatures. Before they can be removed, the kiln takes several more days to cool.[65] Although it was possible for architects to submit sketches for custom decorative pieces, stock items were less expensive since once the models were made, the design could be duplicated at practically no extra cost.[66]

The production of terra cotta was big business in the early 1900s, and companies such as the Chicago-based Northwestern Terra Cotta Company advertised in local newspapers, trade journals, and *Polk's Seattle City Directory*.

Cast Stone

Ornamentation made of cast stone began to replace that made from terra cotta by 1930. It was a less expensive substitute due to its shorter production period. Unlike the terra cotta process that fires, or bakes, the molded shapes, the materials for cast stone consolidate through either "a dry tamp" or "wet cast." In the former process, a mix of materials is pressed and compacted into molds and can be removed after a short time. In the latter, a more plastic mix, is poured and vibrated into molds but requires at least a day of setting before removal. The choice of molds, whether wood, plaster, or sand, depended on the "production method, the intricacy of the piece to be cast, and the number of units to be manufactured."[67]

The well-known California-based Gladding, McBean and Company established a business in Seattle, as well as Portland, to capitalize on the Northwest's passion for terra cotta.

It is difficult to tell the difference between terra cotta and cast stone ornamentation, "[s]ince one of the features of terra-cotta is its ability to mimic other materials."[68] Whichever material the architect or builder specified for decorative effect, it lent the building a unique identity and imparted visual pleasure.

Artificial stone blocks, also known as cast stone, were made to resemble natural cut stone. Popular in the 1920s, they were a manufactured product of cement and fine aggregates, such as sand and crushed stone. They were versatile, durable, and resisted weathering, and were used for both ornament and facing, but apparently not structurally. They were "condemned" by architects for their lack of aesthetic appeal, despite the manufacturer's claim that they were as "beautiful as the original stone."[69] Litholite, "a new building material," and Debesco Cast-Stone Blocks, "scientifically made," were two such products.[70]

Architects, builders, and contractors, often relying on indigenous supplies and materials, designed and built a body of apartment buildings that served a population not only looking for a place to live, but a new way to live. These lively and versatile apartment buildings allowed Seattle to grow at a pace congruent with the times by providing housing for all, whether a newly arrived young schoolteacher, a growing family, or wealthy businessman. One of the more remarkable features of the buildings is their longevity, which reflects well on the care given to their design and construction.

5

Downtown Apartments:
Between the Water and Hills

These are exceptional apartments; tile bath and shower, inlaid floors, large living room, commodious kitchen and dinette. Adjacent to the business district, yet away from traffic. Save time and carfare.

Close-in, 2- and 3-room suites in a FIREPROOF building at prices that will interest you. Fully carpeted floors in each apartment, electric ranges, refrigeration, etc.

A popular fire and soundproof building with rentals including light, gas, phone, and elevator service. Two and three-rooms at $40 and up; furnished $55 and up. Frigidaire being installed.

From the beginning, downtown Seattle's growth was constrained by Elliott Bay on the west and the slopes of First and Capitol hills to the east. Those same forces have obliged Seattle's downtown to continue to develop to the north, to the south, and in a more concentrated fashion, between the water and the steep hills.

Prior to and during the early 1900s, Pioneer Square, south of today's central business district, was the hub of most Seattle social and commercial activity. By 1914, when Seattle's first skyscraper, the Smith Tower, appeared in that neighborhood, street regrades and an advanced trolley system had expedited movement beyond Pioneer Square. Office and retail development advanced north, eventually stopping at Olive Way.

In Seattle's new downtown, "business, administrative, commercial, cultural, and entertainment functions were centralized."[1] As in other cities, tall, steel-framed buildings began to define Seattle's urban core. The Eitel Building, a steel high-rise constructed in 1904 at the corner of Second and Pike, was one such example. The building's architect, William Van Siclen, also designed numerous apartment buildings.

Large department stores, "a new urban institution," attracted shoppers to the area.[2] In 1906 Frederick and Nelson was operating at Second Avenue and Madison, but in 1914 moved north and east to larger and more elegant quarters at Fifth and Pine, a location outside the traditional retail core. The move was considered a "daring gamble" at the time.[3] In 1928 the Bon Marche, after having been in business at two earlier locations, followed Frederick and Nelson and erected a $5 million building at Third Avenue and Pine Street.[4] The third of Seattle's retail triumvirate, Nordstrom, which began in 1902 as a shoe store at Fourth Avenue and Pike Street, moved to Fifth Avenue, between Pike and Pine Streets, in 1937. The retail neighborhood, no longer considered a gamble, proved to be prime retail territory.[5]

Entertainment venues dotted the area. The Tilikum Theater, one of many early motion-picture houses, opened in 1913 at Pike Street and Fourth Avenue. Large elaborately decorated theaters dominated the 1920s. The 5th Avenue Theater, Seattle's most exotic, featured revues

and silent films, while the Orpheum, which opened two years later in 1928 at Fifth Avenue and Stewart Street, was Seattle's most opulent. The 1920s also witnessed the advent of talking pictures, and when the Fox Theater opened at Seventh Avenue and Olive Way in 1929, it featured only "talkies," the latest innovation.[6]

The new downtown was more than a site for business, administrative, and commercial activities, or even cultural and entertainment functions. Seattle General Hospital and School for Nurses opened at 909 Fifth Avenue in 1900. It operated at this location for seventy-one years. One block due west of the hospital, the YMCA opened its doors in 1931. The private Rainier Club, which Neal Hines, author of *Denny's Knoll*, refers to as "that center of financial-professional mingling," held its meetings in a downtown mansion prior to moving into its new quarters located in the 800 block of Fourth Avenue in 1904.[7] Plymouth Congregational Church settled at its Sixth-and-University site in 1911, and First Methodist–Episcopal moved into its landmark domed structure at Fifth and Marion in 1910.[8]

Two other distinct downtown neighborhoods, Belltown and the Denny Triangle, followed different paths of development. Belltown, located north of the emerging commercial district, was a small community of businesses and housing near the waterfront. It initially developed concurrently with Pioneer Square, but it never achieved the same importance. The physical borders of Belltown are debatable, and on some maps they overlap the borders of its eastern neighbor, the Denny Triangle. The latter is more delineated than the larger Denny Regrade area. Developed later than Belltown, the Denny Triangle came into its own after the removal of Denny Hill, the largest of Seattle's regrade projects, which began in 1911. By 1939, a map of the Greater Business District of Seattle indicated that downtown's borders extended from Pioneer Square north to Denny Way, the northern boundary of both Belltown and the Denny Triangle, and from the waterfront on the west to the beginnings of First and Capitol hills on the east.[9]

In 1962 the construction of Interstate 5 forced a mass demolition, including numerous apartment buildings, through the heart of downtown. And in 1988 the Washington State Trade and Convention Center, which spreads over and around the northeast corner of the current central business district as well as the lower southwest corner of First Hill, claimed extensive property, including the sites many apartment buildings occupied. In addition to these two significant events, the destruction of an apartment for a higher and better use of a property occurs at a regular pace. A few important, but no longer extant, downtown apartment buildings appear in the following discussion. They remind us of a past when apartments dotted Seattle's downtown landscape, and their loss prods us to value and preserve those that remain.

Commercial District: Heart of Downtown

Investors, developers, architects, and builders were quick to design and build apartments, increasingly an attractive housing option in downtown Seattle. Well situated and furnished with the most up-to-date amenities, they were an easy walk or a short trolley ride to work and left more time for apartment dwellers to enjoy downtown's shopping and entertainment opportunities. In the early years of the twentieth century, a surprisingly large number of apartment buildings coexisted with businesses, hotels, theaters, and other advantages of a vibrant downtown, in the very heart of Seattle.

1. PACIFIC/MILNER/MILNER HIGHLAND/PENBROOK/ PENNNINGTON/LEAMINGTON (1916) 317 MARION STREET

On January 12, 1918, "J. K. Leamington sold to H. W. Hollis the Leamington Hotel ... for $33,000 cash." The article in the *Seattle Times* went on to say that it had been built three years earlier by Reverend E. Lincoln Smith, the former pastor of Seattle's Pilgrim Congregational Church. Although a little unusual for a minister to be investing in a downtown building, especially since he left Seattle in 1912 to work in New York City for his denomination, it seems he had had a good idea. Neither strictly a hotel for visitors and travelers, nor wholly an apartment building, it was intentionally built to suit both types of residents. Smith may have based his decision to include apartments on the fact that by 1910 Seattle was sated with 475 hotels, many of which had been erected to accommodate the influx of people related to Alaskan gold field activity, as well as visitors to the 1909 Alaska-Yukon-Pacific Exposition.[10]

Seattle architects Julian Everett and W. R. B. Willcox designed the Leamington so that it reflected its dual roles. The three-story apartment wing and the four-story hotel wing, each L shaped, join to form one U-shaped building, with the base on Marion Street. The exterior of the building makes a decided statement about which is hotel, and which apartments. The east, or apartment wing, of the red brick structure occupies the southwest corner and extends along Fourth Avenue. Its facade is restrained, with decorative terra cotta largely restricted to the two entrances, one centered on Marion Street and the other on Fourth Avenue. Tall windows with mock balconies and wrought-iron railings

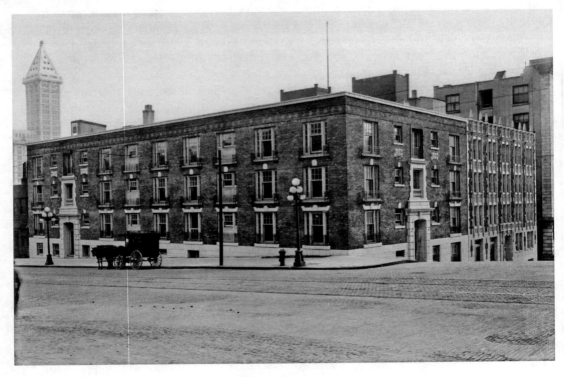

The Smith Tower, built in 1913, looms beyond the Leamington's Fourth Avenue entrance. The terra cotta base and trim on the building's east side look bright and new in this undated photograph. *University of Washington Libraries, Special Collections, Todd 12198.*

and a decorative band of brickwork between the top floor windows and parapet add appeal, add interest. *Hotel News of the West* described the two- and three-room apartments as attractive and up to date, with "modern kitchenette equipment, folding beds and a plentiful supply of closets and accessories necessary to comfortable apartment life."[11] The facade of the hotel wing, however, displays a profusion of decorative terra cotta in its bid to attract hotel patrons.

In 1924, during its era as the Penbrook, Anna Clebanck, "a hotel woman of capability and charm," managed the building, which she had recently purchased. "With a record of successful hotel and apartment house operation behind her," Clebanck was one of a surprising number of women who engaged in Seattle real estate at a time when few women worked outside the home.[12]

After being abandoned in 1991, the building, known at the time as the Pacific Hotel, was purchased by Plymouth Housing Group. A combination of low-income and historic-preservation tax credits made it possible to reopen the building in 1995 and offer over a hundred units of low-income housing. For its efforts, Plymouth Housing received the State Historic Preservation Office's Award for Outstanding Achievement in Historic Preservation. An enlightened cooperative effort, it was a win for the historic building, a win for homeless people, and a win for Plymouth Housing. It is also listed on the National Register.

2. VINTAGE PARK HOTEL/KENNEDY/SPRING APARTMENT HOTEL (1922) 1100 FIFTH AVENUE

Another downtown survivor is the Vintage Park Hotel, whose original owners bragged, "Fifth Avenue, where all activities, social, business, shopping and amusement center. Here,

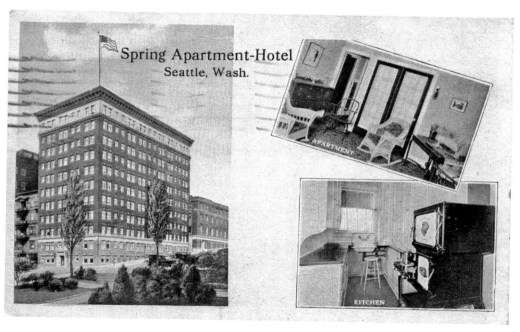

In the 1920s, postcards were a popular form of advertisement for hotels and apartment buildings. Photographs of the exterior of the Spring and two rooms inside one of the units appear on this 1925 postcard. *Postcard courtesy Kathy Wickwire.*

opposite the Public Library and the Olympic Hotel, is located our beautiful, fireproof, eleven-story building, fully furnished and equipped. Radio in each room."[13]

In early 1922, the *Seattle Daily Journal of Commerce* announced that negotiations on the Spring Apartment Hotel had closed and construction would soon begin on the largest and most up-to-date apartment hotel in Seattle, "if not in the Northwest."[14] Respected Seattle architect John Graham designed the elegantly proportioned brick apartment hotel for the northeast corner of Fifth Avenue and Spring Street. It is a good model for considering the three parts of a building: base, shaft, and cap. Terra cotta tile clads the base and the two floors that face Fifth Avenue, receding to one floor on Spring Street. A bold terra cotta cornice visually separates the base and the shaft. The shaft, the intervening eight floors, relies on terra cotta keystones and sills for decoration and contrast against the red brick. At the eleventh floor, the color of the brick changes, another contrast and a clever reference to the cream-colored terra cotta used on the base. The Spring's cap features a bracketed cornice underlined by dentils. As with the top floor, or cap, of most older buildings, the Spring's is highly decorative. Unfortunately, few people look up to appreciate that particular section of a building.

Terra cotta surrounds the entrance, placed at the center of the Fifth Avenue facade. When built, the ground floor contained a modestly sized lobby, a stairwell and passenger elevator, seven apartments, laundry, boiler, and trunk room.[15] A true apartment hotel, the 115 two- and three-room apartments were efficiency units that featured built-in Dutch breakfast rooms in the kitchens and large dressing room/closets in connection with each room.[16] Advertised radio hookups for each apartment were the result of a "radio-phone installation in the lobby which [was] capable of giving service to every apartment."[17]

When constructed, no storefronts surrounded the entrance, nor was parking provided for tenants' cars. Today, shops and restaurants front the Vintage Park, a luxury boutique hotel, and it offers guest parking via an interconnected parking garage. Stewart Brand, author of *How Buildings Learn*, writes that "real estate has vastly more influence on the shape and fate of buildings than architectural theories or aesthetics."[18] The Spring's prime location determined its fate, which deemed it more suitable to conversion to an upscale hotel rather than remaining an apartment building.

3. WALDORF (1907, DEMOLISHED) 704 PIKE STREET

The building that sat on this important corner for many years is no longer extant. Back in 1905, a healthy economy spurred the formation of the Waldorf Building Company, a corporation that let the contract for the first large downtown apartment building in Seattle. It would cost $200,000.[19]

When construction began on the imposing Waldorf Apartments at the northeast corner of Seventh Avenue and Pike, its novel use of reinforced concrete for structural material made the news: "The Waldorf is one of the most remarkable of the reinforced concrete structures ever undertaken in the Northwest. Concrete in fact is a material whose utility in building purposes has only recently been fully recognized, and reinforced concrete is newer still."[20] The Waldorf's fireproof qualities, abetted by the use of concrete, were promoted to a public not all that far removed from Seattle's Great Fire of 1889. One advertisement stated that "there is no wood of any kind in the building except the flooring, the doors, and the window sash."[21] Henderson Ryan, in collaboration with the New York architecture firm of Howells and Stokes, designed the building with twin projecting blocks.

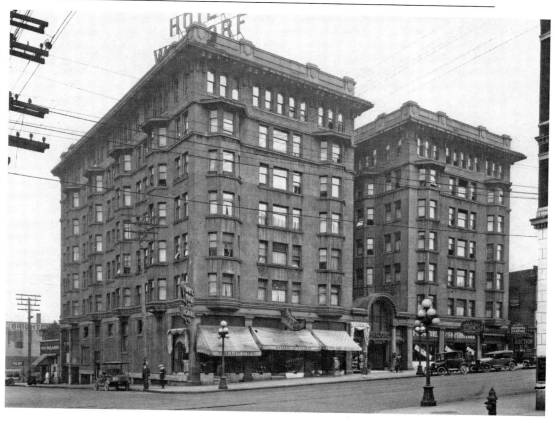

On September 23, 1906, the *Seattle Post-Intelligencer* described the Waldorf as Seattle's most elaborate apartment house and stated that **"no person will be rented an apartment who cannot furnish good references."** *Museum of History and Industry, all rights reserved, unless otherwise noted.*

Stores occupied the street-level spaces on either side of the impressively tall, arched Pike Street entrance.

Three-, four-, and five-room suites occupied the upper six floors. Except for bathrooms and kitchenettes, every room was an outside one. The Waldorf appealed to a desire for comforts and conveniences not readily available in housing other than newly constructed apartment buildings. Proposed features included central vacuums, hot and cold water at all times, a telephone in each suite, gas ranges and refrigerators in all apartments, and the most up-to-date fixtures and plumbing.[22] The advanced plumbing made possible showers and needle baths in some units.[23] The basement of the building held a grand dining room, cold-storage units, barber shops, and a complete laundry.[24] And if more incentives were needed, the Waldorf boasted "first-class" janitorial service and the very best streetcar service in the city.[25] On March 27, 1907, the formal opening took place.

In 1921 the Waldorf's owners, who decided that hotel rooms would be more financially rewarding, converted it to a hotel. They did, however, retain the two upper floors for light-housekeeping, or apartment, units. In 1970, a private buyer, working with the Federal Housing Authority, created housing for seniors in the renamed Waldorf Towers, "still at its prime downtown site."[26] Its prime site was its literal downfall, for in the late 1980s it was razed to accommodate construction of the Washington State Trade and Convention Center.

Commercial District: Sixth, Seventh, and Eighth Avenues

Slightly removed from the hubbub of the commercial center, yet near enough to partake of its conveniences, numerous apartments appeared on the eastern fringe of downtown, particularly on Sixth, Seventh and Eighth avenues, between Pike and James streets. Apartment dwellers would have been within an easy walk of downtown shops, the YWCA, and the public library. The Central School, between Sixth and Seventh avenues, and Marion and Madison streets, made apartments in the neighborhood a good choice for teachers and for families.[27] Churches sprinkled the area. By 1940, First Presbyterian, at the corner of Seventh Avenue and Spring Street, was the largest Presbyterian church in the world.[28]

1. DOVER/AMON/HIGHLAND/LAVETA (1904)
901 SIXTH AVENUE

Seattle architects Thompson and Thompson designed the four-story Laveta for the northwest corner of Sixth Avenue and Marion Street.[29] From 1906 through 1912 the building was known as the Highland, and the entrance was at 518 Marion.

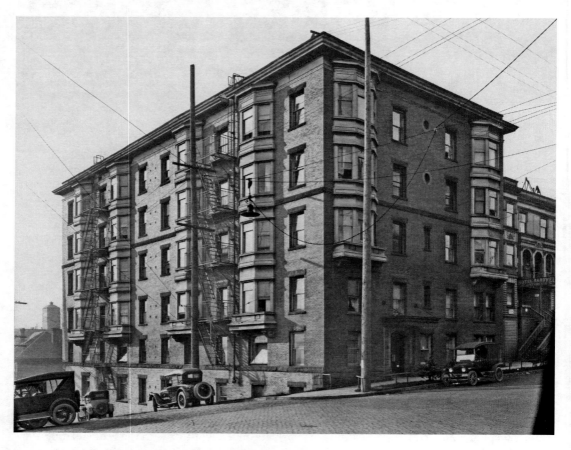

In this undated but post-regrade photograph of the Amon, the polygonal bays that start almost midway up the facade are a reminder that prior to the regrade only the top three floors faced Sixth Avenue. *University of Washington Libraries, Special Collections, Todd 12173.*

Perched above Interstate 5, the Dover is one of the oldest surviving downtown apartment buildings.

Post-regrade, while the building would have still been jacked up, an additional three floors were built beneath the building, and at the same time the main entrance relocated to Sixth Avenue. Owner Howard Amon, for whom it was renamed, hired architects Blackwell and Baker to draw plans for the alteration.[30] The new off-center front entry featured a handsome marquee with electric lights shimmering behind the plate-glass scalloped edges.[31] The original entrance on Marion was replaced with a window, and a secondary entrance was created at the post-regrade basement level. Rusticated stone elaborately framed this arched entrance, complete with glass fanlight.[32]

At the time of Amon's purchase, the building contained seventy-two units, which consisted of "[f]our and five-room apartments, containing every convenience; close in; everything in best of condition."[33] In 1939 Captain Harry Crosby bought the by-now-renamed Dover.

2. ZINDORF (1910) 714 SEVENTH AVENUE

The construction of Interstate 5 in the 1960s plowed under the block of businesses, a fire station, homes, and apartment buildings that once were the only obstacles between the Dover and the Zindorf.[34]

A drawing of the Zindorf that appeared in a local newspaper shortly before it opened revealed a lavish use of art tile on its facade. The accompanying article described other unusual artistic touches: "[T]he main hall floor is tiled, the entrance and stairs are being

finished in marble and art tiling on walls, ceilings and floors, with art glass in doors and side-light."[35] Today, the facade, with the exception of decorative trim around the arched opening, has been painted over, but the *texture* of the tile work is still discernible. Inside the protected entry, however, it is a delightful surprise to find the art tile in almost pristine condition. As a 1914 advertisement stated, this is "a building of neat design."[36]

Constructed of reinforced concrete, the four-story-plus-basement building contained seventy-one two-, three- and four-room apartments, which featured disappearing beds.[37] The central openings above the front door, now blocked up, once had balconies with flower-bedecked window boxes, and the west-facing windows features striped awnings. A photo of the charming Zindorf merited inclusion in Charles Bagley's 1916 *History of Seattle*.

3. LOWELL (1928) 1102 EIGHTH AVENUE; EMERSON (1928) 1110 EIGHTH AVENUE

The Emerson opened on July 15, 1928; the Lowell opened five months later on December 16, 1928. Architect Harry E. Hudson designed the two attached structures, which, at the

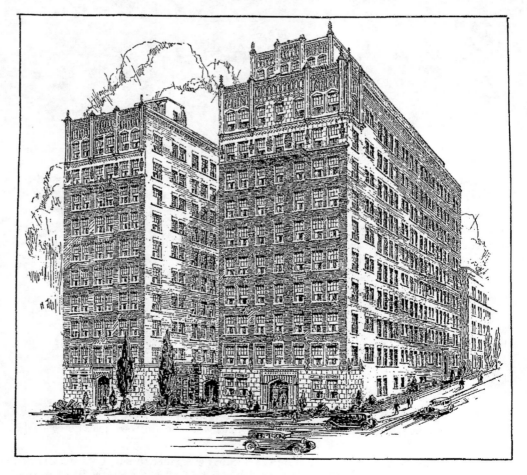

As depicted in this drawing from the December 12, 1928, *Seattle Times*, **the west-facing Lowell and Emerson apartments enjoyed a commanding view of downtown Seattle.**

time of their construction, were said to represent the largest number of apartments in a single building north of San Francisco.[38] The Lowell is an L-shaped building conjoined to the rectangularly shaped Emerson, which together form an H. Their juncture creates the Lowell's garden court entrance.

Stylistically the architecture of the Lowell and the Emerson is similar. The two differ in size and scale of ornamentation. The Lowell, situated on the corner, has eleven stories and contains 158 units; the smaller Emerson has ten stories with 37 units. Ivory-colored terra cotta and textured brick embellish both buildings. The top floor of each is elaborately detailed with pointed arches, filigree screens, mock crenellations, terra cotta, and blue tile, which, when viewed from a distance, create a dazzling display against the sky.

At opening, the Lowell could boast of an unusual feature: "four wonderfully attractive five-room Bungalow Apartments on the roof."[39] The two-room apartments had a living room, Pullman-type kitchen, wall bed, tiled bathroom and closet and enjoyed the "countless other little niceties of service that contribute[d] to the comfort, pleasure and convenience" of living in the Lowell.[40]

4. EXETER (1928) 720 SENECA STREET

In June of 1927, on a steep site at the northwest corner of Eighth Avenue and Seneca Street, work began on a $1 million apartment hotel designed by Stuart and Wheatley. "Situated strikingly at the base of First Hill, this magnificent Tudor Gothic structure overlooks the city and the mountains, giving its guests unsurpassed panoramic views from three sides," a writer extolled.[41] The square ten-story building, faced in buff-colored pressed brick, fit in well among other similarly sized residential buildings. Although a fine building, the Exeter was not in the luxury category of some of the high-rise apartments just above it on First Hill, but it admirably fulfilled the need for near-downtown living for the middle class.

Above the heavily decorated arched entrance, the Exeter's name is cut into a stone banner placed between two crested shields, and for good measure, a small terra cotta lion clutching an initialed crest protects each side of the opening. A brochure for prospective tenants described the lobby as being in the Tudor Gothic style, whose floors and furnishings were a "cheerful symphony of graceful design and lovely colors." It was also the location of the two elevators that conveyed tenants upstairs to their apartments. From the first basement floor, another elevator went to the garage, whose three subgrade floors were capable of storing 150 cars. At street level, a dining room, one corner of which was used as a breakfast room, was available to residents. In addition to regular meals, the space could be reserved for bridge parties and afternoon teas.[42]

In reporting the number of units in the Exeter, *Hotel News of the West* wrote that there were 139 apartments and 43 hotel rooms and bachelor apartments, arranged so that larger suites of four or five rooms could be created by joining one or more units to another. Some of the units already were larger; they included spacious living rooms, an additional alcove, and fireplace with mantel. The first six floors were rented completely furnished, from china to the "latest in equipment to delight the lady tenant, from the Hotpoint range and Frigidaire refrigerator to the smallest dish."[43]

The Exeter, today bordered on the west by Interstate 5 and the Eighth Avenue elevated access ramp, serves as a retirement facility. Purchased by Presbyterian Ministries in 1963, the Exeter's website uses almost the same description as the earlier brochure: "Wonderfully positioned in the heart of downtown Seattle."

Architects Stuart and Wheatley inventively used terra cotta to define the Exeter's horizontal divisions and to highlight the vertical bays on the west and south facades. *Museum of History and Industry, all rights reserved, unless otherwise noted.*

5. EAGLES/SENATOR APARTMENTS (1925)
700 UNION STREET

Near but not on Eighth Avenue, the mighty Eagles Auditorium fully occupies the northeast corner of Seventh Avenue and Union Street. Seattle architect Henry Bittman designed this architecturally significant structure, considered one of Seattle's most beautiful terra cotta buildings, in the Renaissance Revival style. Also known as the Fraternal Order of Eagles Temple, it served as the organization's national headquarters.[44]

Architect Henry Bittman embellished every inch of the stunning and highly decorative facade and roofline of the Eagles Auditorium.

Beige, blue-flecked architectural terra cotta sheathes the two street-facing facades of the six-story building, constructed of steel and reinforced concrete. The Union Street facade is divided into five bays, and the Seventh Avenue facade into nine. Since fraternal organizations often considered it financially prudent to have commercial spaces at the ground level of their buildings, the architect incorporated storefronts and a mezzanine office level between the bays of the Eagles Auditorium. Granite blocks and rusticated terra cotta clad the base, from which fluted pilasters rise four stories to a terra cotta cornice. The top floor is crowned "with an ornate copper cornice embellished with eagles, [and] serves as the crowning visual element of the structure."[45]

Few people realize that the top four floors have always held apartments, another nod toward financial prudence for the fraternal organization that constructed the building. Bittman's initial plan called for only a three-story building, with no mention of apartments. Less than a year later, a drawing closely resembling the final product accompanied an article that stated the building would include eighty apartments.[46] Bittman, a structural engineer as well as architect, designed a complex plan that called for a two-story lodge room, with balcony and stage, above a below-grade two-story billiard room, restaurant, gymnasium, and storage vault. Above this was a four-story-tall grand ballroom, surrounded on three sides by floors of apartments.[47]

A separate recessed entrance for residents of the apartments is at the east end of the

Union street facade. In large letters, *The Senator* is embedded in the floor outside the lobby entrance. A 1925 advertisement stated that the apartments and single rooms with bath featured overstuffed furniture throughout, Murphy In-A-Door beds, and every modern convenience.[48]

Like many fraternal organizations, Eagles membership in Seattle declined in the latter part of the twentieth century, and the building became an albatross. After a decade of vacancy, the Seattle Housing Resources Group, a nonprofit affordable housing developer, and A Contemporary Theatre (ACT) innovatively collaborated to renovate the historic auditorium. Upon completion in 1996, the former ballroom became the new home of ACT Theater, and the refurbished studio and one-bedroom apartments were renamed the Eagles Apartments. The building is listed on the National Register.

And lest one condemn the current rage for tearing down buildings so that something new can take their place, the heading that accompanied Bittman's drawing in the *Daily Journal of Commerce* on June 19, 1924, read, "To Clear Site for Million Dollar Eagle's Temple Bids Called for Wrecking of Present Buildings." Such was the fate of the Dreamland Dance Hall and an old church to the north.[49]

Denny Triangle Area

The Denny Triangle roughly encompasses the space bounded by Westlake on the west and Melrose Avenue on the east, and between Pike Street to the south and Denny Way to the north. Today, Interstate 5, rather than the once more significant Melrose Avenue, has become the dividing line between downtown and Capitol Hill. But when discussing early apartments, Melrose remains the eastern border.

1. STUDIO APARTMENTS (1928) 907–911 PINE STREET

The Seattle Theater, renamed the Paramount in 1930, opened to much fanfare on March 1, 1928. C. W. and George L. Rapp, an architectural firm with offices in Chicago and New York, drew the plans for the theater, while local architects Marcus Priteca and Frederick Peters designed the studios and commercial spaces.[50] A multiuse building similar to the Eagles Auditorium, the theater building housed a four-thousand-seat auditorium, contained street and mezzanine shops, and had forty studio apartments on its upper floors.

Overhung by a metal marquee, the apartment building's entrance is just east of the theater's larger entrance. If the decor of an apartment building's lobby was intended to convey a message to residents' visitors, the lobby of the Studio Apartments left no doubt that it was an upscale establishment. A small vestibule with an elaborate ceiling of carved wood precedes the lobby. Wood-paneled wainscoting and parquet floors, highly decorated columns, and ceilings that combine wood beams and terra cotta trim are patently rich. Visitors would also be duly impressed by the manager or concierge's counter with overhead ornamental iron grill, the stairwell with risers of colorful Malibu tiles, and the two elevators.[51]

The section of the building that houses the apartments is eight stories tall at the front, while the rear section shrinks to five stories. To accommodate the interior demands of the theater, the layout of the apartments varied. For instance, the second and third floors contained only four units, as well as service spaces. Floors four through eight are similar to one another, each with seven studio apartments and two larger units.[52]

Units in the Studio Apartments were "designed solely to meet the exacting needs of the various arts, crafts and professions" and to be "a new focal point for the colony of Seattle's musical artists."[53] Inspired by apartments in New York's Carnegie Hall and the Metropolitan Opera House, L. N. Rosenbaum, local businessman and developer of the theater, provided a similar opportunity for Seattle artists.[54] Seattle musicians and teachers responded to an advertisement which stated that "[y]our studio here makes it convenient for your pupils to see you."[55] As young piano students, Lowell Jensen and Vivian Sandaas recall going to lessons in their teachers' apartments above the Paramount Theater. Jensen remembers her lessons in the 1940s in a studio apartment that was located directly above the theater's marquee. Recitals were held in the same space, which held her teacher's grand piano. Her teacher, Cornelia Appy, a cellist with the Seattle Symphony, lived in a separate apartment in the building. More than her lessons, Sandaas remembers the unimpeded and "wonderful view" that was seen from the studio apartment of her teacher. The 1939 *Polk's Seattle City Directory* indicates that more than half the residents of the Studio Apartments were music teachers, including Miss Appy.

Listed on the National Register, the Paramount was on economically shaky ground for many years. It escaped the wrecking ball when a retired Microsoft executive came to the rescue and restored the theater in 1994–95. The apartments were not included in the restoration but have found a new life as offices for arts groups and other businesses.[56] One of the delights of the north-facing units is the large windows with views onto the busy downtown streets and sweeping views beyond, appreciated years earlier by a young piano student.

2. BONAIR (1925) 1806 EIGHTH AVENUE

The Bonair's location benefited from nearby streetcar routes, as well as the Central Terminal, located at the north end of the same block as the Bonair.[57] Architect Charles Haynes designed the Bonair for Amelia Hemrich, who had married into the Seattle family that founded the Rainier Brewing Company. During Prohibition, the Bonair's easily accessible location may have contributed to the second floor being used "for the purpose of selling and serving intoxicating liquor."[58]

Today dwarfed by larger buildings, the Bonair maintains its dignified street appearance. Cream-colored terra cotta covers the ground floor, and brick veneer, marked with terra cotta and cast stone ornamentation, covers the four upper floors. Pilasters visibly divide the three ground-level shops, each with their intact transom windows, as well as the tall arched opening for the apartment entrance at the south end.

The front door, with Art–Nouveau influenced glass panes and lines, opens into a small space with stairs leading up into the lobby. Here an elevator and stairway access the upper four floors of apartments, all of which benefited from an interior light court at the north end of the central corridor. There were six apartment units per floor; each unit had a large living room with a closet that contained a swing-out bed, a kitchen with built-in table and seats and cupboards, and a bathroom.[59]

The Ray Hotel (1909), abutting the south side of the Bonair, and the Bonair have operated as one apartment building since the early 1980s.

3. JULIE/EL RIO (1930) 1924 NINTH AVENUE

Only a few blocks separate the Bonair and the El Rio. Opened before the Depression began to take its toll, the El Rio was "designed as a swank residence for single young profes-

In this 1932 street scene, the building with the large vertical sign that reads "Central Terminal Stages" is at the end of the block in which the Bonair stands. *Seattle Municipal Archives 5454.*

sionals working downtown."[60] Conveniently near Seattle's Central Terminal, it was also uncomfortably adjacent to a neighborhood known for its houses of prostitution and speakeasies.[61]

Seattle architect John Creutzer designed the five-story reinforced-concrete building. The modified T shape guaranteed that natural light would reach the north- and south-facing units in the event the El Rio acquired neighbors on either or both sides. With retail shops at ground level taking center stage, the apartment lobby is entered through a recessed opening, flanked by patterned pilasters, at the south end of the building. The building's name is incised above the opening. The lobby featured terrazzo floors, plaster walls with decorative frieze, and the elevator. Floors of the corridors and apartment units of the upper four floors were also terrazzo. Each level contained eleven efficiency apartments, five of which faced Ninth Avenue at the top of the T, and six were along the double-loaded corridor. Each efficiency unit, which measured around 400 square feet, had a living room, dinette, kitchen, bath, and dressing room.

Stylized and geometric motifs, Art Deco characteristics, feature prominently on the El Rio's facade.[62] Businesses and corporations initially embraced the style, but gradually it "began to filter down the social scale and into the builders' vernacular, eventually shaping a number of modest building types from inexpensive apartment buildings to diners."[63] Cited for its being an outstanding residential example of the Art Deco style, as well as representative of an efficiency apartment, the El Rio earned a place on the National Register of Historic Places.

In 1999, with funds provided by the city for the purchase of the Julie, Seattle's Low Income Housing Institute began the renovation process that resulted in the Urban Rest Stop, a public restroom/shower facility and forty-seven renovated studio apartments.

4. Manhattan Flats (1905, destroyed) 1722 Boren Avenue, 1107 Howell, 1121 Howell, 1725 Minor Avenue

The Manhattan Flats occupied an entire city block. Seattle attorney J. F. Douglas organized companies to finance and erect the Manhattan Flats, tapping sources in New York and Boston for investment income.[64] In 1906 Douglas and his wife and their two children moved into the Manhattan Flats.

Seattle architect W. P. White designed the project: four separate buildings, the exterior and interior of each slightly different, but consistent with three stories with flat roofs and projecting bays. Two faced Howell, and one each faced Boren and Minor. A courtyard created by the backs of the buildings served as a small park for children and a gathering place for parents. Six stores, located at street levels, could also be entered from the courtyard.

Units ranged from two- to five-rooms, with the larger ones appropriate for families.[65] All residents had free use of steam-heated storage rooms, laundries and drying rooms, and telephones in the public halls. Each contained a bathroom, gas and gas range, electric light "in abundance," garbage chute, dish cupboard, cooler, flour bin, electric bell, and "dozens of other conveniences."[66] In 1905 many single family homes lacked these amenities.

The February 8, 1946, issue of the *Seattle Daily Times*, calling the Manhattan a Seattle landmark, reported that two of the four sections were being razed in order to construct a new building for commercial use.

5. El Capitan/ North (1925) 1617 Yale Avenue

Mrs. Josephine North, another woman deeply involved in Seattle real estate, asked Emil Guenther and Charles Saunders to design her namesake building, which upon completion, she personally operated. Dark brick trim and terra cotta around the entry opening relieve the facade of the five-story buff-colored brick building. The parapet, in which the name El Capitan is centrally displayed, also features dark brick trim. Many units in the building, which is shaped like a chunky T, enjoy spectacular views.

The lobby, replete with onyx wainscoting, mahogany finished floors, and tinted walls, is the location of the elevator, mail boxes, stairwell, and a concierge's booth.[67] The features were "contrive[d] to lend an

Manhattan Apartments

The Manhattan Building Company owns four large apartment houses covering one block of ground in the City of Seattle. These apartments are complete in every respect. Owing to the size of the plant the apartments can be rented and are rented for extremely reasonable rentals. In no other place in the city can a better kind of apartment, with a better grade of apartment house service, be rented for as low rentals. The apartments range from two to five rooms. They are all furnished with gas ranges, and they are complete in every respect.

Before renting an apartment, make it a point to visit the buildings of the Manhattan Building Company.

MANHATTAN BUILDING COMPANY, 1115 Howell St.
Telephones: Main 2727; Ind. 2853.

Advertisements for apartments, such as this one for the Manhattan Flats, appeared in the *Seattle Brides Cook Book*, published in 1912. Focusing on their reasonable rates, apartment owners and managers hoped to attract young couples to make their first home in their building.

atmosphere of refinement in keeping with the general scheme of the apartments." At opening, it had eighty-six two-, three-, and four-room units; the front corner units also had a dining room that featured an additional wall bed. Every suite was a "complete home in itself."[68]

6. OLIVE TOWER (1928) 1626 BOREN AVENUE

Built with the goal of attracting those who wished comfortable accommodations near downtown, the Olive Tower, located on a steeply inclining Boren Avenue near Olive Way, was ready for occupancy in July 1928. True to its time, it catered to car-owning residents by including a direct passage from a garage at the rear of the building to the "fast Otis elevator ... operated continuously by courteous uniformed attendants."[69]

The stylishly modern fourteen-story, 160-room apartment hotel was impressive both for its size and building finish. The *Washington State Architect* praised architect Earl Morrison's "artistic color treatment [that] has occasioned considerable admiring comment.

The Olive Tower, amid its downtown surroundings, narrowly survived Interstate 5 construction.

Cream and ivory are the predominating tones, worked out in stone and terra cotta."[70] The lobby, with massive arches and high windows and finished in tile and mahogany, made a good impression on visitors, while residents lived upstairs in small two-room plus bath and kitchenette units—both signatures of a true apartment hotel.

If a prospective tenant chose to rent a furnished unit, the living room, described as bright and airy, featured a reclining chair with "a built-in recessed nook for books and bric a brac," drapes and davenport that blended with the walls and carpets, and a spinet desk. In the dressing room, fold-down beds, a "marvel of comfort because of a spring filled mattress," would be a part of every unit, furnished or not. A French door led into the dinette, which was adjacent to the kitchen. The kitchen consisted of one large built-in unit that contained the stove, refrigerator, sink, and worktable, with cabinets above. The "brightly colored bathroom" had both a shower and a tub, and the promise of plenty of hot water. Maid service was available.[71]

Today, the Olive Tower, managed by the Seattle Housing Resources Group, a private-sector effort, makes the building's reconfigured eighty-six studio and one-bedroom apartments available to low-income individuals and full-time students. That so many former apartment buildings find continued use as housing points to their solid construction and adaptability to modern-day needs. The Olive Tower's near-downtown location has always been one of its strong points.

Belltown Neighborhood

In 2004, the City of Seattle's *Design Guidelines for the Belltown Urban Center Village* defined the "northern neighborhood of downtown Seattle [as] bounded by Denny Way to the north, Elliott Avenue to the west, Sixth Avenue to the east, and Virginia Street to the south (historically and decades ago, the southern border was Stewart Street)."[72] As the apartments under discussion *were* built decades ago, Stewart Street will remain the southern boundary for this study. The same source also categorized Belltown as Seattle's densest residential community.

A study by Diana Keys, entitled *Single Room Occupancy Hotels*, focuses on Belltown in the early 1900s. Keys used boundaries that overlap but do not match those described in the preceding paragraph; nevertheless, her findings go far in helping to picture what the neighborhood was like at the time. Her research found a wide variety of service-related, industrial, residential, commercial, and recreational buildings, all within walking distance of one another. Specifically, the area contained "40 restaurants, 39 saloons, 11 places of entertainment (including vaudeville theaters, billiard clubs and bowling alleys), and 9 halls and clubs as well as a myriad of small stores and services and a wide range of employment opportunities."[73]

1. RIVOLI (1910) 2127 SECOND AVENUE

Who would not be attracted by the Rivoli's ravishing Second Avenue entrance, obviously meant to attract an upper-class clientele?

The Rivoli, which abuts the north side of the El Rey, another apartment building dating from 1910, is L shaped, with a presence on both Second Avenue and Blanchard Street. For the first year its address was 117 Blanchard, but the following year the address switched to

The Rivoli's heavily encrusted terra cotta opening, topped with the letters RA, and black and white marble floor create an impressive entry.

Second Avenue, where it has remained. Three stories tall on Second Avenue, it becomes four stories on Blanchard as the street drops down toward the Sound.

The name of the New York firm of Howells and Stokes is on the Rivoli's plans, but it is likely that A. H. Albertson, the associate who represented them in Seattle, executed the

design.[74] At the time it opened, a newspaper advertisement enthused that the Rivoli's "2 and 3-room DE LUXE [units enjoy] streams of air and light."[75]

Three decades later, the Rivoli's neighborhood had become less desirable. The 1939 city directory reveals that all thirty apartments were rented, but based on the occupations of the residents, the Rivoli was no longer a high-end building. Half the residents listed no job, and the majority of those employed were blue-collar workers, including three fishermen, two waitresses, two seamstresses, two laborers, an electrician, collector, and mechanic. Even more telling was that among the eight women, fifteen men, and five couples who resided at the Rivoli, only one person, Hilda Vogt, a waitress, had a telephone.[76]

2. CASTLE (1918) 2132 SECOND AVENUE

Opposite the Rivoli, the Castle stands on the southeast corner of Second and Blanchard. Architect George Lawton reused some features on the Castle that he had designed for the Sherwood Apartments two years earlier.

One of the features that Lawton repeated was the window treatment, which he used to provide ornamentation on the Castle's dark red brick facades. On the ground and fifth floors the lintels feature a keystone design. Lintels on the second and third floors are unadorned brick headers. On the fourth floor Lawton splurged and topped each window

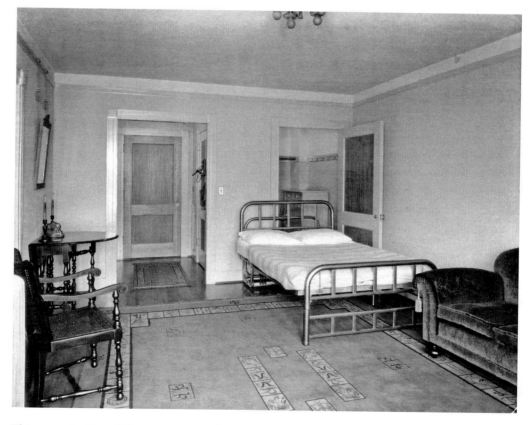

This example of an efficiency apartment fits the description of units in the Castle. *University of Washington Libraries, Special Collections, UW 29473Z.*

with a blind arch filled with a circular design. Both buildings feature similarly designed three-sided bays with trimmed spandrels, and at the roof-line of both, a white-painted cornice, supported by simple block modillions above a dentil molding, tops off each building.

An advertisement in the August 6, 1922, issue of the *Seattle Times* encouraged one to "make this desirable building your permanent home — a few unsurpassed apartments of two and three rooms, hardwood floors, white woodwork, electric laundry equipment." The Castle's corner position was another advantage, since it allows light to penetrate the units on the north side of the long, rectangular building. A light-well on the south side that extends two-thirds the length of the building allows light into the units that face it. The original forty-five units were distributed along the double-loaded corridors of the five-story building. The corner units on the north side, with two exposures, were the more desirable three-room units. All others were two rooms, which were actually one large room with a kitchenette and bath. A dressing room, off the living room, contained a hidden bed.

Many found living at the Castle convenient for attending cultural events and entertaining friends, as announcements in the newspapers' social calendars show. One resident had as her guest a mezzo-soprano, a "former Seattle girl," who was in Seattle for the engagement of her company, the San Carlo Opera. Another Castle resident "entertained with a small luncheon" in honor of her guest, who was in town for the opera.[77]

3. HUMPHREY (1923) 2205 SECOND AVENUE

Architect Warren Milner designed the Humphrey for W. E. Humphrey, member of a prominent Seattle law firm and representative to Congress, who also had an eye out for a good investment.[78] Milner's attention to detail is evident in his meticulous plans.

The Humphrey's Second Avenue entrance, one block north of the Rivoli, is imposing, complete with incised name writ large above the arched opening.

The south-facing elevation on Blanchard is equally striking, but more welcoming. Here the courtyard, created by the three sides of the U-shaped building, serves as a social gathering place as well as a light source for the units that face onto it.[79] The walls inside the courtyard display Milner's deft use of contrasting red and cream-colored brick, but the decorative frieze that appears on other parts of the building is missing in this area. At the roof line, the galvanized iron frieze, which Milner specified be painted white, lightens up the rather sober building.

Each of the seventy-four efficiency-type units, whose rooms were described as "larger than the average for apartment structures," had a kitchen, bathroom, and living room with bed closet.[80] The number of units has remained constant over the lifetime of the Humphrey.

Another group of three apartment buildings, at the intersection of Fourth Avenue and Virginia, exhibit architectural variety.

4. HOTEL ÄNDRA/CLAREMONT (1926)
2004 FOURTH AVENUE

The Claremont Apartment Hotel opened with fanfare, including a musical program and dance attended by several hundred, on January 16, 1926. The lavish lobby boasted wain-

As the decorative terra cotta cornice wraps around to the east elevation of the Humphrey, it becomes the surface on which the building's name is incised. The multipaned double doors and semicircular fanlight are original to the architect's plans.

scoting of marble imported from Belgium, travertine walls, and terrazzo floors.[81] The architectural firm of Stuart and Wheatley designed the ten-story Claremont for the Olympus Holding Corporation of Seattle, with which Stephen Berg, contractor and developer of the Claremont, was associated.

Situated on the corner of Fourth Avenue and Virginia Street, "within two blocks of

The Hotel Ändra/Claremont's exterior and interior were equally imposing. *Hotel News of the West*, March 21, 1925.

everything important," the Claremont's main entrance is on Fourth. Overly tall windows, with leaded transoms, are on both sides of the street-level entrance; windows at the second level feature elaborate pedimented lentils. Above the base, a wide band separates the seven-story shaft, faced with cream-colored brick and terra cotta, and the eighth floor. At the very top level, the cornice emphasizes the parapet wall, complete with terra cotta panels and coping, balustrades, and urns.

Residents enjoyed the opulent public spaces, from the suspended marquee that protected them and their guests as they entered the building, to the dining room, which also functioned as a ballroom, where they could eat if they preferred not to cook in their own apartment. Elevators whisked residents upstairs to the 120 two- and three-room units, about which there was "a noticeable atmosphere of individuality ... each of which is a complete household unit."[82] Nevertheless, they were efficiency units within an apartment hotel, and true to course, there was more emphasis on public spaces than individual accommodations. Kitchenettes with built-ins and breakfast dinerettes, a variation on the dinette,

and a dressing room with a wall bed maximized every inch of the compact units. The Claremont also had fifty single rooms with bath.

In 2005 the Claremont became the upscale Hotel Ändra.

5. Virginian (1917) 2014 Fourth Avenue

In the wake of regrade activity, Victor Voorhees designed the Virginian, a pale brick three-story building that joined other apartments under construction in downtown Seattle in the mid-teens.

Voorhees' plans for the Virginian exist but are difficult to decipher. It is clear that the basement level contained service areas and a number of surprisingly large apartment units, each of which had a living room, dressing room with a hidden bed, dining room (which also had a hidden bed), kitchen, bathroom, and entry hall.[83] Originally containing only fourteen units, today the Virginian has thirty-six, a common means of maximizing expensive downtown property.

Voorhees' plans called for a set of steps to lead to a recessed front entry. This formerly elegant approach has been unsympathetically altered, but many original touches remain: cambered terra cotta door and window jambs, heavy iron lamp standards, and small white hexagonal tiles with a Greek key pattern in black tile on the vestibule floor.

6. Stratford/Nesika (1916) 2021 Fourth Avenue

The Nesika was a lonely building before acquiring its neighbor, the Virginian, the following year. An early advertisement that described the Nesida as having "an elegant view ... unobstructed by other buildings" did not exaggerate.[84]

Architects Blackwell and Baker clad the five-story plus daylight basement building in dark red brick and sparingly applied terra cotta, most evident around the recessed one-and-a-half-story arched front entry. Today the Stratford, shaped like a chunky letter I, consists of fifty-five units, the number unchanged since the time of construction. Hallways at the front and back that run perpendicular to the central corridor ensure easy access to every unit, all of which face outside. At the time of its construction, in addition to "the newest modern conveniences," the Nesika featured hardwood floors, elegant views, elevator, high oven gas ranges, and cooling closets.[85] Current advertisements, while boasting of the Stratford's free cable TV and WiFi network, hasten to include details of the "classic 1916 building," such as Murphy bed, nine-foot ceilings, five-minute walk to everything, and situated near buses going everywhere, the latter proving that some features never go out of style.

Three apartment buildings are within blocks of each other where Fourth and Fifth Avenues encounter Denny Way. Two are over a hundred years old. All have observed many changes in Seattle's skyline, including the construction of the Space Needle, only a few blocks to the north of them. The monorail, built to conduct visitors to Seattle's 1962 World's Fair, brought about another change to the neighborhood's landscape. The first apartment in this group is only too aware of the monorail, as it frequently zips by the building's front windows.

7. Edwards on Fifth/LeSourd (1929) 2619 Fifth Avenue

In 1930 an advertisement for the LeSourd announced "2-rooms, furnished. Everything new. Walking distance. No hills."[86] Prior to the completion of the second Denny Regrade

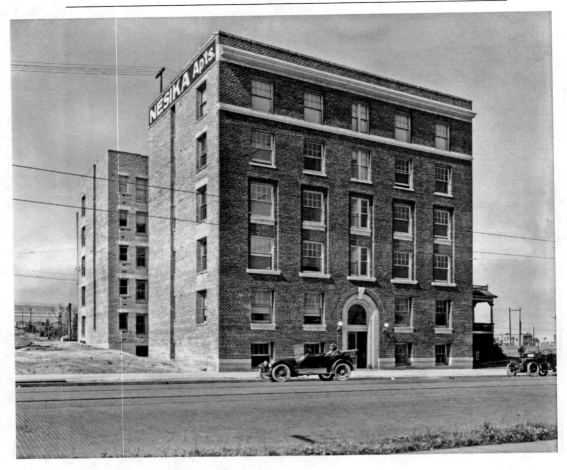

The appearance of the Nesika has remarkably stayed the same; the neighborhood has changed dramatically. *University of Washington Libraries, Special Collections, UW 29466z.*

(1929–30), the "no hills" claim would have been impossible. Indeed, at the opening of the LeSourd on January 10, 1930, it was cited in the *Seattle Times* as the "first of development in [the] regrade area."

L. W. LeSourd, president and manager of a downtown apparel store, engaged Earl Morrison as architect. Morrison designed the six-story reinforced concrete building, with retail spaces at street level and thirty two-room apartments above. The entry to the apartments is at the north end of the brown and tan brick building. An elevator and two sets of stairs provide circulation. Large transom windows, which admit additional light into the commercial areas, end at the base of a wide course of decorative cast stone. The latter, embossed with an Art Deco feather over zig-zag design, extends the width of the facade, horizontally dividing the retail section from the apartments above.

At the time of the opening of LeSourd's namesake building, he inserted the following notice in the *Seattle Times*: "I have used the best of materials and incorporated the latest ideas in apartment construction, which I hope will be appreciated by the occupants of this building."

The cast stone frieze with its stylized Art Deco design rests just above the large transom windows of Edwards on Fifth/Le Sourd.

8. TWENTY-SEVEN HUNDRED FOURTH/HERMOSA (1909)
2700 FOURTH AVENUE

The Hermosa did not begin as the imposing six-story building that it is today. Originally three stories in height, on September 17, 1911, the *Seattle Times* records that owner Ellen Monroe received a permit to build, at a cost of $20,000, three additional stories to the apartment building. Less than a week later, on September 23, 1911, an article in *Pacific Builder and Engineer* said that H. G. Stewart, with architect Theodore Buchinger, wanted bids for an addition to a three-story apartment house at Fourth Avenue and Cedar Street. If C. E. Monroe, also an owner, and his wife retained Buchinger, then the mystery of who designed the attractive building is solved.

Originally listed at 410 Cedar Street in the 1910 city directory, the Hermosa's address has been 2700 Fourth Avenue since 1912. Since the listing for a new apartment building did not usually appear in the directory until the following year, it may be supposed that the Hermosa's construction date was 1909. It was only a couple of years before the owner decided to add on to the building.

Mrs. Margaret Innes bought the Hermosa in 1925. Innes, described as "no newcomer to the apartment house field ... a wealth of practical experience behind her, for she has owned and operated several nicely appointed houses in San Francisco," entered the local real estate scene.[87]

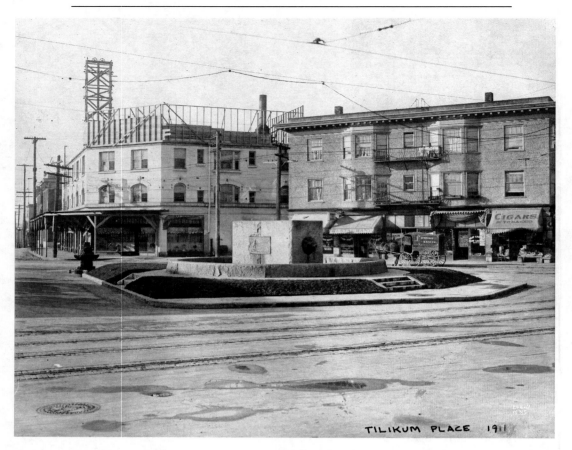

In this 1911 photograph, construction work is underway on the additional three floors to the Hermosa. To the right of the Hermosa is the Wedgwood, another early "mixed-use" apartment building. *Seattle Municipal Archives 30409.*

From its inception, businesses occupied the ground floor spaces. At the time of Innes' purchase, the Hermosa was described as "an excellently appointed apartment house of concrete construction ... it contains 125 rooms and its location is particularly fortunate, as it is located in the very heart of the rapidly growing Fourth Avenue district."[88] Its location, adjacent to Seattle Center and only blocks north of the business district, remains particularly fortunate. Today it is a condominium; businesses still occupy the ground-floor spaces.

9. WATERMARKE AT THE REGRADE/CEDAR COURT/ CEDAR (1908) 320 CEDAR STREET

An announcement appeared in the *Seattle Times* on July 5, 1908, that the Zbinden Brothers would erect an apartment house on the northwest corner of Fourth Avenue and Cedar Street. Swope and Waterman prepared the plans for the sixty-unit building of two- and three-room apartments. A few years later the Cedar was advertising large elegantly furnished rooms, steam heat, hot water, good service, private bath, and disappearing beds, but perhaps most appealing was its claim to be only a five-minute level walk to public

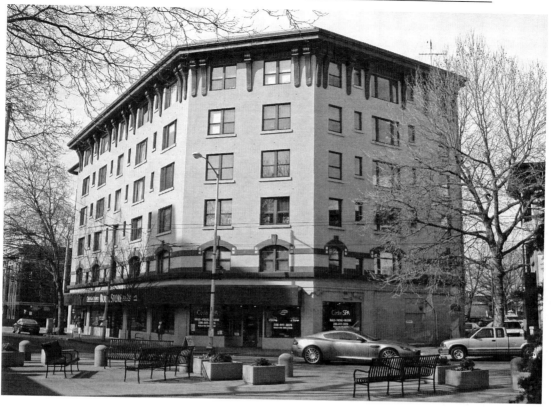

The Hermosa today in its park setting. Note the unusual elongated brackets beneath the cornice.

markets. Typically, emphasis was placed on the entry. The Cedar's vestibule had beam ceilings and marble finishings, while the individual apartments averaged 450 square feet in size.

The Watermarke at the Regrade was included in the 2004 *Design Guidelines for the Belltown Urban Center Village* as an admirable example of facade articulation. It demonstrates how "building modulation creates intervals with architectural elements such as bays and an entry portico that lend a human scale."[89] Indeed, the entry portico, flanked by pairs of Ionic columns and topped by a shallow balcony with iron railings at both the second and third levels, is human scaled and inviting. Less human scaled, but still pleasing, are the oversized and ornately scrolled brackets that support the deep cornice. Appearing deceptively small from the street, the three-story masonry building covers a quarter of a city block and today has sixty-one rental units.

Despite the number of extant pre–1939 apartments on and near Second, Fourth, and Fifth avenues, a study of early *Polk's Seattle City Directories* and Baist Maps indicates that many more apartment buildings once lined the streets of Belltown. In 1973 a newspaper article, "Downtown Housing Situation: Bad and It's Getting Worse," commented that "the Belltown–Lower Denny Regrade neighborhood is given the best chance for survival because it has moderate and middle income apartments. Such facilities won't have as heavy economic pressures applied to them as lower-income housing ... and this increases the likelihood of

A continuous line of scrolled brackets provide visual support of the Cedar's cornice.

survival."⁹⁰ It is paradoxical that many of the early apartment buildings exist today because they *have* become low-income housing. Converted by the city and organizations that advocate for the disenfranchised, these well-constructed apartment buildings have proved to be great renewable resources for housing. But change is constant, and the increasing attraction of downtown living and pressure by the city for more dense downtown housing imperil the survival of smaller and older apartment buildings.

6

First Hill and Renton Hill Apartments

> An imposing six-story brick building located on First Hill. 2 and 3 rooms, furnished and unfurnished; beautiful view, walking distance.
>
> First Hill: 5 and 6 room apartments; steam heat; janitor service; rents $45 and up.
>
> Five large rooms, beautifully papered, ivory and mahogany woodwork ... one of Seattle's most comfortable apartment houses; adults.

First Hill and Renton Hill, formerly Second Hill, once had the reputation as the city's most affluent communities.[1] First Hill, slightly east and uphill from downtown, had a functioning trolley system and enjoyed spectacular views of the Olympic Mountains and Puget Sound. It had begun to attract wealthy home owners in the 1880s. Well-appointed houses, resplendent with the trappings of wealth, hid behind hedges and shrubs. Constructed in 1883, the home of Colonel Granville Haller, complete with stables, occupied an entire block of the northeast corner of Minor and James. Seattle historian Roger Sale wrote that at the turn of the century, "The roll call of First Hill residents is almost a roll call of Seattle's financial muscle."[2] Renton Hill, abutting the east end of First Hill, also had its share of impressive homes, was well served by public transportation, and enjoyed water and mountain views.

Unfortunately, or fortunately, depending on whether one was a property owner or an investor in the neighborhoods, the wealthy soon began to forsake their stylish mansions. Many were converted to boarding and rooming houses and eventually razed to make way for larger buildings. In 1904 a reporter for the *Seattle News-Letter* lamented the coming of apartment houses in an article titled "The Tragedy on the Hill."

> In a greater or lesser degree many homes on the First Hill have been destroyed.... There is nothing so pitiless— so merciless— as contrast, and when the First Hill of today is mentally placed alongside the First Hill of a year ago ... prior to the invasion of the "dollar doublers," as the sponsors of flat buildings are termed by some of the disgruntled home owners. Since the advent of the dollar doublers (who by the way were the first to realize that the very exclusiveness of The Hill was a most valuable asset, and [a] factor in renting small apartments) there have been something like a score of flats, apartment houses and hotels, projected into the midst of the "abiding area of society."[3]

Home owners fought to retain the status of their neighborhood and in some instances purchased adjacent property to prevent undesirable construction. Some who owned unoccupied property on the hill "refused to consider any price where it was known that the purchaser intended to erect either a flat or an apartment building."[4] Conversely, with First Hill lots increasing in value and returns from rentals occasionally exceeding 20 percent, some home owners were not opposed to turning over their homes and vacant lots for apartment houses.

115

By 1910 single-family homes ceased to be built on First Hill, as its location made commercial enterprises, such as apartment buildings, hospitals, hotels, banks, and small businesses, more lucrative investments.[5] Only four of those early homes survive on First Hill; all belonged to wealthy entrepreneurs: W. D. Hofius, president of Hofius Steel and Equipment Company; C. D. Stimson, owner of lumber mills; and Henry H. Dearborn and Martin Van Buren Stacy, real estate developers. The former home of philanthropist Caroline Rosenberg Kline Galland is one of the remaining Renton Hill mansions.[6] These houses add a welcome touch of elegance to the urban landscape.

First Hill and Renton Hill apartments ranged from simple three- to four-story brick structures with simply painted rooms to tall terra cotta–ornamented buildings with lavishly appointed penthouses. "Every known 'style' is used and some which are entirely unknown until 'we did em,'" said Robert Sweatt in the September 1909 issue of *Architectural Record*. Conventional and unconventional, their construction converted First and Renton hills into some of Seattle's most desirable apartment house districts. They can best be studied by looking at some specific neighborhoods within their boundaries. Two are known by hospitals, Swedish and Virginia Mason, which dominate their neighborhoods. The hospitals have had a significant effect on the growth of First Hill, and in their quest for space to grow, they have brought about the loss of numerous early apartment buildings.[7] A third division can only be called a premier residential neighborhood; it covers some of the most visually and socially interesting extant apartment buildings on First Hill. Another study focuses on Madison Street, a once-thriving residential neighborhood on Renton Hill, just east of First Hill. Finally, a brief look at one apartment building, representative of a group of similar apartments confined to one block, concludes the study.

First Hill Apartments: Swedish Hospital Neighborhood

In this urban enclave between James and Madison streets to the north and south, and Ninth Avenue and Broadway to the west and east, the local residents had easy access to St. James Cathedral (an impressive Neo-Baroque structure), O'Dea High School for boys, Jesuit College — now Seattle University — and the city's newest hospitals, Swedish and Columbia/Cabrini. In addition to locally owned shops, a ten-minute streetcar ride transported residents to the downtown shoe stores, tailors, dressmakers, markets, and theaters. Al Wilding recalled that time of his youth:

> As neither my father nor my mother knew how to drive a car ... they made it a point to live in the First Hill and Capitol Hill area, close to street/trolley/cable cars and walking distance to downtown. Even though I was just about six years old, we made a weekly trek walking to the Public Market for fresh produce. Though the cable cars on James and Madison were handy to downtown, there was no money to ride the darn things when walking was free.[8]

Representing a variety of tastes and budgets, approximately thirty apartment buildings were built in the neighborhood between 1906 and 1929. Most surviving buildings are on or near Ninth Avenue, more distant from Swedish Hospital, and thus less affected by its growth.

1. RUSSELL (1906) 909 NINTH AVENUE

Named for owner Emmet Russell, the Beaux-Arts Neoclassical style is well represented on the building's facade: fluted pilasters at both front corners support an entablature, and

similar details flank the recessed entry. At the time of construction, architects Saunders and Lawton interspersed sections of balustrade in the parapet wall and placed a pediment at the center of the roofline. A square plaque depicting a garland, placed midway above the door and beneath the pediment, was a final flourish.

Today the Russell's original clapboard siding is hidden under asbestos shingles, and other former features have disappeared: the parapet-cum-balustrade along the roofline and the charming pediment at its center, and the plaque that filled the now-blank space above the entrance. The entablature, with its beautifully dentiled and bracketed cornice, survives.

At the time of its construction in 1906, *Pacific Builder and Engineer* described the Russell as an apartment house with eight flats.[9] Its name did not appear in *Polk's Seattle City Directory* until 1908, and then under the heading of "hotels." In 1913 the Russell finally appeared in the directory's listing of apartments.

Notices of the availability of a "front parlor room in a modern flat" or a "nicely furnished steam heated room with bath and telephone" at the Russell appeared in early newspaper columns. Based on the frequency of such notices, even in more upscale buildings, it can be concluded that subletting a room was a common practice. Census information also bears out that many individuals and families listed one or two lodgers or boarders in their unit. The majority of advertisements for the Russell, however, were for a "five room modern heated apartment" or an "elegantly furnished three room apartment; close in."

The scale of the two-story Russell as it faces Ninth Avenue is similar to that of a private home. Its appearance may have influenced the owner's decision to choose it for his own residence, for early in March of 1906 an announcement that "Mr. and Mrs. Robert Emmet

Despite some cosmetic losses, the appearance of the Russell has not dramatically changed since this 1937 photograph. *Washington State Archives, Puget Sound Regional Branch 859040 0930.*

Russell have taken an apartment at 909 Ninth Avenue and are now at home to their friends" appeared in the newspaper.[10] Its modest facade, and the fact that it held only eight units, leads one to think of it as a small building with correspondingly small units, but each averaged almost a thousand square feet. The number and size of the units in the Russell have not changed.

2. WESTMINSTER (1907) 903 NINTH AVENUE

On August 22, 1906, the *Seattle Times* reported the sale of the lot to the immediate south of the Russell Apartments. Six weeks later, Stirrat and Goetz, the buyers, took out a permit to erect a three-story brick apartment house on the property and named Andrew McBean as the architect.[11] On November 23, 1907, the *Seattle Times* reported that the firm had sold the Westminster, "a handsome family hotel structure," to Bert Farrar and W. F. Clark, two well-known names in Seattle real estate circles.

The three-story structure on the northwest corner of Ninth Avenue and Marion Street becomes five stories as the hill on which it stands drops off steeply toward the west. The main entrance, once sheltered by a glass and metal marquee, is on Ninth Avenue. On the building's south side, a spacious light well, an opening that allows natural light to reach interior windows, shelters a second entrance that faces Marion Street. When new, partially due to the light well, the Westminster could advertise that the rooms of the thirty-three furnished and unfurnished four-room apartments were large and airy.

In addition to the missing marquee, the three-sided bay windows that appeared intermittently on the east and south elevations have been eliminated. Still visible is the iron fire escape, a reminder of the city's concerns for fire safety in the early years of the twentieth century.

Unfortunately, the Westminster's glass and metal marquee disappeared sometime after this 1937 photograph. *Washington State Archives, Regional Branch 859040 0931.*

3. ENVOY (1929) 821 NINTH AVENUE

Seattle architects William Bain, Sr., and Lionel Pries drew the plans for the Envoy, one of several apartment buildings that Bain's father, David Bain, built and owned.[12] The architects knew the Envoy would be in good company, as its location on the southwest corner of Ninth and Marion was across the street from St. James Cathedral. That fact was frequently mentioned in advertisements for the Envoy, as were its unexcelled views and "few minutes walk to [the] downtown district."

The main entrance is surrounded with a large swath of terra cotta. An unusual feature of the entry facade is the large, multipaned window that punctuates the surface of the terra cotta on each side of the front door. The subtle receding planes that compose the frames around the recessed windows and door point toward a modern leaning for Bain and Pries. Brick that has been painted gray faces the remainder of the first floor's slightly projecting entry bay. Terra cotta or cast stone also appears in a series of shieldlike ornaments spaced along the irregularly notched parapet and coping. The lighter-colored material not only embellishes the facades but provides a contrast to the dark red brick that covers the solid masonry structure.

The Envoy's Ninth Avenue facade is three stories in height, but, similar to the Westminster, it quickly becomes a taller building as Marion Street descends the steep hill. The

The unusual treatment of the Envoy's front entrance is repeated, on a smaller scale, at the side entrance. The Envoy's desirable location allows easy access to downtown and an array of First Hill medical and retirement services.

architects repeat the theme for the secondary entry on the north side of the building, which again features a window cut into its surface. Here, receding lines also create frames for the door and window.

Near the October 1, 1929, opening date, promoters announced that the Envoy's forty-four "ultramodern" two-room efficiency units would have features such as electric fans, ranges, and refrigeration, as well as papered walls and mahogany woodwork.[13] The Envoy has maintained it original number of units.

4. LEIGHTON (1907) 814 COLUMBIA STREET

The *Seattle Times* carried a notice on February 26, 1907, for an "auction sale of elegant furniture — the contents of a nine-room private residence at 814 Columbia." Later the same year, on November 27th, an advertisement for the Leighton, at the same address, appeared in the *Seattle Times*: "Elegantly furnished or unfurnished two and three-room apartments, containing private bath; located in choice residence district on First Hill." Such was the selling of homes on First Hill, with apartment buildings promptly replacing them.

Today the remaining, but much-diminished, architectural details on the exterior of the Leighton consist of the one-and-a-half-story-tall arched entryway capped by its bold

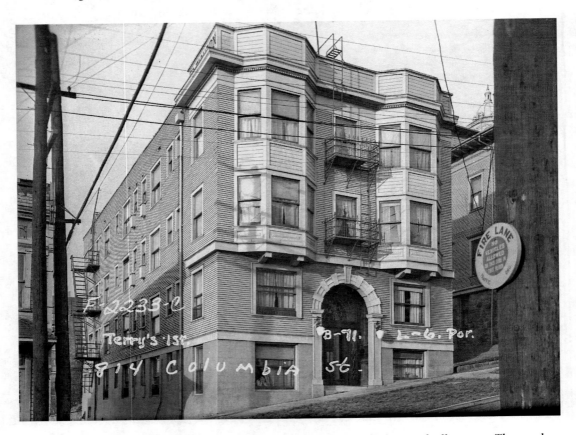

The Leighton when it still possessed its original wood-faced bay windows and tall parapet. The wood-trimmed arched opening with prominent keystone survives. *Washington State Archives, Puget Sound Regional Branch 859040 0891.*

keystone and two ornate iron balconies, once part of the fire escape, at the second and third floors. Asbestos shingles that now cover the building hide the original cedar siding. At some point, a tall parapet that rose above a dentiled cornice was removed. The Leighton's narrow width is offset by its deep length. At the rear, a recessed stairway accesses all but the basement floor. Inside, a small lobby with wood-paneled wainscoting, a decorative wood ceiling, and impressive stairway are reminders of the Leighton's early appeal.

Currently partnering with the Seattle Housing Authority, the Community House Mental Health Agency provides housing for its clients in the Leighton.

5. OLD COLONY (1910) 615 BOREN AVENUE

In mid–1909 a permit was issued for construction of a three-story brick veneer apartment at 617 Boren.[14] According to a newspaper announcement, the Old Colony was built for E. B. Burwell of the Seattle Hardware Company.[15] A month after the *Seattle Times* noted, on January 2, 1910, that the building was "recently completed," it was said to belong to a "syndicate of Butte [Montana] capitalists."[16] Burwell realized a quick turn-around of his investment.

Architect Frank P. Allen's name is on the building permit. He is credited with being the "man who built [the] fair," as his firm had seen to the grouping and construction of

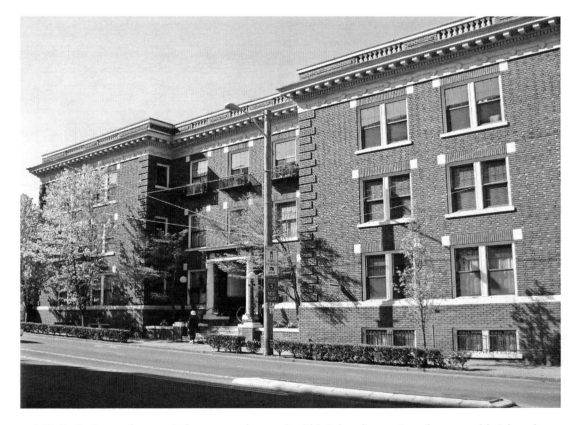

Still displaying early twentieth-century charm, the Old Colony's exterior of warm red brick and lavish terra cotta lends an early-day calm to the now-busy Swedish Medical Center neighborhood.

the temporary buildings prior to the opening of the Alaska-Yukon-Pacific Exposition.[17] Considering that both the exposition and the Old Colony opened in the same year, it is probable that a member of Allen's firm drew the plans for the Old Colony.

Deep courtyards on the south and north facades assured that all twenty-eight of the five-room apartments were well lit and ventilated. Brick was artfully used to create quoins, lintels, and the parapet. Short sections of balustrade intermittently adorn the parapet. Wood was beautifully employed in the frieze and cornice, which wrap around all but the south facade and interior of the light wells. In an effort to cut costs, only the front elevation usually receives such lavish attention.

The building's central bay is a pleasing composition of an inviting entrance via marble steps, large windows with terra cotta sills, and small iron balconies at the third-floor windows. The recessed entry, enhanced with green marble and wood wainscoting, accesses double doors that open into a small vestibule. From here, another set of doors opens into the lobby. A central stairwell with curved wood banisters links the floors, where wide corridors display wood wainscoting, fluted pilasters flanking hall entryways, and cornice moldings.

Today the Old Colony has thirty-two units, four more than when built. Since early advertisements mentioned maids' rooms, it is possible they were later converted to the additional units. Many units retain the original oak floors, nine-and-a-half foot tall coved ceilings, and pocket doors between the living and dining rooms.[18]

An unusual feature at the Old Colony was the placement of the icebox, or refrigerator,

Early advertisements mentioned the Old Colony's large rooms, borne out in this view of a highly decorated parlor. *Museum of History and Industry, all rights reserved, unless otherwise noted.*

inside one of the kitchen closets. At the rear of the closet was another door that opened onto the hall corridor, which allowed the ice man to access the back of the icebox, which also had a rear door. This two-door version of the icebox was meant for upscale apartment houses, as the rear-door feature meant extra expense for the builder. It was a desirable amenity, since it reduced the mess inside the unit created by dripping ice, and the ice man could go about his business without bothering the resident.

The Old Colony, after experiencing numerous changings of hands, fell into disrepair. In 1991 it was spared demolition, restored to its original state, and converted to condominiums.

First Hill Apartments: Virginia Mason Hospital Neighborhood

In the early 1900s, the area bounded by Madison Street on the south and Pike Street on the north, and between Ninth Avenue on the west and Boren Avenue to the east, was a neighborhood of upscale residences. In 1920, Virginia Mason Hospital was established at the corner of Spring Street and Terry Avenue in the midst of this neighborhood. Apartment buildings gradually replaced homes, particularly along Boren Avenue. All the early apartments still visible today on Boren Avenue between Madison and Pike streets were built between 1924 and 1927. They formed an almost continuous street facade, which despite recent losses still makes a strong statement. Together, they were an early example of high-density construction, years before the city began to mandate it. Prior to the widening of Boren in 1946, residents enjoyed pleasantly landscaped parking areas on the tree-lined street.[19]

1. CHASSELTON (1925) 1017 BOREN AVENUE

"Property for sale ... finest locality in city for apartment site." The owner of the property at 1017 Boren placed the advertisement in the *Seattle Times* on June 27, 1924. He obviously found a buyer, for by the next year the Chasselton, constructed on the southwest corner of Boren Avenue and Spring Street, was in business. John Hudson, owner and developer of the apartment building, sold it to a local corporation within months of its completion, indicative that apartments were good investments. They were often sold as soon as built. Hudson, although a licensed architect, relied on others to design the numerous apartment buildings he constructed. Architect Daniel Huntington drew the plans for the Chasselton as well as the recently demolished Northcliffe Apartments, one block north on Boren, also built by Hudson in 1925.[20]

From the large cast stone surround, believed to be the first cut cast stone front on a Seattle apartment house, a Tudor-arched opening leads to the entrance.[21] Inside the small vestibule, wide stairs lead up to the lobby, where residents retrieve their mail and make their way to their apartments via elevator or stairs. The majority of the sixty-two units were efficiencies, with six one-bedroom units placed at some of the front corners. For those with a car, "ample" parking was available in a garage that hugs the southwest corner of the chunky L-shaped building. A garden for residents' use was on the roof of the garage.

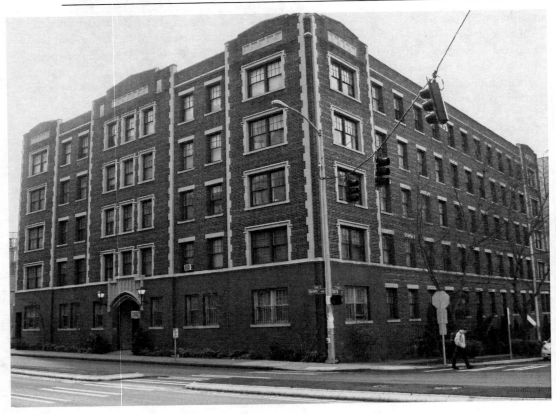

Not visible are shiny brass signs with the building's name on either side of the Chasselton's Tudor-arched entry.

2. MARLBOROUGH HOUSE (1928) 1220 BOREN AVENUE

Across Boren and two blocks north of the Chasselton, the Marlborough House was built on the former site of the home of Margaret Denny, a member of Seattle's pioneer Denny family.[22] On June 30, 1927, the *Seattle Times* announced that the Marlborough Investment Company would build apartments at 1220 Boren Avenue; construction began the following month.[23] A barrage of information ensued, including that the "luxurious lobby with liveried service in attendance" would be a feature.[24]

Architect Earl W. Morrison drew the plans for the Marlborough House after studying some of the finest apartment buildings in New York City.[25] From the beginning it was to be an imposing twelve-story building of steel and reinforced concrete, faced with brown brick. Its form is surprisingly modern, despite Gothic influences at the entrance and top-floor penthouse level. The imposing three-arched entry porch swathed in terra cotta successfully conveyed that this was a fashionable address. Projecting piers are architectural diversions on the tall shaft, which at the penthouse level burst into a profusion of terra cotta.

At an open house on February 7, 1928, prospective tenants were invited to view the eight-room penthouse suite that commanded "a view unsurpassed in America." It featured a large living room and dining room, both equipped with spring floors suitable for dancing; three bedrooms, each with private bath; and a spacious kitchen with butler's pantry. In

Residents of the Marlborough House may take advantage of the enclosed walkway, which connects the building to the sixty-car garage at the rear of the building.

2009 dollars it would have cost $4,650 a month to rent the penthouse. The less well-heeled could rent one of the ninety two-, three-, and five-room units that featured mahogany woodwork, pastel tile bath, and kitchen with a dinette. The service of maids, butlers, valets, a commissary, and laundry created a sense of luxury for those who lived in the Marlborough House. Architect Morrison moved into the building at opening and remained there until 1930.

In 2008, Live Historic, under the development direction of Pioneer Property Group, acquired the Marlborough House. Carefully preserving the building's vintage architectural features, while updating interiors to attract modern-day buyers, condominium units went on sale at the same time the economy deflated. With too few presales, it was foreclosed in early 2009. At the time of this writing, "Two penthouses, each with a spacious private terrace," are now for rent in the once-again Marlborough House Apartments.

First Hill Apartments: A Premier Residential Neighborhood

A significant number of Seattle's earliest and most prestigious apartment houses are in the area located north of Madison and south of Union streets, between Minor Avenue and Broadway. In proximity to Summit Elementary and Broadway High School, First Baptist

and St. Mark's Episcopal churches, and the Olympic Tennis Club, it was a desirable neighborhood.[26]

Reminiscing on his growing-up years in the neighborhood, Edward Dunn recalled that "the cable line we knew the best, of course, was that which ran on Madison Street and originally lurched along all the way from the waterfront out to Madison Park for a nickel." The neighborhood also had its material conveniences, as Dunn also pointed out, since the nearest commercial area was only a block away on Pike Street.[27]

Although many apartments in this area were built to appeal to a more affluent clientele, today they are more aptly characterized by their range of styles and early construction dates.

1. GAINSBOROUGH (1930) 1017 MINOR AVENUE

The Gainsborough opened its First Hill doors in a period of great economic unrest. In rosier times the Gainsborough Investment Company had engaged Earl Morrison, the architect who designed the Marlborough House a few years earlier, to design the luxurious apartment building. Morrison's design for the thirteen-story Gainsborough conveyed affluence. The cut stone–faced base ends at the third floor, where a terra cotta belt of swirling shells demarcates the shift between the base and the more simply clad nine-story shaft of buff-colored brick veneer.

An eye-catching band of large terra-cotta seashells separates the stone-faced ground floor from the brick shaft of the Gainsborough.

A band of richly designed brickwork separates the shaft from the upper two stories, which are faced with diamond-patterned brickwork. Gable-roofed dormers *and* finials provide a touch of fantasy at the roofline. When the building converted to condominiums in 1980, three penthouse units were created from an area "tucked into the gables of the roof," resulting in an additional floor for the Gainsborough.[28]

Morrison did not stop with the impressive exterior. Once residents passed through the three-arched loggia into the "impressively furnished and magnificently decorated lobby," there was both a service and passenger elevator for their convenience.[29] A typical floor plan shows four units, which varied between four, five, or six rooms, on each floor. At least one unit per floor contained a maid's room. At opening, an advertising prospectus characterized the Gainsborough as "The Natural Environment of the Aristocrat."[30]

Seductive conveniences included "commodious closets [to] win a woman's immediate approval," once-a-month free waxing of floors and washing of windows, a uniformed attendant to deliver packages, and a full-time mechanic to service cars parked in the basement garage.[31] Upon the completion of the Gainsborough, Morrison left the Marlborough House and moved into a tenth-floor unit of his latest creation. In 1980 the building converted to condominiums.

2. SAN MARCO (1905) 1205 SPRING STREET

The San Marco has stood at the southeast corner of Minor and Spring for over a hundred years. The architectural firm of Saunders and Lawton designed the building for developer Bert Farrar. A three-story-plus-daylight-basement building, it opened in October 1905 and by late December had became investment property for Senator Frank Clapp. "The buy is regarded as a splendid one," said realtor John Davis. "Every one of the 118 rooms is occupied and has been since the leases were first available."[32] Farrar lived in the San Marco the first year it was open.

Within the front courtyard formed by the wide U shape of the structure, there are three entrances: one in the central section that faces north, and one in each of the two symmetrical side wings. A gabled dormer with curvilinear parapets, typical of the Spanish Mission style, is above the central opening. Gables are similarly placed at the front and side elevations of the two wings. The three recessed and arched entrances, two of which are adorned above with a broken pediment and ornamental medallion, are in themselves works of art. The San Marco's stucco exterior is another reflection of the Spanish Mission style.

In the upper sash of the dormer windows, the curved wood muntins (the framing that holds the windows' panes) feature a curved diamond pattern. All windows on the building's facade originally featured the same pattern. The design is cleverly repeated on the wood stringcourse that separates the upper two stories from the first and in the leaded glass panels above the double wood doors into the vestibules.

Entrance to the ground-floor unit at the east end of the building, and the stairway to the two upper floors, is inside the vestibule, where lavish plasterwork adorns the ceiling. Dotty DeCoster lives in the first floor unit, which retains many reminders of the last century. Off the kitchen there is evidence of a servant/delivery entrance via an interior stairway, removed due to later fire codes. A butler's pantry, now removed, between the kitchen and dining room, facilitated the serving of meals. The rooms, especially the living rooms, are large and feature windows of a size that allows an abundance of natural light. A pier mirror, almost ceiling height, allowed the lady of the house to check her attire before leaving. The

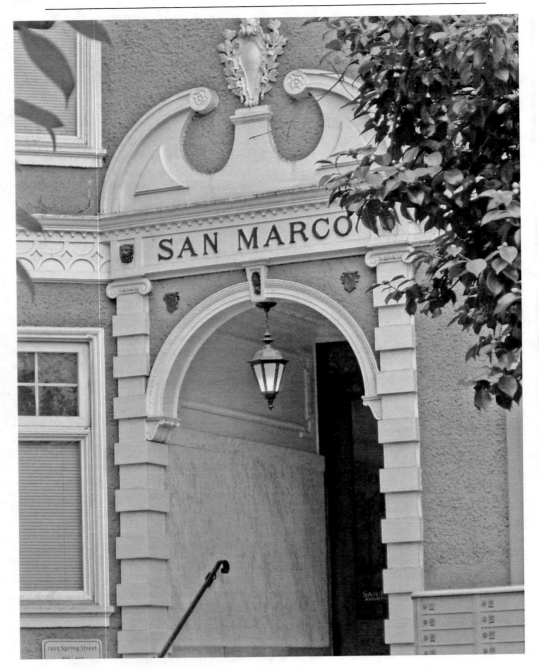

One of the San Marco's three entrances, topped with an elaborate broken pediment. Inside the entrance, the walls are marble.

quality of the interior wood doors, and their locks with metal escutcheons, speaks to on the quality of the workmanship found in the San Marco.

Who lived in this architectural gem? According to the 1910 census, of the ten who responded, there were nine married couples, six of whom had one child living with them.

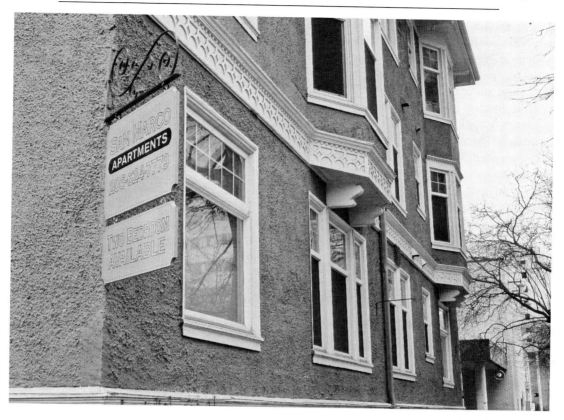

The diamond-patterned design of the stringcourse stands out against the San Marco's stuccoed walls.

One couple also had a sister-in-law living with them, and another had a mother-in-law. Overall, it was a family-oriented apartment building. Five units had a live-in servant. The men's occupations included several managers, an attorney, a professor of forestry, an accountant, a physician, a bank cashier and a United States marshal.[33]

The courtyard, described as being brilliantly lighted at night when the San Marco opened in 1905, continues to be a welcome green space, to passersby as well as residents.[34]

3. 1223 SPRING (1929) 1223 SPRING STREET

The 1223 Spring would be "the finest structure of its kind in the Pacific Northwest," said A. M. Atwood, vice president of John Davis and Company, agent for contractor L. H. Hoffman. At the formal announcement, Atwood further stated that it would "be built with a direct appeal to persons of means who are dissatisfied with maintaining large residences in the suburban districts."[35] Adding to the 1223's appeal was the use of the street address for the apartment building's name, a practice that implied prestige, because it ensured that no other building would have the same name.

The developers, perhaps worried about the economic storm clouds overhead, rushed to commence construction. On January 6, 1929, it was announced that work would begin immediately, with completion by July 1. Although not finished until mid–August, it was still an accomplishment. Earl Morrison was the architect of choice; 1223 Spring and his two

other First Hill apartment buildings, the Marlborough House, completed in 1928, and the Gainsborough in 1930, are all within a few blocks of each other. 1223 Spring shares the block with the San Marco, to its west.

The twelve-story building has a clearly defined base clad in cut stone, above which rises the brick-veneered shaft. Diamond-patterned brickwork and a profusion of terra cotta ornament the exterior of the top floor, which is a thirteen-room penthouse. Arthur Cohen, the principal stockholder in the Spring-Summit Apartment Company that owned the building, initially lived in the unit, described as "one palatial apartment."[36]

The sales prospectus made clear that the only apartments on the first floor would be those of the manager and caretaker, thus shielding residents from unwanted guests. Only two units occupied each of the upper floors. Those in the western half of the building were six-room suites that included three baths and one maid's room. Those in the other half

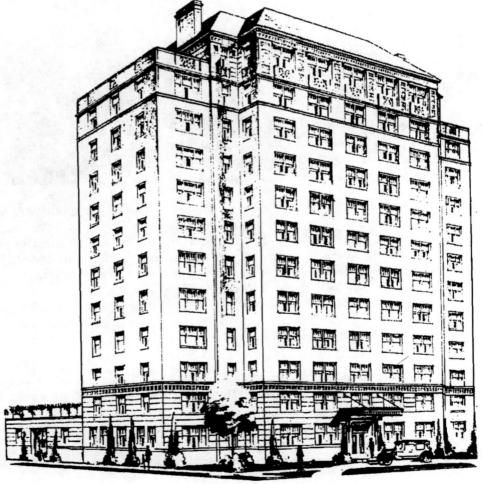

Architect, Earl W. Morrison
Contractor, L. H. Hoffman

The imposing thirteen-room penthouse may easily be seen in this drawing of the 1223 Spring Apartments. *Pacific Builder and Engineer,* May 4, 1929.

were eight-room suites with three baths and two maids' rooms. All featured a foyer, reception room, living room with marble and wood fireplace, and a dining room. A description of the wardrobe space in each bedroom that promised "a drawer for shoes, a hat drawer and a drawer sufficiently large for gowns without folding" was an indication of the level of luxury within the units. The service area included the kitchen, a dining alcove for the servants, pantry, and maids' rooms and bathroom. The area was separated from the owners' living quarters by a service hall, accessible by both a service stairway and elevator.[37]

A garage at the rear, topped with a roof garden, contained separate chauffeurs' quarters, but Florence Lundquist, who lived in the more modest St. Johns Apartments about five blocks from the 1223 Spring, recalled that a resident in her building left home every morning, "very nattily dressed," for his job as a chauffeur for a 1223 resident.[38]

Prominent Seattle citizens, among them David W. Bowen, president of Puget Sound Sheet Metal Works; Alfred Shemanski; owner of Eastern Outfitting Company; Prentice Bloedel, owner of the MacMillan Bloedel lumber business; and Joseph Swalwell, president of Seattle First National Bank, chose 1223 Spring for their home.

4. St. Paul (1901) 1206 Summit Avenue and 1302–08 Seneca Street

The St. Paul is Seattle's first multifamily dwelling to qualify as a purpose-built apartment house, opening the door of First Hill to the construction of apartments that appealed to the upper class. In February of 1901 notices appeared that Spalding and Russell, a Tacoma architectural firm, had prepared plans for the northeast corner of Seneca Street and Summit Avenue.[39] By May, a long article, including a drawing of the under-construction building, advised "those desiring to secure apartments in this building ... to communicate or call at once" upon the office of John Davis, Agents.[40] The St. Paul opened in late 1901, as evidenced by two help-wanted notices for someone for "general housework" that appeared in the *Seattle Times* on January 1, 1902.

Builder Edwin C. Burke owned the property and named the building the St. Paul to honor the city of his birth, St. Paul, Minnesota. Although Burke did not move into the St. Paul upon its completion, there were other distinguished citizens who did. Oliver la Farge, president and treasurer of Metropolitan Realty Company, was an early tenant. The William John Johnston family, owners of the Plymouth Shoe Company, leased an apartment in 1903, according to grandson Andrew Kunz. On July 1, 1906, the *Seattle Times* featured a half-page photograph of H. P. Strickland sitting in his car, a Model K Winton, with the caption that it was the most ornate automobile in Seattle; the article also mentioned that Strickland lived at the St. Paul.

The St. Paul has three entrances: one on Summit and two that face Seneca. Inside each of the three entrances, individual apartments, only two per floor, were entered from a lobby furnished with rugs and pier-glass mirrors. A wide carpeted stairway in each lobby led to the upper floors. This configuration eliminated long corridors, one of the least-liked features of early apartment buildings. Mailboxes, speaking tubes, and electric bells, which allowed tenants to communicate with and open the front door to visitors, were placed just outside the entrance door of each unit. Loggias, on the second and third floors directly above the Seneca entrances, were handsomely furnished and intended as lounging and smoking rooms.[41]

All eighteen apartments had a private vestibule, reception room, parlor, library, dining

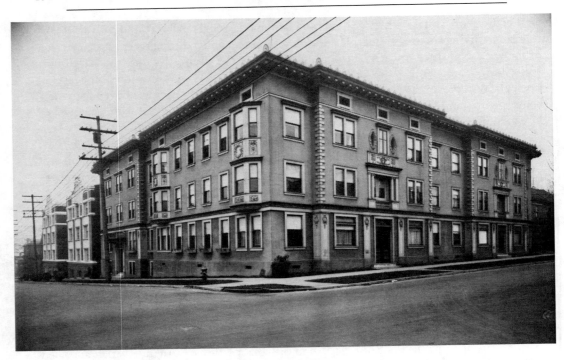

The St. Paul's three entrances and many striking architectural details are apparent in this ca. 1920 photograph. *Museum of History and Industry, all rights reserved, unless otherwise noted.*

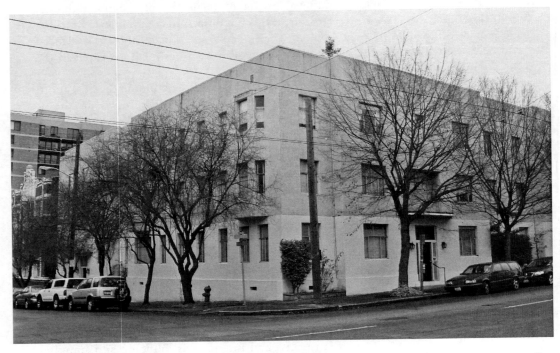

In a contemporary photograph of the St. Paul, most exterior architectural details, such as the small decorative finials along the roofline and eye-catching brick quoins, have disappeared.

room, and kitchen. Twelve apartments had three bedrooms, while the other six had two. Today, the still-large units, which average over 1,400 square feet, have ten-foot-tall ceilings and retain some original features in the kitchens and bathrooms. Each apartment has a back porch, perfect for holding the icebox, connected by an outside stair. The backs of the units face a large courtyard, with trees, shrubs, and brick paths, created by the two wings of the L-shaped building. A structure adjacent to the courtyard originally housed the boiler, which furnished steam heat for the building.

The sale of the St. Paul was recorded in the *Seattle Times* on November 5, 1939: "An echo of Seattle's earlier days was heard in Seattle real estate circles with the announcement that ... Seattle's first major multiple-dwelling building had been sold ... [it] was for years a showplace."

5. ARCADIA (1916) 1222 SUMMIT

The two projecting bays of the Arcadia are just visible in the 1920s photograph of the St. Paul. The Kreielsheimer brothers and Charles Z. Frey engaged builder Isham B. Johnson to design and construct the Arcadia.[42] Johnson used dark red brick, interspersed with contrasting ivory-colored terra cotta, for the exterior of the four-story building.[43] An extravagant amount of terra cotta clads the gabled bays and spandrels below and above the second-floor windows.

The floors of both front lobbies are beautifully covered in buff-colored tiles, with a border of darker tiles and a delicate mosaic. The original glass ceiling fixtures, telephone call box, and green marble wainscoting, which extends up the stairway to the second floor, help to imagine the lobby's original appearance. King County Property Record Cards, usually stingy with compliments, describes the Arcadia's lobby as "elaborate."

Exceptionally large one- and two-bedroom units average almost a thousand square feet.[44] All the original thirty-two units had two separate doors, each with its own doorbell, which opened off the wide corridors. The entry that opened directly into the kitchen would have been for servants and deliveries; the second opened into an entry hallway inside the unit. All apartments had a living room, dining room, kitchen, bedroom(s), linen closets, and large walk-in closets. A hidden bed, behind double wood doors with inserts of leaded glass, was a feature in many units.

Mary Bard Jensen, sister of Betty MacDonald, author of the popular *The Egg and I*, lived briefly at the Arcadia in 1936. Her husband was a physician at the nearby Maternity Hospital.[45]

6. UNION ARMS AND UNION MANOR (1925)
604–614 EAST UNION

The Union Manor–Union Arms is a three-story building that spreads along the entire north side of the block of East Union Street between Belmont and Boylston Avenues. Although it appears to be two separate buildings, each with a different name above a separate entrance, it is actually one single structure.

Contractor John Lorentz bought the two double corner lots in March of 1925, with the "intention of building two apartments on the property."[46] Architect John Creutzer drew the plans for the Union Arms, the building at the northwest corner of Boylston Avenue and Union Street. By the end of September, it was in business. Creutzer's plans were equally suitable for the Union Manor, a mirror image of the Union Arms. Both buildings were

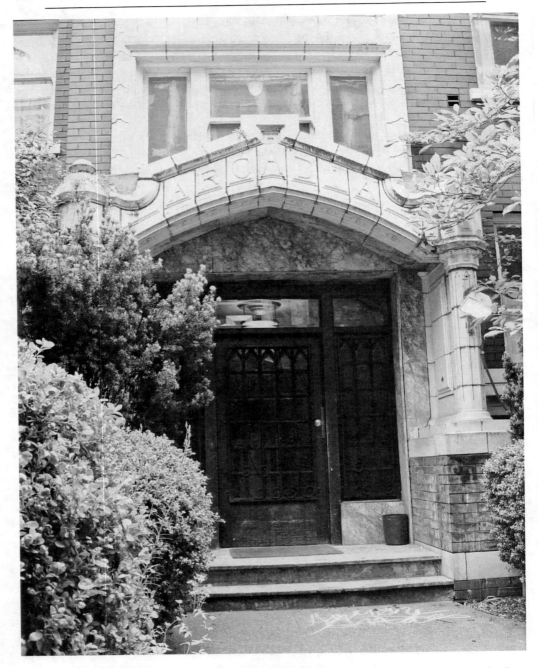

The Arcadia's two main entrances are similar; their heavy oak doors face each other across the deep courtyard created by the U shape of the building.

renting apartments by November 29, when the rental agency announced that "notwith-standing the great volume of new apartment ... construction this year," half the apartments were already rented.[47] Less than five months later, in April of 1926, Lorenz sold the Union Arms and Union Manor to Seattle mayor E. J. Brown.[48]

Today the building evokes the best of 1920s apartments. The identical Tudor- arched entries feature cast stone surrounds, each with the building's name above. An interesting use of brick, a Creutzer trademark, includes the projecting stringcourses, the lintels created by a row of bricks set in soldier fashion, and the parapet, whose common bond pattern is highlighted by a bold use of mortar.

Interior features included conveniently sloped ramps, instead of stairways, that connected the floors. Patterned after indoor automobile parking lots, the ramps, according to a newspaper account, were a recent innovation in apartment house construction.[49] Another feature, common to 1920s apartments, was a service closet, placed near the door of each unit. Approximately two by three feet in size, it opened on the hall side for deliveries. By opening the door of the closet from inside the unit, tenants could retrieve the contents. Since many deliveries were food, Creutzer termed his detailed drawing of this amenity a "grocery closet." The "roomy arrangement" of the seventy-three two-room and five three-room apartments included kitchens with built-in wood cabinets, pull-out breadboards, and china closets. The latter, with doors of many panes of leaded glass, separated the kitchen and large dinette. Cooler cabinets, small food-storage areas cooled by circulating air, are normally in the kitchen against an outside wall. Since all kitchens in the Union Arms and Union Manor were interior rooms, Creutzer inventively placed the cooler cabinets below the dining-room windows behind wood-paneled doors. Looking at the building from Union Street, the four small square openings beneath certain windows indicate the location of the cabinets.

Fortunate to have a garage beneath the building, the Union Arms and Union Manor continues to function as a convenient and well-maintained apartment building on the edge of First Hill.

7. MAXMILLIAN (1918) 1414 SENECA STREET

The Gothic architecture of the large church across the street from the site of the Maxmillian may have inspired the architect as he considered the design for the building.[50] Certainly the dark brick and terra cotta building materials complemented the church's exterior as do some interior features. Prior to construction of the Maxmillian, a residence was on the site, which as late as 1917 was a boarding house.

The terra-cotta-bedecked entry is the Maxmillian's most striking feature. Above the Tudor-arched opening is a wide scroll-like frieze that appears to have unfurled to reveal the building's name. A richly decorated narrow band sits atop the frieze, which is where a three-piece ensemble of vertical bands of terra cotta briefly appear. They reappear in the parapet, with the center piece topped by a lanternlike structure. Earlier photographs show smaller-scaled lanterns, each topped by a Gothic cross, flanking the larger one. Was the architect again acknowledging the church? Another missing feature is a tall flagpole that was positioned squarely and immediately behind the central lantern. Inside the entry area, the sidelights that frame the front door now have beveled glass in only one side. In the small lobby, Gothic crosses are incised in the wood newel post of the stairwell.

Today the Maxmillian has thirty-one apartment units that conform to the modified U shape of the building, the result of a large light well on the east side. There are three efficiencies that share one bathroom, eighteen efficiencies with their own bathrooms, nine one-bedroom units, and one two-bedroom unit.[51] The large room of one of the efficiencies has a shallow closet, in which space the hidden bed surely was stored when not in use. The

The flight of marble steps, accompanied by marble wainscoting, begins at the street and ascends to the Maxmillian's deeply recessed entry.

kitchen possesses what are probably original features: a small free standing sink, glass-doored cabinets, and a cooler box, still attached to the wall.[52]

Two years after opening, the 1920 U.S. Census revealed that all twenty-seven units in the Maxmillian were rented. Residents were mostly young couples, or pairs of siblings, but as advertisements stipulated "adults only," there were no children. Several residents took in boarders. Residents' occupations ranged from doctor and dentist to chauffeur. There were a number of nurses, who may have walked to work at one of the nearby hospitals, and there were a number of high school teachers, who may have walked to Broadway High School, only a few blocks away.[53] Many early apartment buildings did not accept children, but the Maxmillian was even more selective, as it required references for prospective tenants.

Renton/Second Hill Apartments: Madison Street Between Thirteenth and Nineteenth Avenues

Most Seattleites would not be able to name Renton Hill, also known as Second Hill, as one of the seven hills that contributes to Seattle's topography, but the name appeared on area maps as early as 1882. It was named for Captain William Renton, who logged the dense

woods and "installed wooden sidewalks and graded the streets."[54] Realtor C. T. Conover recounted the area's beginnings in the *Post-Intelligencer* on March 12, 1905: "Sixteen years ago this spring we placed on the market Renton [Hill's] addition, extending from Fifteenth to Nineteenth Avenues on both sides of Madison Street. It was a forest and we first had to have it cleared. Of course there was no car line on Madison Street ... and we had to keep teams to drive customers out to the property."

On June 10, 1889, the uppity *Argus* speculated that "Renton Hill is far enough from the business portion of the city so that there is no danger of its being given up to lodging house(s), boarding houses, small trades people, and other things that are bound to flourish near the city proper." Feeling confident, in early 1903 the Renton Hill Improvement Club built a "handsome and commodious" building on Eighteenth Avenue East, one block north of Madison Street. Members enjoyed dancing in the club's large ballroom, which had an alcove for musicians and one of the finest floors in the city. It was built by a stock company formed of prominent residents on property donated by the sisters of William Renton.[55]

By 1907 a newspaper article related that "the region just over the first hill, on Madison Street, and extending well up the slope of the second hill, is getting its share of the building activity these days."[56] Street regrades made it possible for streetcars to go east on Pike from Broadway to where Pike crossed Madison at Fourteenth Avenue, affording easier access to the area. Seattle realtor Henry Broderick felt that with more direct service, "the Second Hill will bear much the same relation to the upper end of town as the First hill does toward the middle and south end."[57] Broderick was correct.

Although Renton's *addition* officially begins at Fifteenth Avenue, the discussion of apartments on Renton *Hill* begins at Thirteenth Avenue and Madison Street, the latter being Seattle's only street that extends from the waters of Puget Sound to those of Lake Washington. An obvious transportation conduit, apartments sprang up along its length.

1. PARK HILL/LAGONDA/ROBINSON (1907)
1305 EAST MADISON AND 1300 EAST UNION

In the space created by the confluence of East Madison and East Union streets and Thirteenth Avenue, architect John Graham, Sr., and his junior partner, David J. Myers, designed a rhomboidal building that fit the site. Evenly placed windows on every floor and facade flooded the units with light, as an early advertisement confirmed: "Not an inside dark room in the building."[58] There was a rear entrance to each apartment, reached via back porches, "through which all deliveries and removals [were] made."[59] A terra cotta surround and marble floor highlight the recessed front entrance, reduced to a narrow bay to accommodate its brief frontage on Thirteenth Avenue. A second main entrance is on Union Street. Originally, a parapet, with intermittent insets of balustrades, rose above the cornice at the roofline.

Within a few days of the Robinson's opening on October 1, 1907, an article in the newspaper reported that only seven of the twenty-three four-, five-, and six-room apartments were still available. White enamel paint and "delicate colors" that decorated the interiors, living rooms with beamed ceilings, one or two closets in each bedroom, a large kitchen with pass pantry, and "every modern convenience possible" attracted potential renters, who had to provide references if they wished to live in the Robinson.[60]

The Robinson Apartments, named for A. Robinson, who filed the plans and built them, has changed names more than once. In 1917 it became the Lagonda. A year later, there was

an announcement in a local newspaper of a couple whose wedding had been held at the Lagonda. It was a testimony to the size of the building's living rooms, as sixty guests had been in attendance.[61] The Lagonda prospered until the late 1960s, when it began to decline. More recently, Capitol Hill Housing, whose mission is to provide affordable housing while preserving neighborhood character, acquired the property, now called the Park Hill. It offers a mix of studios and one-, two-, and three-bedroom units.

2. HELEN V/ALGONQUIN (1907) 1321 EAST UNION

When architects Graham and Myers let the contract for the Algonquin in February of 1907, it was "for the first fourth of a $200,000 apartment house."[62] Developers and owners Meacham and Van Zandt had grandiose plans for the Algonquin, the first of a projected group of four L-shaped apartment houses that together would create "an immense court-yard." Carriages would access the courtyard, filled with trees and flowers, via an elliptically shaped drive.[63] On August 18 of the same year, the *Seattle Times* reported that the architects were drafting plans for the enlargement of the project, but only the first phase of the plan ever materialized.

The entrance to the Algonquin announces its Georgian style. Doric columns support

If earlier plans had been implemented, a carriage drive would have occupied the grassy space in front of the Algonquin. *University of Washington Libraries, Special Collections, UW 29468z.*

the projecting porch on which a railed balcony originally sat.[64] Many panes of glass once filled the Palladian window that is above the porch. Narrow sidelights are on either side, and beautiful woodwork and tracery fill the arched opening that crowns the window.[65]

Red brick covers the wood-frame building and makes a strong statement, as the lintels and quoins are also formed of brick. An added feature is the three-story polygonal bay in the center of the east wing; a secondary entrance near the inside corner is formed from the wing's intersection with the facade. Plans for the Algonquin called for two five-room and three four-room suites on all three floors. Each of the rather luxuriously fitted units featured a private hallway, numerous closets, a sanitary bath with terrazzo floor, and hardwood floors in the living room and bedrooms.[66]

Twenty-one years later the building had a new name, the Helen V. Prior to its reopening, Seattle architect Victor Voorhees directed a remodeling that resulted in thirty-eight suites of two and three rooms, each with a large living room, dressing room, disappearing bed, and electric refrigeration.[67] Soon after the remodel, an advertisement for the Helen V, "a building and location you will be proud to call home," described the front area as the "finest playfield in the city, surrounded with a high ornamental fence and equipped with lawn swings—a safe place for children to play."[68] The play area eventually succumbed to an unattractive parking lot. Today the Helen V rents thirty-eight units, which are divided into seven one-bedroom units and thirty-one studios.

3. MADKIN/ALTA VISTA/RENTON (1905)
1625 EAST MADISON

A committee from the Renton Hill Improvement Club, after viewing a published prospective of the proposed Renton Apartments, approached developer Henry Leighton about his intention to construct an apartment building with stores at the ground level to say they opposed it and "any other similar structures" in their neighborhood. Most upset that stores were included in the plan, the group threatened to boycott any that might open there, claiming they would "prove a detriment, hurt property values, and in short prove an 'eye-sore' for the entire section." Leighton, whose company dealt in rents, loans, insurance, and real estate, said he was "willing to do the right thing if the committee would meet him halfway."[69] The Renton opened in August 1905 without a store.

The Renton changed its name in 1914 to the Alta Vista, which was fitting due to its location at the height of Madison Street. At the time, an advertisement rather poignantly stated that while "there are newer apartments and perhaps some that have a few more added attractions, ... there are none [that] have enjoyed and still retain a more generous support of the apartment house resident than this building."[70] It became the Madkin sometime after 1939.

Marble wainscoting and steps lead up to the black-and-white tiled entry with double wood doors featuring a transom of beveled glass. Inside the small vestibule, another set of double doors, with beveled glass inserts, opens into a hall. Early advertisements indicated that there were seventeen four-, five-, and six-room units, all with outside rooms, which meant there were no interior, or windowless, rooms. The "strictly HIGH CLASS" building had extra rooms, for which there was no charge, for servants. Since public records indicate that today the Madkin has twenty-three units that average 850 square feet, the original seventeen would have been quite large in comparison.

At the time of the 1910 U.S. Census, with all but a few units accounted for, the Renton

The Madkin's distinctive entry bay features latticework, an iron railing, and rustic stone.

was a very full house. Some units were occupied by an unusual combination of residents, such as one woman, who was the head of the household, and her daughter, son, sister, and cousin; in another unit lived a couple and their two daughters, a father-in-law, and a servant; and another couple and their son shared their space with two lodgers. Occupations were just as varied: real estate broker, miner, manager of a clothing company, two retail merchants of dry goods, proprietor of a lumberyard, marine engineer, and commercial traveler. In one unit a mother lived with her two adult daughters, both of whom were dressmakers, and who may have worked at home. Another mother lived with her adult daughters, one of whom was a saleslady of millinery and the other a telephone operator.[71]

An advantage to the building's location was its proximity to the nearby Reform Temple De Hirsch Sinai. Helen Rucker, daughter and daughter-in-law of pioneer Jewish families, recalled that several Jewish people lived at the then Alta Vista in the 1920s.[72] Female Temple members often belonged to several Jewish women's organizations that held their meetings at the Temple.

The Madkin is still an apartment building — in business for over a hundred years.

Renton/Second Hill Apartments: Seventeenth Avenue Between Union and Spring Streets

Although many apartments still dot the Renton/Second Hill landscape, a row built in the late 1920s on both sides of Seventeenth Avenue between Union and Spring streets

enriches the neighborhood with some of Seattle's most interesting, and still desirable, apartments. Although each building is different, there is a similarity in massing and scale that makes them comfortable with one another. An advertisement that appeared in the *Seattle Daily Times* on August 19, 1928, read, "One Year's Rent Free to anyone who can find another apartment house in all Seattle offering what we do." Though the advertisement referred to the Mayfair Manor, the same could be said for all eight apartments in the block.

Seattle builder Samuel Anderson's company designed and built four of the eight apartments: the Fleur de Lis, Betsy Ross, Barbara Frietchie, and Carmona. Anderson, who made a practice of incorporating historical themes and names to his apartment buildings, applied visually appealing ornamentation to each of the basic three-story buildings. Seattle architect Edward Merritt affixed Art Deco details to the Dixonian. The architectural firm of Schack and Young also used Art Deco motifs on the Martha Anne and Margola. On the latter, Mayan details at the entry were added for good measure. All outfitted their buildings with up-to-date kitchen and bathroom furnishings and fashionable amenities and accessories.

A description of just one building, the Fleur de Lis, will suffice as representative of the group that is sometimes referred to as the "International Village."

FLEUR DE LIS (1929) 1114 SEVENTEENTH AVENUE

If the name did not give away builder Anderson's intention, the red tile-clad mansard roof with tiny dormers was a sure sign that the Fleur de Lis was to be of "French Provincial design." Traditionally the fleur-de-lis signifies royalty, and Anderson did his best to convey that association.

The Fleur de Lis is a simple rectangular building that is three stories tall over a full daylight basement. Its appearance is distinguished by details of the entry bay, ornamental ironwork window boxes on the top floor, and diamond-paned leaded-glass casement windows between spandrels that once were more decorative.

The central bay juts out far enough to provide space for the recessed entry and a landing for the stairwell, which begins inside, near the front door. Above the entry, the windows on the upper two floors, with their display of elaborate fleurs-de-lis, are not only beautiful, they provide natural light to the stairwell behind them. According to the plans, the lancetlike windows on both sides of the central bay are in the living rooms of the front units. More specifically, they are inside closets in the living rooms.[73]

The living rooms were spacious. The just-mentioned closets were next to a large bed closet that provided an extra sleeping space. A fireplace was on the wall opposite the bed closet. All units had a bedroom, kitchen, dinette, and bathroom, the latter with "showers equipped with all necessary hooks."[74] Each unit had its own generous private entry hall off the central corridor. There were four units per floor, two on each side of the corridor that runs from the front of the building to the rear, where there was a second stairwell. Luxurious interiors featured mahogany woodwork, double-coved ceilings with a Tiffany brocade texture finish, extra long tubs, ample electrical outlets, and separate radio aerials.[75]

On September 16, 1929, the *Seattle Times* mentioned that the Fleur de Lis would be ready for occupancy on October 1, and that reservations should be made immediately to ensure getting the unit one desired. Anderson must have felt confident, but it was a risky time to be offering almost-luxury-level apartments. By late April of the following year, advertisements for the Fleur de Lis tempted would-be residents with "reduced rentals."

Stained glass fills the slender windows on each side of the Fleur de Lis' ornate entry bay, which features additional, larger, stained-glass windows on the second and third floors.

A condominium building since 1978, the well-maintained vintage character of the Fleur de Lis is a credit to its sister buildings and the neighborhood.

A 1928 survey conducted by the John Davis Real Estate Company reported that "this year ... there are more than twenty-five apartment buildings now under construction to be

ready for the spring rental market. These buildings average more than thirty-two apartments [units] each." A number of the new apartment buildings, "generally ... fine structures," were on First Hill.[76] In the past, one of the grand homes that housed only one family might dominate a city block. In deference to Seattle's growing population and other factors, apartment buildings, often with thirty or more individual units, gradually replaced them. Apartments, along with the disappearance of single-family homes and the encroachment of hospitals and medical offices, transformed First Hill.

7

Capitol Hill Apartments
West of Broadway

3 and 4-room apartments containing all conveniences; appointed with everything modern that make high-class apartments ... in an exclusive district.

Beautiful view 2-room, southwest corner; large building of splendid character: excellent furnishings, suitable rental.

Each apt. is a complete home with surroundings of dignity and refinement. A cordial invitation is extended for your inspection.

Originally, only a steep slope separated the east side of downtown Seattle and West Capitol Hill. In the 1960s, the construction of Interstate 5 created an unfriendly gulch between the two. A large area, the physical boundaries of West Capitol Hill are Melrose Avenue on the west and Broadway on the east, and Pike and Pine streets on the south and Galer Street to the north. Capitol Hill is a conglomerate of mini-neighborhoods.

In the early 1900s the electric streetcar provided transportation for the majority of Seattleites. By 1901 the Seattle Electric Company was operating streetcars on Broadway, the Hill's main north–south arterial. Dubbed the City Park Line, it provided "direct service to and from the heart of the city" via Pike Street.[1] The same year a second electric line, known as the Capitol Hill Route, opened; it also began downtown, reaching Fifteenth Avenue, another important arterial, via Pike Street, from which point it traversed the entire length of Capitol Hill.[2] By 1907 the Bellevue–Summit Line, so-called for the two streets it ran up and down, extended from Pike and Pine streets north to Roy Street. By 1923 cars and buses were using an *improved* Olive Way to access West Capitol Hill. Public transportation provided good service to the varied neighborhoods. And, not for the faint of heart, as early as 1910 three sets of stairs, located on the northeast edge of the hill, linked West Capitol Hill and the Eastlake neighborhood.

Schools, churches, entertainment venues, fraternal organizations, and women's clubs, in addition to mom-and-pop stores, accommodated the growing number of people who were moving into newly constructed apartments, as well as the resident population who lived in a wide range of single-family homes.

Because the area on the west side and atop the slope was "close in ... within easy striking distance of the business district," investors considered it ideal for apartment construction.[3] Seattle architectural historian Larry Kreisman wrote that the apartments formed a "harmonious relationship to one another along the street," due to their "consistent materials, stylistic elements, and building heights."[4]

Mixed housing, small businesses, and several commercial thoroughfares resulted in a grand mix. Unlike many Seattle neighborhoods that have a special name, such as First Hill

or Queen Anne, this large area did not acquire a name until the 1930s, after which Seattleites began to refer to Broadway and streets west as Capitol Hill.[5]

Auto Row Apartments West of Broadway

In 1905 the automobile arrived in Seattle. As soon as the first one went on the market, Pike and Pine streets, bordered on the west by Melrose and by Twelfth Avenue on the east, experienced growth of an unanticipated nature. Not only were beautiful automobile showrooms built, but a wide range of auto-related business moved into the area. Property in the Auto Row neighborhood, just east of downtown's Denny Triangle, was more affordable, but still accessible to prospective car buyers.[6] The southwest corner of West Capitol Hill "became the auto center of the Northwest, and remained so until after World War II."[7]

In 1906 a local newspaper reported that "Seattle is fast becoming one of the leading automobile cities in the United States in proportion to its population. The whir-r-r of the powerful machines is heard in all parts of the city from morning until late at night."[8] In only a few years, auto parts shops, tire stores, garages, service stations, and dealer showrooms lined Pike and Pine and side streets up to Broadway, and the neighborhood became known as Auto Row. By 1939, car-related businesses saturated the blocks.[9] Reminders of the automobile's glory days still abound; a few buildings may adhere to their original calling, but most have been transformed into a wide range of new venues: businesses, restaurants, and a bookstore.

In 1928, M. A. Hartnett, vice president of Seattle realty company Ewing and Ewing, was referring to the western edge of the neighborhood when he said, "Apartment-house building and development in the district north of Pine to Aloha and bounded by Melrose on the west to Broadway on the east is outstanding in the city."[10] The steep verge of West Capitol Hill discouraged, but did not altogether stop, the construction of apartments along Melrose Avenue, particularly on the east side of the street.

1. MELROSE (1916) 1520 MELROSE AVENUE

The Melrose is one of only three extant pre–1939 apartment buildings on Melrose Avenue. W. W. Noyes designed the shoebox-shaped four-story building for owner Sutherland McLean. While it is overall a rather spare building, Noyes carefully supplied it with some fine features. The lintels of the windows above the arched entry repeat the shape. Substantial terra cotta window boxes, which earlier featured a small balustrade all around their top edges, front the windows on the floors upper. The same windows have varying numbers of small panes in the upper sashes. Noyes used a combination of stucco on the front section of the first floor and dark brick for the upper floors. Three sets of polygonal bay windows adorn both the north and south facades, and a lovely cornice, originally of galvanized iron, caps the Melrose.

Units of varying sizes occupy the basement and first floor, while four units on each side of the double-loaded corridor occupy the second, third, and fourth floors. Not all units are the same size, but each has an entry hall, bathroom with corner sink, small kitchen, large living room, and a very large bed closet. The latter, of course, housed a bed that would either fold down, swing out, or pivot into place in the living room.[11]

The Melrose currently serves as a facility for Capitol Hill Housing, which aspires to provides affordable housing while preserving neighborhood character. One of the attractions of the Melrose is that it can still advertise "public transportation in all directions."

2. SUMMIT ARMS/BEAUMONT (1909) 1512 SUMMIT

Contractor F. E. Winquist built the four-story brick Beaumont Apartments on two city lots on the east side of Summit Avenue. Winquist, his wife, five children, and three servants were living in the building at the time of the 1910 census.[12]

Architects Elmer Ellsworth Green and William C. Aiken faced the masonry structure with red brick, which contrasts with the stucco-covered three-story bays at the front corners. The building's most striking feature is the brick arched opening that rests on heavy pillars and frames the recessed entry. Based on a 1908 newspaper drawing, many architectural details are still intact: the two decorative gables at either end of the parapet, the iron guardrails on the upper balconies, and the circular masonry design across the lowest balcony.[13]

But changes have occurred at the Summit. A grand set of steps leading *up* to the arched opening have disappeared, and the entrance is now a step *down* from the sidewalk; and the original three recessed openings above the front entrance have increased to four. Either a

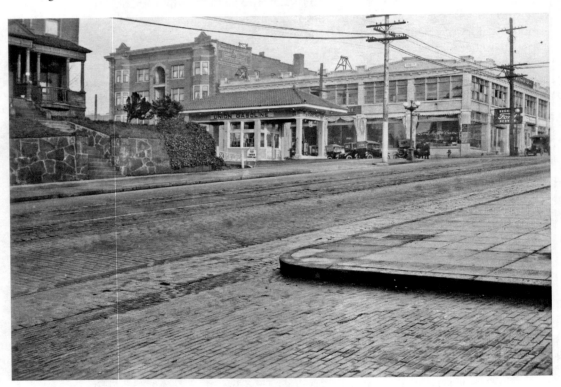

The Beaumont Apartment building hovers in the background of this 1920 scene, where Pike Street and Summit Avenue intersect. A Ford dealership, the large white building, and a Union Service Station across the street reflect the automobile's impact on the neighborhood. By 1939 a parking lot had replaced the residence with the stone retaining wall, seen in the foreground. *University of Washington Libraries, Special Collections, SMR 149.*

regrade project near Summit or an owner who implemented alterations in the building could have caused the changes. Information at the time of construction mentioned twenty-seven three- and four-room units.[14] The units today average 833 square feet, described by a current tenant as "quite spacious."

Not only did a car dealership abut the Beaumont to the south, but a used car lot and the First Hill Garage were neighbors to the north.[15] The Summit Arms, undaunted by its neighbors, remains in business.[16]

3. GLENCOE/SHASTA/LORENA/HALL (1907)
1511 BOYLSTON AVENUE

In October of 1907 S. L. Hall received a permit to build a three-story apartment house on Boylston Avenue, a block away from Pine Street with its three car lines. Open for business by April of the next year, it briefly advertised as the Hall before being renamed the Lorena, which it remained until around October 1927 when it became the Shasta. Two years later the building became the Glencoe, its most enduring name.

Three stories with twenty-two units, the appearance of the current-day Glencoe is remarkably unchanged from the picture carried in the paper over a hundred years ago.[17] The most pronounced feature of the solid brick building is the centrally located Romanesque

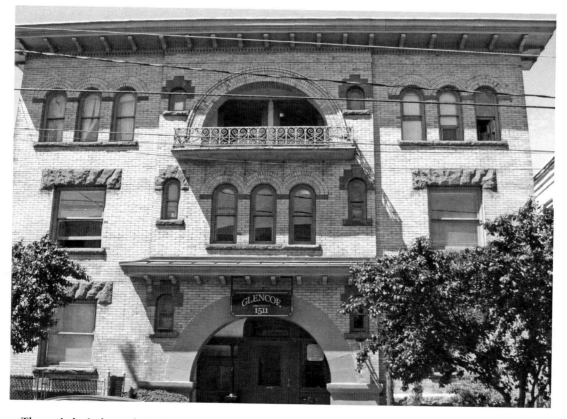

The varied windows, their placement and the use of brick and rustic stone for lintels and sills, make the facade of the Glencoe a pleasurable study.

arch, resting on thick masonry blocks. The central door, with sidelights and transom, is not the only door at the front. A smaller door at a slightly lower level accesses the basement.[18] In front of this door, the floor is composed of a pattern of small blue and white tiles. It is likely that the main entrance area also had this same treatment but has been obliterated by heavier traffic. A cast-iron light standard, with a decorative base, separates the two entrances.

The symmetrical arrangement of windows on the facade and the oversized rough red sandstone lintels atop the four large windows are striking. Other features include the red-tiled pent roof, a sloping panel often positioned above a window but here over the arched entry to provide protection and ornamentation, the repeat of the arched opening at the third floor with decorative iron railing, and a deep cornice across the front of the buff-colored brick building.

From a total of twenty-two units, renters had the option of a three-room housekeeping unit with wall bed, private bathroom, and kitchen, or a single room, which probably shared a bathroom with others on the same floor. There were both furnished and unfurnished units, and although the cost for a furnished unit would be higher, it meant a first-time renter did not have to acquire furniture before moving in, a feature pointed out in many rental advertisements.

Although the building's design has not been attributed, it is difficult not to credit Henderson Ryan, who designed the nearby Bel Fiore, which bears a strong resemblance to the Glencoe.[19] The sets of three small arched windows are a Ryan trademark. Looking up at the top front corner of the south facade, a faded *Glencoe Apts.* painted on the wall is still visible.

4. STARBIRD/STARBIRD COURT (1907)
1512 BOYLSTON AVENUE

While living in Alaska, John H. Starbird gained a reputation as a flamboyant character.[20] He was a Klondiker, a term applied to people who went to the Klondike gold fields in Canada, where gold was discovered in the late 1890s. After Alaska, he came to Seattle and engaged in construction, building the Starbird Flats on the northeast corner of Pike and Boylston in 1903.[21] He was one of the first to move into his new building.[22] In 1907 he built another apartment building, the Starbird Court, on Boylston Avenue, just around the corner from the Flats.

The Starbird Court is a simple rectangular building with narrow light wells that make such deep indentions midway along the north and south facades that there appears to be two separate buildings, one in front of the other. Bay windows that run the height of the building are at each of the four corners of the front section only, and a deep unadorned cornice extends across the top of the west-facing facade.

A 1906 advertisement for the building mentioned "2, 3, 4 rm. Flats, steam heat, gas ranges, walking distance."[23] Although the Starbird had twenty-four sinks, one per unit, the building's twenty-four apartments shared eight tubs and eight toilets. Beginning in 1904, Seattle's building code required water closets for all apartments, although they were not required to be within individual apartment units until 1914.[24]

5. ST. JOHNS/ALTON/EADIES/
KAIN (1907) 725½ EAST PIKE STREET

On August 1, 1907, the *Seattle Times* announced the sale of the Kain, "one of the first of modern apartment houses erected in Seattle ... completely furnished with fine golden

and weathered oak," to a party who had recently moved to Seattle. It is likely that the Kain Investment Company, established in 1906 and engaged in buying and selling all kinds of business and residential properties, constructed the building on the southwest corner of Pike and Harvard.[25] Following a few other ownerships, it became the St. Johns in 1917, and the name has remained the same. For many years it was the home of Florence Lundquist. Although her father worked in West Seattle, the family preferred to live in the St. Johns in exchange for managing the building, which Florence's aunt and uncle owned. In addition to the St. Johns, Florence's aunt and uncle owned two other Capitol Hill apartment buildings at various times.

The main entrance of the St. Johns is at street level, centered between retail establishments. (It was common for apartments that were upstairs, above shops or businesses, to add ½ to their address.) Residents entered here, also the location of the mailboxes, and ascended stairs to a lobby, similar to a large hall, on the second floor. This was the location of Florence's aunt and uncle's apartment. Florence recalls that the small lobby area remained gloomy despite a light court that extended the height of the building and was meant to brighten the interior.

The Lundquist family's apartment consisted of a living room, one bedroom, a kitchen with an eating area, and a bathroom. Florence slept in the living room on a Murphy bed, which her mother would restore to its nesting place each morning. When closed, a decorative mirror attached to the outside of the door caused the door to blend into the background. The kitchen, an interior room, had opaque glass windows onto the corridor. The other side of the corridor had large windows that opened onto the back porch, an arrangement that allowed more light to penetrate their apartment. The units in the building varied. Not only were there comfortable apartments similar to the Lundquist's, but there were studio apartments with a small kitchen and bathroom, and sleeping rooms with washbasins, whose occupants shared a bathroom down the hall.

Florence remembers that a cleaners and barbershop occupied the east side of the building, and a grocery store the west. She also recalls that the barbershop was raided, as the barber, unknown to her family, had a sideline as a bookie. "Customers" fled to all parts of the building, hiding in broom closets and bathrooms. She also remembers Lillian, an "older and very nice" prostitute who lived in one of the smallest units and "had quite a few callers."[26]

Florence was living at the St. Johns in 1925 when she began first grade at nearby Summit School. In the summer, she and her mother rode the trolley to Madison Park, on the shore of Lake Washington, for picnics and swimming. Florence lived in the St. Johns until 1943, when she graduated from Broadway High School, located just a block from her home. After graduation, the family moved back to West Seattle, but Florence's story testifies to the length of time that many people lived in apartments. Businesses still occupy the street-level spaces of the St. Johns, and a city bus still passes nearby en route to Madison Park.

Continue exploring Auto Row in Chapter 9, which discusses apartments on and near Pike and Pine streets on the east side of Broadway.

A Walk Around the Block

The five apartments included in this study have addresses either on Harvard or Boylston avenues, which run east–west, or East Howell and East Olive streets, which run north–south.

Florence and her aunt, Ellen Schmitz, pose for a picture on the wooden porch at the rear of the second floor of the St. Johns. Florence says the porch was a good spot to roller-skate. A clothesline and a "little house" that held a washing machine shared space on the porch. *Photograph courtesy Florence Lundquist.*

It is truly a walk around the block. Although only fifteen years separate the earliest building from the latest, the styles of architecture run the gamut. In 1907, *Seattle of Today* described this small West Capitol Hill neighborhood as one of the most desirable sections of the city, where a large number of thoroughly modern apartment houses and hotels were conveniently located.[27]

On the northwest corner of East Olive Street and Boylston Avenue, the Boylston Avenue Unitarian Church was dedicated in March of 1906. At its opening, Dr. S. A. Elliott, son of the president of Harvard University, preached the dedicatory sermon. The church, "one of the handsomest of its kind in the city," was built during the heyday of construction in this area and lent a touch of civility to the developing neighborhood.[28] Prior to the automobile, accessible places of worship, similar to schools, shops, and nearby trolley connections, added to the ease and appeal of living in an apartment.

Broadway High School, another neighborhood amenity, opened in 1902 at the northwest corner of Broadway and Pine. As the city's first dedicated high school building, it was called Seattle High School, but when Lincoln High School opened in another part of town in 1908, the name was changed to Broadway High School. Some feared that the school was too large and too far from downtown, but within a year it was full.

1. LENAWEE (1918) 1629 HARVARD

For decorative effects, Seattle architect John Creutzer detailed six different window treatments for the large Lenawee. Their variety, placement, and his handling of the lintels provided all the necessary ornament on the facade, and indeed, on all elevations of the Lenawee. Other features of note, however, are the brickwork on the top floor, which is

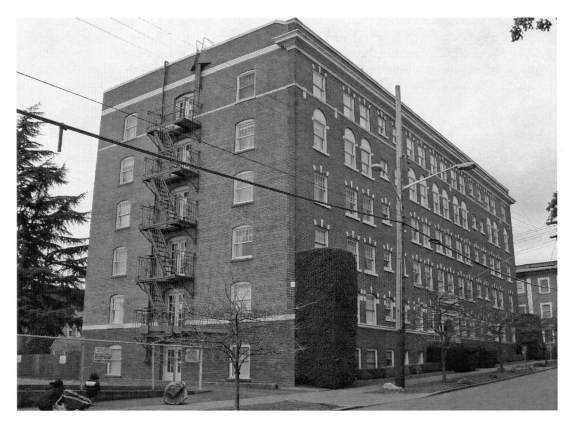

A wood-frame construction lies beneath the Lenawee's brick exterior. The fire escape's artful details make it more than just a utilitarian fixture.

dly different from the rest of the building, with darker brick forming an X-shaped design between each of the windows. And just below the parapet, when the cornice that extends across the building's facade stops at the building's south corner, embedded white tiles inventively continue in cornicelike fashion. On a smaller scale, stringcourses below the first- and top-floor windows repeat the same treatment.

The entry is surmounted with a balustrade that rises to the base of the second-floor windows. A shallow entry porch leads to the double wood doors with large glass insets, flanked by sidelights and a transom window. Inside, the small marble-trimmed entry leads up to the north–south corridor, where it becomes evident that no space was wasted on an elaborate lobby. To the right of the main stairwell were a small office and the elevator. At the south end of each corridor, French doors opened to the fire escape. Seventy-eight units of two- and three-room apartments, all "attractively furnished," filled the five floors plus basement.[29] Although the front corner units at the south and north ends had one extra room, labeled "dining room" on the plans, the large Lenawee is basically an efficiency apartment building.[30] The kitchens featured space-saving tables with benches, which had hinged lids for extra storage space. Creutzer added a nice touch when he called for copper netting to cover the vents of the cooler boxes, whose outside openings have since been filled in so carefully that they are hard to discern.

Residents of the Lenawee in 1920 represented a wide spread of ages and occupations. There were couples, both young and middle aged. It was the first home for some couples, who were "at home" at the Lenawee after their marriage. Some lived there with their children, who could easily attend the nearby Summit Elementary or Broadway High School, located directly across from the Lenawee. Nurses and one doctor would have chosen to live there for its easy access to local hospitals. All would have been proud to call the Lenawee home, which continues to function as an apartment building.

2. PETRA/SILVER BOW/CYRUS (1908) 1703 HARVARD AVENUE

It is rare to find an apartment building of the Petra's vintage in such pristine condition, particularly one of wood construction.

The columns at the pedimented entry, the ironwork balcony outside the two central windows on the third floor, the elaborate cornice, and the attached columns that span the height of the building — all still intact — can also be seen in architect W. P. White's depiction in the *Seattle Times* on March 17, 1907. White drew the plans for the Cyrus, as it was originally known, for a cost of $20,000. The original number of fifteen apartments, "completely and elegantly furnished," have remained constant.[31]

3. RIALTO COURT (1907) 1729 BOYLSTON AVENUE EAST

The Rialto Court's elaborately-leaded glass three-part fanlight above the double front doors is arresting. One can imagine that the same rich pattern also initially filled the sidelights, which are now plain glass. Inlaid blue tiles on a background of white tile spell out the building's name in the entryway floor. Although this most often has meant that the building's name has not changed over the years, on at least one occasion the author discovered a large doormat that hid the "evidence" of an apartment's earlier name.

Similar to other apartment buildings that hoped to lure newlyweds to rent an apartment in their building, the Rialto Court placed a full-page advertisement in the *Seattle Brides*

The Petra is one of few surviving apartment buildings with a wood exterior.

Cook Book when it was published in 1912. Beneath a photograph of the building was all the necessary information: "40 2, 3, and 4-Room Suites, Furnished and Unfurnished. With all modern conveniences, private halls, private baths, private phones, steam heat, hot and cold water, regular kitchen, folding wall beds, janitor, laundry, dry room, electric light and store rooms ... one block from Pine Street with its five different car lines and one-minute service."[32]

4. BUENA VISTA (1907) 1633 BOYLSTON AVENUE

One year after construction of the Boylston Avenue Unitarian Church, S. T. Arthur, a Spokane transplant, opened the Buena Vista diagonally across from it. When built, the Buena Vista's unusual architecture distinguished it.

Architects Josenhans and Allen referenced the Mission style, popular at the time, when they featured red clay tile on the pent (small cantilevered) roofs above select third-floor windows, a modified bell tower at the top of the northeast corner, and shaped parapets at two other corners. But bay windows and recessed porches on the upper two floors remind that it is, at heart, a Seattle-centric apartment building. The architects' permit specified twenty-seven apartments, varying between two-, three-, and four-room units.

At its opening, The Grote-Rankin Company, furnishers of the building, touted the Buena Vista's corner position on two paved streets, cement walks, good view of the Sound,

All hints of the Buena Vista's original Mission style features — pent roof with red clay tile, bell towers, and shaped parapets — are missing.

and nearness to four car lines. The company supplied the Hoosier Kitchen Cabinets, as well as the furniture, "handsome in the extreme, some of the rooms being finished in golden oak, some in weathered oak and others in mahogany ... the finest ... Wilton Velvet Carpeting ... and Marshall & Stearns' patented wall beds."[33] Conveniences such as hot-water heat, electric lights, hot and cold running water, and gas for cooking may have been more tempting amenities in 1907 than velvet carpeting.[34]

5. PORTER (1917) 1630 BOYLSTON AVENUE

A sales brochure by the Steel Realty Development Corporation gushingly extolled the Porter's "sweeping view of Puget Sound and her thousand islands, fringed with towering peaks of the Cascade and Olympic Mountains."[35] Although the Porter features the typical bays and recessed porches of many Seattle apartment buildings, it displays more interesting features, both on the exterior and the interior, than many of its type. Arches, a judicious use of terra cotta on the facade, curved marble steps leading to the entry surround topped with a balustrade, and large square multiwindowed bays on the north and south sides of the building contribute to its appeal.

An automatic electric elevator delivered residents to the social hall, located on the roof, which was also used as a reading room and was equipped with a built-in library and radio phone. The laundry and drying room also were on the roof. The four stories in

The Porter's entrance is surrounded by terra cotta, including the balustrade above.

between held thirty-four apartments: seven four-room units, fifteen three-room, and twelve two-room, all of which opened off the double-loaded corridors.[36] Each apartment's entry hall had both a house and direct telephone, large closet, and the useful service closet, accessible from the outside corridor, whereby deliveries could be placed in the upper half and trash removed from the lower. The living rooms had built-in bookcases and buffets, the

bedrooms featured large closets, and French doors separated sleeping porches, complete with wall beds, from living rooms.[37]

Many units were efficiencies, but the Porter also had some larger units. They, added to amenities such as those found on the roof, place it in the intermediate category of apartment buildings.

Olive Way Apartments: Up the Slope to Broadway

In addition to the trolley lines on Pike and Pine Streets, Olive Way provided another transportation link between downtown and Capitol Hill. Olive Way originates near Third Avenue, where it straddles the business district and Belltown, and then proceeds eastward toward the slope of West Capitol Hill. By 1908 automobiles could navigate Olive Way's tricky incline, but it was neither a convenient nor direct route from downtown to the top of West Capitol Hill.[38]

Gradually, but not without objections, improvements were made.[39] In 1921, the city issued an ordinance that provided for widening, improving, and regrading Olive Way from East Olive Street to the intersection of East John Street and Belmont Avenue.[40] In effect, the new route would slash its way through the neighborhood by the shortest distance possible.[41] In 1923 the *Seattle Times* real estate section reported that opening up Olive Way from Bellevue to Broadway made the whole district easily accessible for both pedestrian and automobile traffic.[42] In 1924, when the Seattle Title Trust Company issued a First Mortgage Gold Bonds offering for the Biltmore Apartments, it remarked that the building directly faced "the new Olive Way arterial highway."[43]

Streetcars ascended and descended West Capitol Hill via the gentler, regraded Pike and Pine streets and then turned north and ran along Summit before returning south along Bellevue, providing a large population with easy access to downtown. Trolleys and an improved motorcar connection to downtown encouraged investors and developers, as well as property owners, to build apartments on or within a few blocks of Olive Way. Amidst stores, private homes, and service stations, apartment buildings made their presence known. A look at some apartment buildings along Olive Way will show that they ran the gamut of architectural styles and appealed to those who were seeking a convenient, comfortable, and affordable lifestyle.

Some buildings along the route predate the reorienting of Olive Way, such as the first four: the Celeste, Lauren Renee, Bel Fiore, and Alexander.

1. CELESTE/PAULA/ALLEN (1906) 304 EAST OLIVE PLACE

Paula Nichols, who came to Seattle in early 1924 "from the East," bought the Allen in 1925 and promptly changed its name.[44] That same year Nichols commissioned an architect to design an apartment building for another West Capitol Hill site, defying prevailing views regarding the usual roles of women who worked outside the home.[45]

The Celeste is on East Olive Place, a one-block-long street that originally was a continuation of Olive Street. The initial fifteen units, a number that has remained fairly static, were divided among three- and four-room apartments. A 1937 photo shows a well-cared-for three-story building that becomes four stories—and even gains some daylight basement windows, on the steeper Melrose-facing facade. Clinker brick covers the lower half of the wood-frame structure, with clapboard facing the upper two. Balconies with graceful bowed

Top: A 1937 photograph of the Celeste/Paula/Allen. *Washington State Archives, Puget Sound Regional Branch 872560. Above:* A 2010 photograph shows that many changes have impacted the Celeste's exterior.

ironwork railings and diamond-paned doors add spark to the central recesses above the entry. As the contemporary photo shows, siding covers the top two floors, white paint covers the brick on the lower floor, and the once delightful central recesses have disappeared.

2. LAUREN RENEE/EL DORA (1912) 312 OLIVE PLACE

The most imposing of the cluster of four apartments, the Lauren Renee abuts Olive Way, but its main entrance is on East Olive Place.[46] In 1914, owner August Johnson hired architect John Creutzer to remodel his apartment house. As early as 1900 a residence was at 1700 Bellevue, an address the El Dora would have on several occasions due to its corner position.[47] That it was the residence of the minister of the Swedish Evangelical Church was regularly included in a *Seattle Times* column, "In Local Pulpits," starting in 1900 and running through August 1902. Sometime after that date, it is probable that Johnson bought the house, enlarged it, and it became an apartment building. By December 19, 1914, a notice in the *Seattle Times* said, "Nearly completed," and gave the address rather than a name.

Since Creutzer included drawings of "oldest grade" and "new grade" on his plans, it is likely that a regrade project prompted Johnson's request. The plans also show that the once impressive entrance on Olive Way—complete with quoins, heavy door with sidelights and transom, and a balustrade—had the trappings of an apartment building.

The Lauren Renee's Bellevue Avenue East entry porch, whose roof is supported by two

The Lauren Renee anchors the busy corner of Bellevue Avenue and Olive Way.

square piers of granite, is far more modest than the original on Creutzer's plans. At the foundation level, quoins and quoinlike decoration around the first-floor windows are granite. The second floor is faced with red and a darker-toned brick in a Flemish bond design, which means that alternate headers (the short side) and stretchers (the long side) appear in each course. The upper two floors are faced with wood shingles, as are the first-floor bays. These contrasting features are characteristic of the Queen Anne style.[48]

Today the Lauren Renee has twenty-five units that vary from four efficiencies to three apartments with two bedrooms and two bathrooms.

3. BEL FIORE/MARNE/UHLAN/JOSEPHINE/ ROSENBAUM (1907) 1707 BELLEVUE AVENUE

The *Seattle Post-Intelligencer* reported on November 11, 1906, that the Douglas Investment Company had received a permit for construction of a three-story apartment house. By August of the following year, owner Lewis Rosenbaum was advertising his new building only to tenants who could provide references. In addition to the usual amenities, very early advertisements mentioned a men's poolroom and a ladies' parlor.[49] By 1912 an advertisement in the *Seattle Brides Cook Book* for the then Uhlan Apartments stressed large roomy kitchens, two wall beds, laundry with electric irons, ironing boards, and dryers, but not a word about a poolroom for the men or a parlor for the ladies.

The Bel Fiore is the oldest of the three apartment buildings that huddle together on Bellevue Avenue.

Originally a pent roof extended the width of the central bay above the Bel Fiore's most outstanding feature, the heavy Romanesque arch that forms the opening to the recessed entry.[50] Resting on large, squatty, attached pillars, the arch, along with the bay windows at the second and third floors and three small arched windows at the center of the second floor, define the building. Architect Henderson Ryan used these same features on other apartment buildings he designed.[51] A second door, slightly lower and to the left of the main entrance, accesses the basement. Lockers and storage, laundry facilities, furnace room, and, originally, one living unit were in the basement. The two-door arrangement is a most unusual feature, but one that Ryan also employed at the Glencoe Apartments. The original twenty units have been subdivided into twenty-nine.

4. ALEXANDER (1909) 1711 BELLEVUE AVENUE

Unlike the oft-renamed Bel Fiore, the Alexander has never changed its name, presumably due to the large, raised letters that spell out the name across the lintel, which white

The third member of the trio, the Alexander, was built in 1909, two years after the Bel Fiore.

pilasters with Corinthian capitals support. Similar to its neighbors to the south, the Alexander is three stories. Above the stone-clad first floor, the stucco surface of the upper floors is ornamented with white-painted brick quoins that reach up to the overly tall parapet, now bereft of some form of earlier ornamentation. Transom-like windows, with their multitude of small panes, located above both the large first-floor windows and the double sets of windows on the two upper floors, are visually attractive, as well as practical.

5. OLIVE CREST (1924) 1510–24 EAST OLIVE WAY

Wedged into a triangular site on the southwest corner of the busy intersection of East Olive and East Denny ways, the Olive Crest Apartments sit above six storefronts strung out along Olive Way. The storefronts retain some of the building's original features, including the brick pilasters that visually separate each of the businesses, large transom windows above expansive store windows, and marble bulkheads. The Seattle architectural firm of Lawton and Moldenhour dotted the building's red brick facade with cast stone medallions. They ran a band of brick laid in soldier fashion (set vertically with narrow edge exposed) above the large ground-floor transom windows and the second- and third-floor windows, both a decorative and a practical move, as they also served as the lintels. The brick wall off the front elevation gently curves, an interesting way to turn the corner, as it becomes the west wall. The architects' choice of brick for the exterior contributed to the findings of a

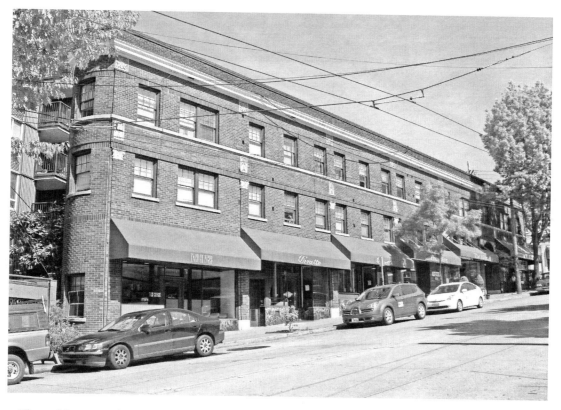

The architects used light-colored cast stone to advantage against the Olive Crest's dark red brick facade.

study done in Seattle in 1939, which found that of more than 1,200 apartment buildings, 56.4 percent were brick.[52]

The entrance to the apartments, not visible in the photograph, has a large arched opening with more cast stone accents. A heavy wood door with glass panels, enhanced by sidelights and a leaded-glass elliptical fanlight, opens into a small vestibule. A second wood and glass-paneled door opens into the lobby. Upstairs are nine units described in a 1928 advertisement as follows: "Lovely light 2 and 3-room apartments, bedroom, extra wall bed, Frigidaire."[53] The Olive Crest continues as a mixed-use building with apartments above an ever-changing and eclectic group of retail establishments at street level.

6. BILTMORE (1924) 418 LORETTA PLACE

The Biltmore is West Capitol Hill's largest and most recognizable pre–1939 apartment building. Developer Stephen Berg constructed the six-story building according to plans by the Seattle architectural firm of Stuart and Wheatley.

In the Tudor Gothic style, brick and a mass of terra cotta face all surfaces of the Biltmore. A deep court created by the building's U shape leads to the entry, which has an elaborate surround of terra cotta. Double doors open into a gracious lobby, finished in marble and mahogany. A tea room, which served luncheons, teas and dinner, "a great convenience to our guests," was mentioned in early advertisements.[54]

Promoted as exclusive but inexpensive, prospective tenants could choose between furnished or unfurnished apartments.[55] In 1929, advertisements mentioned that a four-room unfurnished unit included abundant heat, 24-hour telephone service, a courteous and efficient staff, and baths with showers—all in a fireproof and soundproof building with beautiful views! There were two elevators, one primarily for freight and one that whisked residents to the 125 units.

The size and configuration of the units vary greatly, as a study of a typical floor plan reveals. Although the Biltmore has qualities of a luxury apartment building—tall, many units per floor, eclectic style, and designed by an architect—most of the individual units, are compact efficiencies. The architects secreted a wall bed, and sometimes two, in almost every unit, to maximize the number of people who could live in them. Only a few apartments on each floor have a separate bedroom, and only one on the southeast corner of each floor features a bedroom *and* dining room. These select units are large and homelike, with box-beam ceilings and ample closets.[56]

A mortgage bond offering issued at the time of the Biltmore's construction made much of its convenient location.

> Excellent transportation facilities are provided by the Bellevue-Summit car line, which passes the building, and by the car lines on Pine Street, three blocks distant. The apartment is adjacent to, but not directly facing the new Olive Way arterial highway. It has all the benefits of this short route to the center of the city, with the advantages of quiet side streets for parking purposes. It is only twelve minutes' walking distance (less than three-fourths of a mile) from the center of the retail shopping and theatre district.[57]

Berg also commissioned Stuart and Wheatley to design a small two-story building, known as the Biltmore Annex, across the street at 117 Summit Avenue East. Built for the convenience of Biltmore residents, it held a food market that faced Summit, and a fruit and produce shop, entered through double arched doors at the corner of Summit and Loretta. On the north side, a small commercial establishment faced Loretta. There are four

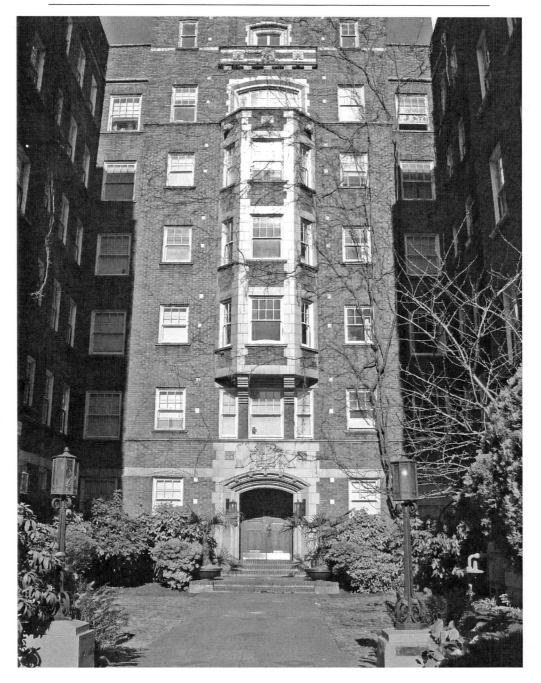

Partly in shadow, most of the Biltmore's terra cotta-bedecked entry bay is awash in sunlight.

apartments on the second floor, entered at the south end. Geometrically patterned terra cotta tiles, copper gutters and drains, and a clay tile roof complement the brick facade. Also in the Tudor style, the Annex is a little jewel of a building, completed one year after the Biltmore.

7. AMBASSADOR (1923) 505 EAST DENNY WAY

The appeal of the Ambassador's location was not lost on its promoters, who claimed that it was in a "permanently established high-grade apartment district."[58] Architect Earl A. Roberts designed the quietly elegant building for J. R. Young.

Inside the tall arched entryway, flanked by terra-cotta pilasters, a small waiting area is a convenient place for locating one's keys. The wooden front door, with plate-glass panel and matching sidelights and large transom, is an entrance designed to impress guests.

Inside, stairs lead both down to the basement apartments and up into the lobby, "finished in Bataan mahogany, with the walls and ceiling paneled and beamed with orna-mental plaster and richly decorated."[59] In the lobby is the elevator, and in the original plans, a small post office and drinking fountain. The central corridor runs parallel to Denny, end-ing at the fire stairwell and a door opening onto an alley. The six-story-plus-basement building's plan is a simple rectangle, except for a slight extension at the southwest corner, allowing for a short perpendicular corridor that accesses three additional units.[60]

At opening, the Ambassador offered seventy two-room and five three-room apart-ments. Pullman diners and concealed beds maximized space in the units.[61] Some of the one-bedroom units even featured a bed closet in the bedroom as well as one in the living room. A novel feature was a radio system in every apartment, with the central receiving station on the sixth floor.[62]

In 1991 the building was renovated and the original seventy-five apartments reduced to forty-eight in order to create larger condominium units.[63] A 2006 sales flyer reminded interested parties that they could walk to museums, theaters, galleries and all that downtown and Capitol Hill have to offer, no doubt similar to what the management told prospective renters in 1925.

8. HARVARD CREST (1927) 135 HARVARD AVENUE EAST

Olive Way finishes its ascent at Boylston Avenue East, straightens out, and becomes East John Street. One block east sits the aptly named Harvard Crest. The northwest corner of the dark brick building imitates the soft curve of the street corner on which it is located.[64] On this rounded portion of the wall, there are large decorative cast stone squares at the first and third levels and a larger square of variegated brickwork at the second level. Smaller plaques drift along the wall of the brick parapet. Cast stone generously frames the entrance, where the build-ing's name is incised above the Tudor-arched opening that accesses the recessed entry.

From the vestibule, one corridor leads directly to the rear entry and a second set of stairs. Units open off this hallway, and a double-loaded corridor runs perpendicular to it. The central stairwell is located where the two corridors intersect. Architect William Aitken arranged the thirty-four units, which averaged 650 square feet, around the unusually shaped building.[65]

The Harvard Crest was built for Hiram Chevalier and Emil Pohl, who promptly sold it to Mr. and Mrs. Frank Burgess, for whom the "investment value of the property was the controlling influence."[66]

9. CAPITOL/FLEMINGTON (1924) 200 E. BROADWAY

In 1906, nearly twenty years prior to the construction of the Capitol, a member of the newly-formed North Broadway Development Club sent a boosterish article to the *Seattle*

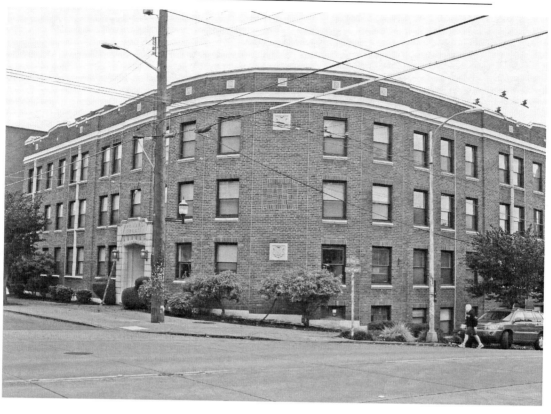

This gentle curve on the Harvard Crest is a perfect backdrop for the terra cotta and brick inserts.

Post-Intelligencer that predicted Broadway, at the time an eighty-foot-wide boulevard with "the best system of double track streetcar service along its entire length," would become an important Seattle thoroughfare.[67] In 1924, when John Fleming decided to build an apartment building on the northeast corner of Broadway and John, Broadway had become one of Seattle's most prestigious shopping streets.

Ground-level shops anchor the imposing Capitol Apartments. The storefronts, their transom windows, and tile bulkheads, though modernized over the years, are still fairly intact. The prime location has attracted a variety of businesses. In the 1930s, residents only had to go downstairs to the Manning-Marriatt Coffee Store, Restaurant and Bakery to purchase "coffee, freshly roasted the very morning you buy it — and fresh, wholesome Mrs. Mariatt's bakery goods."[68]

Fleming chose architect Howard. E. Riley to design the five-story apartment building. Riley worked with A. F. Mowatt, a contractor who was often involved in apartment construction. Light-colored terra cotta, used for the pilasters, belt courses, sills of the well-articulated windows, balustrade, and ornamental medallions, is a good foil to the building's red brick veneer.[69] As the south facade stretches east along John Street, the number of floors increases to six. It is on this facade that terra cotta grandly clads the entry bay, located not quite on center, the full height of the building. Granite steps lead to the recessed entry with marble floor and walls. Double oak doors with glass windows and brass hardware open into the small lobby.

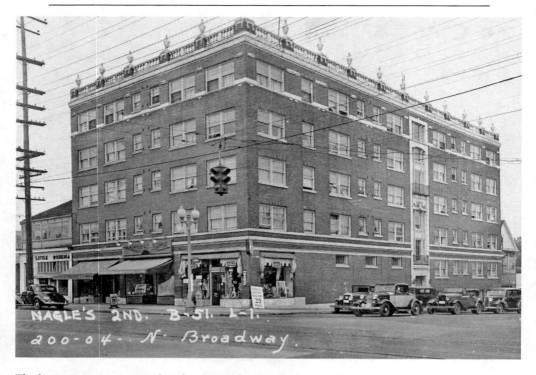

The large terra cotta urns placed at intervals atop the length of the Flemington's balustrade likely were removed due to earthquake concerns. *Washington State Archives, Puget Sound Regional Branch 600350 1225.*

This July 2009 photograph, taken at the very beginning of construction for Sound Transit's Broadway Station, shows the Capitol's proximity to the project.

On the ground floor, the elevator is in the center of the L-shaped corridor. The fifty-two apartments, which average slightly less than 600 square feet, are divided between thirty-eight two-room and fourteen three-room units.[70] Most have an entry hall, living room with bed closet, kitchen, and bathroom.[71] All, however, were "equipped with the latest improvements known to apartment house construction," such as the "latest lighting and plumbing fixtures ... radio connection ... numerous electric convenience outlets ... [and] the only automatic smoke control in Seattle."[72]

City fathers, who early on pushed for the improvement of East Olive Way, were wise. Apartments along its route, as well as on the side streets which it crossed, continued to be built up until the eve of the Great Depression. The intersection of Broadway and John Street, the address of the Capitol, has long been a transportation crossroads. It will become more so on the completion of the Broadway station of Sound Transit (a comprehensive light rail system under construction), located one block south of the Capitol. In the early years of the second decade of the twenty-first century, apartment construction is again heating up in anticipation of that event.

Apartments along the Western Edge

In the early 1900s, the city enhanced this neighborhood by building three sets of stairs that connected the upper reaches of West Capitol Hill with Eastlake Avenue, a thoroughfare directly below the more northern end of the hill. The stairs not only provided direct access to the Eastlake and Cascade neighborhoods but offered another option for walking downtown. The Republican Street stairs are the most intact of the three.[73] When the Republican Hill Climb was completed on February 25, 1910, they "mounted the hill in three sections. At the top of each section there was a landing and the barrier of a curving wall where the stair split into two to circumvent it, becoming one stair again on the other side."[74]

1. Chardonnay/ Bellevue (1907)
203 Bellevue Avenue East

The Chardonnay is one of the largest, oldest, and architecturally most interesting structures on West Capitol Hill. Architect F. H. Perkins, prolific designer of apartment buildings, drew the plans for the H. S. Turner Investment Company. Many of Perkins' original details survive, including the upstairs recessed galleries on the front and rear elevations, which even current advertisements extol for their viewing potential. Some of the doors that access the porches retain portions of their original leaded and beveled glass sidelights and transoms. Above the porches, the heavy frieze, dentils, and deep cornice supported by brackets are the building's boldest features. Missing are the tall, graceful columns that rose across the front, balustrades at the first and second levels, diamond-shaped panes in the upper sashes of the windows, and distinctive parapet at the center of the facade.[75]

The Chardonnay, a three-story building that presents a narrow face to the street, is very deep, extending to the rear alley. It also gains a floor at the rear due to its location on the steep hill. Perkins varied the exterior facade by featuring a concrete block foundation, clinker brick facing on the first floor, and stucco on the second and third floors, the latter since replaced by asbestos shingles.[76] Graceful stairs lead up from the sidewalk at either side of the unusually large front entry porch, with its floor of small hexagonal blue and white

In the foreground, trolley tracks on Eastlake Avenue are visible. Only the top tier of the Republican Hill Climb stairs remains. *Photograph courtesy Lawton Gowey.*

tiles. The heavy wood door with sidelights of beveled glass and the marble tile entrance are reminders of the Chardonnay's more sumptuous origins.

In 1907, the Bellevue featured hot-water heating and modern plumbing, features worth bragging about.[77] The original eighteen units, divided into three-, four-, and five-room apartments, opened onto very wide hallways. Today, there are twenty-one units that average 800 square feet.

The Chardonnay's most distinctive feature are the recessed galleries across the two upper floors, both on the front and rear elevations. One of the two sets of stairs leading up to the large entry porch is visible in the photograph.

2. CARROLL (1908) 305 BELLEVUE AVENUE EAST

Looking much as it did when constructed, the Carroll comfortably possesses the northwest corner of Bellevue Avenue East and East Thomas Street. From the front, the brick building is three stories, but at the rear, it becomes five as the hill drops off behind it. On the south elevation, there are two entries, both done with more care and detail than side entries usually receive. The building is rectangular in shape, broken only by a modest light well on its north side. Numerous window bays are on all facades.

The front entry of the Carroll invites a study of the parts that make it an attractive whole. A shallow slanting roof of red tile, supported by pilasters at the rear and columns at the front, is deep enough to offer protection from the elements. The front door features sidelights and a three-sectioned transom window of elaborate beveled and leaded glass. An ironwork balcony is above the roof, and a charming, many-paned oval window is at each side of the porch.

Once inside, a large vestibule with marble steps, wainscoting, and brass mailboxes greets residents and visitors. Through a second glass door, one enters a very large lobby, complete with curving staircase. The Carroll was built at a time when such features were purposely designed to reflect well on tenants and impress visitors.[78] In 1908, the Carroll

A rich ensemble of details, particularly the beveled and leaded-glass sidelights and transom, beautify the entry of the Carroll.

offered a choice of apartment sizes among its thirty-one units, including twelve three-room units and nine six-room units. In 1928 it advertised that it was "one of the best up-to-date apartments in the city. Solid brick, fire-proof. A real home."[79]

3. THOMAS PARK VIEW/THOMAS (1909)
411 EAST THOMAS STREET

The Thomas Park View is almost kitty-corner from the Carroll and within one block of the Chardonnay. These three fine buildings, constructed within a few years of each other, raised the bar for apartment buildings on West Capitol Hill. Originally named simply the Thomas, it became the Thomas Park View after the city purchased property across the street in 1970 for a small city park.

The undulating series of three-sided bays on the two upper floors define the three-story building, whose shape is almost perfectly square. At either side of the entrance, Ionic columns begin at the top of the basement level and reach to just below the second-floor balcony. A canopy now detracts from the deeply recessed entry that has marble steps and tiled wall. Above the entrance, Ionic columns again appear, this time on either side of the delicately curved iron balconies on the upper two floors. The wide wood frieze above the top-floor windows continues to the line of dentil work just beneath the roofline. Patterned brick clads the first floor, while a simple application of stucco covers the upper floors.

The Thomas Park View is an example of the Seattle-centric building form: recessed spaces in the center of the upper floors and a varying number of bays on either side.

A series of advertisements that ran in the *Seattle Times* during the month of May 1910 announced that the new and beautiful three-, four-, and five-room apartments were in a fine neighborhood and close in. By 1937, according to its property record card, the Thomas had a greater variety of sizes among its fifteen units: one one-room and one two-room apartments, and six three-room and seven four-room apartments. Such a configuration would attract a wider range of tenants. The property record card also included a curious bit of information when it mentioned a "store front," complete with wood bulkhead, as part of the building. It is not inconceivable that someone operated a business at the Thomas—the basement level on the west side is accessible—but a cursory search yielded no results.

4. ST. INGBERT (1928) 309 EAST HARRISON STREET

The St. Ingbert, which faces Harrison Street rather than a nearby Bellevue Avenue, is situated at the very top of one of the three sets of community stairs built in 1907. An amenity enjoyed by the entire West Capitol Hill neighborhood, the stairs were built during the glory days of the City Beautiful movement, when Seattle and other cities around the country took a special interest in "urban amenities and public improvements."[80]

Plans, dated May 21, 1928, were very informally drawn by contractor L. J. Hellenthal, who designed the apartment building for himself.[81] The entry facade is striking, with a profusion of light-colored terra cotta that contrasts with the red brick veneer. Art Deco–influenced fluted pilasters flank the recessed opening. A lighter color of brick that faces other walls, white quoins, and a diamond-shaped design of buff-colored brick in the space above the top-floor windows reflect on Hellenthal's thoughtful use of materials.

The original thirty-three two-, three-, and four-room units showcased mahogany interior trim and included a radio in each apartment. Unusual for the time, the basement garage provided enough spaces for the cars of all tenants. The building site drops off in such a way that the front elevation, which is only three floors where it faces East Harrison Street, increases to five, plus a basement, at the rear of the building, which cantilevers over Melrose Avenue East.

5. ROY VUE (1924) 615 BELLEVUE AVENUE EAST

Architect Charles Haynes designed the Roy Vue Apartments for W. H. and Guy H. Bergman, who built and operated them.[82] The Roy Vue's facade visually commands most of the block, but much of the building's bulk is out of sight, as the rear of the building drops down the steep slope behind it.

At the time of its opening, the architecture was described as "semigothic," due to Tudor additions such as the parapeted gables and quatrefoils. The latter are repeated in the terra cotta entry surround and spandrels between the second and third stories.[83] White terra cotta ornamentation tempers the expanses of red brick veneer.

Stepping through the arched opening, an iron gate separates the small vestibule from the "arcade," Haynes' term for the walkway that leads to a fountain and large garden, created and enclosed by the two wings of the U-shaped building. From the arcade, paths wind through the garden to separate entries, shared by only two units on each of the three floors. There are no indoor corridors, but the kitchens in most units have a second door, connected by stairs to an outside service door. Each stair landing, which also accessed only two units per floor, was the location of a large refrigerator for each unit. The two front

The entrance to the St. Ingbert is only steps away from the Harrison Street stairwell, similar to, but less complete than, the Republican Street Hill Climb stairs.

The Roy Vue almost monopolizes the west side of the block.

corner units, which were smaller than the remaining eight on each floor, had only one entrance.[84]

A living room, separate dining room, a dining alcove adjacent to the kitchen, bedroom, dressing room, and bathroom composed the larger units.[85] A bed closet was secreted in the dressing room and opened out into the dining room, creating an extra sleeping space for the tenant or temporary sleeping quarters for guests. In the smaller units, which did not have dining rooms, the bed closet opened into the living room, "particularly being of large dimensions."[86] The original thirty-two suites of three, four, and five rooms averaged over 1,100 square feet. The basement, which extended under the entire building, held individual storage spaces, heating equipment, electric washers, and maids' rooms with baths. Beyond the pergolas at the rear of the garden, steps drop down to a row of garages off the alley.

The amenities, number of rooms in each unit, and their overall size, while not luxurious, placed the Roy Vue in the upper reaches of the intermediate category of apartments. It appealed to those who desired, and could afford, the Roy Vue's gracious surroundings.

6. BELROY (1931) 703 BELLEVUE AVENUE EAST

The Belroy held its opening on April 12, 1931. On the very same day, realtor A. M. Atwood commented in the *Seattle Post-Intelligencer* that it was a "favorable sign" that money

available for apartment house construction was the lowest it had been in years. He reasoned that fewer apartments being built would strengthen rents, reduce vacancies, and make good investments of those already built.[87] Atwood listed five caveats for an apartment building to be a good investment: well located, modern conveniences, substantially built, occupied by law-abiding citizens, and located in a good rental district.[88] The Belroy satisfied four of the qualifications, but only time would tell if its residents were "law abiding."

It was a bold move to build anything in the midst of the Depression, but the Belroy was a bold building. From the street, the facade gives no indication of the dramatic west-facing elevation "on the cliff where the slope of Capitol Hill plunges almost downward onto Eastlake."[89] Architects William Bain, Sr., and Lionel Pries considered the steep site an opportunity to provide views for most residents. Since its construction, the long edge of the L shaped building has sat behind a row of early 1900s houses that faced the street. Mid 2011 the houses were razed to make room for additional units to the form of two adjoining buildings, one of which will be six-stories tall.

The architects, who adopted a Moderne, or Art Deco, approach for the Belroy, emphasized the rectilinear lines of the building by painting broad bands of the brick exterior a dark gray, in contrast to the red brick. Rows of bricks at both edges of the bands were laid in a different pattern to accentuate the effect. One of the predominant characteristics of Moderne architecture is rectilinear ornament, and Bain and Pries successfully employed

The rear of the Belroy, with its striking territorial outlook, becomes a showcase for the Moderne, or Art Deco, style. The metal windows, streamlined and factory made, optimized residents' views.

this technique with the Belroy.[90] Another characteristic is the zigzag motif, which they used not as ornament, but as one of the forms for the building, the "saw-toothed west elevation."[91] The result was the creation of large two-sided bay windows that provided sweeping views of city and mountains.

When the Belroy opened, a large ad proclaimed that its fifty-two two- and three-room apartments, both furnished and unfurnished, had all the usual conveniences. What it did not mention was that seven of the three-room apartments had electric fireplaces and that the garage, accessible from the interior of the building, had an attendant on hand to park or remove tenants' cars.[92] Not only did the architecture attract attention, for years a twenty-foot-high lighted B was mounted on the roof of the Belroy.[93] A former resident of the neighborhood, Beverly Strain, said everyone referred to the building as the Big B, "no one called it the Belroy."[94]

"People relish the idea of living in the same building as their friends," said A. M. Atwood, vice president of John Davis and Company, in 1930.[95] This was recently borne out when an obituary in a local paper mentioned that the deceased and her husband had "started life together in the Belroy Apartments on Capitol Hill, near good friends."

7. ROUNDCLIFFE (1925) 845 BELLEVUE PLACE EAST

General contractor E. J. Rounds built the Roundcliffe for himself. When looking at the site, it is obvious why Rounds chose *cliff* to complete the building's name. The firm of Stuart

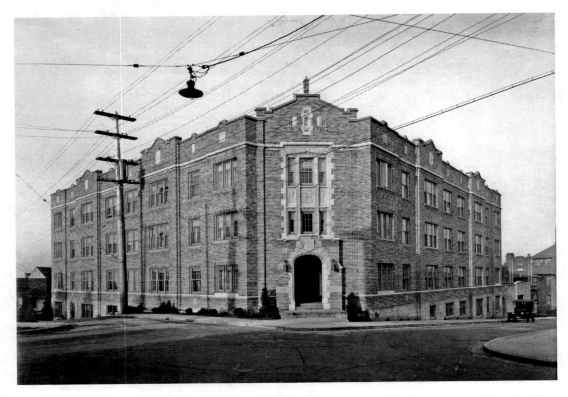

The V-shape of the Roundcliffe works well on its corner site, as each wing accommodates the hill that descends behind it. *University of Washington Libraries, Special Collections, UW 29465z.*

and Wheatley designed the thirty-one-unit building with "airy rooms, so situated that all apartments have a wonderful view."[96] Terra cotta frames the second- and third-floor windows above the arched opening. Inside the recessed entryway, the floors are black marble.

As a young girl, D'Arcy Nicholson Larson and her mother lived in the Roundcliffe.[97] By 1940, hampered by war restrictions and a "cost-conscious" manager, the halls of the Roundcliffe were dimly lit, the carpets worn, and the heating and maintenance minimal. Wonderful views of Queen Anne Hill and Lake Union made up for some of the discomforts.

Larson and her mother had a one-bedroom unit. Their entry hall, the location of the bathroom's entrance, had an arched opening into the living room, from which one could enter the bedroom on one side, or the dining room on the other. Another arched opening connected the living room to the dining room, from which a door led into the dinette/kitchen. The bedroom had a dressing room/closet, described as extra large in newspaper advertisements, which D'Arcy's mother fitted out with a twin-size bed, small chest and dressing table.[98] It served as a bedroom for D'Arcy, who remembers it as "very snug." Windows on the north side of the bedroom, living room, dining room and dinette faced a grassy courtyard, where tenants sunbathed in the summer and a neighbor's cat, which went out a window on a leash, enjoyed.

Because the residents were mostly middle-aged married couples, D'Arcy and a school friend who lived nearby often met at a neighborhood drugstore, which became their hang-out. D'Arcy lived in the Roundcliffe for ten years, "the happiest of times—middle school through college."

In the small lobby, with a tiled floor and Spanish motif, a "bank of mailboxes" was on the right side and "stairs in the middle divided the space ... one hallway curved to the left and the other ... to the right." A laundry in the basement had a washing machine with roller/ringer and washtubs and lines overhead for drying. "Schedules were enforced," recalled D'Arcy.

An attached garage accommodated twenty cars, but the turning point for the Summit-Bellevue trolley line was conveniently right outside the Roundcliffe's front door. On November 14, 1925, the *Seattle Times* ran a notice for a guild meeting, which stated that it would be in the home of a Roundcliffe resident and added directions: "Summit car to the end of the line." Today, Metro bus number fourteen, successor to the trolley, follows the same route.

8. BEN LOMOND (1910) 1027 BELLEVUE COURT EAST

Squeezed onto a site that appears unbuildable, the Ben Lomond is on Bellevue Court East.[99] Designed by architect Ellsworth Green, the Ben Lomond is yet another building that grows—from three stories to five—by virtue of its location on the steeply sloping north end of West Capitol Hill. The most noticeable aspect of the building is two small hip-roofed structures on either end of the roof, which played a key role in the life of the Ben Lomond.

Apartment advertisements frequently stated "No children," although one did announce, "WELL BEHAVED CHILDREN ALLOWED."[100] When the Ben Lomond was constructed, it was a "novel distinction" that Oscar Oliver, the Ben Lomond's owner, welcomed them.[101] Oliver was ahead of his time by providing what a local newspaper described as one of the "special features for the children's comfort": "two sun rooms, or play rooms, on the roof [that] have been designed for the little folk."[102]

This roof structure, one of two atop the Ben Lomond, was built to provide a sun-filled space for children to play.

Ten years after its construction, figures from the 1920 census show that families with small children lived in only one-third of the units. Surprisingly, nearly another third of the units had families with grown children living at home, including one couple with four sons whose ages ranged from twenty-seven to thirty-seven, and a woman and her three daughters, whose ages were between twenty-two and thirty-three.[103] Nearly twenty years later, the 1939 *Seattle Real Property Survey* reported that only one Seattle apartment unit in ten had a child, or children. As the number of units in an apartment building increased, the proportion of tenants with children decreased until only one household in sixteen in larger buildings had children living in them.[104]

The Ben Lomond's wide corridors and five- and six-room units would have suited families. With no figures for the square footage of each of the original twenty-four units, one can conjecture that they were quite large, since today's reconfigured forty suites average 800 square feet. Units possess many original features that reflect on the building's family-friendly approach: large living rooms with ample windows and kitchens with generous cabinet space.

Light-colored brick, ingeniously used around the windows and for the quoins, relieves the Ben Lomond's dark red brick exterior. Pent roofs, held in place by long, thin brackets, are above most of the top-floor windows. An arched door from the second floor opens onto a large deck supported by the entry porch. The main entry area has been much compromised, but the front door with its leaded-glass details remains intact.

9. BELMONT COURT/750 BELMONT (1929)
750 BELMONT AVENUE EAST

The 750 Belmont exhibits the recognizable flair of Fred Anhalt, well-known Seattle apartment developer. Anhalt, who undoubtedly knew that the best apartment houses were often identified by addresses rather than names, used street addresses to name many of his apartments.[105] Doing so ensured that the "name" was exclusive.[106]

Although Anhalt chose the building elements, Edwin Dofsen, a self-taught draftsman, drew the plans for the 750 Belmont. The irregularly shaped building, a concession to the site, shrinks from four to three stories as it ascends Belmont Avenue East. In front, two wings form a triangular courtyard, beneath which is a garage that tenants access via a circular stair within a brick tower. The steel and wood-frame construction supports exterior walls of brick veneer, stucco, and exposed wood. Wood shingles, gabled and hipped roofs, casement windows with leaded glass, and custom-made ironwork are common elements in Anhalt's buildings, as are front and back doors and small balconies, all of which he specified for the 750 Belmont. The Belmont Court's sixteen units vary greatly in size, another Anhalt hallmark. Although the average is almost 900 square feet, six boast over 1,000 square feet.

10. BAMBERG (1910) 416 EAST ROY STREET

The Bamberg stands primly on the north side of East Roy Street. Designed by architect John Carrigan, the handsome brickwork reflects well on owner Charles Bamberg, a brick

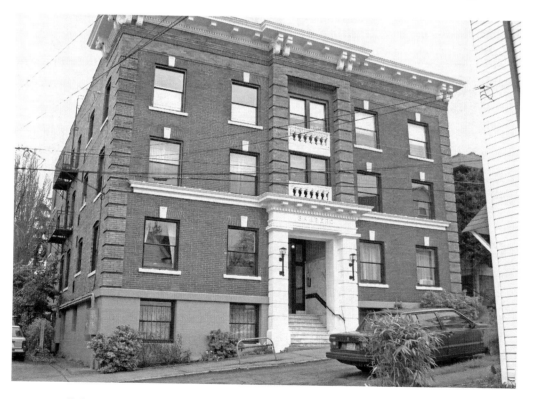

All the individual features of the Bamberg's facade add up to a satisfying whole.

contractor as well as general contractor, who "erected ... a number of the large structures of the city and also apartment buildings."[107] At the time of construction, Bamberg lived on Summit Avenue, on property that partially abutted the east side of the Bamberg. By 1914 he had moved around the corner and taken up residence in his own apartment building.

Who else lived in the Bamberg? The 1920 census reveals some interesting tenant facts. There were four families with one or two young children. A father and his three grown children, all employed, lived in one unit. Two couples and two small children, all with the same last name, shared a unit. A son and daughter-in-law lived with his parents. One couple shared their unit with two lodgers, and in another, three sisters, all in their twenties, lived together.[108] In twenty-first-century Seattle, it is very unlikely that such a number and mix of people would live together in a one- or two-bedroom apartment. And the Bamberg had only *two* of the latter.

Gray brick, in a swath between the third-floor windows and cornice, as well as outlining the central bay above the entry, contrasts beautifully with the red brick and white accents. Above the elegant door surround is a cornice, similar to the one at the roofline, with dentils and modillions, that extends the width of the facade. A balustrade stands guard at each of the center windows.

Inside, some units still contain original features, such as the tall pier glass, or mirror, attached to the wall of the living room.[109] An early advertisement mentioned "polished oak floors; garage accommodations if desired."[110] When the three-story building opened, it had fourteen units; today it is a fourteen-unit condominium building.

West Capitol Hill suffers from an embarrassment of riches related to the number of apartment buildings it contains. In early years of the twentieth century, apartments in other areas of Seattle had good views and good public transportation. But the area between Melrose Avenue and Broadway on the west side of Capitol Hill, with its nearness to downtown, continues to be an unusually desirable neighborhood.

8

Capitol Hill Apartments
East of Broadway

12th NORTH and MERCER. 4-room corner suite in this beautiful new building in the fashionable Volunteer Park District.

One block north of Madison. Capitol Hill's largest apartment home has available a three-room ultra modern apartment.

Choice apartment for choice people: living, dining and bedroom, tiled bath, inlaid hardwood floors, Tiffany lighting fixtures; lease only $60 month.

When the name Capitol Hill first appeared on city maps in 1901, it referred to a tract located between Eleventh and Twentieth avenues East, from Roy Street north to Galer Street, excluding Volunteer Park.[1] James A. Moore, an astute businessman, paid $225,000 for the 160-acre tract in 1900. The son of a prosperous Nova Scotia builder and shipowner, Moore had the necessary funds and contacts to expedite the purchase of the property.[2] Originally covered with underbrush, by 1905 homes dotted the streets. In 1907 Moore bought an adjacent forty acres that extended the eastern boundary of his Capitol Hill tract to Twenty-third Avenue East, and the northern boundary one block north to Garfield Street. Moore not only had money, he carried enough clout to impose restrictions that prohibited the construction of businesses and apartments on his land, contending that they ruined neighborhoods of expensive homes. Many of his early advertisements carried the stipulation: "No store, business blocks, nor flats will be permitted on the property."[3] Because of Moore's restrictions, investors and developers cast their nets in other directions, and few apartments ever found their way onto his property.

Shared Walls defines East Capitol Hill in today's broader context, with Broadway as the western boundary and Twenty-third Avenue East remaining the eastern. Madison Street becomes the southern boundary, and Galer defines the northern edge. Trolleys along Broadway and Fifteenth and Nineteenth avenues East spurred the development of apartments and small businesses along their routes. Neighborhood amenities included public, private, and parochial schools, churches, a firehouse, hospital, movie theaters, and two Olmsted parks.[4]

Auto Row (East of Broadway)

Auto Row, one of numerous but distinct neighborhoods that dot East Capitol Hill, developed along the area's southern edge. Concentrated along Pike and Pine streets, the number of businesses that sold and served motorcars peaked between Broadway and Twelfth

Avenue, "a multi-block area adjacent to early streetcar routes in a previously residential neighborhood of modest single-family dwellings."[5] By 1912 three trolley lines from downtown climbed an improved (leveled and widened) Pike Street to reach this area, where the popularity and demand for the new automobile resulted in Seattle's earliest Auto Row. It was apart, but not too far removed, from the more upscale Capitol Hill neighborhood developed by Moore, which was home to people more likely to be able to purchase and maintain expensive automobiles.[6]

Lavishly decorated automobile showrooms occupied prominent corner locations. In between and on side streets, all manner of car-related businesses infiltrated the neighborhood, as did apartment buildings. Today, reminders of the automobile's glory days abound on and near Pike and Pine between Broadway and Twelfth Avenue. Some buildings remain associated with their original calling, while others have been transformed into a variety of new venues. In 2010 the Elliott Bay Bookstore moved into a space first occupied in 1920 by a Ford truck service center.[7] Many of the Auto Row buildings have been reinvented more than once, indicated by a sign that reads, "Reintroducing the Packard Building: new apartment homes within a renovated historic building."[8]

The lively neighborhood did not limit itself to automobiles. In 1909 the Oddfellows, a fraternal organization, built a beautiful meeting place on the southwest corner of Tenth Avenue East and East Pine Street. Directly across the street from the Oddfellows building, the largest early structure in the neighborhood, is one of Seattle's most popular — and oldest — parks, Cal Anderson Park.

In the early years of the twentieth century, amidst the varied activities of the neighborhood, property owners and investors built apartment buildings along Pike and Pine and contiguous sides streets. One owner blatantly named his new building the Auto Row Apartments.[9]

1. HAYDEN/ROE (1908) 910 EAST PIKE STREET

Abraham Roe, original owner of the Roe, built the three-story masonry building that stands midblock between Broadway and Tenth Avenue East. Roe moved into his namesake building upon its completion.[10] Inside the recessed entry, a hexagonal tile floor with the date 1908 embedded in the design leaves no doubt about the construction date.[11]

Despite its current condition, there is evidence that care and expense were taken with its construction. The extent of the brickwork in the lintels and quoins, the arched entrance, and the ironwork of the second-floor balcony and railing at the third floor bespeak better times. Leaded glass of an unusual design fills the transom above the front door, a later replacement. Sixteen apartments of two and three rooms filled the two upper floors.

By 1909, the Fisk Rubber Company, which manufactured car tires, was occupying the street-front spaces of the Roe. The business was identified as one of Fisk's Pacific Coast "Branch Houses."[12] The tire company must have inspired competition, as a similar business moved into the ground floor of the Bluff, an apartment building immediately east of the Roe.

2. BLUFF (1909) 920 EAST PIKE STREET

Capitalizing on the Bluff's location in the heart of Auto Row, the Firestone Tire and Rubber Company moved into one of the street-front spaces; the building's ground-floor industrial-sized windows topped by light-filling transoms imply that it was built for such

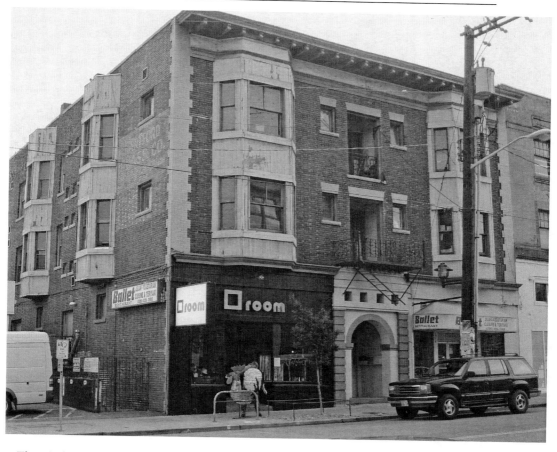

The windows in the Roe appear to be original. Brick structures do not commonly have wood bays, which on the Roe are showing their age.

a use. By the mid-thirties, a motor parts business and a hardware store faced Pike Street. At the same time, Grant Piston Rings occupied one of the commercial spaces at the north end of the building's Tenth Avenue facade.[13] Over the years a variety of businesses have tenanted the ground-floor spaces, including the Comet Tavern since 1936. Stewart Brand, author of *How Buildings Learn*, writes that "buildings are shaped and reshaped by changing cultural currents, changing real-estate value, and changing usage," as the Bluff so aptly demonstrates.[14]

The entrance, not quite on center, to the apartments is slightly recessed and barely discernable from afar. Although in poor condition, the door's transom of diamond-shaped panes and accompanying sidelights is quite likely original. A bold belt course of decorative brick functions as a divider between the ground-floor commercial spaces and the upper floors' residential spaces. The apartment windows, with ten panes over one, are evenly spaced on the building's two street facades. Recessed spandrels lodge between the larger windows, providing architectural relief. More decoration, in the form of infilled rectangles, proceeds around the frieze, the space between the upper windows and the parapet. Originally a cornice projected between the frieze and parapet.[15]

Today it is difficult to reconcile early advertisements for the Bluff's "elegantly fur-

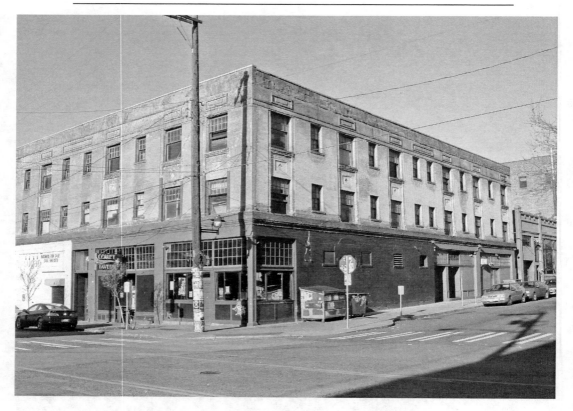

The Bluff, a well-proportioned three-story masonry building, has been on this corner for more than a hundred years.

nished" two-, three-, and four-room apartments, "everything first class and complete," with its current appearance.[16] The city has declared the Bluff's twenty-eight apartments uninhabitable. The building and the neighborhood would benefit from a sensitive rehabilitation that showed appreciation for the Bluff's long history.

3. WINSTON/ELYSIUM/MANDALAY/LORRAINE COURT (1907) 1019 EAST PIKE STREET

During the brief two-year period (1905–1907) of Breitung and Buchinger's partnership, the Seattle architecture firm drew the plans for the Lorraine Court.[17] When completed, two stores fronted Pike Street, and seventy rooms divided among twenty units occupied the upper two floors.[18] A truncated entrance at the southwest corner welcomed store visitors from both Pike Street and Eleventh Avenue East.[19] The apartments are accessed via what has been described as a "wonderfully inappropriate Renaissance entrance."[20] Details such as bay windows on the corners of the upper two floors, a stylish cornice, and a parapet wall, all evident in a 1907 newspaper drawing, add to the building's appeal.[21]

One of the joint owners, A. M. Birkel, was in the hotel and restaurant management business.[22] He and F. W. Dickman must have sensed a good business opportunity in the growing neighborhood when they built the Lorraine Court. Today it is one of the few extant wooden structures with its original facade and overall appearance intact. The rear of the

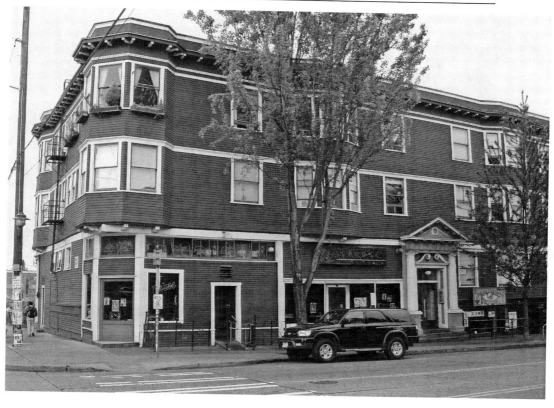

The Winston's elaborate entry, with columns and pediment, is somewhat a surprise on this otherwise modest building.

Winston has open interconnecting porches at all three levels, once a common apartment building feature, and a sure sign of an early construction date.

4. PIKE STREET APARTMENTS (1903) 1200 EAST PIKE STREET

The Pike Street Apartments are a case study for a hybrid building. Simply put, a hybrid is a building that starts out being one thing and ends up being another. A more refined definition is from the Pike Street Apartments' Seattle city landmark nomination: "Hybrid buildings ... represent pragmatic, small-scale vernacular development, which may have been driven by changes in streets or grade levels, use along the street, and economic limitations on new purpose-built construction."[23] In the instance of the Pike Street Apartments, the 1912 widening and regrading of Pike Street drove it from its straightforward appearance to a mix of ground-level spaces and apartments above.

The earlier photograph shows the original two-story structure's multiple gables and whimsical octagonal tower at the southwest corner. Each of the three porches accessed two apartments—one downstairs and one upstairs. Shingles covered the attic portion of the tower as well as the gable ends, which were supported by three small columns at either side of the railed-in porches. Clapboard faced the remainder of the wood-frame building.

By 1910 the building had been lifted and moved back far enough to accommodate the widening of Pike Street. A brick structure was tucked in front at the new grade, and a deck

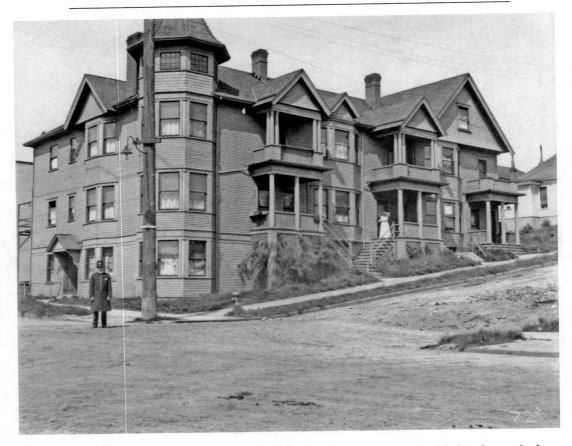

The Pike Street Apartments in 1909, prior to the regrading of Pike Street, which led to changes in the structure of the building. *University of Washington Libraries, Special Collections, Lee 72.*

was built atop it for residents to use to access a sidewalk at the east end of the building. Initially the four commercial spaces presented an attractive whole: each shop had a recessed central entrance and a multilight transom, and a dentiled cornice extended the length of the south face and store portion on Twelfth Avenue East. Alterations and modifications have continued over the years.

Unusual architectural features, a prominent location, and a series of restaurants at the corner have made the Pike Street Apartments an unofficial East Capitol Hill landmark. A survivor of many changes, both in the neighborhood and to the building, it deserves applause. Frank G. Winquist, who called himself a contractor and who was granted the building permit, went on to develop other apartment buildings in the neighborhood.

5. BRISTOL (1907) 1616 THIRTEENTH AVENUE; LA VILLA/FARRAGUT (1907) 1620 THIRTEENTH AVENUE

A drawing of the proposed Winquist-Turner Flats appeared in the *Post-Intelligencer* on December 30, 1906. By the time the building was ready for occupancy in September of 1907, it bore a slightly more appealing name, the Bristol Farragut Apartment Houses.[24]

Frank Winquist, acting as general contractor, and Judge E. J. Turner selected architect

Frederick Sexton to design the building. What at first appears to be one building on the outside is two separate entities inside: the Bristol on the north end and the Farragut at the south end.[25] But the Bristol has a third more square footage than the Farragut. At the center of the ground-level floor of the building is a large opening that allows access to the rear. From here, the difference in size is evident. Also visible are the back porches on each building.

Sexton gave each entrance a spacious porch with piers supporting a projecting roof. The building's handsome brickwork, particularly the flat gauged arches above the first- and second-story windows, is noteworthy, as is the wide frieze and heavy cornice with brackets and dentils and modillions that emphasize the roofline.[26] Sexton must have thought well of the building, for he and his wife were living there at the time of the 1910 census.[27]

Prior to the opening of the Bristol Farragut Apartment Houses, a newspaper announcement stated there would be a total of forty-two apartments of three and five rooms. In early 1909 the Farragut's location was "an ideal one, nice paved streets; just a step to the Capitol Hill car, yet far enough from the car tracks that no discomfort is felt from the noise and jar of the cars ... tasty decoration ... throughout."[28] Changes over the years have resulted in each of the connected buildings now having twenty-five apartment units. Those in the larger Bristol have greater square footages but do not compare with earlier descriptions of a "large three-room apartment with two wall beds; large size kitchen; fine condition."[29]

6. PINE STREET APARTMENTS/GORDON (1907)
1202 EAST PINE STREET

In November of 1906 Jane Brydsen took out a permit for an apartment building, which would be called the Gordon.[30] Brydsen, also known as Mrs. Captain Brydsen, and her husband John lived in the Gordon upon its completion. In the 1910 *Polk's Seattle City Directory* she was listed as the proprietor, while her husband's occupation was given as master, Straits

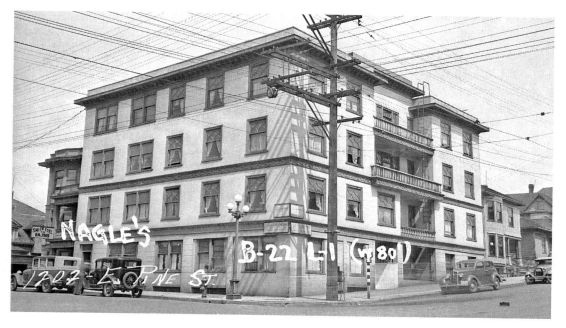

The Gordon in 1937. *Washington State Archives, Puget Sound Regional Branch 600300 0635.*

Current photograph of the Gordon, whose only remaining reminder of its former appearance is the bracketed cornice below the roofline.

Steamship Company.[31] Similar to other women in real estate, owning and operating an apartment building was likely a satisfying and financially rewarding occupation, perhaps even more so for Brydsen, whose husband's work may have required frequent or lengthy absences.[32]

Architect F. A. Sexton, who designed the nearby Bristol Farragut, prepared plans for a sixteen-unit, two-story-plus-basement building, but according to early photos, the Gordon started out with three floors of apartments.[33] When the Gordon opened in 1907, it advertised "new, thoroughly modern; select 3 and 4 rooms," which could be rented for $27.50 or $35.00 per month.[34] By 1937, the Property Record Card for the Gordon stated that it had twenty-seven apartments and was four stories in height. Doubtless the regrading of Pine and Pike streets around 1910–12 impacted the Gordon, and Mrs. Brydsen, as many owners had done, took advantage of the situation by adding an additional floor to her apartment building. In 1937 Jane Brydsen was still listed as the owner of the building.[35]

Fifteenth Avenue East Apartments (East Denny Way to Mercer Street)

As early as 1908 a writer for the real estate section of the *Seattle Post-Intelligencer* opined that "probably there has been no section of the city where during the last year, in the same

area there have been erected as many apartments and where there promises to be more activity during the coming year than on Capitol Hill."[36] So many streetcar routes traversed the area that "minutes from downtown" was a major selling point for apartment owners. In 1901 the Seattle Electric Company extended its Pike Street line to Fifteenth Avenue. From there it built a new line that ran from Pine Street as far north as East Harrison Street. Cars traveled north on one track and returned south via Fourteenth Avenue. By 1906 a single track that could accommodate cars going both directions was built from Harrison to Galer Street.[37] On the return, the trolley ran south along Fifteenth until it reached Mercer Street, where it turned west for one block and then continued south along the Fourteenth Avenue tracks back to Pine Street. This route bypassed the blocks of Fourteenth Avenue East between Prospect and Mercer streets, thus protecting the lineup of expensive homes, also known as Millionaire's Row, from exposure to a trolley's noise and bother. James Moore, the developer of this exclusive corner of East Capitol Hill, made certain that tracks were not built on the street on which he lived.

Merchants followed the streetcars. A jumble of eager entrepreneurs offered an array of goods and services on Fifteenth and Nineteenth avenues. The ubiquitous mom-and-pop grocery stores arrived first, followed by laundries, dry cleaners, pharmacies, shoe repairs, bakeries, candy shops, and beauty and barber shops. Attesting to the high incomes of many of the residents of Capitol Hill's stately homes, Augustine and Kyer, one of Seattle's oldest quality food firms, opened up at 500 Fifteenth Avenue East in 1914.[38] Safeway operated at several addresses along Fifteenth and Nineteenth avenues.

Apartments near Fifteenth Avenue East range across a variety of sizes, materials, and architectural styles, particularly the latter. From the light-fantastic Fredonia to the ultra-modern Laurelton, apartment buildings in the neighborhood are a visual adventure.

1. LAURELTON (1928) 1820 SIXTEENTH AVENUE EAST

"Setting a New Standard in Apartments," bragged the Laurelton management when this modernistic apartment house opened. Designed by the Seattle architectural firm of Baker, Vogel and Roush, the Laurelton occupies a large 120-by-120-foot lot, surrounded by lawns. The four-story-plus-basement building has stucco exterior walls with forty-five-degree wings at each corner, so designed that all apartments have outside rooms and three-way views. It was an unusual building for its time and for its location among Capitol Hill's more traditional architecture.

Large industrial metal sash windows, enjoyed by all thirty-two units, reinforce the building's modern design. A scattering of red brick tiles—a series at the center of the parapet, near the stairs, and in a chevron effect at the top of each wing—lend a touch of color and ornamentation to the monochromatic walls.

Residents and visitors can approach the front porch via stairs from both sides. Entering into the lobbylike hall, one comes to the stairs and elevator, which are located dead-center in the building. On each floor the units are spaced around the stairwell and elevator. Each apartment begins with a small vestibule, with a door into the bathroom and an opening into the living room. From the living room one can go into the dinette, which opens into the kitchenette. Also from the living room there is a door into the winglike extension, which houses the bedroom. Despite being designated a bedroom on the building plans, a closet with double doors opens up to reveal a hidden bed, specifically a Wall Beds Ad-a-Room by the Marshall and Stearns Company.[39] With the bed folded away, the tenant could

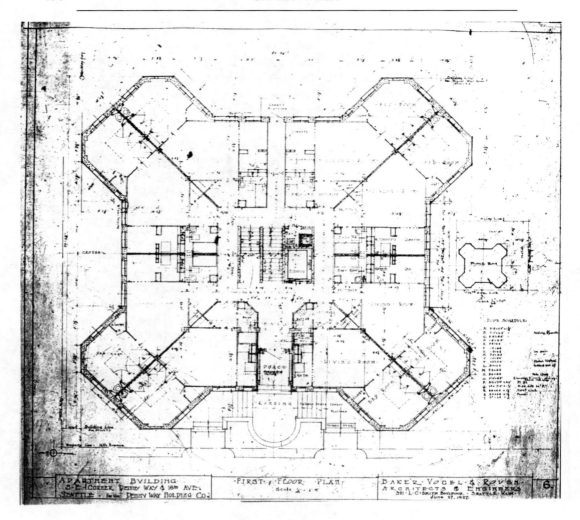

Baker, Vogel and Roush's plan for the Laurelton shows their willingness to experiment with a more modern style.

have entertained in the bedroom, which could have doubled as a solarium due to its sunny exposure.

The units could be rented furnished, complete with upholstered mohair chairs and sofas, a style popular in the 1920s, or unfurnished.[40] A special feature of the building included "Baker interlocking stairways, providing virtually two fireproof stairways in one" from the basement to the top floor.[41] An automatic elevator and parking at the rear of the building added to the incentives for moving into the Laurelton, a thoroughly modern building for its time.

2. BUCKLEY (1928) 201 SEVENTEENTH AVENUE EAST; SHEFFIELD (1929) 200 SEVENTEENTH AVENUE EAST

Seattle architect Edward L. Merritt and builder Charles Arensberg collaborated on the design and construction of both the Buckley and the Sheffield. Arensberg had been in the

Top: The Buckley, along with the Sheffield, distinguishes the intersection of Seventeenth Avenue East and East John Street. *Above:* The Sheffield is similar in appearance to the Buckley, but not a mirror image.

field for twenty years when the Buckley, which he said represented "one of the most complete and one of the best constructed buildings of this type in the city," opened in 1928.[42] A local newspaper reported that two to three thousand people visited the Buckley on its opening day, proof that Seattle was a growing city and housing was in short supply, and that prospective tenants considered it a choice building.[43]

The Buckley's angled corner entrance, awash with gleaming cream-colored terra cotta, beckons one to enter the tasteful brick building. The Gladding, McBean Company supplied both the brick and terra cotta, the latter appearing again on a bay toward the end of both street facades. The arched opening is enhanced by lanterns set in niches, reminiscent of the Collegiate Gothic style. Richly toned wood, molded in a shape that repeats the curve of the entrance opening, surrounds the glass door, leaded-glass sidelights, and three-part fanlight. Inside, a diamond-patterned tile floor, hand-painted walls, and a stone fountain on the north wall grace the Buckley's spacious lobby.

Interiors of the thirty-two units, divided among two-, three-, and four-room suites, included entrance halls with guest closets, "Tiffanized walls" and mahogany trim in the living rooms, leaded-glass doors between the rooms, and bedroom closets spacious enough for both a built-in dressing table and clothes press. The larger suites had a bedroom, while the smaller units had large closets that concealed a wall bed. For the ladies, the real attraction was the kitchens, the "last word in kitchen design and equipment."[44] A landscaped roof garden, built atop the garage, provided a restful outdoor area for residents.[45] Recognizing the increase in automobile ownership, Arensberg provided a parking space for each unit, appreciated even more by today's renters.

The Sheffield, described as "a companion building to the Buckley," is across Seventeenth Avenue East from the the other building. Arensberg and Merritt collaborated again on the Sheffield, which opened to public inspection on September 8, 1929, almost one year to the day after the Buckley. Similar to the Buckley, the Sheffield is three stories in height, faced with brick, and features an ornamented terra cotta angled entry bay. A writer for the *Seattle Times* described the building's style as "in general follow[ing] the English Renaissance type of architecture."[46]

Up a few steps from the sidewalk, beneath a sign with the building's name incised in terra cotta, the recessed entry invites a pause to admire the beautiful woodwork. The glass-paneled front door has a blank wood transom above, but on either side, the small panels above the sidelights display a delicate wood carving. The sidelights are leaded glass and have a medallion inset with a large *S*. Inside, the opulent lobby was furnished with "Oriental rugs, silken panels, Tiffany walls and ceiling, luxurious furniture, statuary, marble fireplace and ornamental lightening [sic] fixtures." An electric log in the fireplace and heat from the "artistically covered steam radiators" promised warmth and comfort on cold dreary days. Both stairs and an elevator access the upper floors.[47]

When built, the Sheffield had twenty-three units: three in the basement, six on the first floor, and seven on both the second and third floors. Except that four units, rather than three, are now in the basement, the numbers and configurations for the upper floors remain much the same. Originally, the smaller apartments featured an alcove containing a recessed bed, secreted behind French doors, and a living room, kitchenette, dinette, and bathroom. The five-room apartments, "complete homes in themselves," had interior hallways, living room, two bedrooms, dining room, and kitchen, in addition to a dinette and bathroom. On the roof of the underground garage, a garden contained plantings, cluster lights, ornamental benches, and a fountain.

A year into the Great Depression, both the Buckley and the Sheffield promised $5 off the first month's rent to attract tenants.[48] Today a condominium building, the original hand-painted murals still adorn the walls of the Sheffield's lobby.

3. Gables (1911) 403–409 Sixteenth Avenue East

In 1902 a barn stood on the northwest corner of Sixteenth Avenue East and East Harrison Street. Three years later a two-story frame dwelling replaced the barn.[49] In 1911, architect Robert T. Knipe received a permit to construct an apartment house at the same address.[50]

The four-story-plus-basement Gables apartment house is actually two separate buildings. One, referred to as the Annex, is on the southwest corner of the lot. Adjacent to the north side of the Annex is the larger U-shaped building. Although newspaper accounts of the day addressed only the latter, both, according to permits, apparently were built in 1911.

Brick, supplied by the locally owned Denny-Renton Brick and Coal Company, is generously and inventively used on both buildings and elevates the building's appearance. The wide recessed entrance of the larger building is faced with Pedrara Mexican onyx and Tennessee marble, used where it would most impress.[51] Once inside, tenants and guests entered

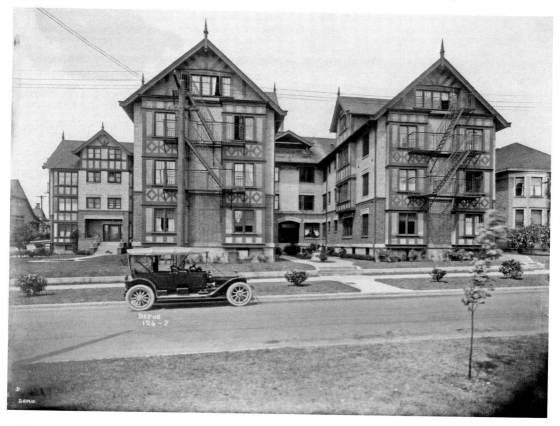

The September 9, 1911, issue of *Pacific Builder and Engineer* described the style of architecture for the Gables as "Old English." *University of Washington Libraries, Special Collections, UW 29467z.*

a high-ceilinged lobby with an enormous fireplace. Here also was a service elevator and stair-way. At the doorways the "latest appliances in telephonic communications" were installed.[52]

Initial advertisements for the larger building mentioned twenty-four three- and four-room apartments on the first three floors, each with a living room, kitchen, dining area, and bathroom. In the larger units, in addition to a separate bedroom, a Douglas wall bed was stored in one of the living-room closets. Amelia Middleton, who was living in the Annex in early 2000, still used the extra bed when she had company. Attached to the headboard of the bed was the original reading light, which still worked. The living room was very large, the bedroom of moderate size, and the kitchen tiny. The "dining area" mentioned in early advertisements was in one end of the living room. All units in the Annex opened off a wide hallway.

Although construction was nearing completion, it was still premature to announce that a spacious observatory, billiard room, dancing hall, and a roof garden would be on the building's fourth floor.[53] A year later, the *Seattle Post-Intelligencer* reported that the owner of the Gables, a Mr. Boone, had solicited bids for the completion of the top floor.[54] Five months later, confirming that the work had been done, a classified advertisement mentioned a completed billiard room and social hall at the Gables—somewhat scaled back, but still attractive, amenities.

Today the two buildings compose the Gables Cooperative. Numerous units have been reconfigured, remodeled, and updated, but the building's charm has never waned.

4. RAGLEY (1922) 1608 EAST REPUBLICAN

The Ragley is similar to many Seattle apartments built in the early twenties: three sto-ries, brick with terra cotta or cast stone trim, inviting exterior and comfortable interiors. The Ragley, however, went a step beyond. An impressive multilevel entrance with elegant but subdued lobby, large well-arranged units with thoughtfully planned kitchens and an excess of closets, and the convenience of eight garages at the rear of the buildings attracted enough renters that within a year of opening it was advertising for "discriminating people."[55]

Max Ragley, the building's developer and owner, was a doctor by training but gave up his profession to focus on real estate, handling "his own properties, which are extensive."[56] Still, he may have helped financed construction costs of the Ragley with money from eastern investors, a common practice in the early 1920s.[57] "Eastern capital in ever increasing volume is being poured into Seattle for investment in high class apartments.... In fact it is almost impossible to supply the demand.... Despite the fact that this year will break all records for several years in apartment construction, it is predicted that 1923 will see even greater explan-sion along this line."[58]

Ragley hired architect B. Dudley Stuart to design the three-story-plus-basement build-ing. Within a year of completion, Ragley sold it to Lewis Levy, who then hired the firm of Stuart and Wheatley to provide some alterations, including the addition of three units and two maids' rooms in the basement.[59]

A colorful glass sign in the transom announces the Ragley. After mounting the steps of the marble-wainscoted vestibule, there are only two units on either side of the lobby. Generously sized, each had two bedrooms and a plethora of closets: coat and parcel closets in the entry hall, with more lining the hall, including a linen closet. With no lobby to con-sume space, the second and third floors have five units each. Initial advertisements for the fourteen apartments (prior to changes that Levy made) mentioned soundproof walls and floors, individual ventilation, solid oak floors, and tiled bathrooms and "Roman bath" (with

At the rear of the Ragley, two building blocks each hold four garages, in which the cars park nose to nose. Cars access the garages from the street or alley.

no elaboration on that amenity).[60] Stuart's meticulous drawings of the kitchen and linen cupboards, doors to the apartments, the main entrance, and stairwell show a careful regard for the smallest detail.

Opposite the entrance, another set of doors open outside to the unusual arrangement of garages at the rear of the building.

5. Fredonia (1907) 1509 East Mercer

Architect Henderson Ryan and property owner Byron Monroe, who a year earlier had collaborated on the Monroe Apartments one block south of the Fredonia, joined forces a second time to produce the Fredonia.[61] The Fredonia's red-tiled turrets topping the corner window bays, shaped gables along the roofline, and the trios of windows with arched openings outlined in contrasting brick resulted in a fairy-tale version of Spanish Mission style.

Prominently sited on the southeast corner of Fifteenth Avenue East and East Mercer Street, several retail establishments faced busy Fifteenth. The entry to the apartments is via a massive arched opening, a Ryan trademark, on Mercer, a quieter side street. The twelve units were divided among three- and four-room suites. "Private baths, ice chests, laundry and all outside rooms in a most beautiful location ... and only $25 up; half what others ask for same accommodations," noted a 1908 advertisement.[62] Today Capitol Hill Housing operates the Fredonia. The twelve units, the number unchanged since 1907, have one or two bedrooms.[63] Today the Fredonia's appearance, minus the turrets, is more subdued.

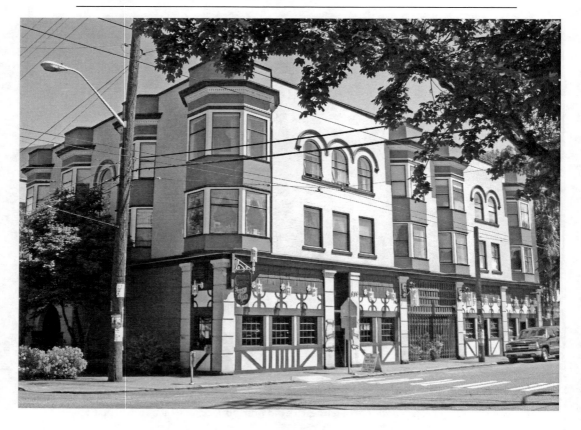

The ground floor of the Fredonia is still commercial.

6. MONROE (1906) 426 FIFTEENTH AVENUE EAST

The first mention of the Monroe Apartments was in May of 1905, when a notice appeared in the *Seattle Post-Intelligencer* announcing that architect Henderson Ryan had finished plans for a two-story apartment building, including four street-level stores, for the corner of Fifteenth and Republican. At that time, excavation was already under way. It concluded by saying that "the class of construction is becoming quite popular with a number of investors."[64]

Obviously the owners, Mr. and Mrs. Monroe, had built for investment purposes, since by June of 1906, the newspaper reported that Mrs. Monroe and husband had sold their just-completed brick apartment house.[65] Over the years, numerous businesses have occupied the street-front spaces. A drug store long anchored the north end of the building, but locals have taken advantage of a grocery store, meat market, hardware store, and beauty salon, among others, at the site.

Looking today at the bare-bones exterior of the Monroe, it is difficult to imagine the building it once was. Projecting bays with decorative spandrels were at the upper corners of the facade, and a pair of bays was in the center and spaced out along the north elevation. To reach the seven upstairs apartments, residents then and now enter through a door at the south end of the building. A 1922 advertisement provided the bare facts: "Four-room apartment; modern; rooms light and airy; Capitol Hill District."[66] By 1924 the Fifteenth

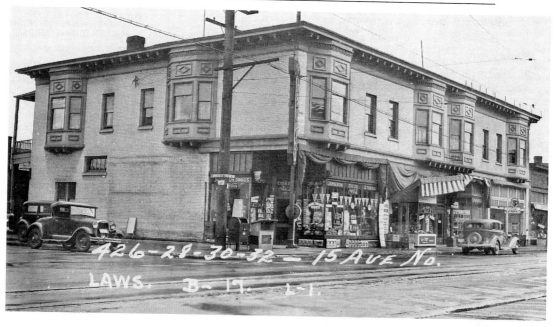

Eventually the Monroe would be stripped of the second-floor bays and all ornamentation. *Washington State Archives, Puget Sound Regional Branch 423240 0635.*

Avenue Garage had been built behind the Monroe. It faced Republican Street but was so near the rear of the Monroe that it almost touched the back porch of the apartments; it was removed at a later time.

7. MALDEN (1908) 1454 EAST HARRISON

In late 1907 a local newspaper reported that a building at the northeast corner of Harrison Street and Malden Avenue would be "one of the most modern and expensive apartment houses to be erected on Capitol Hill in some time."[67] The Terrell-Maverick Company, singled out as being one of the first to realize the advantage of building apartments in the area, constructed the Malden. The same newspaper account reported that Lewis Terrell would be the architect. He was within bounds when he called himself an "architect," but his name does not appear in early Seattle directories' lists of architects, and in the 1910 census he gave his occupation as real estate broker. Nevertheless, he designed a charming building.

Looking at the Malden from the street does not reveal the unexpected curve of the building's east wall, which reveals itself as the lobby's curving east wall. From the lobby a second door opens onto a gravel parking lot, which at an earlier time might have been the site for a lawn or garden for residents. Red clinker brick on the first floor pleasingly wraps around the curve and continues in a straight line to the rear.

The Malden's front door is an extravaganza of beveled and leaded glass in the large transom and sidelights. After stepping inside the small inner lobby, marble stairs lead up to the main lobby, where directly ahead is a freestanding clinker brick fireplace. The fireplace chimney, also of clinker brick, is round and disappears from sight as it rises up toward the next floor. The staircase, following the shape of the wall, curves upward around the back of the fireplace. The lobby is a welcoming space.

Before a 2010 improvement, the exterior of the two upper floors of the east side of the building were covered in a light tan colored imitation brick (the type that came in rolls) that reached to the top of the second-floor windows, where red imitation brick took over. It has since been replaced with a clapboardlike covering. Brick veneer, in different shades and finishes, covers the remaining walls, including the striated parapet. Brick is used to create the quoinlike effect that edges the vertical sides of windows above the first floor and the building's corners.

The Malden opened with twenty-four units arranged in two- and three-room suites, with every one of the rooms facing outside. Early management thought the building's brickwork worth mentioning when advertising: "3 rooms, $22.50. Choice Capitol Hill apartments. Neat brick."[69]

8. La Crosse (1907) 302 Malden Avenue

F. H. Perkins, praised by the *Seattle Post-Intelligencer* as "one who lays claim to early seeing the advantages of erecting this particular class of structures [apartments]," drew the plans for the LaCrosse.[70] With its back to busy Fifteenth Avenue East and its entrance on quiet Malden Avenue, the La Crosse is one of Perkins' most distinctive apartment buildings.

The architect lived in Southern California before moving to Seattle in 1903, which may have influenced his choice of Mission style for the La Crosse. The building's exterior walls are clad in stucco, a characteristic of the style, although a newspaper article described it as "cement plastered and flashed with granite."[71] Another characteristic is the gabled parapets at two corners, as was the original (metal) tile roof. Most telling is the square hip-

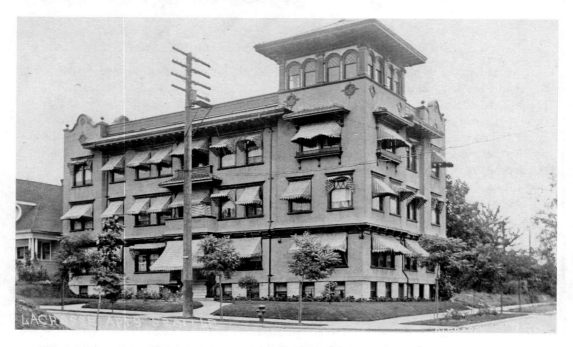

The striped awnings, useful on buildings that face west, added even more flair to the La Crosse. *Postcard courtesy Kathy Wickwire.*

roofed tower on the southwest corner, which rises a story above the roof and distinguishes this East Capitol Hill landmark. A very early photograph shows the tower as an open-air pavilion, the roof supported by sturdy balusters.[72] At some point it was enclosed with two pairs of arched windows on each side, and the blind arches were infilled with the same diamond pattern found in the doors to the balconies and upper sashes of windows on the second and third floors. In addition to the diamond theme, some very un–Mission Ionic capitals appear on the tower's fluted pilasters and atop the square piers flanking the main entrance.

Marble stairs and white tiled walls lead up to the wood-paneled front door, which has glass in the top half, as do the leaded and beveled sidelights. Inside, a door on either side of the foyer accesses one of the two ground-floor units. Units on the two upper floors have the same floor plan, with one side mirroring the other. Dottie DeCoster, who lived at the La Crosse in the 1970s, recalled pleasantly high ceilings, large windows, especially in the living and dining room (the latter with built-in china cabinets), two bedrooms with small but adequate closets, and a "poky" kitchen with a back door and stairway to the alley behind the building.[73]

In June of 1907, the owners bragged about a "telephone communicating system from the vestibule to apartments," seven units of five and six rooms, and hot-water heating.[74] A few months later, a news items said it had six six-room apartments and janitor's rooms. Since the 1910 census contacted seven units, the census takes may have considered the janitor's room a rental unit, or the owner had officially converted the janitor's rooms into a rental unit. Today it has nine units, with an average square footage of 1,144 square feet.

In 1920, five families with children (between the ages of seven and twenty-four), one couple with no children, and three adult sisters who shared one unit lived in the La Crosse. The same year, it received special notice when tenant Arthur V. Dickey, upset at the high price of sugar, installed bee hives on the roof. "I'm proving that even the apartment house dweller has a chance and that it is possible to keep bees and at the same time live in an apartment house," said Dickey. In one year he gathered forty gallons of honey, reported the *Seattle Times*.[75]

Developer Frederick Tetzner, who partnered with architect Perkins on a number of Capitol Hill apartments, and Mrs. Eliza Purdy built the La Crosse. In addition to being the owner, Purdy lived in her building for the first few years.[76]

9. BERING (1930) 233 FOURTEENTH AVENUE EAST

Construction on the Bering was under way in June of 1930.[77] Though in retrospect it seems financially perilous to have begun construction on an apartment house a year into the Great Depression, developers of the Bering must have been optimistic. A. M. Atwood, president of John Davis and Company, glorified the city in an article he wrote for *Script*, a Hollywood publication. "Where do they get this 'Hoover Depression' stuff? ... Just because New York is in the dollar doldrums you'd think the whole USA was.... You pessimists ought to go up into the Northwest. Seattle is simply booming.... The busiest city on a busy Coast."[78] But not for much longer. Once buildings that had their funding in place prior to 1929 were completed, there was very little new apartment construction through the remainder of the 1930s. During Seattle's two peak periods of apartment construction, 1905–1914 and 1925–1929, more than seven hundred apartment buildings went up. Between 1930 and 1939, only eighty-six were built.[79]

Fortunately, work went ahead on the Bering, which looks today very much as it did upon completion. By October, an advertisement in a local newspaper said, "The new and charming apartment is nearing completion. Several suites are available for early choice, 2, 3, 4 and 5-room gorgeous apartment homes. Appointments of exceptional merit. Many never shown before. Advance inspection is recommended for interested parties." In today's money, monthly rents at the Bering would have ranged between $600.00 and $1,600.50.[80]

Architect Max Van House designed the four-story rectangular building, relieved only by a shallow light well on the south side.[81] The red face brick is a perfect background for the array of cast stone that decorates the street facades. The cast stone is most evident in the central entry bay and the three bays on the north side, where it appears from the ground to the roofline. Perched on the southwest corner of Fourteenth Avenue East and East Thomas Street, windows at the rear have fabulous views of the city, the Sound, and sunsets. Windows, many of them leaded with stained-glass medallion insets, are abundant.

The Bering's front door features a touch of Art Deco in the pair of back-to-back *B*s in the arched transom. Once past the front door, steps in the vestibule lead up to the lobby, where there is oak wainscoting and textured walls and ceilings—no more Art Deco. On one wall the brass mailboxes have pride of place.[82] A wide stairway with wooden railings, but gracefully designed ornamental iron supports, leads from the lobby to the upper floors. Many residents use the elevator, with its cage door, black and white hexagonal tile floor, and wood walls beneath the cove ceiling.[83]

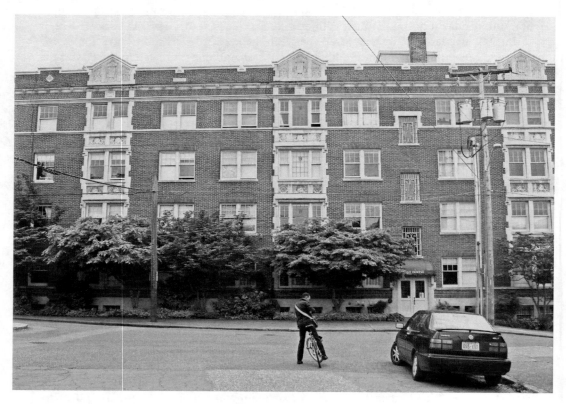

Residents who lived on the north side of the Bering could look up Fourteenth Avenue East to watch for the approach of the trolley, as a portion of the southbound tracks were still on Fourteenth.

The number of units in the Bering, twenty-eight, remains unchanged since 1930. Converted to a condominium building in 2000, the units range in size from a 420-square-foot unit to a thousand-plus-square-foot, two-bedroom corner unit.

Nineteenth Avenue East

The neighborhood skirting Nineteenth Avenue East was becoming a good place to live in the early 1900s. The Seattle Electric Company began the new Nineteenth Avenue line in the fall of 1907.[84] Beginning at the King Street (train) station in Pioneer Square, the trolley traveled north on Second Avenue to Pike Street, from whence it went to Nineteenth Avenue, where it proceeded north to its destination of Interlaken Boulevard. At that point it turned around for the return trip. Cars on the new line began picking up passengers between 6 and 6:30 in the morning and continued until midnight. In 1914 a cash fare cost five cents, but one could purchase six tickets for twenty-five cents or twenty-five for one dollar. Metro bus number twelve, whose terminus is Interlaken Boulevard, still operates on Nineteenth Avenue East.

Nineteenth Avenue did not become as busy a shopping street as Fifteenth and Broadway, but it had its share of commercial establishments. In 1909, a pharmacy and grocery store opened at the northwest corner of Nineteenth and Aloha. [85] Other businesses followed, some on the ground floor of apartment buildings, as well as a school, a playfield, and, in 1925, the Roycroft Theater.[86]

1. MONTRACHET/HALLETT (1922)
956 EIGHTEENTH AVENUE EAST

The gambrel-roofed Montrachet, clad with artificial stone darkened by time, is one of the more atypical apartment buildings on East Capitol Hill.[87] It is also one of the few built within James Moore's development, albeit many years after he issued his "restrictions" regarding the construction of apartments or businesses in his domain. Although the Hallett is sizable in bulk and three stories tall, it manages to blend in among the large single-family homes of the quiet neighborhood. D. L. Hallett was the owner-builder, and as no name is on the plans, he may also have designed the building.[88]

The front door, with its attractive pattern of wood and glass—the pattern is replicated in the French doors inside the units—opens into a corridor with coved ceilings. All units have an entrance off the main corridor, but the larger units also have a separate outside entrance, with private porch, on the south side of the building, accessed by an exterior stairway.

The Montrachet has eleven units, five of which measure almost 1,600 square feet. These spacious units have a living room with multiple windows on two walls and a fireplace that is faced in tile and has a finely detailed wood mantel. There is also a separate dining room, large kitchen with a walk-in pantry, two bedrooms, and an entry hall and bathroom. Hallett included two other rooms that he called sleeping porches.[89] The remaining smaller units have many of the same features as the larger ones.

Spacious accommodations, fine details, and a convenient location attract, and retain, renters in the Montrachet.

2. PARK/NASH/CHALMERS (1910)
606 NINETEENTH AVENUE EAST

On May 10, 1910, a large heading in the *Seattle Post-Intelligencer* announced that "Nine-teenth Avenue North Has Recently Come to the Front as an Apartment House District." A picture of the Chalmers, with one of the street-level shops sporting a large canopy, appeared just beneath the heading. A variety of businesses have occupied the six storefronts from opening day to the present, and they miraculously maintain much of their integrity.[90] The Roycroft Radio Shop, owned by the Felzer family, and a sporting-goods store are just two of many former occupants.

In the center of the six glass-fronted shops, a tall arched opening brings one to the door for the apartments. The door is an inappropriate replacement, but the lovely wood-framed glass arch above the door and the tiled floor of the entryway are original. Once inside, a tiny vestibule is only large enough to access the tall stairway to the second floor. Over the years, fire codes and decisions by owners have resulted in some rather unconventional spaces, but the eighteen units are comfortably sized and are very light, since most have large windows that face the street. Large entry halls, as well as claw-foot tubs and wide, shallow closets that once held hidden beds, are features in many of the units.[91]

In 1913 a newspaper advertisement described the Chalmers as having "properly sized rooms, 3 or 4; tinting that blends with good-looking woodwork; first quality fixtures; large wardrobes."[92] Many things have changed at the park, but not its convenient location on Nineteenth Avenue East.

3. JENNOT/KITTITAS (1909) 1911 EAST ROY STREET

The Jennot is almost hidden behind a large two-story brick structure on Nineteenth Avenue East, originally built to house automobiles. When the large homes in the neighborhood were constructed, no one anticipated such a need, but it was not long before it seemed no one wanted to leave his fancy new car parked out on the street. A group of wealthy men provided funds and in 1907 built the Capitol Hill Automobile Garage, where they could leave their cars after work and have them delivered to their home the next morning.[93]

Two years after the garage was built, the comely two-story Jennot was in place. It is a simple, compact, wood-frame building that has a shallow light well on the west side. Cedar siding, followed by composition brick and, today, clapboard, have covered the building's exterior.

At the base of the Jennot's parapet, a shallow overhang shields rain from the bay of windows on either side the entrance. From the tiled floor of the recessed entrance, residents enter through the front door (with leaded-glass transom) into the hall, also the location of the wooden stairwell. At the end of the hall on both floors, a door exits to a rear porch. The inside halls, both upstairs and down, have four units on either side. Today all are one-bedroom apartments that average 525 square feet.

A small community garden separates the rear of the Jennot and that of the Mercer-wood.

4. MERCERWOOD (1912) 1914 EAST MERCER STREET

Beginning in 1925, the Hyde Chocolate Company occupied the ground floor of the building at 1914 East Mercer Street. It is an early mixed-use building, as apartments occupied

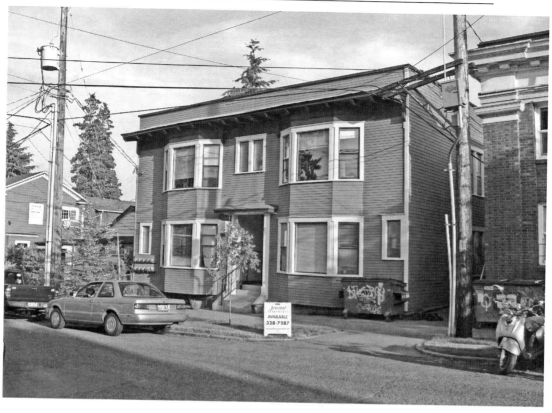

The builder of the modest Jennot/Kittitas showed pride in its construction.

the upper floor. The building's solid brick construction and the industrial-style windows at the front and along the east and west walls of the ground floor indicate that the building was purpose-built for commercial or industrial use. One other indication is at the rear northwest corner, which rather than having the usual sharp corner is gently curved. The story goes that horses pulling wagonloads of supplies, including large amounts of sugar for the candy company, needed the wider berth to make the turn to reach the back of the building. Since the candy business did not begin until 1925, it was likely small trucks that needed the wide berth.

The downstairs may have been industrial, but the upstairs was residential. Early photos show that the two large front windows were composed of three separate windows, each with an upper sash of small leaded-glass panes. Such a window is still visible on the upstairs east wall. The decorative frames around the windows, which slightly extend from the multicolored brick facade, are a very unusual feature. The great frames still exist around all three, but three-part metal windows now fill the front windows. No longer extant is the decorative cornice beneath a well-defined parapet. But the front door of today remains much the same, particularly the transom with ten small panes of glass. Early records indicate there were only four apartments, but sometime in 1945, the number changed to six: three two-room and three three-room units, all with one bedroom.[94] In one of the larger units, located on the southeast corner, a very small entry hall opens into the large living room, full of light due to its corner location. It is said that the patriarch of the Hyde Candy Company lived in this unit.[95]

Clem Felzer, a longtime Nineteenth Avenue East resident, remembers when he would "peek in the window and the lady making candy would hand me a sample."[96] As a young boy, Clem and his family lived in the Jennot Apartments, directly behind the Mercerwood, and later in the Park (Nash/Chalmers).

5. LORRIMER/LORIMER (1910) 1914 EAST REPUBLICAN

In 1910, when the Lorrimer was "brand new," its location was deemed to be in a good residential district.[97] By the time it changed hands in 1923, for "a consideration of $20,000," the *Seattle Daily Journal of Commerce* reported that the Lorrimer was one of the best known structures on Capitol Hill.[98] It is curious that the modest building was one of the "best known." The sale occurred during a time when Seattle apartments were "commanding the interest of local and outside capitalists to an extent never before paralleled in the history of this city."[99] A photograph of the Lorrimer that accompanied the latter article reveals that fundamentally it has changed very little since 1923.

A feature of the Lorrimer not observed on any other Seattle apartment building is the arrangement of doors at the entrance. There is an impressive central door, with

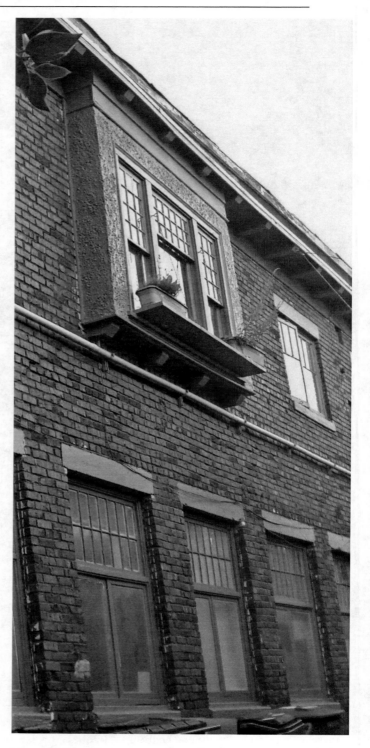

The windows on the east wall of the Mercerwood reflect the building's industrial use on the ground floor and residential use above.

A most unusual feature at the Lorrimer is the three doors at the front. The large central door opens into an entry hallway, and the two side doors directly access each of the first-floor units.

twenty panes of glass framed in wood that fill more than half the overly large front door. It was a door to be proud of, but there are two additional doors! A door directly on either side of the large one is a private entrance into each of the first-floor units.

Brick covers the first floor of the three-story frame structure. Originally shingles faced the upper two floors, but by the mid-thirties stucco had been applied and has remained ever since.[100] Inside the central door, there is a small hall just large enough to accommodate the stairwell. In all, the building has seven units: two per floor and one in the daylight basement. All units run from the front of the building to the rear. The upstairs units, one on either side of a central hall, average nearly a thousand square feet. When built, each of the four- and five-room units featured an "instantaneous water-heater attached to boiler" and china and cooling cabinets.[101] Today the outside vents for the cooling cabinets are visible in the brick wall outside the kitchens. A back hall accesses the bathroom and bedroom and a door to a back porch, where a rear stairwell, to all units, is now enclosed.

One of the Lorrimer's more unusual interior features is the projecting space on the second level, directly above the front entrance porch. It is unusual in that it still exists, as such areas often were filled in to give more space to units on either side. Supported at the outside corners by daintily capped piers, the inside may have been envisioned as a sunny spot for residents to gather and socialize.

6. CASA DE CINQUE/WENZEL (1910)
506–508 NINETEENTH AVENUE EAST

The Wenzel is very intact, from its primly arched front entrance outlined by terra cotta rope and topped with a protruding "keystone," to the two second-story triangular oriel windows, on up to the three round vents spaced across a band beneath the eave. A picture of the Wenzel that appeared in the same May 1910 newspaper article that trumpeted Nineteenth Avenue as an "Apartment House District" shows all the same features. Under the picture, it states, "Apartments erected by the Wenzel estate."[102]

Egg-and-dart trim highlights the handsome wood front door that has a large glass-panel inset. The small recessed entrance is graced by a tile floor bordered by a Greek key design; the same floor continues inside the vestibule. Marble wainscoting in the entrance also goes beyond the front door and extends up the stairs to the second floor, where there are five apartment units.

The unit that occupies the north corner of the building is nicely lit due to the oriel window in one bedroom and the large bay window in the living room, as well as nine-foot-tall ceilings. A pocket door divides the living room from a room that may have served as a dining room, but was more likely, as now, used as a second bedroom. The bathroom, located just off the small entrance space, has a canted, or angled, door, as does the front bedroom. Such touches not only make the space work better, but they add a touch of whimsy. The kitchen, completely updated, leaves not a clue to its former layout and amenities.[103]

At street level, a store occupied the space on either side of the entrance to the apartments. A 1910 photo shows a canopy outside the window of the store on the south end. At some point, Widdop's Vegetable Stand had the space, and Pratt's Grocery was in business in the other.Currently, a medical facility, which occupies the northeast corner of Nineteenth and Republican, owns the building and uses the former ground-floor spaces. Capitol Hill Housing manages the upstairs apartments.

7. REGIS/REX ARMS/LANE (1910) 1812 EAST REPUBLICAN

The owner-builder of the Lane took full advantage of the site that slopes down to Nineteenth Avenue East. The entrance to the apartments was on quieter Republican, but the storefronts were placed on Nineteenth, where they captured foot and trolley traffic. When built, the Lane's appearance was simpler than today, but more refined. Consistent brick veneer covered the east and south facades, and the storefronts, divided by simple columns, were designed to attract a high-class trade. A salient feature missing today is the railing around the perimeter of the roof of the section near Nineteenth Avenue East. Early plans show a door, at the east end of the third-floor corridor, opening out onto the roof. At the time of construction, Miss E. Gibson owned the Lane.[104]

Because of Republican Street's slope, the section not abutting Nineteenth has three floors plus a basement, while the lower half has only two floors, with storefronts occupying the ground floor.[105] Over the years the number of units has varied very little, but they have become more standardized. For instance, instead of a variation between one-, two-, three-, and four-room apartments, today there are sixteen one-bedroom units and ten efficiencies.

Today, the Republican Street entrance is one of the building's good features. The woodwork that frames a newer door also frames sidelights with narrow panes of glass. *Regis,* set in the transom above the front door, does not appear consistent with the spirit of other glass used around the door nor with the age of the building. Inside, the vestibule/lobby is

A year after the Lane's opening, this early postcard indicates a dry goods store and a real estate office occupied two of the three business spaces. *Museum of History and Industry, all rights reserved, unless otherwise noted.*

home to an imposing stairwell. On all floors a corridor runs parallel to Republican, and all units open onto it. In 1922 the management advertised, "Situated in a good residence district, this desirable homelike structure, nicely furnished 2 and 3-room apartments. Also may be had unfurnished." The Regis is still in a good residential district and is still renting units.

Volunteer Park and Beyond

There is an interesting concentration of buildings at the confluence of Harvard Avenue East and East Roy Street. It includes the former Woman's Century Club, founded in 1891 by a group of prominent women who built their "stately brick clubhouse ... in a neighborhood that was a center for women's activities" in 1925.[106] Across from the Women's Century Club building was the Cornish School of the Arts, founded by Nellie Cornish in 1921. The respected school grew to occupy a number of blocks in the area and remained until 2005, when it moved to larger quarters. The school's beautiful theater, a small jewel which still hosts cultural events, remains in the neighborhood. Across from the theater is the meeting place for the Daughters of the American Revolution, also part of this group.

Not far from this small cultural center is Volunteer Park, one of the prizes in Seattle's string of parks and drives designed in the early 1900s by the New York–based firm of the Olmsted Brothers. Among the park's appeals were a children's area with wading pool, a bandstand, and a conservatory. In 1933 the Seattle Art Museum established itself in a handsome Art Deco building on the grounds of the park, adding to the cultural attractions of

East Capitol Hill.[107] When advertising their apartments, many owners wisely capitalized on the proximity of their buildings to Volunteer Park.

1. LOVELESS (1931) 711 BROADWAY EAST

Located less than a block from the cultural confluence just mentioned, where the north end of Broadway encounters East Roy Street, and a half-block jog to the west, Seattle architect Arthur Loveless built his office on the northwest corner of the intersection in 1925. In 1931 he moved the building back to the northwest corner of the site for his use as a home. He then added apartment units, creating a rectangle of buildings around an inner courtyard. Known as the Loveless Building, it is a Seattle architectural icon.

Stores and eating establishments occupy the ground-floor spaces that face both Broadway and East Roy Street. A variety of materials—stucco, wood, and cut stone—create an interesting exterior for the wood-frame building.[108] A row of dormer windows on the shingled roof, arched doorways, and leaded-glass windows add to the charm of the two-story building.[109]

Since the building's inception, the apartments inside the gate have provided a retreat from the busyness of Broadway. The number of units has varied over the years. Originally there were eight, and there have been as many as eleven. The current tenant of the unit that formerly was Loveless' home says that all apartments are different, and all have "something special about them."[110] Facing the courtyard, beautified with a fountain and tasteful landscaping, her unit nestles in the corner. Special touches include a beautifully tiled floor inset with a simple flower design in the entry hall. To the left, an oversize fireplace fills the south wall of the large living room. Leaded-glass casement windows, some featuring colored inserts of medieval scenes, line its east and west walls.[111] Large leaded-glass windows brighten the dining room, which is to the right of the entry. Upstairs are two bedrooms and a bathroom.

One interesting tenant, Myra Wiggins, a photographer, painter, musician, writer, and poet, and her husband Fred moved into the almost new Loveless Apartments in 1932. The socially conscious Wiggins had chosen well. It was "a bustling neighborhood with shops and fine homes, and a good location for Myra—she was just a few blocks from the soon to be opened Seattle Art Museum." She opened a studio in their small apartment, where in 1934 she held the first of her annual "at-home" events, attended by several hundred people.[112]

2. TEN-O-FIVE EAST ROY (1930)
1005 EAST ROY STREET

Just minutes from busy Broadway, two of Fred Anhalt's most impressive apartment buildings, the Ten-O-Five East Roy and the 1014 East Roy, face each other across Roy Street. Anhalt applied many of the same elements that characterized his other apartments to both Roy Street buildings: Tudor effects, such as arches, turrets, leaded-glass windows, crosstimbering, and stucco on the exterior; and oak-plank flooring, hand-sawn open beam ceilings, and fireplaces to give the interior the feel of a comfortable home. An article in *Building Economy* remarked that "it is not every city ... that can steal a march on the East. And yet visitors from there always express astonishment at finding the massive, stately mansions of the English type ... plumped down almost in the heart of the city."[113]

An opening in the Broadway facade of the Loveless Building allows a look through this lovely gate into the courtyard, which the apartments face.

Working with draftman Edwin E. Dofsen, the Ten-O-Five East Roy was completed in April of 1930, the tail end of Seattle's building frenzy prior to the Depression. Stretching from one end to the other of the admittedly short block of East Roy, the Ten-O-Five is designed around three stair towers. In the tower lobbies, a winding, freestanding stairway rises and allows access to a few apartments on each floor. The grandest of the three, writes Seattle architectural historian Larry Kreisman, "rises shell-like in a great circular motion

The exterior of the Ten-O-Five East Roy, similar to other Anhalt apartments, features Tudor architectural styling, shingle roof, leaded glass windows and clinker brick.

to a rondule colored glass lantern on the third level. It is a magnificent structural tour de force."[114] Initially, city engineers had said it would be impossible to build, but Anhalt's determination, coupled with Dofsen's engineering skill, solved the problem.[115] Clinker bricks, usually considered rejects, cover the exterior walls. Anhalt believed they gave a more realistic finish to his Tudor-style apartments.[116]

The interior spaces are equally impressive. The twenty-five units vary in size from 850 to over 2000 square feet. The largest units have spacious entry halls, dining rooms, and living rooms with working fireplaces. The "cheery" kitchens had "built-in electric dishwashers ... little round things that were set into the countertops right besides the sink." Anhalt admitted that "they wouldn't be much by today's standards, but they were revolutionary then."[117]

The Ten-O-Five also had an underground garage, with more than enough spaces for all the tenants. During excavation a natural spring was struck, which had to be paved over, creating the huge garage. Tenants could access the garage via a turret, located near the steps to the sidewalk, and descend to the garage. To maintain his buildings, Anhalt's organization cared for the gardens and took care of all maintenance, including keeping the woodwork varnished and polished. During the Depression, Anhalt was forced to sell Ten-O-Five East Roy for $54,000. Construction costs had been $135,000.[118]

The Ten-O-Five, which remains an apartment building, has been a Seattle city landmark for thirty years and is listed in the National Register of Historic Places.

3. Eight Apartments in the 700 Block of Tenth Avenue East: 711, 715, 725, 729 (West Side) and 718, 722, 726, 730 (East Side)

In March of 1925 realtor Henry E. Ewing told the *Seattle Times* that "increasing demand for housing facilities in Seattle is bringing into popularity the small type of apartment," well liked in many large cities on the East Coast. Besides providing homes for small families, the apartments "are said to be profitable." Ewing said he envisioned two-story buildings with four apartments. The owner of the building would occupy one apartment, giving him a home as well as income. His suggestion was borne out by Sam Koretz, who owned and resided in the Huntley (715 Tenth Avenue East) in the 1930s. His granddaughter, Marlene Clein, recalls that Koretz had to learn to operate the furnace boiler. Ewing also suggested building several in the same locality, so that one janitor could service several buildings. Ewing named Capitol Hill and the North Broadway districts as being "particularly adapted to this type of apartment."[119] The builders and owners of apartments on Tenth Avenue East appear to have followed his advice.

Although two-story brick apartments with a small number of units are scattered throughout East Capitol Hill, this one block has eight, all built between 1926 and 1927. They share many similarities, including size, shape, material, and number of units.[120] There are numerous pairs and trios of two- and three-story buildings all around Seattle, but this group of eight may be unique.

Only two of the buildings, on the west side of Tenth but at the south end, differ visually from the others. The square footage of the pair is also slightly less than the others.[121] A study of the two, 711 and 715, reveals that builder Benjamin Holroyd purchased the two lots in July of 1926 from Josephine Wills, with the intent of improving the property with a three-story apartment building.[122] (Although all eight buildings are described by the King County

Parcel Viewer as two stories, one could argue that they are three stories since the daylight basements are well above ground.) By December of the same year, a photograph of the two appeared in the paper with the announcement that Holroyd had sold them, a quick, and no doubt remunerative, business transaction.[123]

All the buildings are rectangular in plan and feature a raised entry porch, reached by steep steps. On the second floor, all have French doors—some still retaining the original fanlight—that open onto a small balcony created by the projecting entry porch. The 711 and 715 have a pair of tall arched windows and no balcony, likely later changes. All are similar in plan: two floors with two one-bedroom units on each floor. An entrance directly beneath the front porch accesses the basement level, which has two efficiency units.[124]

Who designed them? Spokane architect Glenn Davis proposes that Seattle architect Earl Morrison could have designed one pair or all. He also suggests that Morrison might have developed a design that was built "unsupervised, and then replicated by the contractor without architect input or compensation."[125] According to Michael Doucet, author of *Housing the North American City*, this was standard practice across the continent. Doucet wrote that one critic called it "a game of 'follow the leader' where 'plans were copied blindly or stereotyped plans were taken from the files and adapted to new plots without question.'"[126] The eight buildings, although small and simple, exhibit a sureness of design that could be from the hand of Morrison.

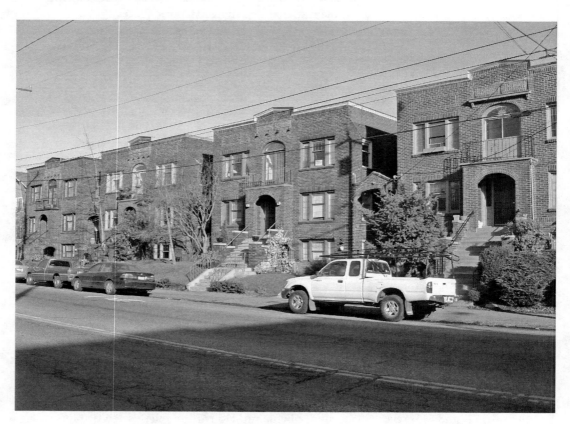

A group of four boxy brick apartment buildings line up on one side of Tenth Avenue East. There are two additional pairs, separated by some single-family homes, on the opposite side of the street.

"Located in an exclusive residence district, this building contains six-room suites with appointments to satisfy the most discriminating home lover. It is built for those who wish and can afford room and luxury."[127] Although the preceding was an advertisement for the Highland, it could have applied to any of the three other choice apartments—the Park Court, Fairmont, and Washington Arms—that line the west side of Eleventh Avenue East between East Prospect and Aloha streets. All were built between 1920 and 1924, and all are equally desirable today as when built. A discussion of two, the Park Court and the Washington Arms, is representative of all four.

4. PARK COURT (1922) 921 ELEVENTH AVENUE EAST

In May of 1922 Henry Schuett commissioned the Seattle architectural firm of Stoddard and Son to produce plans for a four-story, eight-unit apartment building. By mid–January of the following year, a notice appeared in the society page of the *Seattle Times* announcing that Mr. and Mrs. Henry Schuett and their daughter Henryetta had "removed to the Park Court Apartments on 11th Avenue North."[128] The owner and his wife were among the first to move in, but others quickly followed. George Stoddard, the son in the architectural firm, designed the Park Court. Schuett did not have to go far to find an architect, as the younger Stoddard was married to his older daughter, Marjorie.[129]

The Park Court has lost very little of its original integrity. Beautiful brickwork, cast stone keystones above pairs of leaded-glass windows, and the elegant entry porch are

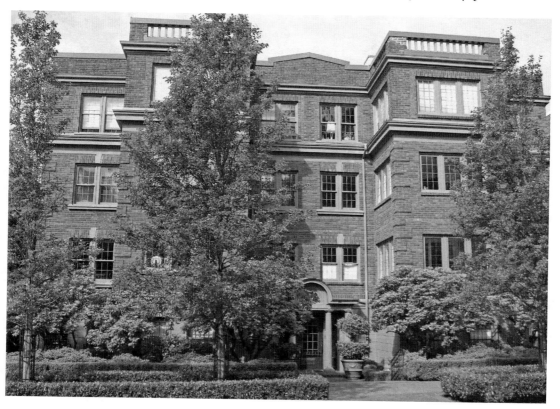

Handsome brickwork covers the facade of the Park Court.

evidence that the building's construction was appropriately funded. Brick largely covers the facade of the four-story building, but Stoddard called for scored cement plaster to cover the ground floor. It is symmetrical in design and has two projecting bays, which on the second and third floors are accentuated by brick quoins. At the very top, the center parapet has a slightly pointed design, but a balustrade interrupts the facade of the parapet of the two bays. Stoddard's plan called for true, vase-shaped balusters rather than the current infill. The use of balustrades is often associated with Georgian Revival architecture, which in part describes the style of the Park Court.

The plans show a rather lavish concern for comfort and show. Whether or not they were all implemented in the interiors is unknown. The plan for the second floor calls for two units, almost the same in size and layout. Each has a large reception hall that opens into the more formal spaces (living and dining rooms and solarium) and a hall that accesses the two bedrooms and bathroom, as well as the kitchen on the west. An added feature in both is a butler's pantry, complete with built-in china cupboard and table, between the kitchen and dining room. There is a second door into the kitchen reached by service stairs; one set of stairs is on the north side, and one set is on the south side of the building.

On Stoddard's first-floor plan he writes, "Owner's apartment only second and third floor." Reserving two entire floors of a building for one person was something New Yorkers did to make their apartments large and impressive.[130] Schuett may have thought better about that decision, but he did consider the Park Court his building, as details for the basement, or ground-floor, plan, include large, separate spaces for "owner's storage" and "owner's laundry."[131] Although the terrazzo-floored vestibule and large curving stairwell take up much of the central space of the ground floor, one efficiency unit, three maids' rooms, a janitor's unit, boiler and fuel rooms, a large laundry room, and tenant storage spaces are on the same floor.

Today a condominium building, the Park Court has three efficiencies on the ground floor and six large units on the upper floors, each measuring 1,375 square feet. All the large units enjoy the original fireplaces and now have either one and a half or two bathrooms, instead of the original one. A six-car garage at the rear of the building is reserved for tenants of the larger units.

Henry Schuett did not long enjoy living at the Park Court. The owner of Seattle Feed and Seed Company for twenty years, he died in July of 1924, eighteen months after moving into the Park Court.

5. WASHINGTON ARMS (1920) 1065 EAST PROSPECT STREET

The Washington Arms, on the corner of Prospect and Eleventh Avenue and across the street from Volunteer Park, retains its 1920s style and design. Property owners Mae and Charles Young chose architect Victor Voorhees to design the building.[132] Mae handled the business of the Young and Young real estate firm while Charles worked for the Army Corps of Engineers at the Hiram M. Chittenden Locks.[133]

To fit the building to the narrow site created by the curve of East Prospect Street as it follows the southwest boundary of Volunteer Park, Voorhees designed a building in the shape of an asymmetrical U that perfectly fits the unusually shaped lot. The entry courtyard forms the base of the U, and the two wings, one 127 feet long and the other only 44 feet, form the two sides. Voorhees accomplished an even larger feat when he deftly created three floors of luxurious apartments within its bounds.

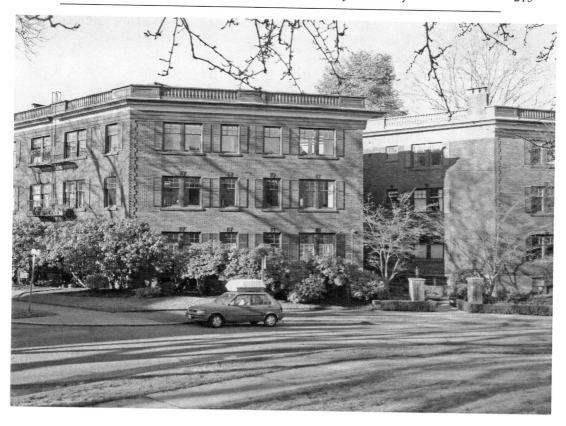

The entry to the Washington Arms is between the two wings of the asymmetrical building, which conforms to the curve of East Prospect Street, the dividing line between the apartments and Volunteer Park.

In 1919, the *Seattle Times* reported that at this location, a three-story-plus-full-basement apartment house would have sixteen five- and six-room apartments as well as a maid's room for each apartment in the "semi-basement."[134] Indeed, Voorhees' plan for the basement shows fifteens maid's rooms, all of which shared one bathroom.[135] The maids shared the floor with the laundry, coal bin, heating room, a large storeroom, and one efficiency unit.[136]

Upstairs, there were five units on each floor. Except for the unit at the northeast corner, the configuration was the same on all floors. That unit on the ground floor had only one bedroom, as the lobby commandeered the space that in the same unit on the second floor became a second bedroom. All units had a private hall off the main corridor, which increased each tenant's privacy but at the same time created a great deal of underused space. Each level contained one one-bedroom unit, three two-bedroom units, and one three-bedroom unit, and no two were alike on the same floor. But all had a wood-burning fireplace, French doors between the living and dining rooms, oak floors, and tiled baths. Voorhees' plans indicate that in the living room of some units (including the largest), there was a wall bed, euphemistically called a guest bed.

The round entry portico supported by columns speaks of the Colonial Revival style. Other instances of the style are the classical cornice and the parapet, with infills of balusters,

which originally appeared atop the portico. Voorhees varied the window arrangements: those on the fist and second floors have brick lintels with painted wood keystones; solid wood shutters with small cutouts frame the pairs of windows on the first floor, while louvered shutters frame those on the second and third floors. Artfully composed brick quoins define the corners of the building. Without an early photograph of the entrance for proof, it is unknown if Voorhees' drawing for the front door—indicated on his plans as solid wood, almost rustic, with enormous black hinges—was implemented. The building's current wood and glass door, with its lovely glass sidelights, feels more appropriate.

Variously described in early advertisements as "one of Seattle's finest buildings" and "beautifully located," the Washington Arms is now a condominium building.

6. 1006 EAST PROSPECT (1904) 1006 EAST PROSPECT

This charming small building is a relief after all the grand apartments on Eleventh Avenue East. That there is little information about it reflects on its status as a simple building for ordinary folks. But more people lived in such modest apartment buildings than those similar to the ones on Eleventh Avenue East. Today the wood frame three-story building has six one-bedroom/one bath units. It is near the ever popular Broadway District and a bus line that travels between the University of Washington and downtown Seattle.

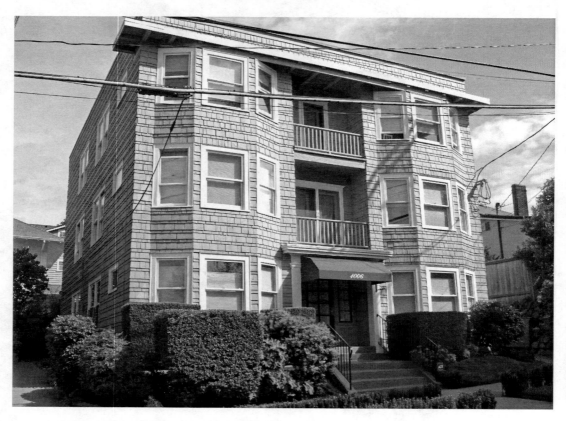

Except for the addition of the canopy, the 1006 East Prospect apartment building looks exactly the same as it did in 1937, the date of the earliest known photograph.

The geometrical designs in the terra cotta sets the La Vanch apart from more traditional apartment buildings in the neighborhood.

7. LA VANCH (1931) 956 TENTH AVENUE EAST

Architect Earl Morrison placed the three-story buff-colored brick and terra cotta building twelve feet back from the sidewalk in order to leave space for a front lawn and shrubbery. Because near-in Seattle property was costly, few apartments could boast this pleasant amenity.[137] But neighbors may have been a little shocked to see such a "modern" building in their midst.

Terra cotta enhanced with low-relief geometrical designs ornaments the central bay, particularly above the front entrance, where large windows feature leaded-glass panels with Art Deco–influenced designs. The spandrel between the second- and third-floor windows has vertical strips of terra cotta in Art Deco styles. The Art Deco glass is repeated in the sidelights and front door, which opens into a tiled hall. A wide staircase leads to the carpeted hallways of the upper floors and the twenty efficiency apartments divided among two- and three-room suites. With characteristic enthusiasm, a story in the *Seattle Times* called attention to the La Vanch's many fine features, such as cast bronze hardware and lighting fixtures, kitchen cabinets enameled in peach, sinks and drain boards of "black and white tile with an Oriental inset effect," large and dustproof cupboards, and a special boiler that guaranteed an "abundance of hot water."[138]

An entrance on the south side is an extra convenience, as are the garages at the rear, which, for the most part, appear to have their original paneled doors with multipaned glass windows.

Apartments built between 1900 and 1939 on East Capitol Hill were as varied as the area's terrain and the people who inhabited them. First concentrating mainly along the trolley lines, apartment buildings also infiltrated side streets, often creating small neighborhoods of apartment buildings. The ones mentioned in these studies are just a sampling of the large number that were built and for the most part still provide a comfortable place to live inside their well-constructed walls.

9

Apartments All Around the Town

A five room corner apartment in the finest residential section of Queen Anne. Modern in every respect. Oak floors, white woodwork, papered walls, sleeping porches. REFRIGERATION.

Desirable 3 room suite, fireplace, garage if desired, opposite University campus, furnished or unfurnished.

LIVE ON THE BEACH AT ALKI. Unusual 4-room corner apartments with hardwood floors, mahogany woodwork, very large dressing rooms, tiled bath. 200 ft. from the water and 10 minute drive by paved boulevard to city.

During the first four decades of the 1900s, apartment buildings were erected all over Seattle for the same reasons they were built downtown and on First and Capitol hills: they were good investments, and Seattle needed housing. Streetcar lines, which eventually extended to the city's limits, made living in an apartment a viable option for everyone. In 1939 the city's northern boundary was Eighty-fifth Avenue east of Fifteenth Avenue, and Sixty-fifth Avenue west of Fifteenth. Roxbury Street west of the Duwamish River and an imaginary line that ends near Rainier Beach on the east side of the river were the southern boundaries.

The following ten apartments, which truly are scattered all around Seattle, were chosen for their diverse locations. A few are large and architecturally important; some are similar to those found in every corner of the city; a few were built in the early 1900s and one nearly at the end of the time frame of this study, but every apartment has a story to tell.

1. BEACON HILL: JEFFERSON PARK APARTMENTS (1924)
1756 SOUTH SPOKANE STREET

Despite Beacon Hill's proximity to downtown, its topography deterred its early development. A long ridge, which runs north to south with a steep slope on its west and a gentler slope on its east, did not encourage population growth. Early narrow-gauge electric lines followed circuitous routes on Beacon Hill, but it was not until the 1920s that apartment buildings began to be constructed along the lines, which by 1929 extended as far south as South Spokane Street.[1] Ease of transportation and a location directly across from Jefferson Park — which encompasses fifty acres and affords views of downtown, the Sound, and mountains — added an edge to the Jefferson Park's appeal.[2]

Engineer J. M. Baird designed the three-story apartment building that, except for its smaller-scale windows, resembles a well-designed school. The West Coast Construction Company built and owned the Jefferson Park Apartments. A series of quatrefoils and terra cotta ornamentation surrounding the central opening suggest the Gothic style.[3] A string-course of light-colored terra cotta runs above the third-floor windows; similar terra cotta

appears in the cornice and coping of the parapet. Bolder and lighter-colored mortar is used in the latter, which along with the terra cotta accentuates the building's dark red exterior of burlap-textured brick. The building's name is emblazoned directly above the opening into the marble-floored entry porch, where on one wall hangs a large wooden mailbox with

This photograph of the Jefferson Park's entry shows the location of the three windows of the "sleeping porch" above the band of quatrefoils.

twenty-five small metal doors. Not necessarily its original location, it is nevertheless a nostalgic survivor of the building's earlier years.

Inside the entry hall, stairs lead up to the main corridor, which runs parallel to the length of the building. Across the corridor, another set of stairs leads down to the centrally located rear exit. Off the main corridor, on each of the three floors, there were four units on the east side of the central hall and four on the west side. An additional unit was in the basement. Today the Jefferson Court has eleven efficiency units and fifteen one-bedroom units, which almost matches the number of units in the original plan. Baird cleverly created a sleeping porch, which he added to the second- and third-floor units directly above the entry space on the ground floor.[4] This was a judicious use of the small amount of "found" space, but it would also have been a plus when renting the units. The basement contained the usual necessities: laundry, boiler room, and tenant storage spaces, as well as one one-bedroom unit. Also in the basement was the garage, accessed from the rear. Typical of the time, there were spaces for only fifteen cars, an indication that no one anticipated that most future residents would own a car.

The 1930 census confirms that most residents had blue-collar jobs, a reflection of Beacon Hill's historically low-to-middle-income population. Living in the Jefferson Park Apartments were mechanics, salesmen, truck drivers, a sheet metal worker, and one baker, as well as a dentist and "aviator." In the late 1930s, one entrepreneurial Jefferson Park resident conducted a business from his apartment. He took orders, presumably by the phone number listed in his classified advertisement, for Western Wall Bed Services, which offered wall beds — "recess, door, and roller" — and "replaced coil springs." Working out of one's apartment was not unusual. Advertisements for dressmaking and music lessons, for example, frequently appeared in newspapers.

2. UNIVERSITY DISTRICT: WILSONIAN (1923)
4710 UNIVERSITY WAY NORTHEAST

When the Washington state legislature voted in 1891 to relocate the University of Washington from downtown Seattle, it was to a larger site several miles to the northeast in a fledgling neighborhood that would become known as the University District.[5] In addition to the university's move, expanded public transportation that connected downtown Seattle to the Alaska-Yukon-Pacific Exposition held on the grounds of the university in the summer of 1909 influenced the growth of the University District. By 1929 it was considered Seattle's most important commercial area outside downtown.[6]

Corinne Simpson Wilson, developer and owner of the Wilsonian Apartments, was one of many women involved in Seattle real estate, but one of few to establish her own business. Although she maintained an office in downtown Seattle, in 1909 she opened what today would be called a branch office in the University District. A good businesswoman, she must have sensed the area's possibilities. In 1923, when she and her husband George constructed the Wilsonian on the prominent northeast corner of Northeast Forty-seventh Street and University Way Northeast, she considered it the pinnacle of her real estate career.[7]

Near its opening date, the Wilsonian was the subject of feature articles in both Seattle newspapers and *Hotel News of the West*, with the latter displaying a photograph of the apartment building on the cover of its April 26, 1924, issue. All three discussed at length every detail of the building's construction, suppliers, and furnishings. The *Post-Intelligencer* noted that "Seattle's need of an apartment hotel of the highest class, in a refined district ... is met

by the seven-story Wilsonian."[8] *Hotel News of the West* went further by declaring it "one of finest to be found outside New York City."[9]

Seattle architect Frank Fowler designed the building, whose overly tall entrance block sits far back from the street, due to its location in the center of the U-shaped building. Light-colored brick, whose "harmonious colors and pleasing textures [brought out] the beauty of the exterior," faces the seven-story reinforced concrete structure.[10] Terra cotta clads and ornaments the structure, particularly around the newer double doors and transom of the front entrance. The building's name is incised in a panel directly above the transom, and atop all is a cartouche, supported by scroll-like features, on which the letter *W* appears. Terra cotta appears again in the overly wide and highly decorative belt course between the second and third floors, in the lintels and sills, in another belt course below the top floor, and in the cornice. The careful handling of such details adds distinction to the building.

The Wilsonian's restaurant and ballroom were considered assets for both the business and social life of the area.[11] The large ballroom, with its made-for-dancing spring hardwood floor and Tiffany glass windows and crystal lamps, attracted parties and events for many years.[12] A large tile fireplace graces the lobby, where the original furniture was upholstered

Described as Italian Renaissance in style, a term associated with clean lines and symmetry, it was a fair, if a little over-the-top, appraisal of the Wilsonian. *University of Washington Libraries, Special Collections, UW 4521.*

in silk and mohair. Sunday concerts in the lounge were free to residents and their guests.[13] Wrought metal lamps, each with the Wilson crest, were in the corridors, lounge, and each apartment. Mrs. Wilson fancied birds, and there were fifty canaries in the building. A photograph of the living room of one of the units shows a large birdcage suspended from its own special stand.[14]

The original ninety-nine units, no two of which were alike, were divided among two-, three-, four-, and five-room units. The kitchenettes were furnished with up-to-date appliances, including refrigerators "automatically cooled from an ice plant in the building."[15] Bathrooms were equipped with tubs and shower baths, and every unit had a built-in wall bed. Today there are ninety-five units distributed among efficiencies and one- and two-bedroom units.

Bertha Landes, Seattle's mayor from 1926 through 1928, moved into the Wilsonian soon after it opened and lived there until 1941. The Wilsonian's proximity to the University of Washington would have been convenient for her husband, a teacher and later dean of the School of Arts and Sciences, and for Landes herself, who returned to lecturing after serving as mayor. Census information from 1930 shows that at least three other residents were professors at the university.[16]

3. Mount Baker: Mt. Baker Court Condominium/Mount Baker Apartments (1939) 3601 South McClellan Street

Visible from this southeast Seattle neighborhood, and the source of its name, is Mount Baker, a year-round snow-capped mountain one hundred miles to the north. Stretched along the shore of Lake Washington, the water and views of its namesake contributed to the prestige of living in the neighborhood. Developed by the Hunter Tract Improvement Company, it was restricted to single-family-only residences.

The Mount Baker Park Improvement Club, established in 1909, is said to be one of the oldest continuously active community clubs in the United States.[17] Not only did it maintain stringent restrictions regarding what kind of houses could be built and who could buy them, it passed a resolution stating its disapproval of the construction of boarding or lodging houses within the neighborhood. The club frowned on any nonresidential construction, but over time the demands of residents in the rather isolated neighborhood were heard, and one commercial building was allowed. On June 1, 1930, the *Seattle Times* reported that construction of a three-story business center would begin on August 1. Five stores would occupy the street-level spaces, offices for doctors and dentists would be on the second floor, and a garage would be in the building's basement. It did not mention how the third floor would be used, but club and district meetings were allowed to use the space.[18] The article did mention that "no other stores are permitted within a wide range."

Prominent Seattle architect John Graham designed a complex building for the unusual site. The zigzag shape of the upper floors of the east facade, the patterns of the decorative cast stone, and the metal window sashes speak to the building's Art Deco style. The building's shape resembles a quarter of a pie, with the store spaces facing the curving east and north streets, giving them prominent exposure. Tenants of the stores over the years have included Kefauver Grocery and Meats, Condie's Pharmacy, Baker Dye Works, Fletcher Floral and Landscape Service, Van de Kamp's bakery, and realtor James Wheeler. At last, Mount Baker residents could shop close to home.

This overall view of the Mount Baker building shows the shops below and the apartments that now occupy the top floor.

The building's north side faces Mount Baker Park, a linear park that leads down to Lake Washington. The park was designed by John Charles Olmsted, of the Olmsted Brothers firm. The Mount Baker Park Addition was incorporated into their citywide plan for Seattle.

In January of 1939 a local newspaper reported that the construction of eight complete apartment units of two and three rooms was under way in the upper floor of the Mount Baker Center Building. Thus, the Mount Baker is the only building included in *Shared Walls* that was not originally an apartment building. The owners engaged Alban Shay to carry out the renovation. No doubt the owners, the Mount Baker Center Inc., "composed of local investment interests," felt income-generating housing was a more profitable function for the space than its previous usage.[19] This prompts re-referrencing Brand's contention that "real estate has vastly more influence on the shape and fate of buildings than architectural theories or aesthetics."[20]

The eight apartments were surprisingly small for the rather upscale neighborhood. There were seven two-room efficiency-style units and one three-room unit. The smaller units, which varied in size, rented from $37.50 and $45.00 in the late 1930s. Each had a parking space in the garage. Today the eight units comprise the Mt. Baker Court Condominium. The entrance area, unlike many older apartment buildings, has been tastefully updated. Possibly recalling the door's original transom and sidelights, the spare interpretation leaves no doubt that it is a new entry, without detracting from the building's Art Deco heritage.

4. CENTRAL DISTRICT: MADISON VIEW/CASCADE VIEW/WOODSON APARTMENTS (1908) 1820 TWENTY-FOURTH AVENUE

The property on which Zacharias and Irene Woodson constructed their apartment building can be traced to 1882, when black Seattle pioneer William Grose bought twelve acres of land from another Seattle pioneer, Henry Yesler. Grose's acquisition was situated between Twenty-fourth and Twenty-seventh avenues, and Howell and Olive streets. Grose then gave away lots to friends or sold them.[21] According to Seattle historian Richard Berner, the "most prestigious Black residential area, the Madison Street community," stemmed from this property.[22] It is unknown whether Woodson bought his property or it was a gift. It lies near the heart of the neighborhood known today as the Central District.

Woodson built the three-story Woodson Apartments, the first specifically for African-American tenants, in 1908.[23] Similar to other Seattle property owners, the Woodsons anticipated an influx of visitors seeking lodging when the Alaska-Yukon-Pacific Exposition opened the following summer. Afterward, the building would become a long-term investment rental property. A prosperous businessman, in addition to the Woodson Apartments, his holdings included a rooming house, a flat building, two tenement houses, and a ten-acre tract in the country.[24]

The attractive three-story building had a deep porch at both the raised first-floor

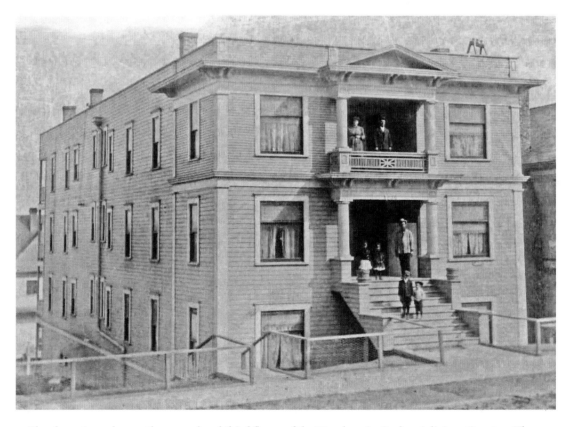

The elegant porches on the second and third floors of the Woodson invited socializing. *Courtesy The Black Heritage Society of Washington State Inc.*

entrance level and the second floor. Columns supported the second-floor porch, and the columns at that level supported a small pediment. The building began almost at the sidewalk and extended to the alley at the rear, where a porch extended across the back of the building. Inside, a hallway ran from front to back on all levels.[25] Information from the Woodson's 1936 Property Record Card indicates that there were twelve three-room apartments; every room had a sink, but the total of six toilets and five tubs meant that bathroom facilities were shared.

The Woodson Annex appears in the 1913 *Polk's Seattle City Directory* at 1824 Twenty-fourth Avenue, adjacent to the north side of the Woodson. It is plausible that Woodson built it in 1912, since newly constructed buildings did not appear in the directory until the following year. Its facade is similar to the Woodson, as is its bulk and setback from the street. An undated photograph of the two buildings, standing side by side and referred to as the Woodson Apartments, accompanied a brief biography of Zacharias Woodson that appeared in Horace Cayton's guide to the Lincoln Industrial Fair Association.[26]

Counting both buildings as one would explain why the 1910 census lists twenty-one entries for the Woodson. Among the residents enumerated by the census were thirteen couples, five of whom had one or two children. Woodson and his wife had two sons but also had four boarders living with them. Woodson was the only resident with more than four people living in a unit, although his apartment could have been larger. Regardless, he was

The former Woodson Apartment building, today a twelve-unit condominium, looks toward a second century of use.

probably acting out of kindness in providing a place to live for the four men, one of whom was a young minister.[27] The professions of the tenants represented a cross-section of jobs, from teamster, cook, dressmaker, and chauffeur, to nurse, minister, teacher, and physician.[28]

The Woodson Annex is still visible in a photograph taken for its 1937 Property Record Card. But by 1959 it had disappeared, according to a photo from that time. The original 1909 Woodson Apartment building still stands today. A 1965 photo shows the building bereft of its porches, its most appealing feature. By 1998 the building had a different name, the Cascade View Apartments, and bore no resemblance to its original appearance. A single awning above the front entryway provided the only relief. Moving forward another ten years, it is evident that another, kinder renovation has occurred.

5. West Seattle: La Playa Vista/ Friedlander (1927) 2250 Bonair Place

In 1851, Seattle's first settlers landed at Alki Point, entitling West Seattle to call itself Seattle's oldest neighborhood. The Duwamish River effectively separates West Seattle from the "mainland," so that through the years the area relied on boats, ferries, and bridges to make the trip to Seattle. After its annexation by the city in 1907, the city built a drawbridge, the first of a series of bridges.

The location of the Friedlander is about one mile southwest of Alki Point. It is only a few blocks away from the sandy beach that lines the northern perimeter of the Alki community. The beaches were such a popular recreational destination that in 1907 a special streetcar line, the Luna Park, was inaugurated.[29]

In the mid-1920s, West Seattle was one of the fastest-growing areas in the city. The *Seattle Times*, in trying to justify the area's unusual growth, mentioned its proximity to the industrial area, construction of a new bridge that would connect West Seattle with Seattle, public improvements, a new school, and a thriving business district. As an afterthought, it remarked that "besides all its other advantages, [it] is surrounded on three sides by water and has a magnificent maritime and mountain view."[30] It was in this atmosphere that S. Friedlander, a prominent Seattle jeweler, engaged architect Alban Shay to design an apartment building. The previous year, Friedlander had built the Friedlander Court, a bungalow-style apartment designed by John Creutzer, a few blocks from his new venture. Friendlander must have sensed the advantages of investing in apartments. Both still operate as apartment buildings today.

Beach houses were filling in the area around the site of the future Friedlander. Perhaps Shay was thinking of the coastal resorts of Spain when he ornamented the apartment building with white stucco and a red tile roof. But it was the more salubrious aspects of the location that were emphasized at the time of the Friedlander's opening. "For those who demand the pure, invigorating and health-giving saltwater air ... [the Friedlander] is the ideal home for those who find pleasure and health in the fresh, salt air, with its freedom from smoke and dirt."[31] It did not hurt that all outside rooms enjoyed a panoramic view of Puget Sound and the snow-capped Olympic Mountains.

The three-story Friedlander is built against a hillside. The main entrance is on the ground floor, but Shay placed only two efficiency units at the front of this level, leaving the poorly lit rear area for the laundry, boiler and garbage rooms, storage lockers, two garage spaces, and a hallway. The latter led to a rear entrance that exited conveniently near the garage. The garage, a one-story free standing building on Shay's plan, became a two-story

The Friedlander is only a short walk to the beach. *Museum of History and Industry, all rights reserved, unless otherwise noted.*

garage, based on the early photograph, prior to or during construction. The two garage spaces on the upper floor may were accessed from a rear street. Shay paid as much attention to the rear of the building as he did to the front: multipaned sidelights framed the rear glass door, which was protected from the elements by a red tile overhanging roof.

On the second and third floors, two efficiency units were on the west side of the hallway, and a two-bedroom unit was on the east side. The rather spacious efficiencies had a kitchen and dinette, a living room with an extra-large bed closet that might have passed as a small bedroom, an entry hall, bathroom with tile bath, and numerous closets. On the opposite side, the two-bedroom unit occupied the same amount of space as the two efficiencies. It featured a separate dining room and a long hallway to access the bedrooms.[32]

The Friedlander's resort-like location, commodious spaces, and small number of units must have made it easy to rent, for advertisements rarely appeared in the newspapers.

6. QUEEN ANNE: DE LA MAR (1909)
115 WEST OLYMPIC PLACE

The Queen Anne neighborhood, one of the city's oldest, was near enough to down-town's businesses, shopping, and entertainment to be convenient, but at the same time enjoyed its remoteness. The wealthy erected their often-fanciful mansions on the choicest

sites near and atop the very steep hill. Beginning in the early 1900s, a range of apartment buildings appeared in the same areas for similar reasons: prestigious neighborhood, convenience to downtown via multiple trolley lines, and outstanding views.

As early as 1889 a cable car line reached the foot of Queen Anne Hill, and the "horse drawn Queen Anne & Lake Union streetcar line was converted into a just invented electricity powered line."[33] By 1910 six streetcar lines were running on the hill, including the Kinnear Park line, which ran past the De la Mar.[34]

Pioneer real estate investor and developer George Kinnear called upon the Seattle architectural firm of Schack and Huntington to design the De la Mar, one of the city's handsomest apartment buildings. Reputedly, Kinnear had it built for the convenience of friends who would come to Seattle for the Alaska-Yukon-Pacific Exhibition, opening in the summer of 1909. But it was not until one month before the exposition closed that an advertisement in the September 18, 1909, edition of the *Seattle Post-Intelligencer* announced DELAMAR APARTMENTS — NOW READY.[35] In February of the following year, when a drawing of the De la Mar appeared in the *Seattle Times*, it was still referred to as "recently completed."[36] At the time of the 1910 U.S. Census, conducted at the De la Mar in April, only seven units were occupied.[37]

After announcing its readiness, the *Post-Intelligencer* notice touted the building's steel and fireproof construction, brick and terra cotta exterior, hardwood floors, large kitchens, servants' rooms, excellent views, and four convenient trolley car lines. But the pièce de résistance may have been the "large ballroom for use of tenants."[38]

On November 8, 1909, the *Seattle Times* noted that Dr. and Mrs. Frederick Adams, among the first to move into the De la Mar, would be "at home" after November 20. Less than a year later, another announcement, one of many regarding social events held at the De la Mar, appeared in the newspaper when Dr. and Mrs. Adams gave a reception and dance. Another party required forty-five tables in the ballroom, and a Mrs. Turner entertained at a large auction-tea held in the ballroom. It was a popular amenity.

Standing inside the large courtyard, embraced on three sides by the building's U shape, it is difficult to take in all the fine details of the De la Mar. The building's terra cotta base, made to resemble stone, extends to the sills of the first-floor windows. The pilasters — shallow rectangular columns — rise three stories tall and are spaced around all three walls facing the courtyard, as well as the west facade. The pilasters support a frieze, above which there is a terra cotta balustrade. Some first-floor windows feature elaborate projecting pediments, while terra cotta keystones cap all other windows. The grand entrance, which slightly projects from the face of the building, is a delight of terra cotta elements. The building's name is carved in stone on a beam upheld by Ionic columns. The door's hardware and beveled-glass transom and sidelights are of a style and quality that befit the building.

The De la Mar's elegant lobby was designed to impress: statuary, stained-glass windows, two staircases, and marble wainscoting and columns. A coat of arms, composed of multicolored tiles, is embedded in the center of the lobby floor, which itself is composed of small white hexagonal tile and bordered by a Greek key design.

By the time of the 1920 census, twenty-seven units were occupied, which may have reflected the total number of units in the De la Mar.[39] At that time, the De la Mar was home to a largely managerial and professional group of people, including attorneys, physicians, and one architect.[40] The latter was Carl F. Gould, "among the most influential Seattle architects of his generation."[41] Half the census respondents were middle-aged couples. Children of varying ages, from Gould's very young son and daughter to adults still living at home with their parents, must have enlivened the high-ceilinged and extrawide hallways.[42]

Centered in front of the De la Mar's entrance is a shallow pool, in which a cast-iron figure serves as a lamp post.

Time and neglect took its toll on the once-glamorous apartment building, and on June 23, 1974, the *Seattle Times* mentions the restoration of the formerly condemned building. Today it is the De la Mar Condominium — a superb building with spectacular views of mountains and water.

7. WALLINGFORD: VALENCIA/MARIE MOSS/ TRURO (1909) 1722 NORTH FORTY-FIFTH STREET

The Valencia, at the northwest corner of North Forty-fifth Street and Wallingford Avenue, stands squarely in the heart of the Wallingford business district. Despite its early construction date, two important Wallingford buildings preceded it: Interlake School (1904), across the street from the future Truro, and Lincoln High School (1906), Seattle's second high school, a few blocks distant. By 1907 the Seattle Electric Company had initiated the Wallingford Avenue line, which carried riders from downtown, via a circuitous route, to a terminus near the Truro's future site. During the 1909 AYP Exposition on the grounds of the University of Washington, the Wallingford line was extended to the exposition's loading platform. When the Truro opened in 1909, streetcars were rumbling down Forty-fifth, which became the major east–west street in the University District.[43]

Wallingford's borders can be loosely described by the north shore of Lake Union to the south and Woodland Park to the north, and, prior to Interstate 5, the western edge of the University District to the east and the Fremont neighborhood to the west. As the neighborhood grew, businesses and apartment buildings began to line Forty-fifth Street, Wallingford's main thoroughfare, with apartments seeping onto adjacent streets of the largely single-family residential neighborhood.

In form, today's Valencia is unchanged from when the original owner built it. At ground

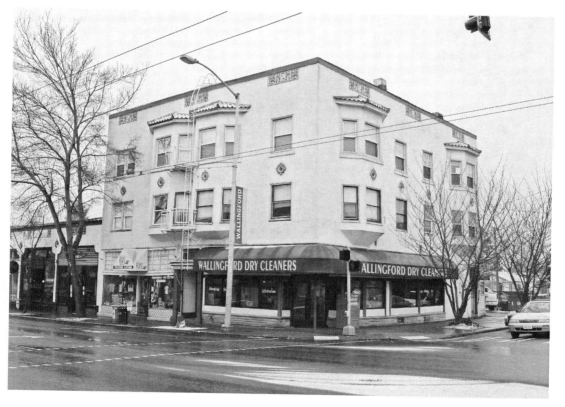

The upper floors of the Valencia have changed little since 1928, but the lower floor has responded to tenants' needs.

level, the three-story building, with its centrally located apartment entrance and a store on either side, was typical of the time. But the exterior acquired its touches of Mediterranean Revival style in 1928 when architect Henry Bittman designed a one-story addition to the west of the Valencia for owner David Baldwin. To blend with the new building, cosmetic changes were made to the Valencia. Written on Bittman's plan, available for viewing at the City of Seattle Department of Planning and Development, are instructions for the upper two floors: "this part of old building to be stuccoed." Other changes included removing the existing cornice and replacing it with iron tile coping along the roofline, the addition of colored cast-cement rectangular ornaments just beneath the roofline, and the round ornaments (also colored cast cement) between the second- and third-floor windows. For the bulkheads, Bittman specified new tile, which might be the green and white squares visible today below the windows of one of the storefronts.

Advertisements for the building consistently mention three-room suites, steam heat, and "Wallingford car." William Hartford and his wife and son lived in the Truro in 1920. He defined his work as "operator/movie pictures."[44] Since the then Paramount Theater (today's Guild 45th Theater) was located a few blocks west on North Forty-fifth, it is tempting to surmise that he moved his family to an apartment that would be convenient to his job at the neighborhood theater.[45]

A variety of businesses have occupied the storefronts: a grocery store, a pharmacy, and a popular lunchroom with its own bakery. The latter occupied the corner space until 1925 when Straker Hardware and Auto Supply took the space. Mr. and Mrs. Straker had been renting an apartment in the Valencia since 1922. When the opportunity arose to move their business, located a few blocks east, into the downstairs space, they began their long tenure as both residents and business owners. The hardware store operated on the corner for over forty years, and Mr. Straker remained in the apartment until the 1950s.

8. COLUMBIA CITY: ANGELINE/NICHOLS (1910)
3716 SOUTH ANGELINE STREET

In 1889 the first streetcar in the area, known as the Rainier Valley Electric Railway, drew people to the locale south and slightly east of downtown Seattle. The Rainier Valley Electric Railway was also the means for moving lumber into Seattle, which was rebuilding after the Great Fire that occurred in the same year. By 1893 Columbia City had incorporated as a town, and the businesses that gradually developed along the rail line are now part of the Columbia City Historic District.[46] Of special interest within the district is Columbia Park, home to a Carnegie Library, which was built in 1915 and continues its role as a branch of the Seattle Public Library system, and a Christian Science Church, which was built six years after the library and now serves as the Rainier Valley Cultural Center. The Angeline Apartments sit just outside the Columbia City Historic District.

Seattle annexed Columbia City in 1907, and according to some sources, the Angeline was built the same year.[47] Whether it was then or 1910, the date recorded on the building's Property Record Card, Columbia City pioneer Ralph Nichols, Sr., built it and gave it his name.[48] A state senator and city councilman, Nichols also operated a fuel business. In 1904 he built a steam plant, fueled by coal which he supplied, and later used the heat the plant generated for his apartment building.[49]

Located two blocks east of Columbia Park, the Angeline is an early apartment building of unusual design. Porches run almost the full length of both sides of the long, narrow rec-

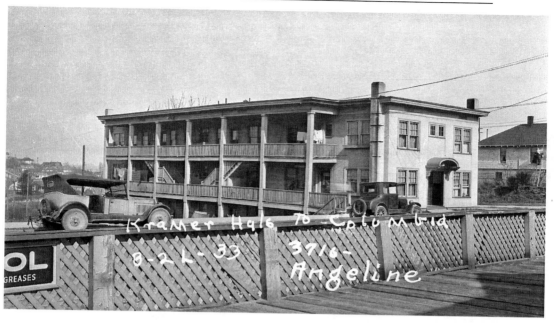

The Angeline in 1937. *Washington State Archives, Puget Sound Regional Branch 392940 0060.*

tangle of a building. On the west side, the porches are at three levels, accommodating the basement level created by the slope of the property. On the east side, there are only two levels. On both sides, doors from each of the upstairs units facing the porch converge on two stairwells that descend to street level. Only a small canopy above the front door relieves the flat facade. The roof was equally flat. Initially the Angeline had eleven units, distributed among six two-room, three three-room, and two four-room apartments, all on the upper two floors. At some point four two-room apartments were installed in the basement, and one unit on the second floor was divided into two, bringing the total number up to sixteen.[50]

Today the porches and their railings appear similar to earlier photos, which showed that, among other things, they were a good place to hang the family wash. The canopy feature at the main entrance is similar, as is the placement of the windows, including the small pair above the front door. The glaring difference is a new gabled roof that replaced the flat roof.[51]

Very little has been written about the Angeline Apartments. The *Seattle Times* listed no advertisements for the small, working-class building, which probably never wanted for renters. Word of mouth within the neighborhood would have been sufficient. One bit of news that did make the paper was not good. In 1925 a repairman working in the Nichols Apartments was overcome by gas. "Efforts to revive him with a lungmotor failed."[52]

9. BALLARD: LAUREN MAY/WESTWOOD (1928)
5814 TWENTY-SECOND AVENUE NORTHWEST

In the recent past, Ballard has become a trendy neighborhood, but at the turn of the last century it was a city unto itself that claimed to be the "Shingle Capitol of the World."

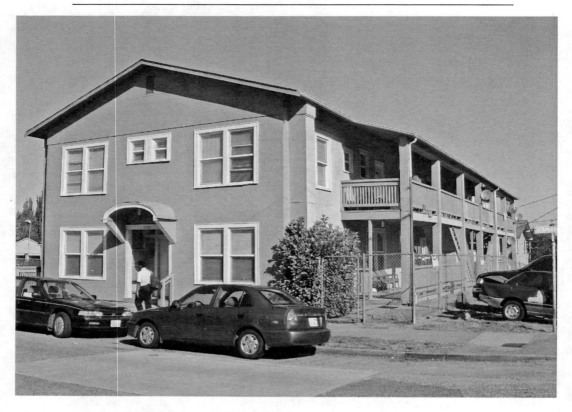

A recent photograph of the Angeline, viewed from the opposite side, shows the gabled roof that replaced the flat one.

Its fishing and timber industries and water-oriented location (Salmon Bay and Shilshole Bay form its southern and western boundaries) attracted immigrating Scandinavians to the area. As early as the 1890s, Ballard had railroad and streetcar service, designed more to exploit development of the area than to serve the population. When the Seattle Electric Company opened the Fremont Ballard line in 1902, it was the first of a "network of new lines—built, this time, to serve legitimate transportation needs rather than to bolster dubious real estate speculation."[53] In 1907 Seattle annexed Ballard. After 1910 the business district shifted away from the water-oriented Ballard Avenue to Market Street, which became the area's new "Main Street." Construction of a ship canal, the final connection of waterways to join Lake Washington and Puget Sound, culminated at the Hiram Chittenden Locks in Ballard in 1917. To the north of Market Street, residential areas, which included apartment houses, sprang up. In April of 1928, "Ballard's newest apartment," the Westwood, was under construction.[54]

From the street, the Westwood appears to be a simple rectangle, but if it were viewed from above, it would reveal itself as a chunky L. Such a shape allows all units to have outside rooms. Amenities such as electric refrigeration, mechanical ventilation, radio outlets, built-in loudspeakers, fully equipped electric laundry, and basement garages had become standard fare for apartments by the late 1920s.

Architect Howard Riley added flourishes of cast stone around the entrance and select third-story windows. Above the arched entry, a large urn rests in the center of a rather

grand broken pediment. Beneath this montage is the building's original name, one of few instances where the original name has changed despite its being etched in stone. The frieze is supported by terra cotta pilasters, richly decorated. Dark wood with curving edges, a most unusual treatment, frames the front door's sidelights and transom windows, which are composed of panes of leaded glass. The entry is, altogether, quite impressive.

Riley's plans stipulated nine efficiencies and one one-bedroom unit on each of the three floors. The three larger units, one above another, overlooked the open space, perhaps turned into a garden, formed by the L. Efficiency units line the double-loaded corridors and featured the usual entry hall, with a closet on one side and a bathroom on the other, a living room, dinette, and kitchen, with nicely detailed wood cabinets and cupboards. In most instances, the hall closet was a sizable dressing room and the site of a hidden bed, which opened out into the living room by another door.

At the time of the 1930 census, the Westwood was totally occupied, by a mix of single people, childless couples, and three families with a child. Occupations listed by the census taker were varied, but there was a preponderance of people in the medical field: three nurses, two of whom were sisters who lived together; two dentists, an ophthalmologist, optometrist, and druggist; and a State Department of Health employee.[55] This could have been coincidental, but it also could be related to the fact that in early 1928 the Ballard Accident and General Hospital opened on the third floor of the Ballard Fraternal Order of Eagles building. Since the hospital also provided twenty-four-hour emergency service, living nearby would have had its advantages.

Along with a storage room, laundry, janitor's room, boiler space, two living units, and the garage in the ground-floor space, the architect also specified a playroom, an unusual feature. The owners must have thought it would be an incentive to renters, but it was not until after the Depression was on the wane that numerous birth announcements of residents of the Westwood began to appear in the newspaper, perhaps putting the playroom to good use.

10. Yesler: Clairemont/Monmouth (1909)
2012 East Yesler Way

The Yesler cable car started service in 1877 and continued operation until 1940. It began in Pioneer Square, near the downtown waterfront, and ran to Lake Washington. Initially built to entice people to buy lots along its route, its destination was the Leschi recreation area on Lake Washington, also a point of departure for ferries to the east side of the lake. Property along Yesler Way nearer downtown was an easy sell, as an announcement for the Monmouth declaimed:

> Yesler Way has been considered by real estate men and investors the typical apartment house street in the city ... where this building stands is the center of the largest paved district of Seattle. It is only seven minutes from First Avenue and with its three minute car service affords to the traveling man the courthouse and city hall employees and railroad men the most effective residence in point of time and service.[56]

The stretch of Yesler Way between downtown and Twenty-third Avenue, and its surrounding blocks, has traditionally been considered part of Seattle's Central District. It has been home to waves of immigrants. In the years leading up to the First World War and for many years afterward, a "distinctive Jewish neighborhood lay between Twelfth and Twentieth Avenues, bounded on the south by Yesler Way and on the north by Cherry Street."[57]

The Bikur Cholim Synagogue, designed by Marcus Priteca and dedicated in 1915, served the community for sixty years.[58] Three other synagogues were in the immediate vicinity. Shops and restaurants catered to the Jewish population. When the Yesler Library opened in 1914 on the northeast corner of Yesler and Twenty-third Avenue, "the makeup of the neighborhood was reflected when the library received a petition asking for more books in Yiddish."[59]

It was prior to the neighborhood's settlement by Jews that the Monmouth Apartments opened in 1909. Edward Brady, a prominent Seattle attorney with a penchant for developing property, and J. H. Raymond, a contractor and builder, were the parties responsible for the Monmouth's construction. Brady married his wife in Monmouth, Illinois, which was perhaps the inspiration for the building's name.[60]

Seattle architects Thompson and Thompson broke up the large structure so that it appears to be four separate buildings. It is, however, one large building in the center of the block, with a connecting building at either end. Entrances are on Yesler Way and Twentieth and Twenty-first avenues. Bay windows on the upper two floors of the three-story brick and stucco buildings relieve the facade of the block-long structure.

In June of 1909 the *Seattle Times* announced that tenants—by reservation only—were moving into the Monmouth. The number of suites, fifty-two, has not changed in the intervening years, although their configuration has. Initially there was more variety: seven two-room units, thirty-six three-room, four four-room, and five five-room. A janitor may have

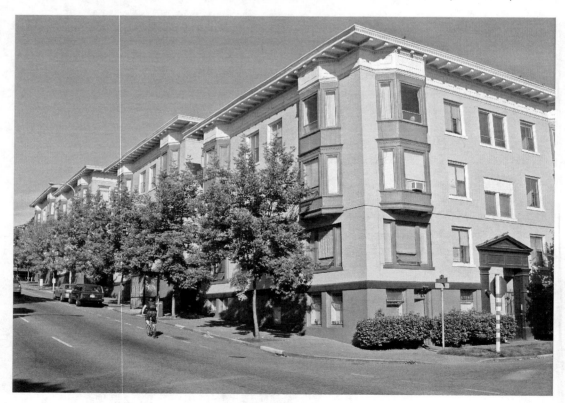

The Monmouth stretches along the entire north side of Yesler Street. Entrances to the buildings on the end were on the side streets.

lived in the four-room unit in the basement.[61] A small unit was an economical choice for a single person, but families could be comfortable in the larger ones. In one such family's unit, in the absence of an outside porch, the refrigerator stood in the entry hall where it was within easy reach of the ice man. Also in the entry hall was the telephone. Near the telephone was the parents' bedroom, and next to it was the living room, rarely ventured into because it was "reserved for guests." Next to the living room was a small kitchen, and next to it was a second bedroom where the children slept and which served as a playroom during the day for the three children. A small radiator heated each room. "Looking back, it seemed like a nice and cozy place to be, remembered the young daughter of the family."[62]

Shared Walls is an attempt to record the role that apartment buildings played during Seattle's early years of development. With determination and will, many will be preserved and continue to serve their purpose of providing a home, "a nice and cozy place," for future residents. These early buildings enrich our landscape and remind us of another era. Remembering and honoring that past adds perspective to our present.

"Common buildings are common because they're part of communities. To see the community values, we need to see them in relationship to the overall cultural system."[63]

Chapter Notes

Chapter 1

1. Warren, *King County and Its Emerald City: Seattle,* 7.

2. Andrews, *Pioneer Square: Seattle's Oldest Neighborhood,* 9.

3. The Denny Party, considered the first Americans to settle and begin to develop the city, consisted of ten adults and twelve children. They arrived at a point they called Alki on November 13, 1851. For the names of earlier non–Indians who came to this area but did not stay, see Thrush, *Native Seattle,* 27–30.

4. Thrush, *Native Seattle,* 14. Lushootseed, or Whulshootseed Salish, is the traditional language of numerous Northwest Coast tribes.

5. Courtois, "Historic and Prehistoric Archaeological Sites," 33. In February of 1852 the Denny Party laid claim to the land on Elliott Bay between First and King streets.

6. Yesler Street was originally named Mill Street.

7. Peavy and Smith, *Women in Waiting,* 146–50.

8. Phelps, *Public Works in Seattle,* 5.

9. Rochester, "Conklin, Mary Ann (1821–1873) aka Mother Damnable," HistoryLink.org, essay 1934, http://historylink.org/index.cfm?DisplayPage=output.cfm&file_id=1934, last modified January 1, 1999.

10. Warren, *King County and Its Emerald City: Seattle,* 39. In 1853, 111 of the 170 Seattle residents were males.

11. Andrews, *Pioneer Square: Seattle's Oldest Neighborhood,* 18. Bailey Gatzert became Seattle mayor in 1875, John Leary in 1884.

12. Ochsner and Andersen, *Distant Corner,* 17–18.

13. "Because nineteenth-century American cities and towns were typically filled with wooden buildings," Seattle was not alone in experiencing a devastating fire. Spokane and Ellensburg, two other Washington cities, had major fires the same year as Seattle. Andrews, *Pioneer Square: Seattle's Oldest Neighborhood,* 43.

14. *Seattle Post-Intelligencer,* August 27, 1892. Northern Pacific timetables indicated one could take Pullman sleeping cars or elegant day coaches between Seattle, St. Paul, and Chicago.

15. Berner, *Seattle 1900–1920,* 10.

16. *Seattle Post-Intelligencer,* "Fortunes in Seattle Real Estate," January 4, 1903.

17. Ordinance 1147 passed July 1, 1889. Seattle Ordinances, Office of the City Clerk, Record Series 1801–02, Seattle Municipal Archives. According to Ochsner and Andersen, authors of *A Distant Corner,* fireproof construction was not a requirement. Rather, "a slow-burning" construction approach was adopted, which called for "the use of masonry walls for fire containment, oversized wood structural members ... that

would char but not burn through, enclosures for stairs and other vertical spaces, and standpipes and sprinklers," 61.

18. Ordinance 1148 passed July 2, 1889. Seattle Ordinances, Office of the City Clerk, Record Series 1801–02, Seattle Municipal Archives.

19. *Seattle Post-Intelligencer,* July 3, 1889. Newspapers regularly printed the ordinances.

20. Ordinance 694, the first, passed November 24, 1885. The second, Ordinance 824, passed May 20, 1887. The third, Ordinance 7040, passed July 1, 1901. Seattle Ordinances, Office of the City Clerk, Record Series 1801–02, Seattle Municipal Archives.

21. Building code handbooks, rearranged and abbreviated to make them easier to use, were published every few years. Handbooks are in the City of Seattle Municipal Archives, Special Collections, at the University of Washington Libraries, and the Seattle Room in the Downtown Seattle Public Library.

22. New York's Tenement House Law of 1901, which called for wide light and air courts between buildings, a bathroom in every unit, and protection from fire hazards, among other new building requirements, was painfully long in coming.

23. *Building Inspector's Hand Book of the City of Seattle,* 1902, 9. Seattle Ordinance 7040. Seattle Ordinances, Office of the City Clerk, Record Series 1801–02, Seattle Municipal Archives.

24. Ordinance 17240 passed October 21, 1907. Seattle Ordinances, Office of the City Clerk, Record Series 1801–02, Seattle Municipal Archives.

25. Groth, *Living Downtown,* 92.

26. *Choir's Pioneer Directory of the City of Seattle and King County,* 26.

27. *Seattle Post-Intelligencer,* September 20, 1893.

28. Berner, *Seattle 1900–1920,* 62.

29. One of many communications Meta Buttnick shared with friend of author.

30. After World War II, Seattle's Chinatown was renamed the International District.

31. *Seattle Daily Bulletin,* May 29, 1902. The newspaper refers to the owner as Wa Chung, but according to Berner, *Seattle 1900–1920,* 65, Wa Chong was the name of Gee Hee's first store.

32. Chin, *Seattle's International District,* 30.

33. Cone et al., *Family of Strangers,* 141. Sephardic Jews immigrated from Greece and Turkey.

34. Mumford, *Seattle's Black Victorians, 1852–1901,* 85.

35. Davies, "Sea of Fire," *Columbia: The Magazine of Northwest History,* 35.

36. Groth, *Living Downtown,* 19.

37. The Rainier Hotel, located north of the area destroyed by fire, was hurriedly completed to accommodate

anticipated visitors. Ochsner, *Shaping Seattle Architecture*, 34.

38. *Seattle Post-Intelligencer*, November 17, 1889.
39. *Seattle Times*, September 15, 1910.
40. Placed on the National Register of Historic Places as the Guiry and Schillestad Building in 1985, they were listed as two separate Seattle city landmarks in 1987.
41. Cromley, *Alone Together*, 5.
42. Ochsner and Andersen, *Distant Corner*, 74.
43. Bill LaPrade, "The Geology of Queen Anne Hill," quoted in Reinartz, *Queen Anne: Community on the Hill*, 5. LaPrade explains that the soil of the western half of Denny Hill was hydraulically sluiced into Elliott Bay. The eastern half was leveled by electrically powered shovels and a complex series of conveyors. The two regrade projects removed six million cubic yards of soil.
44. Advertisements for apartments often mention their walkability to the business district.
45. Schwantes, *Pacific Northwest*, 197.
46. Virgil Bogue, married to a granddaughter of Seattle pioneer Arthur Denny, was a protégé of the Olmsted Brothers. Bogue was a civil engineer who had worked for the Northern Pacific Railway and was known as the discoverer of Stampede Pass, the site for a railroad tunnel that eased the passage through the Cascade Mountains to Seattle and Tacoma.
47. A group of businessmen, who feared that the city's business district would shift a mile north to the new civic center and that the value of downtown property they owned or managed would be dramatically lowered, fought to undermine the plan's passage. J. M. Neil, discussing the proposal at length in the *Pacific Northwest Quarterly* ("Paris or New York? The Shaping of Downtown Seattle 1903–14," 22), contended that the issue was more complex than merely self-interest on the part of a few. Neil also pointed out that taxpayers, tired of the displacements and costs of the regrades, objected to additional expenditures, 27.
48. *Real Property Survey*, Seattle, Washington, 1939–40, vol. 1, "History of Housing," 3.
49. Why women were able to participate in Seattle's real estate business invites speculation. At the turn of the last century, work options for women outside the home, other than manual labor, most often centered on teaching and nursing. Perhaps women's involvement in real estate, and particularly in the business of apartment houses, received tacit approval due to a subliminal connection to the home.
Although higher education was becoming more acceptable, for the average young woman it meant taking business courses that would allow her to find a clerical job in Seattle's growing economy. This could have led to involvement in the realty business or to managing an apartment building, but too many newspaper accounts refer to women selling and buying property, often with the intention to build an apartment building on their site. This would have required more money than a clerical job produced. It is probable that women who had money to invest received it as an inheritance or were married, or a widow, to someone who had funds.
50. *Hotel News of the West*, October 18, 1924, 4.
51. *Seattle Times*, December 28, 1905.
52. Doucet, *Housing the North American City*, 395.
53. *Seattle Daily Journal of Commerce*, April 14, 1924.
54. *Seattle Times*, August 30, 1925. For more on L.N. Rosenbaum, see Judith W. Rosenthal, "The Man Who Built Seattle's Paramount Theatre: L.N. Rosenbaum," *Columbia: The Magazine of Northwest History*, Summer 2007.

55. Hancock, "Apartment House in Urban America," 158.
56. *Seattle Times*, January 27, 1929. Between 1925 and 1929, the city issued building permits for 496 apartments.
57. *Seattle Times*, February 5, 1928.
58. Woodbury, *Apartment House Increases and Attitudes toward Home Ownership*, 9, 13.
59. Olshen, "An Apartment House Survey in the City of Portland," 3.
60. Doucet and Weaver, *Housing the North American City*, 391, 395.
61. *Apartment Operators Journal*, "The Vacancy Situation," June 1929, 4.
62. *Real Property Survey*, Seattle, Washington, 1939–40, vol. 1, "History of Housing."
63. Doucet and Weaver, *Housing the North American City*, 403.
64. Lambert, *Built by Anhalt*, 77.
65. Sale, *Seattle Past to Present*, 55. Sale drew his information from demographic analyses and residential surveys.
66. Barth, *City People*, 57.
67. Fullerton, *Transit and Settlement in Seattle, 1871–1941*, 31.
68. Hebert, *Traffic Quarterly*, "Urban Morphology," 639.
69. Two Seattle cable car lines, the Yesler and Madison, both of which operated on steep streets, continued in service until 1940.
70. Williams, *Capitol Hill: Hill with a Future*, 41.
71. Blanchard, *Street Railway Era in Seattle*, 61.
72. Smerk, "Streetcar: Shaper of American Cities," *Traffic Quarterly*, 575.
73. Upton and Vlach, *Common Places*, 487.
74. Ochsner, *Shaping Seattle*, xxv–xxvi.
75. Ochsner, *Shaping Seattle*, xxvi.
76. Hockaday, *Greenscapes*, 100.
77. Groth, *Living Downtown*, 76.
78. *Seattle Times*, March 7, 1909.
79. Bagley, *History of Seattle*, 527.
80. Abbott, *Urban America in the Modern Age*, 25.
81. Seattle Office of Policy Planning, *Background Report on Multi Family Land Use Policies*, 19.
82. The ordinance defined and separated all land uses into six use districts: First Residence (for single-family residences); Second Residence (for apartments and other forms of multifamily housing); Business and Commercial; and Manufacturing and Industrial. The four area districts regulated building bulk and lot coverage through front, rear, and side yard requirements. The five height districts limited vertical dimensions, the goal of which ostensibly was to ensure plenty of light and air, but it had the effect of reducing density. Seattle Office of Policy Planning, *Background Report on Multi Family Land Use Policies*, 20.
83. *Pacific Builder and Engineer*, July 28, 1922, 7.
84. E. L. Gaines, "Seattle Zoning Plan," 7–8. Over the years, however, the city council has granted a number of conditional variances.
85. *Seattle Times*, June 3, 2005.
86. Durham, "Community Clubs in Seattle," 54.
87. Baar, "National Movement," 5, 9.
88. Baar, "National Movement," 5.
89. Baar, "National Movement," 3.
90. The Massachusetts State Supreme Court declared that apartments presented potential fire dangers and excluded sunlight, warranting the passage of policies that regulated their construction. The United States Supreme Court affirmed the decision in *Welch v. Swasey*, 214 U.S. 91 (1909).

91. "Are Apartments Necessary?" 78.

92. *Euclid v. Ambler* 272 U.S. 365 (1926).

93. Delores Hayden adds a hefty footnote to her discussion of apartments in *The Grand Domestic Revolution: A History of Feminist Designs for American Homes, Neighborhoods, and Cities*:

A note on definitions: in the 1880s the general term, apartment house, included both (*A*) a building consisting entirely of private apartments, as in today's common usage, and (*B*) a building (also called an apartment hotel, family hotel, or residential hotel) consisting of both private apartments and extensive common facilities such as kitchen, laundry, and dining rooms. Type *A* could include apartments of one story (also called French flats), or two stories (duplexes). It usually included kitchens in every private unit, although a "bachelor apartment house" offered units without kitchens. The private apartments in type *B*, an apartment hotel, might be hotel suites or studios (consisting of bed-sitting room, or bedroom and sitting room); semi-housekeeping suites (bedroom, sitting room, dining room); or housekeeping suites (bedroom, sitting room, dining room, and kitchen) [317–318].

94. Sturgis et al., *Illustrated Dictionary of Architecture and Buildings*, vol. 1, col. 82.

95. Shumsky, *Encyclopedia of Urban America*, 29.

96. Even the Department of Commerce showed a bias when it issued a standard state zoning enabling act that authorized cities to regulate the density of population and to make possible the creation of single-family housing districts (Department of Commerce 1922, 5). Baar, "National Movement to Halt the Spread of Multi-Family Housing," 7.

97. A glance at the National Register of Historic Places reveals that towns as diverse as Albuquerque, New Mexico; Bozeman, Montana; Manhattan, Kansas; and Mobile, Alabama, built apartments in the early years of the twentieth century.

Chapter 2

1. "Apartment Buildings," *Pacific Builder and Engineer*, March 16, 1907, 5–6.

2. Kilham, "The Planning of Apartment Houses," *Brickbuilder* 13, no. 1 (January 1904): 2.

3. Not everyone agreed that "modern conveniences" were a good thing. In the September 16, 1902, issue of the *Seattle Daily Bulletin*, a "leading Chicago architect" said that "in a flat she [the American woman] was relieved of a great part of the ordinary domestic work and gained time for frivolity."

4. Dorpat and McCoy, *Building Washington*, 201.

5. Dorpat and McCoy, *Building Washington*, 201–2.

6. Phelps, *Public Works in Seattle*, 174.

7. *Seattle Daily Bulletin*, February 21, 1901.

8. Phelps, *Public Works in Seattle*, 186.

9. Phelps, *Public Works in Seattle*, 191.

10. Donaldson and Nagengast, *Heat and Cold: Mastering the Great Indoors*, 323, note 69.

11. Ordinance #17240 passed October 21, 1907. Seattle Ordinances, Office of the City Clerk, Record Series 1801–02, Seattle Municipal Archives, *Building Code of City of Seattle 1914*.

12. Ordinance #17240 specifies the height and window requirements for kitchens. It also defines apartments as having "separate housekeeping apartments." Seattle Ordinances, Office of the City Clerk, Record Series 1801–02, Seattle Municipal Archives, *Building Code of City of Seattle 1914*.

13. *Seattle Times*, August 26, 1928.

14. Kennedy, *Hoosier Cabinets*, 17–60. The cabinets were made by the Hoosier Manufacturing Company of New Castle, Indiana.

15. The state's abundance of timber led to a well-developed lumber industry, including the production of furniture, sashes, and doors, so that by 1919, lumber manufacturing was Seattle's chief industry.

16. *Building Code of the City of Seattle 1914*, pt. 7, sec. 702.

17. Original architectural drawings of the Charlesgate Apartments show detailed drawings for kitchen cabinetry. Osborn Architectural Drawings, Special Collections, University of Washington. Many plans observed by the author at the King County Department of Planning and Development included the same.

18. Schlereth, *Victorian America*, 111.

19. American Institute of Architects, Washington State Chapter, *The Monthly Bulletin*, September 1922, 3.

20. Strasser, *Never Done*, 71–72.

21. *Seattle Post-Intelligencer*, August 17, 1907.

22. *Town Crier*, January 12, 1929, 6.

23. Seattle Lighting Department, Acc. 33–1, Box 124/1, 8th Annual Report. University of Washington Libraries, Special Collections. The electric iron, patented in 1882, was the first electrical appliance to achieve popularity.

24. *Seattle Star*, January 30, 1937.

25. *Seattle Times*, October 3, 1926.

26. Kittredge, ed., *Housekeeping Notes*, 10.

27. By the early 1900s, artificial ice had begun to usurp its rival, natural ice. The manufactured variety had the advantage of being readily available and more sanitary. The ice industry, which at first had been leery of the new refrigerators, greatly benefited from the propaganda extolling the benefits of ice.

28. Memo to author from Al Wilding, November 21, 2005.

29. *Seattle Journal of Commerce*, April 14, 1924. The "outside porch" was off the kitchen, but the porch was on the landing of an inside stairwell.

30. "Architect Calls Electric Refrigerator Inevitable," *Western Architect*, November 1926, 150.

31. *Seattle Times*, August 23, 1925.

32. Donaldson and Nagengast, *Heat and Cold: Mastering the Great Indoors*, caption under picture, no page number.

33. *Seattle Times*, May 2, 1923.

34. Cowan, *More Work for Mother*, 94.

35. *Building Inspector's Handbook of the City of Seattle, Washington*, 1902, 55. University of Washington Libraries, Special Collections.

36. *Building Code of City of Seattle 1914*, pt. 7, sec. 730. "At least one water closet (toilet) and sink for each family living in such apartment, provided, however, that if more than 10 persons live in any such apartment, there shall be one additional water closet for each 10 additional persons."

37. Between 1921 and 1925 the production of enameled sanitary fixtures in America increased from 2.4 million in 1921 to 5.1 million in 1925. See Giedion, *Mechanization Takes Command: A Contribution to Anonymous History*, 685.

38. Schlereth, *Victorian America*, 128–29.

39. *Architectural Forum* 41, no. 5 (November 1924): 228.

40. *Seattle Daily Times*, March 8, 1907.

41. Information about needle baths is from "The Stand-Up Bath," *Plumbing and Mechanical*, July 1994, http://theplumber.com/standup.html (accessed March 15, 2011). Also see Gordon Bock, "Past Perfect: Go with the Flow." *Old House Journal*, http://www.oldhouse journal.com/Past_Perfect/magazine/1388 (accessed March 1, 2011).

42. Conversation between Jacqueline Williams, friend of author, and Naomi Israel, September 16, 2008.

43. Buttnick's family lived in several apartments during the 1920s.

44. *Seattle Times*, August 24, 1924.

45. Jyl Leininger, "Life in Seattle and Environs in the 1930s, 1940s and beyond — as Told by Margaret Reed," HistoryLink.org, essay 2265 (April 7, 1999), http://history link.org/index.cfm?DisplayPage=output.cfm&file_id=2265. The mangle, an electric ironing machine, came in a variety of shapes and sizes.

46. *Seattle Times*, January 6, 1929.

47. "The Space Problem in Modern Construction," *Pacific Builder and Engineer*, September 26, 1908, 348–49.

48. In 1866 an inventor placed a bed in a piano and claimed it did not "impair its qualities as a musical instrument." Giedion, *Mechanization Takes Command: A Contribution to Anonymous History*, 434.

49. Jyl Leininger, "Life in Seattle and Environs in the 1930s, 1940s and beyond — as Told by Margaret Reed," HistoryLink.org, essay 2265 (April 7, 1999), http://histo rylink.org/index.cfm?DisplayPage=output.cfm&file_id=2265.

50. *Hotel News of the West*, July 26, 1924, 18.

51. *Seattle Times*, September 8, 1929.

52. William L. Murphy applied for a patent for the bed in 1900.

53. "Evolution of Beds," *Pacific Builder and Engineer*, March 27, 1909, 109–110.

54. Memo from Al Wilding, November 21, 2005.

55. Schlereth, *Victorian America*, 141.

56. Horowitz, *The Morality of Spending: Attitudes toward the Consumer Society in America*, 73.

57. *Seattle Times*, October 4, 1925.

58. Cromley, *Alone Together*, 151. Also see Dolkart, *Morningside Heights*, 319.

59. Gainsborough advertising brochure, Pamphlet and Textual Documents Collection, *Seattle: Hotels and Apartments*, University of Washington Libraries, Special Collections.

60. *Seattle Times*, July 26, 1925.

61. *Architectural Forum*, "Distinctive Wall Effects: The Tiffany Finish," Advertising Supplement, September 1925, 72.

62. *Architectural Forum*, September 1925, advertising supplement.

63. Advertisement for Fleur de Lis in *Seattle Times*, September 13, 1925. Advertisement for the Sovereign in *Seattle Times*, August 23, 1925.

64. Gelernter, *History of American Architecture*, 156.

65. "Seattle Telephone History," *Portage, The Magazine of the Museum of History and Industry*, 6.

66. Arrol Gellner, "A Light-Bulb Era for Housing," *Los Angele Times*, Real Estate, June 18, 2006, http://articles.la-times.com/2006/jun/18/realestate/re–gellner18.

67. "Seattle Telephone History," *Portage: The Magazine of the Museum of History and Industry*, 7.

68. David Wilma, "Sunset Telephone Company Serves 3,612 Subscribers on March 6, 1899," HistoryLink.org, essay 1687 (September 24, 1999), http://historylink.org/index.cfm?DisplayPage=output.cfm&file_id=1687.

69. Written communication between Larson and author.

70. *Seattle Times*, April 5, 1931.

71. *Building Code of the City of Seattle 1914*, pt. 7, sec. 713.

72. *Seattle Times*, August 26, 1928, 27. Arensberg did not mention that the garden was atop the garage roof.

73. Doucet and Weaver, *Housing the North American City*, 398.

Chapter 3

1. University of Washington Libraries, Special Collections, Architects' Reference File: Dose, West & Reinoehl. *Architecture of Dose, West & Reinoehl*, 2.

2. Bain, *Building Together*, viii–ix.

3. Follett, "Hotel Pelham," *American Art Journal*, 69.

4. Follett, "Hotel Pelham," *American Art Journal*, 69.

5. Stark, "Victorian Pattern Books," in Luxton, *Building the West*, 56.

6. Luxton, *Building the West*, 16.

7. Ochsner, *Shaping Seattle Architecture*, xviii.

8. Smeins, Linda, "Two Design Lectures: Pattern and Plan Book Home Designs," *Preservation Seattle Online Magazine*, https://www.historicseattle.org/events/event detail.aspx?id=34&archive=1.

9. Andersen and Krafft, "Pattern Books, Plan Books, Periodicals," in Ochsner, *Shaping Seattle*, 64. Also see Daniel D. Reiff's *Houses from Books*, which he describes as "a detailed investigation of the whole phenomenon of 'houses from books,'" from 1738 to 1950, ix. And one should not assume that pattern books do not exist in the twenty-first century. A perusal of a public library shelf will reveal a wide range of contemporary pattern books and periodicals.

10. *Seattle Times*, June 30, 1907.

11. *Seattle Post-Intelligencer*, April 21, 1907.

12. Kreisman, *Apartments by Anhalt*, 7.

13. Lambert, *Built by Anhalt*, 50.

14. Sears, *Book of Modern Homes*, 12.

15. Roth, *Concise History of American Architecture*, 127.

16. *American Architect and Building News* 91, no. 1625 (February 16, 1907): iv.

17. *Washington State Architect* 5, no. 7 (June 1925): 9.

18. Ochsner and Andersen, *Distant Corner*, viii.

19. Ochsner, *Shaping Seattle*, xx–xxi.

20. American Institute of Architects, "History of the American Institute of Architects," http://www.aia.org/about_history.

21. American Institute of Architects, "History of the American Institute of Architects," http://www.aia.org/about_history.

22. Ore, *Seattle Bungalow*, 93. Ore discusses the issue of "infringement" in the housing industry.

23. American Institute of Architects, "History of the American Institute of Architects," http://www.aia.org/about_history.

24. American Institute of Architects, Seattle chapter, "AIA Seattle History: Timeline 1894–1994," http://www.aiaseattle.org/archive_aiaseattlehistory.htm.

25. Planel, *Locks and Lavatories: The Architecture of Privacy*, 60.

26. Gail Dubrow and Alexa Berlow, "Vernacular and Popular Architecture in Seattle," in Ochsner, *Shaping Seattle*, 284.

27. Eichler, *Merchant Builders*, xiii.

28. Aitken's education mentioned in his obituary in *Seattle Times*, July 12, 1961.

William H. Aitken, U.S. Census of Population, *Fourteenth Census of the United States: 1920*, Population Schedule, Washington, King Co., Seattle, ED #332, sheet 11B, line 5 (T625, roll 1931), database: http://persiheritagequestonline.com: 2009.

29. A "Self-Guided Tour through Historical Landmarks of Sumner, Washington" (http://www.ci.sumner.wa.us/Living/Walking_Tour.htm) includes Aitken's 1924 Masonic Lodge. Not only has Aitken's theater, the Lincoln, survived, but the vaudeville and silent movie house has been restored and now serves as a venue for concerts, films, and community events in Mt. Vernon, Washington.

30. Albertson's firm designed St. Joseph's Catholic Church and the Cornish School for the Arts, both located on Seattle's Capitol Hill, and the YMCA and Northern Life Tower in downtown.

31. *Seattle Times*, February 27, 1910.

32. *Seattle Times*, June 27, 1911.

33. *San Jose Mercury News*, February 5, 1911.

34. *Oregonian*, July 6, 1943.

35. *Seattle Times*, April 4, 1959.

36. Rash and Estep, "Frederick William Anhalt," in Ochsner, *Shaping Seattle*, 223.

37. *Seattle Times*, July 18, 1996.

38. Dietz, "William J. Bain, Sr.," in Ochsner, *Shaping Seattle*, 216–17.

39. *Journal of the American Institute of Architects* 7, no. 5 (May 1947): 235.

40. Frank L. Baker, U.S. Census of Population, *Thirteenth Census of the United States: 1910*, Population Schedule, Washington, King Co., Seattle, ED #159, sheet 12B, line 69 (T625, roll 1659), database: http://persiheritagequestonline.com: 2011. Census information confirms Baker's immigration date to U.S. as 1894. Ochsner, *Shaping Seattle*, 339, mentions his education.

41. The giant Sears building is now the corporate headquarters for Starbucks Coffee and is an exemplary instance of adaptive reuse, that is, finding new life for a building whose original purpose has changed.

42. Scarce information on Baker's life gleaned from two obituaries: *Seattle Times*, September 16, 1939, and *Architect and Engineer*, March 1939. It was the latter, page 54, that carried the tribute.

43. Bagley, *History of Seattle* 3:664–65.

44. *Hotel News of the West*, October 23, 1926, 10.

45. *Seattle Times*, January 6, 1966.

46. *Impressions of Imagination*, "Architect and Engineer: Henry Bittman," by Link, 39.

47. *Seattle Times*, November 18, 1953.

48. University of Washington Libraries, Special Collections, "Pacific Coast Architecture Database," James E. Blackwell (ID 2403), https://digital.lib.washington.edu/architect/architects/2403.

49. Bagley, *History of Seattle*, 3:633–34.

50. Seattle Public Library, "Architects Scrapbooks," A-Bq, no. 4: James E. Blackwell.

51. *Seattle Times*, April 6, 1939.

52. Bagley, *History of Seattle*, 3:785.

53. John Carrigan, U.S. Census of Population, *Thirteenth Census of the United States: 1910*, Population Schedule, Washington, King Co., Seattle, ED #126, sheet 18B, line 89 (T624, roll 1660), database: http://persiheritagequestonline.com: 2011. See chapter 8 for the history and a description of the Gordon Apartments.

54. *Pacific Builder and Engineer*, November 10, 1906, 4.

55. University of Washington Libraries, Special Collections, Architects' Reference File, John Alfred Creutzer,

Medical and Dental Building Special Souvenir Announcement.

56. John Creutzer, World War I Draft Registration Card, database: Ancestry Library Edition (access available at Seattle Public Library). Obituary from AIA, Washington State Chapter, vol. 9, no. 8 (1929): 2, found in Architects' Reference File: John Alfred Creutzer, University of Washington Libraries, Special Collections.

57. Everett's birth and death statistics come from California Death Index, 1940–1997.

58. *Town Crier*, September 21, 1912, 15. A number of Everett's designs, including Leamington, are listed on the National Register: the pergola in Pioneer Square, Fire Station No. 23, the Julius Redelsheimer House, and Temple de Hirsch (demolished).

59. Frank Fowler, World War I Draft Registration Card, database: Ancestry Library Edition (access available at Seattle Public Library).

60. Henry Bittman, who was himself a qualified engineer, and Schack and Myers, who had hired engineer Arrigo Young, are known exceptions.

61. American Architects' Biographies, vol. F: Fowler, Frank Hoyt.

62. *John Graham and Company*, 2.

63. Hildebrand, "John Graham, Sr.," in Ochsner, *Shaping Seattle*, 90.

64. *John Graham and Company*, 4.

65. *Impressions of Imagination*, "The Architect of Tradition: John Graham, Sr.," by Hildebrandt, 25.

66. Colin Barr, "Elmer Ellsworth Green," in Luxton, *Building the West*, 341.

67. Andersen and Krafft, "Pattern Books, Plan Books, Periodicals," in Ochsner *Shaping Seattle*, 68.

68. Luxton, *Building the West*, 485. Luxton's book, an account of early architects who practiced in British Columbia, discusses at least a dozen well-known Seattle architects who practiced in Vancouver or Victoria at one time or another during the early years of the twentieth century.

69. *Seattle Journal of Commerce*, January 5, 1927, 8. The list of licensed Washington State architects living outside the state in 1927 included Green's name. He died one year later. His obituary mentioned that Santa Clara, California, was his home.

70. E. E. Green's obituary appeared in the *Humboldt (California) Standard*, February 18, 1928, 9.

71. Emil Guenther, U.S. Census of Population, *Fourteenth Census of the United States: 1920*, Population Schedule, Washington, King Co., Seattle, ED #204, sheet 1B, line 89 (T625, roll 1928), database: http://persiheritagequestonline.com: 2011.

72. A few months later, Guenther was in trouble again in San Antonio for allegedly embezzling "forfeit money" given him by contractors bidding on a project. *San Antonio Siftings*, March 19, 1887.

73. Luxton and Andersen, "Emil Guenther," in Luxton, *Building the West*, 244.

74. See note 71 for census information.

75. Charles Haynes, U.S. Census of Population, *Twelfth Census of the United States: 1900*, Population Schedule, California, San Francisco, ED #124, sheet 9B, line 58 (T623, roll 103), database: http://persiheritagequestonline.com: 2011.

76. A large advertisement in the *Seattle Times*, July 26, 1925, noted that "from the days of 1818 when Samuel Hudson built the old log homestead ... down to the present, the Hudsons have builded and builded well."

77. Hanford, *Seattle and Environs*, 67.

78. Virginia Mason Medical Center, owner of the

Northcliffe, razed the building in Spring of 2008 for expansion of the medical facility.

79. John S. Hudson, U.S. Census of Population, *Fourteenth Census of the United States: 1920*, Population Schedule, Washington, King Co., Seattle, ED #94, sheet 3A, line 5 (T625, roll 1926), database: http://persiheritagequestonline.com: 2011. Later addresses are from *Polk's Seattle City Directories*.

80. Luxton, *Building the West*, 244. "An alternative architectural association made up of architects who either didn't qualify for the American Institute of Architects or had been expelled from it," is Luxton's definition of the Washington State Society of Architects.

81. *Seattle Times*, October 27, 1945.

82. Daniel R. Huntington, 1880 U.S. Census, Schedule 1, Texas, Tarrant Co., Arlington, ED #92, page 22B, line 13 (T9, roll 1328), database: http://persiheritagequestonline.com: 2009. Huntington, eight years of age at the time of the census, and his family lived in Arlington, located between Dallas and Ft. Worth, Texas, where his father was a dry goods merchant.

83. *Pacific Builder and Engineer*, "Ace Men of the Pacific Northwest," October 6, 1928, 44.

84. Huntington's partnership with Fisher from Colorado Architects Biographical Sketch: http://colorado-history-oahp.org/guides/architects/fisher.pdf. The *Pacific Builder and Engineer* article, "Ace Men of the Pacific Northwest," commented that Fisher and Huntington's work was "largely in the residential and apartment line."

85. Thomas Veith, "Huntington, Daniel R.," in Ochsner, *Shaping Seattle*, 114–119.

86. Huntington served in 1918–1919 and again in 1925.

87. Isham Johnson, U.S. Census of Population, *Thirteenth Census of the United States: 1910*, Population Schedule, Washington, King Co., Seattle, ED #167, sheet 6B, line 83 (T624, roll 1661), database: http://persiheritagequestonline.com: 2011.

88. Isham Johnson, U.S. Census of Population, *Fourteenth Census of the United States: 1920*, Population Schedule, Washington, King Co., Seattle, ED #129, sheet 9A, line 4 (T625, roll 1926), database: http://persiheritagequestonline.com: 2011.

89. Mohl, *The New City*, 45. Mohl quotes architectural historian Carl Condit, who said Jenney's Home Insurance Building in Chicago was the first true skyscraper. Jenney employed internal steel skeletons and light masonry curtain walls that revolutionized construction techniques and allowed taller structures to be built.

90. Josenhans' and Allan's careers are largely derived from Bagley's *History of Seattle*, 3:636–639.

91. *Washington State Architect* 12, no. 10 (September 1932): 2.

92. Robert I. Knipe, U.S. Census of Population, *Thirteenth Census of the United States: 1910*, Population Schedule, Washington, King Co., Seattle, ED #126, sheet 11B, line 67 (T624, roll 1660), database: http://persiheritagequestonline.com: 2011.

93. *Washington State Architect* 8, no. 5 (April 1928): 2.

94. *Architect and Engineer* 93, no. 2 (May 1928): 114.

95. Ochsner, *Shaping Seattle*, multiple resources.

96. Ritz, *Architects of Oregon*, 256–57.

97. Norman, *Portland's Architectural Heritage*, 133.

98. Bosker and Lencek, *Frozen Music*, 58.

99. Obituary in *Oregon Journal*, July 13, 1945.

100. Thomas Veith, "Arthur L. Loveless," in Ochsner, *Shaping Seattle*, 150. Although Veith's biography states that Loveless ran out of funds before he graduated from

Columbia University, his obituary in the *Seattle Times*, January 11, 1971, states that he graduated from the institution.

101. Hanford, *Seattle and Environs*, 521.

102. Ore, *Seattle Bungalow*, 84.

103. Vergobbi, *Seattle Master Builders Association*, 43. Stanley Long and Gardner Gwinn were the other two members of the triumvirate.

104. Vergobbi, *Seattle Master Builders Association*, 42–43.

105. University of Washington Libraries, Special Collections, Architects' Reference File: Edward L. Merritt. Information based on small 1924 calendar, with beautiful colored drawings of famous buildings, which Merritt's firm distributed as a form of advertising.

106. *Portrait and Biographical Album of McLean County, Ill.* (Chicago: Chapman Brothers, 1887), 633.

107. Architects and Architecture in Peoria Biographical File, Reference Department, Peoria Public Library, Peoria, Illinois.

108. Luxton, *Building the West*, 477.

109. The original Trianon Ballroom building still stands at 218 Wall Street in Seattle's Belltown neighborhood.

110. *Seattle Times*, June 23, 1949.

111. *Seattle Times*, "Retired Architect Is '90 years young,'" November 15, 1970.

112. *Pacific Builder and Engineer*, November 3, 1928, 44.

113. That Morrison graduated from the Art Institute of Chicago in 1913 comes from "Ace Men of the Pacific Northwest," *Pacific Builder and Engineer*, November 3, 1928, 44. Morrison's obituary in the *Seattle Times*, January 3, 1955, states that he graduated from the Armour Institute of Technology, also located in Chicago, in 1914. (The Armour Institute opened in 1893 and offered professional classes in engineering, chemistry, library science, and architecture. Armour merged with the Lewis Institute in 1940, creating the Illinois Institute of Technology.)

114. *Pacific Builder and Engineer*, November 3, 1928, 44.

115. "World War I Draft Registration Cards," database, Ancestry Library Edition (accessible at Seattle Public Library), entry for Earl Morrison. Morrison's birth date from World War I draft registration card; date and place of death from obituary, *Seattle Times*, January 8, 1955.

116. David J. Myers, U.S. Census of Population, *Twelfth Census of the United States: 1900*, Population Schedule, Massachusetts, Suffolk, 20-WD, Boston, ED #1467, sheet 5A, line 8 (T623, roll 686), database: http://persiheritagequestonline.com: 2011.

117. Rash, "Schack, Young & Myers," in Ochsner, *Shaping Seattle*, 157.

118. Reinartz, *Tukwila, Community at the Crossroads*, 128.

119. Noyes' obituary in *Seattle Times*, February 24, 1932.

120. Charles Osborn, U.S. Census of Population, *Twelfth Census of the United States: 1900*, Schedule No. 1, Population, Washington, King Co., Seattle, ED #114, sheet 1B, line 91 (T623, roll 1745), database: http://persiheritagequestonline.com: 2006.

121. Ochsner, *Shaping Seattle*, 349, provided facts regarding Osborn's travels and drawing talents.

122. Forest Ridge Convent, a Seattle City Landmark, now houses the Seattle Hebrew Academy.

123. *Seattle News-Letter*, April 2, 1904, 11.

124. Kathy Sedler (transcription), *An Illustrated History of Los Angeles County, California* (Chicago: Lewis

Publishing Company, 1889), 600, http://www.calarchives
4u.com/biographies/losangeles/la-port.htm.

125. Frank H. Perkins, U.S. Census of Population, *Fourteenth Census of the United States: 1920*, Population Schedule, Washington, King Co., Seattle, ED #83, sheet 1B, line 76 (T625, roll 1925), database: http://persiheritage
questonline.com: 2011.

126. Marcus B. Priteca, U.S. Census of Population, *Fourteenth Census of the United States: 1920*, Population Schedule, Washington, King Co., Seattle, ED #179, sheet 9A, line 35 (T625, roll 1927), database: http://persiheritagequeston
line.com: 2011.

127. Seattle Public Library, "Architects' Scrapbooks," N-R, no. 8: B. Marcus Priteca (*Seattle Times*, September 13, 1959).

128. Sutermeister, "B. Marcus Priteca," in Ochsner, *Shaping Seattle*, 180–183, provided additional information.

129. Stark and Luxton, "Opera Houses, Vaudeville Theatres and Movie Palaces," in Luxton, *Building the West*, 266.

130. In the recent past, the Coliseum Theater was sensitively converted to a Banana Republic retail store.

131. Cone, Droker, and Williams, *Family of Strangers*, 303.

132. Howard Riley, U.S. Census of Population, *Fourteenth Census of the United States: 1920*, Population Schedule, Washington, King Co., Seattle, ED #47, sheet 9A, line 44 (T625, roll 1925), database: http://persiheritageque-
stonline.com: 2010.

133. *Oregonian*, September 18, 1938.

134. Prosser, *A History of the Puget Sound Country*, 217.

135. Luxton, "Russell, Babcock & Rice," in Luxton, *Building the West*, 412.

136. The 1901 *Polk's Seattle City Directory* lists the firm of Spalding, Russell and Heath at 61–62 Downs Block. The following year only Spalding's name is listed at the address.

137. *Tacoma News Tribune*, March 19, 1938, 1.

138. Barnes, "Patented Ramp in Liberty Theatre Seattle," *Pacific Builder and Engineer*, April 27, 1917, 16.

139. *Seattle Post-Intelligencer*, March 26, 1905.

140. *Seattle of to-day*, "H. Ryan," 133. Ryan's age/date of birth is inconsistent within the 1880, 1900, and 1910 censuses.

141. The 1894–95 (combined years) Fort Smith, Arkansas, city directory lists Ryan's home and business addresses. Fort Smith Public Library, Fort Smith, Arkansas.

142. Ryan was awarded the construction contract for Old Central (1893), the first permanent structure built on the campus of Oklahoma State University (originally Oklahoma Agricultural and Mechanical College), http://www.seic.okstate.edu/shpo/shpopic.asp?id=710006
72.

143. *Seattle Post-Intelligencer*, May 19, 1907.

144. Henderson Ryan, U.S. Census of Population, *Thirteenth Census of the United States: 1910*, Population Schedule, Washington, King Co., Seattle, ED #110, sheet 23A, line 43 (T624, roll 1659), database: http://persiher-
itagequestonline.com: 2011.

145. Ochsner and Andersen, *Distant Corner*, 167.

146. Saunders' final work before his death was a pedestal, for a statue of George Washington, on the University of Washington campus.

147. *Seattle Times*, March 14, 1923.

148. *Architect and Engineer* 121, no. 2 (May 1935): 58.

149. *Seattle of to-day*, 1907, 223.

150. *Pacific Builder and Engineer*, August 17, 1907, 7, and Ochsner, *Shaping Seattle*, 350. *Shaping Seattle* accounts for Sexton's years in Tacoma and Everett.

151. Ochsner, *Shaping Seattle*, 350–51. Shay biographical data from *Shaping Seattle*.

152. On October 10, 1937, the *Seattle Times* ran a picture of a home built entirely of concrete — with steel window frames— designed by Thiry and Shay, described elsewhere in the paper as "those architectural exponents of the 'modern trend.'" The house was described as "one of the city's novel dwellings."

153. *College Signal* 18, no. 8 (January 29, 1908): 11. Published twice a month by students of the Massachusetts Agricultural College, the state land grant college that eventually became the University of Massachusetts, the *College Signal* noted that after Spalding's graduation (1881), he worked in Minnesota as an architect, but then moved to Seattle where he "met with a large degree of success." *Seattle of to-day*, 1907, 126, states that Spalding was a graduate of the University of Boston. He may have graduated from both colleges, but the above information is more convincing.

154. Ochsner, *Shaping Seattle*, 351.

155. Macy and Bonnemaison, *Architecture and Nature: Creating an American Landscape*, 79. Robert Reamer, then practicing in San Diego, was hired to design the hotel. Reamer moved to Seattle in 1915, where he had a long successful career.

156. *Sketches of Washingtonians*, 1907, 283.

157. *Pacific Builder and Engineer* 6, no. 24 (June 13, 1908): 229.

158. Frank William Scott, ed., *Semi-Centennial Alumni Record of the University of Illinois*, 1918, http://books.google.com/books?id=HAgTAAAAIAAJ&ots=cqb1
TBoq64&dq=Semi-Centennial%20Alumni%20Record
%20of%20the%20University%20of%20Illinois&pg=
PP1#v=onepage&q&f=false.

159. Luxton, "Bertram Dudley Stuart," in Luxton, *Building the West*, 380.

160. Krafft and LaFever, "City of Seattle Landmark Nomination Application: Mayflower Park Hotel," 13.

161. *Seattle Times*, October 16, 1977.

162. *Seattle Times*, August 15, 1914; *Seattle Times*, March 23, 1924.

163. Dates and places of birth and death information for both Thompsons from "Grand Army of the Republic Cemetery, Seattle, Washington," http://worldcconnect.
rootsweb.ancestry.com.

164. Van House family picture album (http://family.
webshots.com/album/697917), which includes a photograph of Max Van House, http://family.webshots.com/
photo/1003489318000593069iyNcxwZusF.

165. A court case mentions Van House, "an architect residing in that city (Butte)," Supreme Court, Department One, No. 30615, December 17, 1918.

166. Don Glickstein, "Victor Voorhees: Architect in a Prosperous Seattle," *Columbia*, Winter 2003–04, 42. In addition to apartments, Voorhees designed houses, a factory, bank, theater, laundries, automobile showrooms, stores, a city hall, and three large downtown commissions, the Lloyd Building and the Vance Hotel, both built in 1927, and the Vance Building, built in 1929–30.

167. *Pacific Builder and Engineer* 7, no. 13 (March 27, 1909): 90.

168. Obituary in *Santa Barbara News Press*, August 11, 1970.

169. Arthur Wheatley, U.S. Census of Population, *Fourteenth Census of the United States:1920*, Population Schedule, Washington, King Co., Seattle, ED #334,

sheet 2B, line 60 (T625, roll 1931), database: http://
persiheritagequestonline.com: 2008. Note: Wheatley's
occupation incorrect; wife and daughter on sheet 5B.

170. William P. White, U.S. Census of Population,
Thirteenth Census of the United States: 1910, Population
Schedule, Washington, Seattle, King Co., ED #140, sheet
4B, line 59 (T624, roll 1661), database: http://persiher-
itagequestonline.com: 2009. At the time of the census,
White's age was forty-six, which means he was born
around 1864.

171. Butte Archives, e-mail message to author, Feb-
ruary 1, 2006.

172. White's partnership with Jesse M. Warren is one
of only two known partnerships (the earlier one in Butte
with Lignell) in which White engaged. The Warren con-
nection comes from a brief biography in Luxton's
Building the West, 486.

173. Luxton, *Building the West*, 486. In Vancouver,
British Columbia, the Bonaventure (1910) and the
Wenonah (1912) Apartment Buildings are extant, as is the
Sylvia, which in 1975 was designated a Heritage Build-
ing.

174. *Washington State Architect*, November 1928, 10,
listed White's residence in Bremerton. *Bremerton Daily
News*, April 6, 1932, 5.

175. Luxton, *Building the West*, 486.

176. Shoettle, "Deceased Architects and Builders."

177. Ritz, *Architects of Oregon*, 426.

178. Shoettle, "Deceased Architects and Builders."

179. *Pacific Builder and Engineer* 6, no. 11 (March 14,
1908): 105.

180. Ritz, *Architects of Oregon*, 426.

181. Cromley, *Alone Together*, 8.

Chapter 4

1. Poppeliers, Chambers, and Schwartz, *What Style
Is It?* 11.

2. Doucet and Weaver, *Housing the American City*,
405.

3. Seattle's Department of Neighborhoods' database
of historic properties attaches a style, or a number of
styles, to each building, http://web1.seattle.gov/dpd/his-
toricalsite.

4. Poppeliers, Chambers, and Schwartz, *What Style
is It?* 66.

5. McAlester, Virginia, and Lee, *Field Guide to
American Houses*, 343.

6. McAlester, Virginia, and Lee, *Field Guide to
American Houses*, 358.

7. Poppeliers, Chambers, and Schwartz, *What Style
is It?* 57.

8. Classes of apartment buildings in *Shared Walls*
are in part derived from those proposed by John Hancock
in his essay "The Apartment House in Urban America,"
presented in *Buildings and Society: Essays on the Social
Development of the Built Environment*.

9. Hancock, "Apartment House in Urban America,"
Buildings and Society, 172, 171.

10. See chapter 3 for a discussion of the various types
of hidden, or concealed, beds.

11. Taylor, "Efficiency Planning and Equipment,"
Architectural Forum, 253.

12. *Seattle Post-Intelligencer*, January 28, 1923.

13. Architect Edward T. Osborn, architectural plans,
the Charlesgate, HA0051, boxes 6 and 7. University of
Washington Libraries, Special Collections, Architectural
Drawings.

14. A 1989 remodel of the Charlesgate eliminated
many of the Murphy beds and kitchen built-ins,
according to manager Eric Kokis.

15. Kokis gave the author a tour, from the basement
to the rooftop, and a glance into one of the units, on July
1, 2005. Kokis said that the majority of the tenants at that
time were artists, writers, singers, and chefs, an indication
of the convenience and proximity of the Charlesgate to
downtown restaurants and art and entertainment venues.

16. Cromley, *Alone Together*, 6.

17. *Architectural Record*, "Over the Draughting Board,"
January 1903, 86.

18. *Architectural Record*, "Over the Draughting Board,"
January 1903, 91. The unnamed author of this article con-
sidered the apartment hotel "the boarding house at its
best and worst." Best because of the freedom it provided
for businesspeople on the move and people with country
homes who wanted a sometime city residence, and it re-
duced the servant problem. Worst because it allowed
women to sacrifice "the dignity of their own lives and
their effective influence over their husband and children,"
since management assumed responsibilities — household
management and meals — that usually fell to women.
The latter allegations may have prompted the author's
anonymity.

19. *Washington State Architect*, August 1921, 9.

20. *Architectural Forum*, November 1924, 253.

21. *Washington State Architect*, August 1921, 1.

22. The Spring and the Claremont apartment hotels
are discussed at length in chapter 5.

23. Hancock, "Apartment House in Urban America,"
Buildings and Society, 172.

24. Other facts about the makeup of the residents of
the Camlin revealed that with the exception of two units
with children, it was an adult community. Excluding the
children, the average age of the residents was forty-four,
with the largest number of residents, thirteen, falling into
the fifty to fifty-nine age group. Seven residents were be-
tween twenty and twenty-nine years of age, and seven
were older than sixty. U.S. Census of Population, *Fifteenth
Census of the United States: 1930*, Population Schedule,
Washington State, King Co., Seattle (T626, roll 2499), 26,
database: http://persiheritagequestonline.com: 2011. U.S.
Census of Population, *Fourteenth Census of the United
States:1920*, Population Schedule, Washington, King Co.,
Seattle, ED #123, sheet 4A, line 42 (T625, roll 1926), data-
base: http://persiheritagequestonline.com: 2011.

25. U.S. Census of Population, *Fifteenth Census of the
United States: 1930*, Population Schedule, Washington
State, King Co., Seattle (T626, roll 2499), 26, database:
http://persiheritagequestonline.com: 2011.

26. Dolkart, *Morningside Heights*, 316.

27. When the Camlin converted to a hotel in 1949, the
kitchens were walled up. In 2003, a membership-only re-
sort chain bought the Camlin. During renovation, the
company unearthed the kitchenettes, some with their 1924
Hotpoint Automatic Electric stoves intact. *Seattle Times*,
September 17, 2003.

28. *Hotel News of the West*, August 14, 1926, 4.

29. U.S. Census of Population, *Fourteenth Census of
the United States: 1920*, Population Schedule, Washington
State, King Co., Seattle, ED #186, page 40, sheets 2B and
3A (T1625, roll 1928), database: http://persiheritage
questonline.com: 2011.

30. Author's interview on April 24, 2008, with former
Moana resident, Warren Munzell, who said the building's
second and third floors have been slightly altered. Now,
some apartments do share walls, although to a very
limited degree.

31. Two entrances into an apartment unit was not an uncommon feature in buildings of the intermediate and luxury classes.

32. *Seattle Post-Intelligencer*, June 30, 1907.

33. Hancock, " Apartment House in Urban America," *Buildings and Society*, 164. Hancock commented on the location of luxury apartments.

34. *Seattle Post-Intelligencer*, April 16, 1913.

35. Balconettes are small, decorative, pseudo-balconies projecting from a windowsill. Buffalo Illustrated Architecture Dictionary (http://www.buffaloah.com/a/DCT NRY/b/balconet.html) and Fleming, Honour, and Pevsner, *Architecture and Landscape Architecture*, 37.

36. Anthemion is an ornament reminiscent of a honeysuckle flower alternating with palm leaves, common in ancient Greek and Roman architecture. Fleming, Honour, Pevsner, *Architecture and Landscape Architecture*, 16.

37. Department of Planning and Development building plans: Olympian.

38. U.S. Census of Population, *Fourteenth Census of the United States: 1920*, Population Schedule, Washington State, King Co., Seattle, Precinct 185, ED #248, page 161, sheets 1B and 2A (T625, roll 1929), database: http://persiheritagequestonline.com: 2011.

39. Dolkart, *Morningside Heights*, 318.

40. *Seattle Post-Intelligencer*, September 11, 1910.

41. The King County Parcel Viewer (http://www.king-county.gov/operations/gis/propresearch/parcelviewer.aspx) displays helpful information for researching extant Seattle apartment buildings. In addition to general facts, such as number of stories, number of units, and average square footages, the Parcel Viewer states the building's construction class.

42. McKnight, "Timber! A Brief Local History of the Building Material," *Preservation Seattle*, May 2004, http://www.historicseattle.org/preservationseattle/preservationenv/defaultmay3.htm.

43. Solid brick masonry implies that two or more layers of brick (known as stretchers) are laid horizontally and are bound together with another layer of brick (known as headers) running transverse to the wall.

44. McKnight, "Brick and Stone Construction," *Preservation Seattle*, July 2003, http://www.historicseattle.org/preservationseattle/techniques/brickstone.htm.

45. Well-known Seattleites Morgan Carkeek and Thomas Burke were associated with the Pontiac Brick and Tile Company as president and treasurer, respectively. Short-lived, the company closed permanently in 1914.

46. Advertisement for Denny-Renton Clay and Coal Company, in 1911 *Polk's Seattle City Directory*, 1630.

47. Ochsner and Anderson, *Distant Corner*, 78.

48. *Seattle Post-Intelligencer*, July 26, 1925.

49. The Adrian Court, an apartment built in 1904, boasted that "everything is of the best, and practically every part of the construction, from the basement to the cornice, is built of concrete." At the time of construction, it was one of only two totally concrete structures in Seattle, evidence of the novelty of the material. *Seattle Post-Intelligencer*, September 11, 1904.

50. *Western Architect*, May 1905, 8.

51. *Seattle Post-Intelligencer*, July 16, 1906.

52. *Seattle Post-Intelligencer*, July 16, 1906.

53. *Washington State Architect*, April 1923, 4.

54. *Real Property Survey 1939–1940*, table 8: "Number and Percentage Distribution of Exterior Material."

55. Condit, *Chicago School of Architecture*, 146.

56. *Pacific Builder and Engineer*, "Fashions in Face Brick," December 26, 1908, 448.

57. "History Lives Here," walking tour, Renton History Museum, http://rentonwa.gov/living/default.aspx?id=1380.

58. At the time of its construction in 1901, the exterior of the St. Paul, Seattle's first purpose-built apartment, was described as covered with cement *plaster* applied to sheet steel lath. *Post-Intelligencer*, May 26, 1901.

59. Portland cement, so called because its inventor named it after stone quarried on the Isle of Portland, is an artificial cement. It was imported to the United States beginning in the 1880s but was gradually replaced by American sources. The first cement plant in Washington was likely started near the Baker River in 1905, resulting in the small company town appropriately named Concrete. Information from "A Brief History of Concrete," by Reuben McKnight, from Historic Seattle's online *Preservation Magazine*, June/July 2004.

60. Grimmer, *Preservation and Repair of Historic Stucco*, 1990.

61. *Impressions of Imagination*, "The History of American Terra-Cotta and Its Local Manufacture," by Smith, 3.

62. *Impressions of Imagination*, "The History of American Terra-Cotta and Its Local Manufacture," by Smith, 4.

63. *Impressions of Imagination*, "The History of American Terra-Cotta and Its Local Manufacture," by Smith, 5. Gladding, McBean recovered and is still in business.

64. Susan Schwartz, "Seattle's Treasury of Terra Cotta," *Seattle Times*, January 8, 1978, pictorial 11. Eagles and walruses made of terra cotta also appear on downtown Seattle buildings.

65. The process for making terra cotta was distilled from *Impressions of Imagination*, 4–5.

66. *Terra Cotta Defined*, ca. 1910. Also, in *Guide to Architecture in Washington State*, authors refer to a frieze around an entrance and comment that terra cotta companies produced this kind of ornament by the foot.

67. Pieper, *42 Preservation Briefs*, "The Maintenance, Repair and Replacement of Historic Cast Stone," n.p.

68. *Impressions of Imagination*, "The Building Catalogue," 57.

69. *Pacific Builder and Engineer*, October 17, 1908, 376.

70. *Pacific Builder and Engineer*, January 5, 1924, 12.

Chapter 5

1. Mohl, *New City*, 43.

2. Mohl, *New City*, 42.

3. Padelford, "Frederick & Nelson Department Store by D.E. Frederick's Great Grandson," HistoryLink.org, 2002.

4. The handsome 1928 building served as the Bon Marche's flagship store until bought out by Macy's.

5. The venerable Frederick and Nelson closed in 1992. After a few years of renovation, Nordstrom moved into the space.

6. The 5th Avenue and the Paramount theaters survive as performance venues.

7. Hines, *Denny's Knoll*, 72.

8. The latter became First United Methodist Church in 1968.

9. Broderick, Henry, Inc., Kroll Map Co., 1939.

10. "Seattle: A National Register of Historic Places Travel Itinerary," http://www.nps.gov/history/nr/travel/seattle/s21.htm (accessed March 1, 2011).

11. *Hotel News of the West*, September 6, 1924, 13.

12. *Hotel News of the West*, September 6, 1924, 13.

13. *Seattle Daily Times*, March 1, 1928.

14. *Seattle Daily Journal of Commerce*, March 2, 1922, 1.

15. Original plans on file at Seattle Department of Planning and Development.

16. *Seattle Daily Journal of Commerce*, March 2, 1922.

17. *Seattle Times*, March 1, 1922.

18. Brand, *How Buildings Learn*, 2.

19. Architects Reference File, Special Collections, University of Washington: Henderson Ryan. When the contract for the Waldorf was let, the building was to be called the Kali-Ila. It appears that dour Seattleites had second thoughts, and the name was changed to the Waldorf.

20. *Seattle Post-Intelligencer*, July 16, 1906.

21. *Seattle Times*, March 8, 1907.

22. A refrigerator, despite its connotation, in 1907 was an icebox.

23. Gordon Bock, "Past Perfect: Go with the Flow," *Old House Journal*, http://www.oldhousejournal.com/Past_Perfect/magazine/1388 (accessed March 1, 2011).

24. Architects Reference File, Special Collections, University of Washington: Henderson Ryan, *Seattle Post-Intelligencer*, March 26, 1905.

25. All information from lengthy advertisement in the *Seattle Daily Times*, March 8, 1907.

26. *Seattle Post-Intelligencer*, July 19, 1970.

27. The declining number of children in the neighborhood, beginning in the early 1920s, led to the school's closure in 1938. The Central School building was demolished in 1953.

28. First Presbyterian Church website, http://www.firstpres.org/who-we-are/our-history/

29. A little history concerning the former names of the Dover: the Laveta Flats first appeared in the 1905 *Polk's Seattle City Directory*'s listing of apartments, with an address of 520 *Union* rather than 520 Marion, an obvious error. To add to the confusion, the 1908 Baist map spelled the name *Layeta*, but at least showed it at 520 Marion. In the 1906 *Polk's*, the building's name appeared twice, both on Marion, as the Laveta Flats *and* the Hyland. The latter spelling is another error, since from 1907 through 1913, it was spelled *Highland*.

30. Plans for the Dover viewed at the City of Seattle Department of Planning and Development. There is no date on any page of the Dover's plans.

31. A flat canopy, such as the one at the Dover entrance, is sometimes referred to as a marquise, the French term for a glass porch or roof. Usually suspended, supported by a rod, they were often of glass and/or metal and more commonly called a marquee.

32. Rusticated stone is masonry cut into large blocks that during construction are separated by deep joints, meant to give a "rich and bold texture to an exterior wall." *Penguin Dictionary*, 498. At the Dover, the shallower blocks were cut in such a way to fit the shape of the arched opening, but the deep joints are present.

33. *Seattle Sunday Times*, June 28, 1914.

34. A plaque near the entrance to the Zindorf states that in 1910 Mathew Patrick Zindorf built the "first reinforced concrete apartment building in the city," a fact the builders of the Waldorf might refute.

35. *Seattle Post-Intelligencer*, September 19, 1909.

36. *Seattle Sunday Times*, June 28, 1914.

37. *Seattle Post-Intelligencer*, September 19, 1909.

38. *Seattle Times*, December 16, 1928.

39. *Seattle Times*, December 16, 1928.

40. *Seattle Times*, December 16, 1928.

41. *Hotel News of the West*, April 29, 1928, 5.

42. *The Exeter: In the Heart of Seattle*, Seattle (Wash) Hotels and Apartments, Special Collections Pamphlet File, University of Washington Libraries.

43. *Hotel News of the West*, May 5, 1928, 5, 6.

44. Some early references referred to it as the Eagles Temple, but in its National Register nomination and other more contemporary sources, it is referred to as the Eagles Auditorium Building.

45. National Register of Historic Places Inventory-Nomination Form, Eagles Auditorium Building, 7, description 1.

46. *Seattle Daily Journal of Commerce*, June 19, 1924, 1.

47. Faget, "Restructuring a Proud Building," *Seattle Daily Journal of Commerce*, "Design '96," November 7, 1996, http://www.djc.com/special/design96/10016902.html.

48. *Seattle Times*, August 23, 1925.

49. *Seattle Daily Journal of Commerce*, June 19, 1924, 1.

50. *Pacific Builder and Engineer*, July 22, 1911, 23. Priteca, who formerly worked out of an office in San Francisco, had shifted his headquarters to Seattle in 1911.

51. Tile identified by Kreisman and Mason, authors of *The Arts and Crafts Movement in the Pacific Northwest*, 114.

52. Plans for the Paramount viewed at the City of Seattle Department of Planning and Development.

53. *Seattle Post-Intelligencer*, February 26, 1928.

54. *Seattle Post-Intelligencer*, February 26, 1928.

55. *Seattle Times*, February 29, 1928.

56. One of the apartments in the Paramount Theater is used as an office for the Seattle Baroque Orchestra. Steve Olans, executive director of SBO, invited the author to view their space. The layout of the apartment is unchanged, and the kitchen retains some of its original features.

57. Since 1927, the Central Terminal, now the Greyhound bus station, has served as a transportation hub. Earlier, one could catch streetcars to other parts of the city from the Terminal.

58. *State v. Johnson*, 151 Washington 262,275 Pac. 569 (1929).

59. Department of Planning and Development: Bonair.

60. Ragan, *Daily Journal of Commerce*, October 18, 1999, www.djc.com.

61. Minister and architectural historian Dennis Andersen said a former parishioner remembered the area in the 1920s as a rough place, with gullies and unending road and regrade work. The parishioner's parents were live-in custodians of Gethsemane Lutheran Church, located less than a block from the El Rio.

62. For the description of the Art Deco style, credit belongs to John Blumenson, *Identifying American Architecture*, 77, and McAlester and McAlester, *A Field Guide to American Houses*, 465.

63. Gelernter, *History of American Architecture*, 242–43.

64. Hines, *Denny's Knoll*, 62. Douglas was also deeply involved with the University of Washington's Metropolitan Tract, an eleven acre site in the heart of downtown Seattle. In 1860 the Legislative Assembly of Washington stipulated that the property should be used for university purposes. By 1895 the University had outgrown the site and moved to its present location. Regarding the development of the Tract after the University had vacated it, Hines states that "how much of the original concept came from Douglas cannot be known, but even the architects themselves apparently regarded Douglas as the guiding hand." 77.

65. Indicative that children were not always welcome in apartment buildings, a reviewer wrote, "This series of flats built to accommodate something like one thousand

people, and strange to relate, families with children are not excluded." *Seattle Mail and Herald*, December 30, 1905.

66. *Seattle Mail and Herald*, "Western Flat Dwellers," September 30, 1905.

67. The El Capitan's owner, Alvin Hendricks, identified the concierge booth during a telephone conversation with author.

68. *Seattle Times*, August 23, 1925, provided the information about the interior of the lobby, the suites, and furnishings of the North Apartments.

69. Oliver Tower Apartments: Seattle (Wash) Hotels and Apartments, Special Collections Pamphlet File, University of Washington Libraries.

70. *Washington State Architect*, August 1928, 8.

71. Olive Tower Apartments: Seattle (Wash) Hotels and Apartments, Special Collections Pamphlet File, University of Washington Libraries.

72. City of Seattle, Department of Planning and Development, *Design Guidelines for the Belltown Urban Center Village*, vii.

73. Keys, *Single Room Occupancy Hotels*, 72.

74. The original plans, viewed at the City of Seattle Department of Planning and Development, offered little help due to their age and illegibility. They did confirm that Howells and Stokes, a New York firm hired by the University of Washington in 1907 to develop a master plan for the Metropolitan Tract, were the architects.

75. *Seattle Post-Intelligencer*, August 21, 1910.

76. The 1939 *Polk's Seattle City Directory* included occupations of residential listings.

77. *Seattle Times*, January 13, 1920; *Seattle Times*, January 25, 1920.

78. Bagley, *History of Seattle*, vol. 3, 1115.

79. Plans for the Humphrey Apartment viewed at the City of Seattle Department of Planning and Development.

80. *Seattle Times*, September 30, 1923.

81. *Hotel News of the West*, January 20, 1926, 11.

82. *Hotel News of the West*, January 20, 1926, 11.

83. Plans for the Virginian Apartment building viewed at the Department of Planning and Development.

84. *Seattle Post-Intelligencer*, August 19, 1916.

85. *Seattle Post-Intelligencer*, August 19, 1916.

86. *Seattle Times*, October 12, 1930.

87. *Hotel News of the West*, May 9, 1925, 3, 22.

88. *Hotel News of the West*, May 9, 1925, 3.

89. City of Seattle Department of Planning and Development, *Design Guidelines for the Belltown Urban Center Village*, 7.

90. *Seattle Post-Intelligencer*, July 22, 1973.

Chapter 6

1. For the purpose of this study, First Hill and Renton/Second Hill will encompass the area between Ninth and Nineteenth avenues and between James and Union Streets, until the point that Union crosses Madison Street at Twelfth Avenue. Then Madison becomes the northern boundary as far as Nineteenth Avenue.

2. Sale, *Seattle: Past to Present*, 58.

3. *Seattle News-Letter*, October 22, 1904, 3.

4. *Seattle Post-Intelligencer*, September 11, 1904.

5. Courtois, "Historic and Prehistoric Archaeological Sites," 1999, 82–83.

6. The Hofius mansion today serves as residence for the archbishop of the Diocese of Seattle; the Washington Trust, a state-level preservation organization, occupies the Stimson-Green Mansion; Historic Seattle, dedicated to preserving Seattle and King County's heritage,

occupies the Dearborn House; and since 1901, the University Club has owned the Stacy mansion. Today, the former Kline-Galland House, on the northwest corner of 17th Avenue and Madison Street, is an assisted-living facility.

7. Beginning in the 1970s, the First Hill Community Council began actively advocating for the preservation of housing, particularly affordable housing. This grassroots activity has been a force in saving many of the old apartments, many of which are now managed by nonprofit groups.

8. Correspondence from Al Wilding dated November 21, 2005.

9. *Pacific Builder and Engineer*, March 17, 1906, 5. The large size of the units, and the ongoing confusion about the term *apartment*, tends to point toward the Russell being an apartment from the beginning.

10. *Seattle Times*, September 4, 1908.

11. City of Seattle Department of Planning and Development, permit 46675. Information from the permit gives the building's estimated cost at $45,000. Stirrat and Goetz, a contracting firm, provided much of Seattle's early infrastructure — grading, paving, and sewers — and also formed an investment company that bought and sold real estate.

12. David Bain also built and owned the Consulate, Embassy, and Viceroy apartment buildings.

13. *Seattle Times*, September 15, 1929.

14. The address of the Old Colony changed from 617 Boren to 615 Boren prior to its first listing in the 1910 *Polk's Seattle City Directory*. While it is three stories plus a daylight basement on Boren, most of the building is a full four floors.

15. *Seattle Times*, January 2, 1910.

16. *Seattle Times*, February 27, 1910.

17. *Seattle Times*, February 27, 1910.

18. Author was given a tour of resident's unit in Old Colony.

19. In 1946, when Boren Avenue was widened between Denny Way and Broadway, it "became a major link in a bypass arterial which connects Rainier Avenue to Aurora Avenue." Phelps, *Narrative History of the Engineering Department*, 109.

20. *Seattle Times*, March 29, 1925, for naming of Huntington as architect. Prior to the demolition of the Northcliffe, First Hill residents and preservations rallied for its preservation, to no avail. One local resident responded to an online vintageseatttle.org profile of the Northcliffe, dated January 4, 2008: "My Grandmother lived in this building.... I have such fond and vivid memories of the lobby, the elevator, the halls, and her very large 1 bedroom apartment. Even as a child I knew this building was unique and special."

21. *Seattle Times*, July 26, 1925. The same article furnished other particulars, including the garage.

22. Margaret Denny, born in 1847 to Arthur Denny and Mary Ann Boren Denny, was living in the family home at 1220 Boren at the time of her death in 1915. After her death, the residence became the Chateau, a boarding house known for its excellent room and board and park-like setting (*Seattle Times*, May 3, 1925, and June 16, 1925). Despite the information in the newspaper, the Chateau does not appear in city directories between 1915 and 1925.

23. Initially the building was called the Chancellor.

24. Liveried service, mentioned in the *Seattle Times* on October 9, 1927, was never mentioned again.

25. Seattle architect Bertram Dudley Stuart has on occasion incorrectly been credited for the design of the Marlborough House, but permits, plans, and numerous

newspaper articles refer to Morrison as the building's architect.

26. St. Mark's Episcopal relocated from downtown Seattle to Seneca and Broadway in 1897. Designated the diocese's cathedral in 1926, it has been at home in its current building on Tenth Avenue East on Seattle's Capitol Hill since 1931.

27. Dunn, *1121 Union*, 42–43.

28. *Seattle Times*, February 17, 1985.

29. *Seattle Times*, August 31, 1930.

30. Gainsborough Apartments: Seattle (Wash) Hotels and Apartments, Special Collections Pamphlet File, University of Washington Libraries.

31. Gainsborough Apartments: Seattle (Wash) Hotels and Apartments, Special Collections Pamphlet File, University of Washington Libraries.

32. *Seattle Times*, December 28, 1905.

33. San Marco, U.S. Census of Population, *Thirteenth Census of the United States: 1910*, Population Schedule, Washington, King Co., Seattle, ED #122, sheet 3B (T645, roll 1660), database: http://persiheritagequestonline.com: 2011.

34. *Seattle Daily Bulletin*, February 20, 1905.

35. *Seattle Times*, January 6, 1929.

36. *Pacific Builder and Engineer*, May 4, 1929, 37–38.

37. 1223 Spring Street Apartments: Seattle (Wash) Hotels and Apartments, Special Collections Pamphlet File, University of Washington Libraries.

38. Conversation between Florence Lundquist and author.

39. Both the *Seattle Times*, February 23, 1901, and the *Seattle Daily Bulletin*, February 21, 1901, noted that plans for the St. Paul were ready.

40. *Seattle Post-Intelligencer*, May 26, 1901.

41. *Seattle Post-Intelligencer*, May 26, 1901.

42. *Seattle Times*, August 13, 1916. Jake, Simon, and Max Kreielsheimer were German immigrants who came to Seattle in the late 1880s. Since Jake died in 1915, it would have been brothers Simon and Max who built the Arcadia. When Max died in 1935, his will showed that he still owned the Arcadia, which Max's wife Olivia and son Leo inherited. Leo went on to create the Kreielsheimer Foundation, a great benefactor of the arts in Seattle. Family history from Paul Dorpat, *Legacy: The Kreielsheimer Foundation*, 138–141.

43. The Arcadia's King County Property Card states the building is three stories. Today it is usually described as a four-story building, which includes the largely above-grade basement.

44. Resident Debbie Gibby gave the author a tour of the Arcadia. Stephen White, another resident, opened his apartment for viewing. The Arcadia's 1937 King County Property Record Card details the thirty-two units as divided among ten five-room and twenty-two four-room apartments, and three two-room apartments in the basement. Gibby says currently there are forty-one apartments and six single rooms in the basement that share two bathrooms.

45. Mary also was a writer, author of the *Best Friends* series.

46. *Seattle Times*, March 22, 1925.

47. *Seattle Times*, November 29, 1925.

48. *Seattle Times*, April 18, 1926.

49. *Seattle Post-Intelligencer*, January 22, 1911.

50. Several sources credit Victor Voorhees as the architect for the Maxmillian.

51. Earlier information states that the Maxmillian had twenty-seven units. It is not uncommon for additional units to be created from basement space no longer given over to large laundry/boilers/storage facilities. Since three of the additional units share one bathroom, it is likely they are located in the basement.

52. Rob Femur kindly allowed a visit to his apartment unit in the Maxmillian.

53. Maxmillian, U.S. Census of Population, *Fourteenth Census of the United States: 1920*, Population Schedule, Washington, King Co., Seattle, ED #208, sheets 6B, 7A, 7B (T625, roll 1928), database: http://persiheritagequestonline.com: 2011.

54. Morda C. Slauson, *Renton: From Coal to Jets*, 7.

55. *Seattle Post-Intelligencer*, January 24, 1903. Related details of the Renton Hill Improvement Club.

56. *Seattle Post-Intelligencer*, May 26, 1907.

57. *Seattle Post-Intelligencer*, January 22, 1911.

58. *Seattle Times*, October 3, 1907.

59. *Seattle Times*, February 19, 1920.

60. *Seattle Times*, October 3, 1907.

61. *Seattle Times*, September 22, 1918.

62. *Seattle Times*, February 17, 1907.

63. *Seattle Post-Intelligencer*, May 26, 1907.

64. Where posts of the balcony were once attached to the brick wall, there are faint outlines of paint. The earliest photograph of the Algonquin documents the existence of a balcony.

65. A Palladian window has a central arched section flanked by two narrow rectangular sections. It takes its name from Andrea Palladio (1508–1580), an Italian Renaissance architect.

66. *Seattle Post-Intelligencer*, August 17, 1907. *Sanitary* usually meant that the fixtures, floors, and walls were made with an easy-to-clean material, such as tile or linoleum.

67. *Seattle Times*, March 4, 1928.

68. *Seattle Times*, August 19, 1928.

69. *Seattle Post-Intelligencer*, April 23, 1905.

70. *Seattle Times*, December 13, 1914.

71. Renton, U.S. Census of Population, *Thirteenth Census of the United States: 1910*, Population Schedule, Washington, King Co., Seattle, ED #96, sheets 12A and 12B (T624, roll 1659), database: http://persiheritagequestonline.com: 2011.

72. Helen Rucker, Manuscript Collection No. 2752, accession no. 2752–008, University of Washington Libraries, Special Collections.

73. City of Seattle's Department of Planning and Development: Fleur de Lis.

74. *Seattle Times*, October 6, 1929. Though a shower curtain with "necessary hooks" seems unremarkable, curtain rings that permitted the curtain to be moved back and forth with ease had just been designed.

75. *Seattle Times*, October 6, 1929. The extremely long advertisement described in detail every aspect of the soon-to-open Fleur de Lis.

76. *Seattle Times*, February 5, 1928.

Chapter 7

1. Williams, *Hill with a Future*, 42.

2. *Seattle Post-Intelligencer*, November 16, 1901.

3. *Seattle Post-Intelligencer*, February 19, 1911, 6.

4. Kreisman, "Perspectives: The Built Forms, Southwest Capitol Hill," 3.

5. *Argus*, December 19, 1931, 2. The *Argus*, which HistoryLink.org describes as "a more traditional, issue-oriented paper," rather derisively wrote that the *Post-Intelligencer* (a Seattle daily newspaper) had added Broadway, "which is not on that hill at all, to the Capitol Hill district."

6. The southwest corner of West Capitol Hill, platted as A. A. Denny's Broadway Addition, lies just east of downtown Seattle's Denny Triangle neighborhood.

7. Sheridan, "Viewpoints Tour: Pike/Pine Corridor," 1.

8. *Seattle Post-Intelligencer*, April 8, 1906.

9. Car dealerships and their showrooms also established themselves between Broadway and Twelfth Avenue East and were collectively referred to as Auto Row. The more recently coined "Pike–Pine Corridor" has all but replaced the once-familiar "Auto Row."

10. *Seattle Times*, August 26, 1928.

11. All exterior and interior information regarding the Melrose comes from plans drawn by architect W. W. Noyes, viewed at the City of Seattle Department of Planning and Development.

12. A newspaper notice of the day referred to the Beaumont as the Winquist Apartments. U.S. Census of Population, *Thirteenth Census of the United States: 1910*, Population Schedule, Washington, King Co., Seattle, ED #123, sheet 5B, line 54 (T624, roll 1660), database: http://persiheritagequestonline.com: 2011.

13. *Seattle Post-Intelligencer*, October 4, 1908.

14. *Seattle Post-Intelligencer*, October 4, 1908. Current information, via King County Parcel Viewer, indicates the Summit Arms has twenty-nine apartments. The number is remarkably near the original twenty-seven, indicating fewer changes over the building's long history.

15. Public garages were built to house the increasingly popular automobile, an unanticipated factor in earlier housing.

16. The buildings of the car dealership and the First Hill garage, which have also weathered many changes, still surround the Summit Arms.

17. *Seattle Post-Intelligencer*, June 2, 1907.

18. A Glencoe resident explained to the author that there were some units and a laundry in the area reached by the smaller door, but the area was not connected by any inside means to the rest of the building.

19. Features found on the Glencoe and Bel Fiore are found on other Ryan apartment buildings: the Roycroft, Fredonia, and in a drawing of the no-longer extant Arcadian, pictured in the *Seattle Post-Intelligencer*, February 3, 1907.

20. Bagley's *History of Seattle* tells the tale of Starbird breaking all records by walking alone from Dawson City to Skagway in fifteen days. Starbird would have covered an average of thirty-one miles per day "through a region of continuous blizzards" (3:727).

21. The Starbird Flats, significant for its long history in the neighborhood, was razed in the recent past.

22. According to Bagley's *History of Seattle*, Starbird built the first hotel, the Glacier, in Dyea, Alaska, in 1897 (726–27).

23. *Seattle Post-Intelligencer*, July 1, 1906.

24. In 1979 the City issued a permit for the installation of additional bathrooms; plans for the work indicate that every unit on the first and second floors received a bathroom.

25. *Seattle of Today*, 138.

26. Personal interview with Florence Lundquist, May 30, 2005, by author.

27. *Seattle of Today*, 150.

28. *Seattle Post-Intelligencer*, March 9, 1906. When the Unitarians moved to the University District in 1922, the Central Seventh Day Adventists moved into the building and remained there until at least 1939, according to *Polk's Seattle City Directory*.

29. *Seattle Times*, October 29, 1932.

30. All information regarding the exterior and interior of the Lenawee from plans, dated January 31, 1918, which John Creutzer prepared for the Bradner Company. Viewed at the City of Seattle Department of Planning and Development.

31. *Seattle Post-Intelligencer*, January 24, 1908.

32. *Seattle Brides Cook Book*, "Rialto Court Apartments," n.p.

33. Grote-Rankin Company advertisement in the *Seattle Times*: "Complete Furnishers of Homes, Steamboats and Hotels," August 25, 1907.

34. *Seattle of Today*, "Buena Vista Apartments," 150.

35. The Porter: Seattle (Wash) Hotels and Apartments, Special Collections Pamphlet File, University of Washington Libraries.

36. Although no original plans for the Porter are on file at Department of Planning and Development, plans used for bath alterations in 1978 likely reflect the original layout.

37. All descriptive information about the Porter is from the Special Collections brochure. Sleeping porches, usually a screened in porch to provide a cool space for sleeping during warm summer months, have been differently interpreted to suit Seattle's cooler climate. As described in plans of the Porter, Montrachet, and the Jefferson Park Apartments, all are enclosed rooms with a wall of windows.

38. A 1908 Baist map illustrates that where Olive *Street* (there was no Olive *Way*) met Melrose, one had to turn north and proceed to the one-block-long East Olive Street (since renamed East Olive Place). Then one drove south along Bellevue Avenue for one block and turned east for the continuation of Olive Street.

39. Residents opposed the extension of Olive from Melrose to Broadway as early as 1907, an indication that the idea surfaced long before action was taken by the city. A report appeared in the *Post-Intelligencer* on February 17, 1907, of a meeting of 112 "prominent ladies and gentlemen of the Harvard Avenue and Broadway districts," where the chairman "spoke earnestly against this scheme that has been proposed by real estate boomers."

40. Seattle Ordinances, Office of the City Clerk, Ordinance No. 41943.

41. The same ordinance, No. 41943, provided for the condemnation of land, with improvements paid by a special assessment upon the properties that benefited. Subsequently, Ordinance No. 43357, issued in 1922, provided for the costs of condemnation through the issue and sale of bonds.

42. *Seattle Times*, September 2, 1923.

43. The Biltmore: Seattle (Wash) Hotels and Apartments, Special Collections Pamphlet File, University of Washington Libraries.

44. *Seattle Times*, January 26, 1924.

45. *Washington State Architect* 5, no. 2 (January 1925): 8. Nichols hired Harry James to design the Louisiana, located at 321 Boylston and now called the Homborness.

46. The El Dora's original address was 312 East Olive, prior to the realignment of sections of East Olive Street into East Olive Way. From 1915 to 1918, the El Dora carried two addresses in *Seattle's Polk City Directory*: the one on Olive as well as one on Bellevue Avenue.

47. City of Seattle Department of Planning and Development, "Plan for Remodeling Apartment House," April 7, 1914. Plans of any earlier structure on this site are not available at the Department of Planning and Development.

48. The Lauren Renee is as an example of the Queen Anne style.

49. *Seattle Times*, August 18, 1907.

50. Usually positioned above a window, a pent roof has only one sloping pane, which protects and ornaments the window below.

51. Ryan used hanging bays, heavy arched opening, and clusters of three windows on the Roycroft. The Fredonia has hanging bays, arched opening and the three windows, arched and clustered. The Bel Fiore and the Glencoe/Lorena bear the most striking resemblance to one another. See discussion of Glencoe for photographs of the two.

52. *Real Property Survey*, Epstein study, table 1–4, "Number and Percentage Distribution by Exterior Material, by Type of Structure, for all Structures, Seattle, Washington, 1939–40." The exterior materials were wood, brick, stone, stucco, and "other."

53. *Seattle Times*, August 5, 1928.

54. *Seattle Times*, April 8, 1926, referred to the Biltmore Tea Room.

55. *Seattle Times*, August 23, 1925.

56. Biltmore resident Mara Benedict invited the author to view the apartment occupied by Mara and her husband, David Shannon.

57. The Biltmore: Seattle (Wash) Hotels and Apartments, Special Collections Pamphlet File, University of Washington Libraries.

58. *(Seattle) Daily Journal of Commerce*, August 30, 1923, 12.

59. *(Seattle) Daily Journal of Commerce*, August 30, 1923, 12.

60. Plans of the Ambassador viewed at the City of Seattle Department of Planning and Development..

61. Pullman diners, mentioned in an announcement regarding the completion of the Ambassador in the *(Seattle) Daily Journal of Commerce*, August 30, 1923, 12, were prefabricated elsewhere and brought in, or assembled on site. They were named for the small kitchens found on trains built by American railroad manufacturer George Pullman.

62. *(Seattle) Daily Journal of Commerce*, August 30, 1923, 12.

63. At the same time the Ambassador was reformatted for condominiums, the developer skillfully incorporated an additional two new buildings, and parking for the entire group, that blend well with the original. *Seattle Times*, June 11, 1991, B5.

64. Although the 1912 Baist map shows a decidedly sharp right turn at the southwest corner of Harvard and John, the 1920 Kroll map shows it to be a rounded corner. Architect William Aitken was sensitive to the siting of the Harvard Crest.

65. Although age has made Aitken's building plan difficult to decipher, it appears that one unit on each floor did have a bedroom. The Harvard Crest is categorized as an efficiency since all other units relied on a bed stored in the dressing room during the day.

66. *Seattle Times*, March 20, 1927. The Burgesses, who bought the Harvard Crest, also owned the Fredonia Apartments.

67. *Seattle Post-Intelligencer*, April 8, 1906.

68. *Seattle Times*, February 15, 1935.

69. Plans of the Capitol/Flemington viewed at the City of Seattle Department of Planning and Development.

70. The information on number and size of units comes from the Capitol/Flemington's Property Record Card. The number of units agrees with the current information found in the King County Parcel Finder, http://www.kingcounty.gov/operations/gis/propresearch/parcel viewer.aspx.

71. Information based on plans of the Capitol studied at the City of Seattle Department of Planning and Development.

72. *Hotel News of the West*, April 5, 1924, 13.

73. Aside from the Republican Street stairs, a portion of the Harrison Street stairwell still exists and is in use. A 1912 Baist map indicates a third stairwell at Mercer Street, but the only stairs in the vicinity are midblock between Republican and Mercer, barely visible for the overgrowth.

74. Paul Dorpat, "Seattle Neighborhoods: Republican Hill Climb," HistoryLink.org, essay 3261 (May 6, 2001), www.historylink.org/essays/output.cfm?file_id=3261.

75. The Chardonnay's 1937 photo from Puget Sound Regional Archives captured the described features.

76. Clinker brick was considered a cast-off by most builders. Earlier kilns, due to their design, produced bricks of different quality, some of which were distorted or discolored due to their nearness to the fire. Later discovered to be usable, they added flair to many apartment buildings in Seattle.

77. *Seattle Post-Intelligencer*, June 30, 1907.

78. Thanks to Tom Ferguson, longtime owner of the Carroll, who talked with the author and showed her around the building.

79. The Carroll's advertisement appeared in the *Seattle Times*, August 9, 1925.

80. Kreisman, *Made to Last*, 50.

81. St. Ingbert plans viewed at the City of Seattle Department of Planning and Development.

82. At opening, the spelling was *Royvue*. It soon appeared in *Seattle's Polk City Directory* as the Roy-Vue, but *Roy Vu* and *Royview* have also been sighted as options.

83. *Seattle Times*, October 19, 1924.

84. The layout of the building and grounds, and the interior spaces, are described based on Haynes' plan of the Roy-Vue, studied at the City of Seattle Department of Planning and Development.

85. *Seattle Daily Journal of Commerce*, April 14, 1924, 1.

86. *Seattle Times*, October 19, 1924.

87. A. M. Atwood, vice president of John Davis and Company, authored "Atwood Sees Apartments for Investment in Demand," for the *Seattle Post-Intelligencer*, April 12, 1931.

88. *Seattle Post-Intelligencer*, April 12, 1931.

89. *Seattle Sunday Times*, April 12, 1931.

90. Whiffen, *American Architecture since 1780*, 235. Whiffen uses the term *Modernistic* rather than *Moderne*.

91. Woodbridge and Montgomery, *Guide to Architecture in Washington State*, 161.

92. *Seattle Sunday Times*, April 12, 1931.

93. Bain, *Building Together*, 96.

94. Author conversation August 20, 2010, with Beverly Strain, who would go to the Belroy to babysit for her aunt.

95. *Seattle Times*, October 12, 1930.

96. *Seattle Times*, August 9, 1925.

97. D'Arcy Larson and her mother moved into the Roundcliffe in 1940, one year beyond the scope of this book, but her memories are a wonderful reflection on the building and the neighborhood's history. Accounts are from telephone conversations and written correspondence between Larson and the author.

98. *Seattle Daily Journal of Commerce*, February 14, 1925, 1.

99. The Ben Lomond's precarious site became even more so when Interstate 5 construction left it propped "over the freeway [so] that a special cylinder retaining wall of concrete and steel was required to hold up the hill

beneath it," according to Paul Dorpat's "Now and Then" column in the *Seattle Times*, April 11, 2004.

100. *Seattle Times*, September 29, 1929. Advertisement was for a new apartment building in the University District.

101. *Seattle Times*, March 14, 1909.

102. *Seattle Post-Intelligencer*, May 1, 1910. In 1914 the building code would require specific yard space, or in its absence, a safe, convenient and healthy place for tenants' play and recreation.

103. Ben Lomond, U.S. Census of Population, *Fourteenth Census of the United States: 1920*, Population Schedule, Washington, King Co., Seattle, ED #178, sheet 4A and 4B (T625, roll 1927), database: http://persiheritagequestonline.com: 2011.

104. *Real Property Survey, 1939–40*, 42.

105. Massey and Maxwell, "Houses of Homes," *Old House Journal*, 28.

106. A quick run through the list of apartment names in the 1939 edition of *Seattle's Polk City Directory* proves that numerous names were used more than once, whereas there could absolutely be only one 750 Belmont.

107. Bagley, *History of Seattle*, 656.

108. Bamberg, U.S. Census of Population, *Fourteenth Census of the United States: 1920*, Population Schedule, Washington, King Co., Seattle, ED #179, sheet 8A and 8B (T625, roll 1927), database: http://persiheritagequeston line.com: 2011.

109. Serendipitously, the author was invited in to view two units of the Bamberg. Unfortunately, the author failed to record the names of the two kind and willing residents.

110. *Seattle Post-Intelligencer*, August 20, 1916.

Chapter 8

1. The name *Capitol Hill* had first been used by Arthur Denny. According to historian Edmond Meany, Denny had set aside a portion of his donation land claim and called it Capitol Hill. But that was in 1889, and by the time Moore purchased his property, Denny's claims had acquired new names and Moore was free to use *Capitol Hill*. For more about the naming of Capitol Hill, see Williams, *Hill with a Future*, 15–16.

2. *Seattle Post-Intelligencer*, July 11, 1900. The property, owned by the Selim Woodworth Estate, had been tied up in legal disputes for over forty years. For more on the story, see Williams, *Hill with a Future*, 11–12.

3. Moore had also set limits on the cost of a residence and the number of feet that homes had to be set back from the sidewalk.

4. Volunteer Park, the site of the Seattle Asian Art Museum, attracts visitors as well as nearby residents, and Cal Anderson Park (originally Lincoln Park), with its playing fields and handsome new fountain, draws scores of people year round.

5. Department of Neighborhoods Historical Site Search (http://web1.seattle.gov/dpd/historicalsite/), Savidge Dealership.

6. Larry Kreisman and Richard Gustave, "Perspectives: The Built Forms; Southwest Capitol Hill," Urban Design Workshop, Fall 1978.

7. Seattle's Elliott Bay Bookstore moved from its longtime Pioneer Square location to the heart of Auto Row in the summer of 2010.

8. The Landmark Nomination form, prepared by BOLA Architecture and Planning, June 2007, for 1205 East Pine Street (the Packard Building) states that it may never have been used as a showroom and garage for the

Packard Company, even though it was designed — and used — as a showroom and garage for other makes of car, p. 8, http://www.seattle.gov/neighborhoods/preservation/lpbCurrentNom1205%20E%20Pine%20text.pdf.

9. The Auto Row Apartments, listed at 1510 Twelfth Avenue in the 1930 city directory, is extant but has a different name.

10. Roe's name appears at the Roe's address in the 1909 *Polk's Seattle City Directory*.

11. When the Roe appeared in the 1909 city directory, it was listed at 912 East Pike; today its address is 910, despite the numbers that remain on the door frame.

12. Earlier, the Fisk Rubber Company operated at 719 East Pike.

13. Bluff: Property Record Card, Puget Sound Regional Archives.

14. Brand, *How Buildings Learn*, 2.

15. On December 19, 1972, the *Seattle Times* reported that a high wind toppled a fifteen-foot section of the parapet on the east side of the Bluff, and that firefighters removed an additional section loosened by the wind. More likely it was the cornice, which "extended about three feet from the roof," rather than the parapet, which still exists. This helps to explains the rather scabbed effect at the top of the building.

16. *Seattle Times*, August 23, 1909.

17. *Pacific Builder and Engineer*, September 8, 1906, 8. It is a fact that at times architects' plans do not come to fruition. But the date, description, owner, and location all point to Breitung and Buchinger's plans being implemented.

18. *Seattle Times*, March 3, 1907. A drawing of "A.M. Birkel's Flat Building" carried a caption with the information about location and number of rooms.

19. The door is still in place but blocked from the inside.

20. Peter Staten, "Found Architecture," a blocked-off story within the larger article "A Neighborhood Rediscovered," *Seattle Weekly*, June 19, 1991, 37.

21. *Seattle Times*, March 3, 1907.

22. *Seattle Times*, October 22, 1937.

23. BOLA Architecture and Planning, Landmark Nomination for 1200 East Pike Street, Seattle, January 2008, 7.

24. Winquist and Turner likely named the building after two admirals: Bristol, who was active during the Spanish-American War, and Farragut, a participant in the American Civil War.

25. The Union Arms (614 East Union) and the Union Manor (604 East Union), constructed in 1926, also has two separate entrances and two different names but is one building.

26. Flat gauged arches are considered some of the most difficult to create because each voussoir, or unit of the arch, is a different size. This would imply that the owners did not cut costs when they built the Bristol Farragut.

27. Bristol Farragut, U.S. Census of Population, *Thirteenth Census of the United States: 1910*, Population Schedule, Washington, King Co., Seattle, ED #126, sheet 5A, line 56 (T624, roll 1660), database: http://persiheritagequestonline.com: 2011. Sexton's wife listed her occupation as "real estate" in the census.

28. *Seattle Times*, April 9, 1909.

29. *Seattle Times*, June 28, 1914.

30. *Seattle Post-Intelligencer*, November 11, 1906.

31. Master is the title for the captain of a merchant ship.

32. The 1910 *Polk's Seattle City Directory* provided information about the Brydsens. The same directory

showed that the president and general manager of the Straits Steamship Company was Joshua Green, an influential early Seattleite.

33. *Pacific Builder and Engineer*, October 27, 1906.

34. *Seattle Times*, August 18, 1907.

35. Gordon: Property Record Card, Puget Sound Regional Archives.

36. *Seattle Post-Intelligencer*, February 2, 1908.

37. Galer Street is still the termination point of the Fifteenth Avenue Capitol Hill Line, today's Metro bus 10.

38. A grocery store was on this site as early as 1906.

39. Announcement for Laurelton in the *Seattle Times*, February 5, 1928.

40. *Seattle Times*, August 19, 1928.

41. *Seattle Times*, February 5, 1928.

42. *Seattle Times*, August 26, 1928. Although Arensburg claimed to have designed and built the Buckley, Merritt's name is clearly on the plans, viewed at the City of Seattle Department of Planning and Development.

43. *Seattle Times*, September 2, 1928.

44. *Seattle Times*, September 2, 1928.

45. Description of the Buckley is from *Seattle Times*, August. 26, 1928.

46. Both quotes in the paragraph describing the Sheffield are found in the *Seattle Times*, September 8, 1929. Again Arensburg takes credit for the design and construction, while Merritt's name is listed in a paragraph between Coast Radio, which supplied the radio receiving set in the lobby, and the cement contractor.

47. Descriptions of Sheffield from *Seattle Times*, September 8, 1929. Mr. Arnsberg also designed a coat of arms that was painted on the wall over the fireplace.

48. *Seattle Times*, October 12, 1930.

49. City of Seattle Department of Planning and Development, permits 17095 and 33782.

50. Knipe received permit 101326 for an 84 ×90 building at 409 Sixteenth Avenue on March 29, 1911. Another permit, 106744, also dated 1911, is for a building measuring 42 ×30. The September 9, 1911, issue of *Pacific Builder and Engineer* featured a two-page article extolling the apartment's virtues but did not mention the Annex.

51. Pedrara onyx comes from a quarry in Baja California Norte, Mexico.

52. *Pacific Builder and Engineer*, September 9, 1911, 117.

53. *Pacific Builder and Engineer*, September 9, 1911, 117.

54. *Seattle Post-Intelligencer*, March 24, 1912.

55. *Seattle Times*, June 7, 1923.

56. *Bagley's History of Seattle*, 3:884.

57. *Seattle Times*, October 4, 1908. In 1908 Ragley had toured eastern cities to learn more about real estate. When he returned he said that Seattle apartment rentals were too high because "we have boosted property way up in what we call the apartment house district — the semi-business portion of Seattle."

58. *Seattle Times*, October 29, 1922.

59. As a team, Stuart and Arthur Wheatley designed a remarkable number of apartment buildings during the height of Seattle's growth. The work they did for Levy shows up on plans of the Ragley viewed at the City of Seattle Department of Planning and Development.

60. *Seattle Times*, September 3, 1922. Today the Ragley has nineteen units.

61. *Seattle Post-Intelligencer*, May 28, 1905. Monroe owned the property.

62. *Seattle Post-Intelligencer*, May 10, 1908.

63. Five of the Fredonia's twelve units are rented at market rate.

64. *Seattle Post-Intelligencer*, May 28, 1905.

65. *Seattle Post-Intelligencer*, July 1, 1906.

66. *Seattle Times*, September 3, 1922, advertisement for the unnamed Monroe Apartments.

67. *Seattle Post-Intelligencer*, December 22, 1907.

68. *Seattle Post-Intelligencer*, February 2, 1908.

69. *Seattle Times*, June 28, 1914.

70. *Seattle Post-Intelligencer*, February 2, 1908.

71. *Seattle Post-Intelligencer*, June 30, 1907.

72. *Seattle Times*, September 8, 1907. The photograph of the La Crosse looks much the same as a drawing that appeared in the *Seattle Times* on March 17, 1907.

73. Thanks to Dotty DeCoster for sharing her memories of living in the La Crosse around 1974.

74. *Seattle Post-Intelligencer*, June 30, 1907.

75. *Seattle Times*, May 2, 1920.

76. In the 1910 census, Purdy was not listed among the residents of the La Crosse.

77. *Seattle Times*, June 8, 1930.

78. *Seattle Times*, October 19, 1930.

79. *Real Property Survey, Seattle, Washington, 1939–40*, sponsored by Housing Authority of the City of Seattle, Jesse Epstein, executive director, table A-2: "Number and Percentage Distribution by Year Built, by Type of Structure, for all Structures."

80. *Seattle Times*, October 12, 1930, 5.

81. City of Seattle Department of Planning and Development, building plans for the Bering.

82. Pat Siggs, Bering resident, said that the mailboxes had been restored.

83. Thanks to Pat Siggs and Joan Trunk for giving the author a grand tour of the building and their penthouse unit.

84. *Seattle Times*, October 6, 1907.

85. Williams, *Hill with a Future*, 171–172.

86. Meany/Longfellow School opened in 1902; the Pendleton Miller family donated the playfield in 1906. For more on the school, playfield, theater, and even a riding stable, see Williams, *Hill with a Future*.

87. Artificial stone blocks, made to resemble natural cut stone, were popular in the 1920s. The product was versatile, durable, and resisted weathering. It was used for both ornament and facing. The blocks were manufactured of cement and fine aggregate, creating an essentially concrete product.

88. Plans for the Montrachet are at the City of Seattle Department of Planning and Development.

89. Dag Randolph, an eighteen-year resident at the Montrachet, generously opened her home to the author.

90. An interesting period in the life of the Park Apartment Building occurred in the late 1960s and early 1970s. In return for low rent, an artists' cooperative agreed to maintain and repair the building, which was on the verge of condemnation. The group was responsible for painting the extant relief mural on the south wall. http://www.pelicanbayfoundation.org/assets/history.html.

91. Susan Bradford, assistant manager of the Park and the Jennot apartments, kindly showed the author around both buildings—more than once.

92. *Seattle Post-Intelligencer*, April 20, 1913, advertisement for the then Chalmers.

93. Marshall, *Elbridge A. Stuart, Founder of the Carnation Company*, 104. Stuart, a Capitol Hill resident, organized the group that funded and built the garage. The former garage has adjusted to the times and needs of the neighborhood. For many years it was a "rest home." Today it is an apartment building.

94. Mercerwood: Property Record Card, Puget Sound Regional Archives. In 1945 the building added two apartments by moving the laundry room from the second floor to the first floor. Two kitchens and two closets were cre-

ated out of the former laundry room, and other units, no doubt, donated some of their space, resulting in smaller units all around.

95. No plans for the Mercerwood are available, but thanks go to the building's owner for a look around one of the units and the information that Mr. Hyde had lived in the same corner suite.

96. Williams, *Hill with a Future*, 172.

97. *Seattle Daily Times*, April 17, 1910.

98. *Seattle Daily Journal of Commerce*, December 31, 1923, 1.

99. *Seattle Times*, April 1, 1923.

100. Today the cornice of the Lorrimer is a reduced version of its original, and the multipaned leaded-glass windows on the first-floor facade are missing.

101. *Seattle Times*, April 17, 1910.

102. *Seattle Post-Intelligencer*, May 10, 1910.

103. Residents Tanya Flanagin and Elden Bossum and son Gabriel warmly welcomed the author into their nifty unit in the Wenzel, now the Casa de Cinque, and offered insights regarding their building.

104. *Seattle Post-Intelligencer*, May 1, 1910.

105. *Seattle Post-Intelligencer*, May 1, 1910.

106. Mildred Andrews, "Woman's Century Club (Seattle)," HistoryLink.org, essay 408 (December 2, 1998), http://historylink.org/index.cfm?DisplayPage=output.cfm&file_id=408.

107. The Seattle Art Museum remained at the Volunteer Park location until 1991, when it moved to larger downtown quarters. After refurbishing the Art Deco structure, the Seattle Asian Art Museum moved into the space in 1994.

108. Loveless: Property Record Card, Puget Sound Regional Archives. Wood used on the exterior of the Loveless building is described as "hewn logs."

109. Larry Brown, *Seattle Times, Pacific Magazine*, "Truly Loveless," June 1, 1986.

110. Judy Amster provided much information and a tour of her unit at the Loveless.

111. Amster says that the stained-glass medallions in the windows supposedly were created by Loveless himself.

112. Glauber, *Witch of Kodakery*, 102, 104.

113. "Seattle Apartments All English in Rank by Themselves," *Building Economy* 7, no. 7 (August 1931): 4–5.

114. Kreisman, *Apartments by Anhalt*, 23.

115. Lambert, *Built by Anhalt*, 72–73.

116. Lambert, *Built by Anhalt*, 63.

117. Lambert, *Built by Anhalt*, 72.

118. Lambert, *Built by Anhalt*, 88–89.

119. *Seattle Times*, March 22, 1925.

120. Building plans for these apartments are not available, but an advertisement for 722 Tenth Avenue East said the three-room units had a combined living room/bedroom. The four-room units had a separate bedroom.

121. Units in the two built by Holroyd are slightly smaller (677 square feet) compared to the other seven (704 square feet).

122. *Seattle Times*, July 18, 1926.

123. *Seattle Times*, December 19, 1926.

124. The author toured one of the basement efficiency units.

125. Davis is a Spokane architect who has been pursuing independent research on the life and career of Earl W. Morrison.

126. Doucet, *Housing the North American City*, 397.

127. *Seattle Times*, August 17, 1924.

128. *Seattle Times*, January 14, 1923.

129. In addition to Schuett's older daughter being married to an architect, his younger daughter, Henryetta, married Seattle builder-architect Fred Anhalt. A second marriage for her, a notice of intent to marry was in the *Seattle Times* in November 1969. She is listed as wife of Fred in her obituary, October 28, 1981.

130. For the ultimate example of an apartment conversion, see "Hearst's Highrise" in Andrew Alpern's *Historic Manhattan Apartment Houses*, 30–32.

131. Plans for the Park Court viewed at the City of Seattle Department of Planning and Development.

132. *Seattle Times*, August 24, 1919.

133. *Seattle Times*, May 11, 2003. "Northwest Living," 24–27. The Youngs also built the Fairmont Apartments, one building north of the Washington Arms, which they originally called the Washington Arms Annex.

134. *Seattle Times*, August 24, 1919.

135. Washington Arms: Property Record Card, Puget Sound Regional Archives. The card records that two three-room apartments and fourteen sleeping rooms and baths were in the basement.

136. Voorhees' plans for the Washington Arms, viewed at the City of Seattle Department of Planning and Development, are remarkably clear. But the information from the Property Record Card, executed in 1936, does not entirely agree with Voorhees' plans for the basement, which conceivably could have changed before construction even began.

137. *Seattle Times*, April 5, 1931.

138. *Seattle Times*, April 5, 1931.

Chapter 9

1. A new form of transportation, Seattle's light rail system, arrived on Beacon Hill in 2008, when the neighborhood became one of the stops between downtown and the Seattle-Tacoma Airport.

2. Jefferson Park was part of John Charles Olmsted's park plan that the city adopted in 1903.

3. The late date of the Jefferson Park's construction suggests that cast stone rather than terra cotta would be the material used for the decorative highlights, but the *Daily Journal of Commerce*, August 21, 1923, 1, said it would be "faced with terra cotta."

4. A sleeping porch, usually a deck or balcony used as a cool place to sleep in warmer months, tended to be just another room in Seattle, with the distinction that windows filled the outside wall.

5. The University District's borders encompass the large area defined on the north by Cowen Park and by the waters of Portage Bay and Lake Union to its south. Montlake Boulevard, which segues into Twenty-fifth Avenue Northeast, is the eastern boundary. Since its construction in the 1960s, Interstate 5 became the western boundary. The University of Washington campus dominates the southeast quadrant of the large space.

6. *University District Historic Survey Report*, September 2002, 14.

7. See Dotty DeCoster's account of the life of Corinne Simpson in the history of the Wilsonian, www.historylink.org/index.cfm?DisplayPaage=output.cfm&file_id=8878.

8. *Seattle Post-Intelligencer*, August 26, 1923.

9. *Hotel News of the West*, April 26, 1924, 14.

10. The Washington Brick, Lime and Sewer Pipes Company of Spokane, Washington, manufactured the "Waco Varsity Face Brick" used on the Wilsonian.

11. Nielsen, *UniverCity*, 67.

12. In 2005–2006, the ballroom, on the north side of the Wilsonian, was razed to make way for a mixed-use development.

13. *Seattle Times*, December 7, 1924.

14. Descriptions of the lobby and interiors of units are from *Hotel News of the West*, April 26, 1924, 14–15.

15. *Seattle Times*, September 30, 1923.

16. Wilsonian, U.S. Census of Population, *Fifteenth Census of the United States: 1930*, Population Schedule, Washington, King Co., Seattle, ED #17–57, sheet 13B, line 42 (T625, roll 1926), database: http://persiheritagequestonline.com: 2011.

17. *Mount Baker Historic Context Statement*, prepared by Caroline Tobin, 21.

18. *Seattle Times*, January 29, 1939.

19. *Seattle Times*, January 29, 1939.

20. Brand, *How Buildings Learn*, 80.

21. Grose, also spelled Gross, was born in Washington, D.C., in 1835. He came to Seattle in 1861, the "city's second black resident and eventually its wealthiest nineteenth-century African American." He opened a restaurant and hotel near the waterfront, in which he and his family lived. After the hotel was destroyed in the Seattle Fire of 1889, Grose settled on his ranch "on the northeastern outskirts of Seattle," which became the prestigious community in which the Woodson was built. Grose biographical notes from Quintard Taylor's *The Forging of a Black Community*, 16, 34.

22. Berner, *Seattle, 1900–1920*, 73–74.

23. Lawson, *Let's Take a Walk!* 34.

24. Cayton, *Selected Writings*, 2:58.

25. A 1977 drawing of the Woodson is on microfilm at the City of Seattle Department of Planning and Development, submitted in connection with the installation of a fire door and wall at the apartment building. The drawing confirms the lengthy hall that runs from front to rear.

26. Horace Cayton, a leading citizen in the black community, helped to organize the Lincoln Industrial Fair Association. It marked the sixtieth anniversary of the Negro emancipation, and it was hoped that the event would stimulate growth and development of black-owned businesses. Woodson himself conducted one of the symposia, "The Negro Business Man."

27. One of the four boarders in Woodson's unit listed his occupation as minister of the A.M.E. Zion Church. Seattle's Mt. Zion A.M.E. Baptist Church was established prior to 1910 and was located not too far from the Woodson Apartments.

28. Woodson, U.S. Census of Population, *Twelfth Census of the United States: 1910*, Population Schedule, Washington, King Co., Seattle, ED #93, sheet 4B, line 60 (T624, roll 1659), database: http://persiheritagequestonline.com: 2011.

29. Blanchard, *Street Railway Era in Seattle*, 67.

30. *Seattle Times*, August 5, 1928.

31. *Seattle Times*, October 2, 1927.

32. Plans for the Friedlander viewed at the City of Seattle Department of Planning and Development.

33. Lange, "Early Seattle Neighborhood Buildings Historic Resource Survey Context Statement," 2005, 7.

34. Streetcars of Queen Anne from http://qahistory.org/streetcars.htm.

35. A thorough search of the *Seattle Times* archives found no mention of the De la Mar serving as a type of private hotel, or of any guests who might have come at Kinnear's invitation. Perusing early newspapers reveals that social events, from the smallest card party to large dances, were duly recorded. Kinnear's guests and their activities would surely have merited mention in the society pages. Seattle architectural historian Dennis Andersen researched other sources, from *Pacific Builder and Engineer* to society journals, and found no information to corroborate the earlier claim that Kinnear built the De la Mar to serve as a hostelry for his friends and guests during the AYP Exposition.

36. *Seattle Times*, February 15, 1910.

37. De la Mar, U.S. Census of Population, *Thirteenth Census of the United States:1910*, Population Schedule, Washington, King Co., Seattle, ED #150, sheet 9A (T624, roll 1659), database: http://persiheritagequestonline.com: 2011.

38. *Seattle Post-Intelligencer*, September 28, 1909.

39. The author has not been able to confirm the original number of units in the De la Mar. Today there are thirty-nine, but some of those have been built in the former ballroom space, and the number may also be the result of reconfiguring the size of the early apartments units.

40. U.S. Census of Population, *Fourteenth Census of the United States:1920*, Population Schedule, Washington, King Co., Seattle, ED #156, sheets 3A and 3B (T625, roll 1927), database: http://persiheritagequestonline.com: 2011.

41. Ochsner, ed., *Shaping Seattle Architecture*, xxvii. Gould, a Harvard graduate who also attended the École des Beaux-Arts, established the School of Architecture at the University of Washington in 1914, which he chaired until 1926.

42. In the wide hallways, gravity-operated pocket doors served as fire doors. Information gathered by author during several visits to the De la Mar.

43. Dorpat, "Seattle Neighborhoods: University District-Thumbnail History," HistoryLink.org, essay 3380.

44. Valencia, U.S. Census of Population, *Fourteenth Census of the United States: 1920*, Population Schedule, Washington, King Co., Seattle, ED #123, sheet 4A, line 42 (T625, roll 1926), database: http://persiheritagequestonline.com: 2011.

45. The Guild 45th (née Paramount) Theater has been in continuous operation since it was built (various sources give 1919, 1920, and 1921 as the construction date).

46. The Columbia City Historic District was listed in the National Register of Historic Places in 1980.

47. E-mail communication dated February 11, 2005, from Buzz Anderson, lifelong resident of Columbia City. Anderson also wrote that the building originally was called Nichol's Flats, but in 1916 it became Nichol's Apartments. It was still Nichol's in 1925, according to a *Seattle Times* article, but listed as the Angeline in the 1930 *Polk's City Directory*.

48. Property Record Card, Puget Sound Regional Archives, gives 1910 as the Angeline's construction date.

49. Nichols not only supplied steam heat for his apartment building, he extended the line south on Rainier Avenue, providing heat for Ed Welch's Columbia Garage, the Masonic Lodge, and the Toby Building, according to Buzz Anderson and related in his 2005 e-mail.

50. Permit 328280, recorded on Property Record Card, Puget Sound Regional Archives, describes the alterations at the Angeline.

51. Photos of the Angeline observed at the office of the Rainier Valley Historical Society show that in 1980 it still had a flat roof.

52. *Seattle Times*, March 23, 1925.

53. Blanchard, *Street Railway Era in Seattle*, 63.

54. *Seattle Times*, April 22, 1928.

55. Westwood, U.S. Census of Population, *Fourteenth Census of the United States: 1920*, Population Schedule, Washington, King Co., Seattle, ED #123, sheet 4A, line 42 (T625, roll 1926), database: http://persiheritage questonline.com: 2011.

56. *Seattle Times*, July 18, 1909.

57. Cone, Droker, and Williams, *Family of Strangers*, 138.

58. The building still stands, but as the neighborhood dynamics changed, the synagogue became redundant. The Seattle Parks Department bought the building and converted it into the Langston Hughes Cultural Arts Center.

59. The Yesler Library, since renamed Douglass Truth, continues as a branch of the Seattle Public Library. Quote from "Douglass-Truth Branch, the Seattle Public Library," HistoryLink.org, essay 4056, http://historylink.org/index.cfm?DisplayPage=output.cfm&file_id=4056.

60. A biography of Edward Brady is in Bagley's *History of Seattle*, 310–11.

61. Monmouth: Property Record Card, Puget Sound Regional Archives.

62. Sarah Benezra's memories of the Monmouth e-mailed to Jacqueline Williams.

63. Carter, "Changing Vernacular," *Common Ground*, 13.

Bibliography

Abbott, Carl. *Urban America in the Modern Age: 1920 to the Present.* Arlington Heights, IL: Harlan Davidson, 1987.

Aldredge, Lydia S., ed. *Impressions of Imagination: Terra-Cotta Seattle.* Seattle: Allied Arts of Seattle, 1986.

Alpern, Andrew. *Historic Manhattan Apartment Houses.* New York: Dover, 1996.

American Architect. "Are Apartments Necessary?" Vol. 98, no. 2326 (July 21, 1920).

American Architect and Building News. "The Radical Evil of Life in Apartment-Houses." Vol. 91, no. 1619 (January 5, 1907).

American Architect and Building News 91, no. 1625 (February 16, 1907).

American Institute of Architects. "History of the American Institute of Architects." Web page of the AIA. www.aia.org/print_template.cfm?pageame=about_history.

American Institute of Architects, Washington State Chapter. *The Monthly Bulletin.* September 1922.

Andersen, Dennis, and Kate Krafft. "Pattern Books, Plan Books, Periodicals." In *Shaping Seattle Architecture: A Historical Guide to the Architects,* ed. Jeffrey Karl Ochsner. 2nd printing. Seattle: University of Washington Press, 1998.

Anderson, Buzz. E-mail communication, dated February 11, 2005.

Andrews, Mildred, ed. *Pioneer Square: Seattle's Oldest Neighborhood.* Seattle: Pioneer Square Community Association, 2005.

Architect and Engineer, March 1939.

Architectural Forum 41, no. 5 (November 1924).

Architectural Forum. "Distinctive Wall Effects: The Tiffany Finish." Advertising Supplement, Vol. 42, no. 3 (September 1925).

Architectural Record. "Over the Draughting Board." Vol. 13, no. 1 (January 1903).

Architectural Record. "The Apartment House." Vol. 27, no. 3 (March 1910).

Armbruster, Kurt E. "Orphan Road: The Railroad Comes to Seattle." *Columbia: The Magazine of Northwest History,* Winter 1997.

AYPE Souvenir Cook Book. Seattle, 1909.

Baar, Kenneth, "The National Movement to Halt the Spread of Multifamily Housing, 1890–1926." *Journal of the American Planning Association* 58, no. 1 (Winter 1992).

Bagley, Clarence B. *History of Seattle: From the Earliest Settlement to the Present Time.* 3 vols. Chicago: S.J. Clarke, 1916.

Bain, William J., and Mildred C. Bain. *Building Together: A Memoir of Our Lives in Seattle.* Seattle: Beckett, 1991.

Baist, G. William. *Baist's Real Estate Atlas of Surveys of Seattle.* Philadelphia: W. E. and H. V. Baist, 1905, 1908, 1912.

Bard, Mary. *The Doctor Wears Three Faces.* Philadelphia: J. B. Lippincott, 1949.

Barr, Colin. "Elmer Ellsworth Green." In *Building the West: The Early Architects of British Columbia,* ed. Donald Luxton. Vancouver, BC: Talonbooks, 2003.

Barth, Gunther. *City People: The Rise of Modern City Culture in Nineteenth-Century America.* New York: Oxford University Press, 1980.

Beecher, Catherine, and Harriet Beecher Stowe. *The American Women's Home.* New York: J. B. Ford, 1869.

Berner, Richard C. *Seattle 1900–1920: From Boomtown, Urban Turbulence, to Restoration.* Seattle: Charles Press, 1991.

———. *Seattle 1921–1940: From Boom to Bust.* Seattle: Charles Press, 1992.

Blanchard, Leslie F. *The Street Railway Era in Seattle: A Chronicle of Six Decades.* Forty Fort, PA: H.E. Cox, 1968.

Blumenson, J. G. *Identifying American Architecture: A Pictorial Guide to Styles and Terms 1600–1945.* 2nd ed. New York and London: Norton, 1981.

Bock, Gordon. "Past Perfect: Go with the Flow." *Old House Journal,* http://www.oldhousejournal.com/Past_Perfect/magazine/1388.

BOLA Architecture + Planning. The Landmark Nomination form, for 1205 E. Pine Street (the Packard Building). http://www.seattle.gov/neighborhoods/preservation/lpbCurrentNom1205%20E%20Pine%20text.pdf (June 2007).

Bosker, Gideon, and Lena Lencek. *Frozen Music: A History of Portland Architecture.* Portland, OR:

Western Imprints, the Press of the Oregon Historical Society, 1985.

Brand, Steward. *How Buildings Learn: What Happens After They're Built*. Willard, OH: R. R. Donnelly & Sons, 1994.

Brandt, Jonathan E. "The New Belle Hotel, Hybrid Building for Belltown." M.A. thesis, University of Washington, 1993.

Broderick, Henry. *Mirrors of Seattle's Old Hotels*. Seattle: Dogwood Press, 1965.

_____. *A Slice of Seattle History by "HB."* Seattle: Dogwood Press, 1960.

Broderick, Henry, Inc.; a Kroll Map Co. Production. *Greater Business District of Seattle* (Map 1939). Seattle: Kroll Map Co.

Buerge, David M. *Seattle in the 1880s*. Edited by Stuart R. Grover. Seattle Historical Society of Seattle and King County, 1986.

Buffalo Illustrated Architecture Dictionary, http://www.buffaloah.com/a/DCTNRY/vocab.html.

Building Economy. "Seattle Apartments All English in Rank by Themselves." Vol. 7, no. 7 (August 1931).

Capitol's Who's Who for Seattle 1939–1941: A Reference Work. Portland, OR: Capitol Publishing, 1939.

Carter, Thomas, interviewed by Catherine Lavoie and Beth Savage. "Changing Vernacular." *Common Ground: Preserving Our Nation's Heritage*, Winter 2004, 13.

Cayton, Horace Roscoe. *Selected Writings; Special Editions and Year Books: 1896, 1917, 1920, 1923*. Vol. 2. Compiled and Edited by Ed Diaz. Seattle: Bridgewater-Collins, 2002.

Chin, Doug. *Seattle's International District: The Making of a Pan-Asian American Community*. Seattle: International Examiner, 2001.

Choir's Pioneer Directory of the City of Seattle and King County. Pottsville, PA, Miner's Journal Book, 1878.

Condit, Carl W. *The Chicago School of Architecture: A History of Commercial and Public Building in the Chicago Area, 1875–1925*. Chicago: University of Chicago Press, 1964.

Cone, Molly, Howard Droker, and Jacqueline Williams. *Family of Strangers: Building a Jewish Community in Washington State*. Seattle: University of Washington Press, 2003.

Courtois and Associates and CH2M Hill Inc., preparers. *Final Technical Report, Historic and Prehistoric Archaeological Sites, Historic Resources, Native American Traditional Cultural Properties, Paleontological Sites*. Seattle: Central Puget Sound Regional Transit Authority, 1999.

Cowan, Ruth Schwartz. *More Work for Mother: The Ironies of Household Technology from the Open Hearth to the Microwave*. New York: Basic Books, 1983.

Cromley, Elizabeth Collins. *Alone Together: A History of New York's Early Apartments*. Ithaca, NY: Cornell University Press, 1990.

_____. "The Cities and Suburbs." In *Encyclopedia of Urban America*, ed. Neil Larry Shumsky, vol. 1. Santa Barbara, CA: ABC-CLIO, 1998.

Davies, Kent R. "Sea of Fire." *Columbia: The Magazine of Northwest History*, Summer 2001, 32–38.

DeCoster, Dotty. "Wilsonian Apartment Hotel (Seattle)." HistoryLink.org, essay 8878, July 29, 2009, http://www.historylink.org/index.cfm?DisplayPage=output.cfm&file_id=8878.

De Long, Willard W. *Seattle Home Builder and Home Keeper, by W.W. De Long and Mrs. W. W. De Long*. Seattle: Commercial Publishing, 1915.

Desmond, E. M. *Seattle Leaders*. Seattle: Pioneer Printing, 1924.

Dietz, Duane. "Architects and Landscape Architects of Seattle, 1876 to 1959: An Annotated List Compiled from City Directories." Unpublished paper, Seattle, 1994.

_____. "William J. Bain, Sr." In *Shaping Seattle Architecture: A Historical Guide to the Architects*, ed. Jeffrey Karl Ochsner. 2nd printing. Seattle: University of Washington Press, 1998.Dolkart, Andrew S. *Morningside Heights: A History of Its Architecture & Development*. New York: Columbia University Press, 1998.

Donaldson, Barry, and Bernard Nagengast. *Heat and Cold: Mastering the Great Indoors*. Atlanta, GA: American Society of Heating, Refrigerating and Air-Conditioning Engineers, 1994.

Dorpat, Paul, and Genevieve McCoy. *Building Washington: A History of Washington State Public Works*. Seattle: Tartu Publications, 1998.

_____. "Seattle Neighborhoods: Republican Hill Climb." HistoryLink.org, essay 3261, May 6, 2001, www.historylink.org/essays/output.cfm?file_id=3261.

_____. "Seattle Neighborhoods: University District — Thumbnail History." HistoryLink.org, essay 3380, June 18, 2001, http://historylink.org/index.cfm?DisplayPage=output.cfm&file_id=3380.

_____, ed. *Legacy: The Kreielsheimer Foundation*. Seattle: Kreielsheimer Remainder Foundation, University of Washington Press, 2006.

Doucet, Michael, and John Weaver. *Housing the North American City*. Montreal: McGill-Queen's University Press, 1991.

Dubrow, Gail, and Alexa Berlow, "Vernacular and Popular Architecture in Seattle." In *Shaping Seattle Architecture: A Historical Guide to the Architects*, ed. Jeffrey Karl Ochsner. 2nd printing. Seattle: University of Washington Press, 1998.

Dunn, Edward B. *1121 Union: One Family's Story of Early Seattle's First Hill*. Seattle: E.B. Dunn Historic Garden Trust, 2004.

Durham, Irene Somerville. "Community Clubs in Seattle." M.A. thesis, University of Washington, 1929.

Eichler, Ned. *The Merchant Builders*. Cambridge, MA: MIT Press, 1982.

Faget, Paul. "Restructuring a Proud Building." *Seattle Daily Journal of Commerce*, "Design '96," November 7, 1996, http://www.djc.com/special/design96/10016902.html.

Fiske, J. Parker B. "Fashions in Face Brick." *Pacific Builder and Engineer* 7, no. 52 (December 26, 1908).

Fleming, John, Hugh Honour, and Nikolaus Pevsner. *The Penguin Dictionary of Architecture and Landscape Architecture*. 5th ed. London: Penguin, 1998.

Follett, Jean A. "The Hotel Pelham: A New Building Type for America." *American Art Journal* 15, no. 4 (Autumn 1983): 58–73.

Foy, Jessica H., and Thomas J. Schlereth. *American Home Life, 1880–1930: A Social History of Spaces and Services*. Knoxville: University of Tennessee Press, 1982.

Franklin, Linda. *300 Years of Kitchen Collectibles*. Florence, AL: Books Americana, 1991.

Fullerton, Janet Elda. "Transit and Settlement in Seattle, 1871–1941." Unpublished master's thesis, University of Washington, 1982.

Gaines, E. L. "Seattle Zoning Plan." *Pacific Builder and Engineer*, July 28, 1922, 7–8.

Gelernter, Mark. *A History of American Architecture: Buildings in Their Cultural and Technological Context*. Hanover: University Press of New England, 1999.

Giedion, Siegfried. *Mechanization Takes Command: A Contribution to Anonymous History*. New York: Norton, 1969.

Gilman, Elizabeth Hale. *Housekeeping: Many Years of Practical Experience in All Branches of Domestic Science*. New York: Doubleday, Page, 1916.

Glauber, Carole. *Witch of Kodakery: The Photography of Myra Albert Wiggins, 1869–1956*. Pullman: Washington State University Press, 1997.

Glickstein, Don. "Victor Voorhees: Architect in a Prosperous Seattle." *Columbia*, Winter 2003/4, 37–42.

Goldberger, Paul. *Why Architecture Matters*. New Haven, CT: Yale University Press, 2009.

Goode, James M. *Best Addresses: A Century of Washington's Distinguished Apartment Houses*. Washington, DC: Smithsonian Books, 1988.

Graham, John, and Company. *John Graham and Company: The First 80 Years*, 2.

Grier, Katherine C. *Culture & Comfort: People, Parlors, and Upholstery, 1850–1930*. Rochester, NY: Strong Museum, 1988.

Grimmer, Anne. *Preservation Briefs 22: The Preservation and Repair of Historic Stucco*. Washington, DC: National Park Service, U.S. Department of the Interior, 1990.

Groth, Paul. *Living Downtown: The History of Residential Hotels in the United States*. Berkeley: University of California Press, 1994.

Groth, Paul Erling. *Forbidden Housing: The Evolution and Exclusion of Hotels, Boarding Houses, Rooming Houses, and Lodging Houses in American Cities, 1880–1930*. Ph.D. dissertation, University of California, Berkeley.

Hancock, John. "The Apartment House in Urban America." In *Buildings and Society: Essays on the Social Development of the Built Environment*, ed. Anthony King, 151–189. London: Routledge and Kegan Paul, 1980.

Hanford, C. H. *Seattle and Environs, 1852–1924*. Vol. 1. Chicago and Seattle: Pioneer Historical Publishing, 1924.

Harris, Richard. "The End Justified the Means: Boarding and Rooming in a City of Homes, 1890–1951." *Journal of Social History* 26, no. 2 (Winter 1992).

Hawes, Elizabeth. *New York, New York, How the Apartment House Transformed the Life of the City (1869–1930)*. New York: Knopf, 1993.

Hayden, Dolores. *The Grand Domestic Revolution: A History of Feminist Designs for American Homes, Neighborhoods, and Cities*. 4th printing. Cambridge, MA: MIT Press, 1989. First MIT Press paperback edition, 1982.

Hayner, Norman S. *Hotel Life*. Chapel Hill: University of North Carolina Press, 1936.

Hebert, Budd. "Urban Morphology and Transportation." *Traffic Quarterly: An Independent Journal for Better Traffic* 30, no. 4 (1976): 633–648.

Hildebrand, Grant. "John Graham, Sr." In *Shaping Seattle Architecture: A Historical Guide to the Architects*, ed. Jeffrey Karl Ochsner. 2nd printing. Seattle: University of Washington Press, 1998.

Hines, Neal O. *Denny's Knoll: A History of the Metropolitan Tract of the University of Washington*. Seattle: University of Washington Press, 1980.

Historic Seattle Preservation and Development Authority. *An Urban Resource Inventory for Seattle, 1975*.

Hockaday, Joan. *Greenscapes: Olmsted's Pacific Northwest*. Pullman: Washington State University Press, 2009.

Horowitz, Daniel. *The Morality of Spending: Attitudes toward the Consumer Society in America*. Chicago: Ivan R. Dee, 1992. Originally published in 1885 by John Hopkins.

Hotel News of the West. "Flemington Thoroughly Modern." April 5, 1924.

Hotel News of the West. "Cambridge Apartments." July 26, 1924.

Hotel News of the West. "Penbrook Operates to Full Capacity under Supervision of Mrs. Anna J. Clebanck." September 6, 1924.

Hotel News of the West. "Apartment and Hotel Market Activity." October 18, 1924.

Hotel News of the West. "Sale of Three Major Hotel Properties Aggregating $500,000 Is Announced by Seattle Brokers." May 9, 1925.

Hotel News of the West. "Claremont Opens Doors with Music Program." January 20, 1926.

Hotel News of the West. April 24, 1926.

Hotel News of the West. August 14, 1926.

Hotel News of the West. "New Exeter Apartment-Hotel Is Opened in Seattle." April 29, 1928.

Hume, Harry. *Prosperous Washington: A Series of Articles Descriptive of the Evergreen State, Its Magnificent Resources, and Its Present and Probable Development.* 1906.

Hume, M. Compiler. *Seattle Architecturally, 1902.* Seattle: Bebb & Mendel, Saunders & Lawton, and De Neuf & Heide, 1902.

Journal of the American Institute of Architects, vols. 1–27, January 1944–1957. Published monthly at the Octagon, Washington, DC, May 1947.

Kahlo, Dorothy Miller. *History of the Police and Fire Departments of the City of Seattle.* Seattle: Lumberman's Printing, 1907.

Kennedy, Phillip D. *Hoosier Cabinets.* Indianapolis, IN: Phillip D. Kennedy, 1993.

Keys, Diana Lynn Wogulis. "Single Room Occupancy (SRO) Hotels: Seattle's Past, Present and Future." Unpublished master's thesis, University of Washington, 1993.

Kilham, Walter H. "The Planning of Apartment Houses." *Brickbuilder* 13, no. 1 (January 1904).

King County, Washington. *The King County Parcel Viewer: Interactive Property Research Tool,* http://www.kingcounty.gov/operations/gis/propresearch/parcelviewer.aspx.

Kittredge, Mabel Hyde, ed. *Housekeeping Notes: How to Furnish and Keep House in a Tenement Flat.* Boston: Whitcomb & Barrows, 1911.

Kreisman, Lawrence. *Apartments by Anhalt.* First published 1978 by the Office of Urban Conservation. 2nd printing, 1982. Copyright 1978, City of Seattle.

_____. *Made To Last: Historic Preservation in Seattle and King County.* Seattle: Historic Seattle Preservation Foundation in association with the University of Washington Press, 1999.

Kreisman, Larry, and Richard Gustave. "Perspectives: The Built Forms; Southwest Capitol Hill." Urban Design Workshop, Fall 1978.

Kreisman, Lawrence, and Glenn Mason. *The Arts and Crafts Movement in the Pacific Northwest.* Portland, OR: Timber Press, 2007.

Kurutz, Gary F. *Architectural Terra Cotta of Gladding, McBean.* Sausalito, CA: Windgate Press, 1989.

Lambert, Steve. *Built by Anhalt.* Seattle: Harstine House, 1982.

Lawson, Jacqueline E. A. *Let's Take a Walk! A Tour of Seattle's Central Area, as It Was Then (1920s, 1930s, and 1940s).* 3rd ed. Jacqueline E. A. Lawson, 5834 N. E. 75th Street, B-301, Seattle, Washington 98115–6394, July 2005.

Leininger, Jyl. "Life in Seattle and Environs in the 1930s, 1940s and beyond — as Told by Margaret Reed." HistoryLink.org, essay 2265, April 7, 1999, http://historylink.org/index.cfm?DisplayPage=output.cfm&file_id=2265.

Lubove, Roy. *The Progressives and the Slums: Tenement House Reform in New York City, 1890–1917.* Westport, CT: Greenwood Press, 1974.

Luxton, Donald, ed. *Building the West: The Early Architects of British Columbia.* Vancouver, BC: Talonbooks, 2003.

Luxton, Donald, and Dennis A. Andersen. "Emil Guenther." In *Building the West: The Early Architects of British Columbia,* ed. Donald Luxton. Vancouver, BC: Talonbooks, 2003.

Lynes, Russell. *The Domesticated Americans.* New York: Harper & Row, 1963.

McAlester, Virginia, and Lee McAlester. *A Field Guide to American Houses.* New York: Knopf, 1988.

MacIntosh, Heather. "Adaptive Reuse and the Cadillac Hotel." *Preservation Seattle: Historic Seattle's Online Monthly Preservation Magazine,* May 2003.

_____. "Seattle's Canyon of Dreams: Preservation along Second Avenue." *Preservation Seattle: Historic Seattle's Online Monthly Preservation Magazine,* May 2003.

McKelvey, Blake. *The Emergence of Metropolitan America, 1915–1966.* New Brunswick, NJ: Rutgers University Press, 1968.

McKnight, Reuben. "Brick and Stone Construction: 1851–1920." *Preservation Seattle: Historic Seattle's Online Monthly Preservation Magazine,* July 2003.

_____. "A Brief History of Concrete." *Preservation Seattle: Historic Seattle's Online Monthly Preservation Magazine,* June/July 2004.

_____. "Timber! A Brief Local History of the Building Material." *Preservation Seattle: Historic Seattle's Online Monthly Preservation Magazine,* May 2004.

McWilliams, Mary. *Seattle Water Department History, 1854–1954.* Seattle: City of Seattle Water Department, 1955.

Mann, F. M. "Plans, Apartment House." Cited in *Brickbuilder* 13, no. 1 (January 1904).

Marchand, Roland. *Advertising the American Dream: Making Way for Modernity, 1920–1940.* Berkeley: University of California Press, 1985.

Marshall, James L. *Elbridge A. Stuart: Founder of*

the Carnation Company. Los Angeles: Carnation, 1949.

Massey, James C., and Shirley Maxwell. "Houses of Homes: The Origins of Apartments." *Old House Journal* 22, no. 7: 24–29.

Meany, Edmond S. "A History of the University of Washington." Seattle: typewritten manuscript, n.d.

Mohl, Raymond A. *The New City: Urban America in the Industrial Age, 1860–1920.* Arlington Heights, IL: Harlan Davidson, 1985.

Morgan, Murray. *Skid Row: An Informal Portrait of Seattle.* Rev. ed. New York: Ballantine, 1851.

Moudon, Anne Vernez. *Built for Change: Neighborhood Architecture in San Francisco.* Cambridge, MA: MIT Press, 1986.

Mullins, William H. *The Depression and the Urban West Coast, 1929–33.* Bloomington: Indiana University Press, 1991.

Mumford, Esther Hall. *Seattle's Black Victorians, 1852–1901.* Seattle: Ananse Press, 1980.

National Register of Historic Places, http://www.nationalregisterofhistoricplaces.com/wa/state.html.

Neil, J.M. "Paris or New York? The Shaping of Downtown Seattle, 1903–14." *Pacific Northwest Quarterly* 75, no. 1 (January 1984): 22–33.

Nielsen, Roy. *UniverCity: The Story of the University District in Seattle.* Seattle: University Lions Foundation, 1986.

Norman, James B., Jr. *Portland's Architectural Heritage: National Register Properties of the Portland Metropolitan Area.* 2nd ed. Portland: Oregon Historical Society Press, 1991.

Ochsner, Jeffrey Karl, ed. *Shaping Seattle Architecture: A Historical Guide to the Architects.* 2nd printing. Seattle: University of Washington Press, 1998.

Ochsner, Jeffrey Karl, and Dennis Alan Andersen. *Distant Corner: Seattle Architects and the Legacy of H.H. Richardson.* Seattle: University of Washington Press, 2003.

Ore, Janet. *The Seattle Bungalow: People & Houses, 1900–1940.* Seattle: University of Washington Press, 2007.

Pacific Builder and Engineer. "Litholite — A New Building Material." Vol. 4, no. 1 (January 6, 1906): 14.

Pacific Builder and Engineer. "The Russell." March 17, 1906.

Pacific Builder and Engineer. "Evolution of Beds." October 27, 1906.

Pacific Builder and Engineer. "John Creutzer." November 10, 1906.

Pacific Builder and Engineer. "Lorraine Court." September 8, 1906.

Pacific Builder and Engineer. "Apartment Buildings." March 16, 1907.

Pacific Builder and Engineer. "The Space Problem in Modern Construction." September 26, 1908.

Pacific Builder and Engineer. "Artificial Building Stone." October 17, 1908.

Pacific Builder and Engineer 7, no. 13 (March 27, 1909): 90.

Pacific Builder and Engineer 12 (July 12, 1911): 23.

Pacific Builder and Engineer. "Gables Apartments, Seattle." September 9, 1911, 117.

Pacific Builder and Engineer. "Debesco Cast-Stone Blocks Are Scientifically Made." January 5, 1924, 12.

Pacific Builder and Engineer. "Ace Men of the Pacific Northwest." October 6, 1928.

Padelford, Gordon. "Frederick & Nelson Department Store by D.E. Frederick's Great Grandson." HistoryLink.org, essay 3774, May 15, 2002, http://historylink.org/index.cfm?DisplayPage=output.cfm&file_id=3774.

Peavy, Linda, and Ursula Smith. *Women in Waiting in the Westward Movement.* Norman: University of Oklahoma Press, 1994.

Perks, Sydney. *Residential Flats of All Classes.* London: B.T. Batsford, 1905.

Phelps, Mary L. *Public Works in Seattle: A Narrative History; The Engineering Department, 1875–1975.* Seattle: Seattle Engineering Department, 1978.

Pieper, Richard. "The Maintenance, Repair and Replacement of Historic Cast Stone." *42 Preservation Briefs*, Technical Preservation Services, National Park Service, U.S. Department of the Interior, n.d.

Pieroth, Doris Hinson. *Seattle's Women Teachers of the Interwar Years: Shapers of a Livable City.* Seattle: University of Washington Press, 2004.

Planel, Philippe. *Locks and Lavatories: The Architecture of Privacy.* London: English Heritage Publications, 2000.

Plumbing and Mechanical. "The Stand-Up Bath." July 1994, 4–6, cited in http://theplumber.com/standup.html.

Polk Seattle City Directories. R.L. Polk & Co., 1900–1939.

Poppeliers, John C., Allen Chambers Jr., and Nancy B. Schwartz. *What Style Is It? A Guide to American Architecture.* Washington, DC: Preservation Press, National Trust for Historic Preservation, 1983.

Portrait and Biographical Album of McLean County, Ill. Chicago: Chapman Brothers, 1887, 633–634. Courtesy of Peoria Public Library, Peoria, Illinois.

Prosser, William F. *A History of the Puget Sound Country.* Vol. 2. New York: Lewis Publishing, 1903.

Queen Anne Historical Society. "Streetcars of Queen Anne." http://qahistory.org/streetcars.htm.

Rash, David, and Thomas Estep. "Frederick William Anhalt." In *Shaping Seattle Architecture: A Historical Guide to the Architects*, ed. Jeffrey Karl Ochsner. 2nd printing. Seattle: University of Washington Press, 1998.

Reiff, Daniel D. *Houses from Books: Treatises, Pattern Books, and Catalogs in American Architecture, 1738–1950; a History and Guide*. University Park: Pennsylvania State University Press, 2000.

Reiff, Janice L. "Urbanization and the Social Structure: Seattle, Washington, 1852–1910." M.A. thesis, University of Washington, 1981.

Reinartz, Kay Frances. *Queen Anne: Community on the Hill*. Seattle: Queen Anne Historical Society, 1993.

Ritz, Richard Ellison. *Architects of Oregon: A Biographical Dictionary of Architects Deceased, 19th and 20th Centuries*. Portland, OR: Lair Hill Publishing, 2003.

Rochester, Junius. "Conklin, Mary Ann (1821–1873) aka Mother Damnable." HistoryLink.org, Essay 1934, January 1, 1999, http://historylink.org/index.cfm?DisplayPage=output.cfm&file_id=1934.

Roth, Leland M. *A Concise History of American Architecture*. New York: Icon Editions/Harper & Row, 1979.

Rydell, Robert W. *World of Fairs: The Century-of-Progress Expositions*. Chicago: University of Chicago Press, 1993.

Sale, Roger. *Seattle Past to Present: An Interpretation of the History of the Foremost City in the Pacific Northwest*. Seattle: University of Washington Press, 1976.

Schlereth, Thomas J. *Victorian America: Transformations in Everyday Life, 1876–1915*. New York: Harper Perennial, 1991.

Schmid, Calvin F. *Social Trends in Seattle*. Seattle: University of Washington Press, 1944.

Schwantes, Carlos A. *The Pacific Northwest: An Interpretive History*. Lincoln: University of Nebraska Press, 1989. Fourth paperback printing, 1992.

Schwartz, Susan. "Seattle's Treasury of Terra Cotta." *Seattle Times*, January 8, 1978, pictorial 11.

Sears, Roebuck and Company. *Book of Modern Homes: Containing 110 Designs with Plans and Total Cost of Building Material*. Chicago: Sears, Roebuck and Co., 1911.

Seattle Brides Cook Book. Seattle: Union Advertising Co., Suite 302, Epler Block, 1912.

Seattle Chamber of Commerce. *Seattle Illustrated*. Chicago: Baldwin, Calcutta and Blakely, 1890.

Seattle, City of. *Building Code of City of Seattle, Official Edition, 1914*. Compiled by Frances W. Grant. Seattle: Union Publishing, 1914.

Seattle, City of. Department of Building and Construction, architectural drawings and permits.

Seattle, City of. Department of Community Development. *A Detailed History of the Corner Market Building and Environs: A Chronicle of Harlan Thomas, Designing Architect of the Corner Market Building*. October 1975.

Seattle, City of. Department of Neighborhoods, Historic Preservation Program. *University District Historic Survey Report*. Caroline Tobin and Sarah Sodt, preparers. September 2002.

Seattle, City of. Department of Neighborhoods, Historical Site Search. www.Seattle.gov.

Seattle, City of. Department of Planning and Development. *Design Guidelines for the Belltown Urban Center Village*. Effective August 26, 2004.

Seattle, City of. Lighting Department, Acc. 33–31, Box 124/1, 8th Annual Report. University of Washington Libraries, Special Collections.

Seattle, City of. Office of Policy Planning. *Background Report on Multi Family Land Use Policies*. Seattle, 1978.

Seattle, City of. Office of Urban Conservation. *Hard Drive to the Klondike: Promoting Seattle during the Gold Rush*. www.nps.gov/archive/klse/hrs/hrs6a.htm.

Seattle, City of. *Building Inspectors' Hand Book of the City of Seattle, Washington*. Containing Revised Building Laws for 1902, 1904, 1907, 1910, 1912, 1914, 1924, 1926.

Seattle, City of. *Early Seattle Neighborhood Buildings, Historic Resource Survey, Context Statement*. Greg Lange, preparer. Cited on Department of Neighborhoods website, http//www.seattle.gov/neighborhoods/preservation/ContextEarly SeattleBldgs.pdf (last modified 2005).

Seattle, City of. *Real Property Survey, Seattle, Washington, 1939–40*. Vol. 1, "History of Housing," 3. Sponsored by Housing Authority of the City of Seattle, Jesse Epstein, executive director. WPA Project Number 3272.

Seattle, City of. *Real Property Survey, Seattle, Washington, 1939–40*. Sponsored by Housing Authority of the City of Seattle, Jesse Epstein, executive director. WPA Project Number 3272. Table 1–4: "Number and Percentage Distribution by Exterior Material, by Type of Structure, for All Structures, Seattle, Washington, 1939–40."

Seattle, City of. *Real Property Survey, Seattle, Washington, 1939–40*. Sponsored by Housing Authority of the City of Seattle, Jesse Epstein, executive director. WPA Project Number 3272. Table 8: "Number and Percentage Distribution by Exterior Material for All Single-Family, Detached, and Apartment Structures."

Seattle, City of. *Real Property Survey, Seattle, Washington, 1939–40*. Sponsored by Housing Authority of the City of Seattle, Jesse Epstein, executive director. WPA Project Number 3272. Table A–2:

"Number and Percentage Distribution by Year Built, by Type of Structure, for All Structures." *Seattle Mail and Herald: A Social and Critical Journal* 7, no. 43 (September 3, 1904).

Seattle of Today. "H. Ryan." 1907. Architects' Reference File, University of Washington Libraries, Special Collections.

Seattle of Today. "Buena Vista Apartments." 1908, 150. Seattle Room, Seattle Public Library.

Seattle Public Library. *Architects Scrapbooks*, vol. 4, A–Bq.

Seattle Public Library. *Costello Scrapbooks*, vol. 24.

Sexton, R.W. *American Apartment Houses, Hotels and Apartment Hotels of Today: Exterior and Interior Photographs and Plans.* New York: Architectural Book Publishing, 1929.

Seymore, W. B. "Pioneer Hotel Keepers of Puget Sound." *Washington Historical Quarterly* 6, no. 4 (1915): 238–242.

Shapiro, Laura. *Perfection Salad: Woman and Cooking at the Turn of the Century.* New York: Farrar, Straus and Giroux, 1986.

Shelton, Jo-Ann. *As the Romans Did: A Sourcebook in Roman Social History.* 2nd ed. New York: Oxford University Press, 1998.

Sheridan, Frances Amelia. "Apartment House Development on Seattle's Queen Anne Hill Prior to World War II." M.A. thesis, University of Washington, 1994.

Sheridan, Mimi. "Viewpoints Tour: Pike/Pine Corridor." February 2000.

Shoettle, Clark. "Deceased Architects and Builders Who Have Worked in Burlington, Vermont." Unpublished manuscript, Special Collections, University of Vermont, Burlington, Vermont, n.d.

Singer, William F. "The Denny Regrade Apartment Building: A Typological Study." Unpublished master of architecture thesis, University of Washington, 1987.

Sketches of Washingtonians: Containing Brief Histories of Men of the State of Washington Engaged in Professional and Political Life. Seattle: W.C. Wolfe, 1906.

Slauson, Morda C. *Renton: From Coal to Jets.* Renton, WA: Renton Historical Society, 1976.

Smeins, Linda. "Two Design Lectures: Pattern and Plan Book Home Designs." *Preservation Seattle Online Magazine*, January 31, 2004, https://www. historicseattle.org/events/eventdetail.aspx?id=34 &archive=1.

Smerk, George M. "The Streetcar: Shapers of American Cities." *Traffic Quarterly: An Independent Journal for Better Traffic* 21, no. 4 (1967): 569–584.

Social Blue Book of Seattle. Seattle: Wood and Reber, 1907/8, 1910–1914, 1921, 1923, 1926–1942.

Society of Architectural Historians, American Architects, Biographies, Frank Hoyt Fowler, http:// www.sah.org/index.php?src=gendocs&ref= BiographiesArchitectsF&category=Resources.

Somerville, H.P. "The Management of Apartment House Properties." *Buildings and Building Management* 25, no. 9 (April 27, 1923): 50–51.

Stark, Stuart. "Victorian Pattern Books." In *Building the West: The Early Architects of British Columbia*, ed. Donald Luxton. Vancouver, BC: Talonbooks, 2003.

Staten, Peter. "Found Architecture," in "A Neighborhood Rediscovered," *Seattle Weekly*, June 19, 1991, 37.

Strasser, Susan. *Never Done: A History of American Housework.* New York: Pantheon, 1982.

Sturgis, Russell, et al. *Sturgis' Illustrated Dictionary of Architecture and Buildings.* An unabridged reprint of the 1901/2 edition. Vol. 1, A–E. New York: Dover, 1989.

Sumner, City of. "Self-Guided Tour through Historical Landmarks of Sumner, Washington." http://www.ci.sumner.wa.us/Living/Walking_To ur.htm.

Susman, Warren. *Culture as History: The Transformation of American Society in the Twentieth Century.* New York: Pantheon, 1984.

Sweatt, Robert C. "The Architecture of the Pacific Northwest." *Architectural Record* 26, no. 3 (September 1909).

Swedish Tabernacle. *Our Church at Fifty: A Record of the Planting, Growth and Fruits of the Swedish Tabernacle Congregation, Seattle, Washington, 1889–1939.*

Taylor, C. Stanley. "Efficiency Planning and Equipment." *Architectural Forum* 41, no. 5 (1924): 253–258.

Taylor, Quintard. *The Forging of a Black Community: Seattle's Central District from 1870 through the Civil Rights Era.* Seattle: University of Washington Press, 1994.

Tazelaar, Mieke. *The Kroll Map Company: A Story of Continuity.* Seattle: Kroll Map Company, 2004.

Temple de Hirsch, Auspices of the Ladies Auxiliary. *One Thousand Favorite Recipes.* Seattle: Merchant Printing Company, 1908.

Terra Cotta Defined. Brochure series, vol. 6. National Terra Cotta Society, 1 Madison Avenue, New York, ca. 1910.

Thrush, Coll-Peter. *Native Seattle: Histories from the Crossing-over Place.* Seattle: University of Washington Press, 2007.

Tunick, Susan. *Field Guide to Apartment Building Architecture: An Illustrated Overview Providing a Simple Way to Identify Buildings Parts, Style and Materials.* New York: Friends of Terra Cotta/New York State, 1986.

_____. *Terra-Cotta Skyline: New York's Architectural Ornament.* New York: Princeton Architectural Press, 1997.

Tunnard, Christopher, and Henry Hope Reed. *American Skyline: The Growth and Form of Our Cities and Towns*. Boston: Houghton Mifflin, 1955.

United States, Bureau of the Census. U.S. Census of Population, *Census of the United States: 1860–1920*. Population Schedule. Washington, King Co., Seattle. http://persiheritagequestonline.com.

United States, Bureau of the Census. U.S. Census of Population. *1930 United States Federal Census*. Population Schedule. Washington, King Co., Seattle. Provo, UT: Ancestry.com, 2002.

University of Washington Libraries, Special Collections. Architectural Drawings, Architect Edward T. Osborn, the Charlesgate, Location M197.

University of Washington Libraries, Special Collections. *Architecture of Dose, West & Reinoehl*. Seattle, WA, 1908. Architects' Reference File: Dose, West & Reinoehl.

University of Washington Libraries, Special Collections. "The Exeter: In the Heart of Seattle." Promotional brochure. Seattle (WA) Hotels and Apartments Pamphlet File.

University of Washington Libraries, Special Collections. "Medical and Dental Building Special Souvenir Announcement." Architects' Reference File: John Alfred Creutzer.

University of Washington Libraries, Special Collections. "Pacific Coast Architecture Database."

Vergobbi, David J. *Seattle Master Builders Association: An 80 Year Journey through History*. Seattle: Seattle Master Builders Association, ca. 1988.

Warren, James R. *King County and Its Emerald City: Seattle*. American Historical Press, 1997.

Washington State Architect 2, no. 9 (August 1921).

Washington State Architect 3, no. 5 (April 1923).

Washington State Architect 5, no. 2 (January 1925).

Washington State Architect 5, no. 7 (June 1925).

Washington State Architect 8, no. 9 (August 1928).

Washington State Archives, Puget Sound Regional Branch, Bellevue.

Western Architect, May 1905.

Western Architect, "Architect Calls Electric Refrigerator Inevitable," November 1926.

Whiffen, Marcus. *American Architecture Since 1780: A Guide to the Styles*. Cambridge, MA: MIT Press, 1969.

Wilcox, Estelle Woods. *Practical Housekeeping; A Careful Compilation of Tried and Approved Recipes*. Minneapolis: Buckeye Publishing, 1883.

Williams, David. *The Street Smart Naturalist*. Portland, OR: West Winds Press, 2005.

Williams, Jacqueline B. *The Hill with a Future: Seattle's Capitol Hill, 1900–1946*. Seattle: CPK Ink, 2004.

Williams, Jacqueline. *The Way We Ate: Pacific Northwest Cooking, 1843–1900*. Pullman: Washington State University Press, 1996.

Wilma, David. "Douglass-Truth Branch, The Seattle Public Library." HistoryLink.org, essay 4056, December 26, 2002, http://historylink.org/index.cfm?DisplayPage=output.cfm&file_id=4056.

Withey, Henry F. *Biographical Dictionary of American Architects (deceased)*. Facsimile ed. Los Angeles, CA: Hennessey & Ingalls, 1970.

Woodbridge, Sally B., and Roger Montgomery. *A Guide to Architecture in Washington State*. Seattle: University of Washington Press, 1980.

Woodbury, Coleman. *Apartment House Increases and Attitudes toward Home Ownership*. Chicago: Institute for Economic Research, 1931.

Wright, Mary C., ed. *More Voices, New Stories: King County, Washington's First 150 Years*. Seattle: Northwest Historians Guild, 2002.

Wright, Lawrence. *Clean and Decent: The Fascinating History of the Bathroom & the Water Closet, and of Sundry Habits, Fashions & Accessories of the Toilet, Principally in Great Britain, France, & America*. New York: Viking, 1960.

Index

Numbers in **bold italics** indicate pages with illustrations.

ACT *see* A Contemporary Theatre

Adams, Harold 44

Aitken, William H. 40; *see also* Harvard Crest

Alaska-Yukon-Pacific Exposition (AYP) 15–17, *16*, 54–55, 88, 225

Albertson, A.H. 40–41; *see also* Rivoli

Alexander *160*, 160–161

Algonquin 46, 53, *67*, *138*, 138–139

Allan, Norris Best 49; *see also* Buena Vista

Allen 156–158, *157*

Allen, Frank P. 41; *see also* Old Colony

Ambassador 164

American Institute of Architects (AIA) 39

Anderson, Samuel 39, 41, 141; *see also* Fleur de Lis

Ändra (Hotel) *see* Claremont

Angeline *see* Nichols

Anhalt, Frederick 37, 39, 41–42, *42*, 65; *see also* 750 Belmont; Ten-O-Five East Roy

apartment hotels 71–74, *73*, 246n18, 297n93; *see also* Camlin; Claremont; Exeter; Olive Tower; Spring; Wilsonian

Apartment Operators Journal 13

apartments: acceptance of children 95, 101, 136, 139, 177 *178*, 248n65; for African Americans 225; bachelors 5, 74; classes of 64, 68–79; definitions of 10, 19, 241n93; influences on construction 11–17; naming of 79, 129, 179, 248n19; opposition to construction 17–19, 115, 223; service/delivery entrances 77, 78, 131, 133, 137, 172, 214; subletting 117; working from 221

Arcadia 32, 49, 133, *134*

architectural styles 64–66; *see also* Art Deco; Beaux-Arts Neoclassical; Collegiate Gothic; Colonial-Georgian Revival; Gothic; Mediterranean Revival; Mission; Queen Anne; Tudor

Arensberg, Charles 34, 190

Argus 137, 250n5

Art Deco 65; *see also* Belroy; La Vanch; Mount Baker Apartments

artificial stone blocks *see* cast stone

Astor Court 76

Auto Row: east of Broadway 181–182, 251n9; west of Broadway 145

Bain, William J., Sr. 36, 42–43; *see also* Bain and Pries; Belroy; Envoy

Bain and Pries *see* Bain, William J., Sr.; Belroy; Envoy; Pries, Lionel

Baird, J.M. 219, 221

Baker, Frank Lidstone 43; *see also* Baker, Vogel and Roush; Blackwell, James Eustace; Blackwell and Baker; Laurelton; Laveta; Nesika

Baker, Vogel and Roush *see* Baker, Frank Lidstone; Laurelton

balconettes 78, 247n35

Ballard neighborhood 233–234

Bamberg 44, *179*, 179–180

bathrooms 26, *27*

Beacon Hill neighborhood 219

Beaumont 47, *146*, 146–147

Beaux-Arts Neoclassical 65, *66*; *see also* Olympian; Russell (Apartments)

beds (hidden) 27–29, *28*, *29*, 75

Bel Fiore *see* Rosenbaum

Bellevue 167–168, *169*

Belltown neighborhood 87, 103

Belltown Urban Center Village, Design Guidelines for the 103, 113

Belmont Court *see* 750 Belmont

Belroy 43, 174–176, *175*

Ben Lomond 47, 177–178, *178*

Bennett, Charles 60, *60*

Berg, Stephen 39, 43 *see also* Biltmore; Claremont

Bering 61, 199–201, *200*

Biltmore 31, 43, 60, 61, 156, 162–163, *163*

Biltmore Annex 162–163

Birkel, A.M. 184

Bittman, Henry 43–44; *see also* Senator; Truro

Blackwell, James Eustace 44; *see also* Baker, Frank Lidstone; Blackwell and Baker; Laveta; Nesika

Blackwell and Baker *see* Baker, Frank Lidstone; Blackwell, James Eustace; Laveta; Nesika

Bluff 182–184, *184*

boarding houses 9, 72, 137, 246n18

Bogue, Virgil 11, 240n46

Bogue Plan 11, *12*, 53, 62, 240n47

Bonair 47, 99, *100*

Borton, C.F. 37

Brady, Edward 236

Breitung and Buchinger *see* Hermosa; Lorraine Court

brick 80, *82*, 82–83, 252n76

Brickbuilder 20

Bristol 58, 186–187

Broadway 144, 164–165

Broadway High School 125, 149, 151, 152

Broderick, Henry 137

Brydsen, Jane 187–188; *see also* women in apartment real estate

Buckley 22, 30, 33–34, 51, 190–193, *191*

Buena Vista 22, 49, 153–154, *154*

Builders Brick Company 80, *81*

Building Economy 208

Building Inspector's Handbook of the City of Seattle, 1902 8

building materials 79–85; decorative 84–85; exterior 82–84, 247n43; structural 80–82; *see also* brick; cast stone; hollow tile; reinforced concrete; stone; stucco; terra cotta; wood

building permits 13, 240n56

Buttnick, Meta 9, 27

cable cars 14, *15*; 116, 126; Queen Anne 229; Yesler 235, 240n69

Cambridge 29, 72

Camlin *31*, 50, 72–74, *73*, *75*, 246n24

Capitol *see* Flemington

Capitol Hill Automobile Garage 202, 254n93

Capitol Hill Housing 138, 146, 195, 206

Carnation Milk Company 7–8
Carrigan, John 44; see also Bamberg
Carroll 169–171, **170**
cast stone 85
Castle 50, 105–106
Castle Crag 27
Cayton, Horace 226, 256n26
Cedar 112–113, **114**
Cedar River Power Plant 21
Celeste see Allen
cement see Portland cement
Central District neighborhood 225
Central School 92, 248n27
Central Terminal 99, **100**, 248n57
Chalmers **24**, 202
Chardonnay see Bellevue
Charlesgate 11, 22, **54**, **70**, 70–71, **71**
Chasselton 49, 123, **124**
City Beautiful movement 11, 172
Clairemont see Monmouth
Claremont 43, 60, 61, 72, 106–109, **108**
Clark, W.F. 118
Clebanck, Anna 89; see also women in apartment real estate
Clein, Marlene 211
closets (package, parcel, service) 33, 135, 155
clubs: Daughters of the American Revolution (DAR) **48**, 207; Mount Baker Park Improvement 223; neighborhood improvement 18; North Broadway Development 164; Rainier 87; Renton Hill Improvement 18, 137, 139; Woman's Century 207
coal 6
codes: bathroom 148, 241n36; kitchen 22; yard 33, 253n102; see also Building Inspector's Handbook of the City of Seattle, 1902
Coliseum Theater 55, **55**, 83, 245n130
Collegiate Gothic 65; see also Buckley
Colonial-Georgian Revival 65, 66, **67**; see also Algonquin; Washington Arms
Columbia City neighborhood 232
Community House Mental Health Agency 121
concrete see reinforced concrete
consumer society 30
A Contemporary Theatre (ACT) 98
coolers (kitchen) 23–24, **24**, 136, 152
Cornish School of the Arts 207
covenants (neighborhood) 17, 18
Creutzer, John 44–45, 158–159, 227; see also El Rio; Lenawee; Union Arms-Union Manor
Cromley, Elizabeth Collins 10, 30, 63
Cyrus 62, 152, **153**

Daughters of the American Revolution (DAR) see clubs
Davis, Glenn 212, 255n125
Davis, John and Company 127, 129, 131, 142, 191
De Coster, Dotty 127, 199
De la Mar 49, 218–230, **230**
Denny Hill 25, 87, 240n43
Denny Regrade 11, 109–110, 110
Denny-Renton Clay and Coal Company 80, **81**, 83, 84, 193
Denny Triangle 87, 98
Depression, Great 14, 33, 193, 199
De Selm 23
Dickman, F.W. 184
dinettes 22, 74
dishwashers 25–26, 211
Disler **82**
Dofsen, Edwin E. 179, 209, 211
Dose, West and Reinoehl 35
Douglas, J.F. 101, 248n64
Dover see Laveta
dressing rooms 28, 69, 177, 235
dryers (clothes) 27, 71, 159
Dudley, Margaret 11, 12, 70; see also women in apartment real estate
Dunn, Edward B. 126
Duwamish Indians 5

Eagles see Senator
Edwards on Fifth see Le Sourd
efficiency apartments 68–71, **69**, **105**
Eitel Building 61, 86
El Capitan 101–102
El Dora **158**, 158–59
electricity 9, 21
Electro-Kold 25
elevators 31–32
Elliott, Charles N. 10
Elliott Bay Bookstore 182
El Rio 45, 99–101, 248n61
Emerson 47, **94**, 94–95
Envoy 45, 119, 119–120
Euclid v. Ambler 19, 241n92
Everett, Julian F. 45; see also Leamington
Ewing, Henry E. **13**, 211
Exeter 60, 61, 95, **96**

Farragut 58, 186–187
Farrar, Bert 118, 127
Federal Housing Authority 91
Felker House 5, **6**
Felzer, Clem 202, 204
Fifteenth Avenue Garage 196–197
fire (Seattle great, 1889) 7, 8, 38, 90
fire escapes 63, 118, 121
Firestone Tire and Rubber Company 182
Fisk Rubber Company 182
Flemington 56, 164–167, **166**
Fleur de Lis 31, 41, 141–142, **142**
Fowler, Frank Hoyt 45; see also Wilsonian
Fraternal Order of Eagles Temple see Senator

Fredonia 57, 195, **196**
Friedlander 58, 227–228, **228**
Friedlander, S. 227

Gables 26, 50, **193**, 193–194
Gainsborough 30, 31, 53, **126**, 126–127
garages 95, **125**, **195**, 211; see also Capitol Hill Automobile; Fifteenth Avenue; roof gardens
Gladding, McBean 84, **85**, 85, 239
Glencoe see Hall
Gordon 44, 58, **187**, 187–188, **188**
Gothic (architectural style) 65; see also Exeter; Maxmillian
Gould, Carl F. 38, 49, 229
Graham, John, Sr. 45–46; see also Algonquin, Graham and Myers; Mount Baker (Apartments); Myers, David J.; Robinson; Spring (Apartment Hotel)
Graham and Myers see Graham, John, Sr.; Robinson
Great Northern Railroad 7, 22
Green, Elmer Ellsworth 37, 46–47; see also Beaumont, Ben Lomond
Grose, William 225, 256n21
Guenther, Emil 47, 101
Guiry 10, 240n40
Gwinn, Gardner 39

Hall **147**, 147–148
Hallett 201
Harrison, Benjamin (president) 7
Harvard Crest 40, 164, **165**
Hayden see Roe
Haynes, Charles A. 47; see also Bonair; Roy Vue
Helen V see Algonquin
Hermosa 111–112, **112**, **113**
Hillcrest 32
Hiram Chittenden Locks 234
Hofius House 59, **59**
hollow tile 81
Hoosier Kitchen Cabinet 22
hospitals: Swedish 116; Virginia Mason 116, 123
hotels 9, 10; see also apartment hotels
Howells and Stokes 40; see also Rivoli; Waldorf
Hudson, Henry E. 40, 47; see also Emerson; Lowell
Hudson, John S. 39–40, 47–48, 123
Humphrey 52, 106, **107**
Huntington, Daniel R. **48**, 48–49, 244n82; see also Chasselton; De la Mar
hybrids 185

iceboxes 24, 122–123, 241n27
Innes, Margaret 111; see also women in apartment real estate
intermediate apartments 74–77
International Village 141
Interstate 5 87, 93, **93**, 102, 144, 252n99

investors, Eastern 19, 27, 101, 194
Israel, Naomi 26–27

Jefferson Park 219
Jefferson Park (Apartments) 219–221, **220**
Jenney, William Le Baron 49, 244*n*89
Jennot *see* Kittitas
Jensen, Lowell 99
Jewish neighborhood 235–236
Johnson, Isham B. 49; *see also* Arcadia
Jones, Nellie 11; *see also* women in apartment real estate
Josenhans, Timotheus 49; *see also* Buena Vista
Julie *see* El Rio

Kain 29, 131, 148–149, **150**
Kinnear, George 229, 256*n*35
kitchenettes 22, 74
kitchens 21–26
Kittitas 202, **203**
Klondike Gold Rush 7
Knipe, Robert 49–50; *see also* Gables
Koretz, Sam 211
Kreielsheimer brothers 133, 250*n*42
Kunz, Andrew 131

La Crosse 54, **198**, 198–199
Landes, Bertha 223
Lane 206–207, **207**
La Playa Vista *see* Friedlander
Larson, D'Arcy 33, 177
laundry rooms 26–27, 71
Laurelton 43, 189–190, **190**
Lauren May *see* Westwood
Lauren Renee *see* El Dora
La Vanch 33, 53, **217**, 217–218
Laveta 43, 44, 60, **92**, 92–93, **93**; 248*n*29, 248*n*31
La Villa *see* Farragut
Lawton, George W. 50; *see also* Castle; Lawton and Moldenhour; Moldenhour, Herman; Olive Crest; Russell (Apartments); San Marco; Saunders, Charles W.; Saunders and Lawton
Lawton and Moldenhour *see* Lawton, George W.; Moldenhour, Herman; Olive Crest
Leamington 45, 63, **88**, 88–89
Leighton **120**, 120–121
Lenawee 45, 83, **151**, 151–152
Le Sourd 53, 109–110, **111**
Lewis and Clark Exposition, Portland, Oregon 16
Linde, Carl L. 50; *see also* Camlin
Live Historic 125
lobbies 30, **31**, 95, 98, 103, 106–107, 133, 192
lodging houses 9–10; disapproval of 223
longhouses *see* Duwamish Indians

Lorraine Court 184–185, **185**
Lorrimer 204–205, **205**
Loveless (Apartments) 208, **209**
Loveless, Arthur 50–51; *see also* Loveless (Apartments)
Low Income Housing Institute 101
Lowell 47, **94**, 94–95
lumber 6, 80, 232, 241*n*15
Lundquist, Florence 29, 32, 131, 149, **150**
luxury apartments 77–79

Madison View *see* Woodson
Madkin *see* Renton
maids' rooms 49, 116, 214, 215
Malden 197–198
Manhattan Flats 62, 101
Marlborough House 53, 124–125, **125**
marquees 93, 98, 108, 118, 248*n*31
Maxmillian 24, 135–136, **136**
McBean, Andrew 10, 51; *see also* Westminster
Mediterranean Revival 232; *see also* Truro
Melrose 53, 145–146
Mercerwood 202–204, **204**, 254*n*94
merchant builder 66 *see also* Anderson, Samuel; Anhalt, Frederick; Berg, Stephen
Merritt, Edward L. 51, 141; *see also* Buckley; Sheffield
Middleton, Amelia 194
Millionaire's Row 189
Milner, Warren H. 51–52; *see also* Humphrey
Mission (architectural style) 65; *see also* San Marco; La Crosse
Moana 54, 75–77, **76**, **77**
Moldenhour, Herman A. 52; *see also* Lawton, George; Lawton and Moldenhour; Olive Crest; Saunders, Charles W.
Monmouth 27, 60, 235–237, **236**
Monroe 57, 196–197, **197**
Monroe, Byron 196
Monroe, Ellen 111, 196; *see also* women in apartment real estate
Montrachet *see* Hallett
Moore, James A. 181, 182, 189, 201
Morrison, Earl W. 52–53, 212, 244*n*113; *see also* Gainsborough; La Vanch; Le Sourd; Marlborough House; Olive Tower; Tenth Avenue East (eight apartments in 700 block); 1223 Spring
Mount Baker Apartments 223–224, **224**
Mt. Baker Court Condominium *see* Mount Baker Apartments
Mt. Baker neighborhood 223
Mount Baker Park Improvement Club *see* clubs
municipal water system 21
Murphy beds 29, 51, 199; *see also* beds (hidden)
Myers, David J. 53; *see also* Algo-

nquin; Graham and Myers; Graham, John, Sr.; Robinson

National Housing Association 17, 18
National Register of Historic Places 10; *see also* Camlin; El Rio; Leamington; Senator; Studio (Paramount Theater Apartments); Ten-O-Five East Roy
NBBJ (Naramore, Bain, Brady and Johanson) 43
needle baths 26, **27**, 91
Nesika 43, 44, 109, **110**
New York Tenement House Law of 1901 8, 239*n*22
Nichols 232–233, **233**, **234**
Nichols, Ralph, Sr. 232
North, Mrs. Josephine 101
Northcliffe 30, 48, 49, 72, 123, 249*n*20
Northern Clay Company 84
Northern Pacific Railroad 6, 38, 240*n*46
Noyes, W.W. 53; *see also* Melrose

Oddfellows building 182
Old Colony 41, **121**, 121–123, **122**
Olive Crest 50, 53, **161**, 161–162
Olive Tower 72, 102–103, **102**
Olive Way 156, 251*n*39
Olmsted, John Charles 16, 41, 224, 255*n*2
Olmsted Brothers 16, 207, 224
Olympian 62, 78–79, **79**
ordinances: building 8, 17–18, 22, 241*n*12; fire safety 239*n*17; land use 240*n*82; Office of superintendent of buildings 8
Osborn, Edward Thomas 53, 54; *see also* Charlesgate

Pacific *see* Leamington
Panic of 1893 38–39
Pantages, Alexander 55
Paramount Theaters: downtown 55, 98–99, 112; Wallingford 232
Park *see* Chalmers
Park Court 59, **213**, 213–214
Park Hill *see* Robinson
parks: Cal Anderson 182; Volunteer 181, 207–208
pattern books 36–38, 242*n*9
Pelham, Hotel 36
penthouses 124–125, 127, 130
Perkins, Frank H. 54, 76; *see also* Bellevue; La Crosse; Moana
Peters, Frederick J. 55; *see also* Studio (Paramount Theater Apartments)
Petra *see* Cyrus
Pike Street (Apartments) 185–186, **186**
Pine Street (Apartments) *see* Gordon
Pioneer Square 16, 86
Plank, Marion 11; *see also* women in apartment real estate
plaster 83

Plymouth Housing Group 89
Pontiac Brick and Tile Company 80
porches: icebox/rear 24, 133, 137, 185, 202, 233, *233*; sleeping 201, 221, 251*n*37
Porter 154–156, *155*
Portland, Oregon 13, 16
Portland cement 83, 247*n*59
Presbyterian Ministries 95
Pries, Lionel 42; *see also* Bain and Pries; Belroy; Envoy
Priteca, Benjamin Marcus 54–55, 236; *see also* Studio (Paramount Theater Apartments)
Puget Sound 18, 39
Puget Sound Power and Light *23*

Queen Anne (architectural style) 65; *see also* El Dora
Queen Anne neighborhood 228–229

radios 33
Ragley 194–195, *195*
Rainier Club *see* clubs
ranges (kitchen) 22–23, *23*
Rapp, C.W. 98
Rapp, George L. 98
Real Property Survey 178
Reed, Margaret 27, 28
refrigerators 24–25, *25*; *see also* Electro-Kold
Regis *see* Lane
reinforced concrete 82, 90
Renton 139–140, *140*
Renton, William 136, 137
Renton Hill 136–137
Renton Hill Improvement Club *see* clubs
Republican Hill Climb 167, *168*
Rialto Court 152–153
Riley, Howard H. 55–56; *see also* Flemington; Westwood
Rivoli 41, 103–105, *104*
Robinson 46, 53, 137–138
Roe 182, *183*
roof gardens 33–34
Rosenbaum 57, *159*, 159–160
Rosenbaum, Lewis N. 13, 99, 159, 240*n*54
Roundcliffe 60, 61, *176*, 176–177
Roy Vue 24, 47, 172, 174, *174*
Rucker, Helen 140
Russell (Apartments) 50, 58, 116–117, *117*
Russell, Ambrose 56; *see also* St. Paul; Spalding, Albert Walter
Russell and Babcock *see* Russell, Ambrose; Spalding, Albert Walter
Ryan, Henderson 36, 56–57, 148; *see also* Fredonia; Monroe; Rosenbaum; Waldorf

St. Florence *28*, *29*, 29
St. Ingbert 172, *173*
St. James Cathedral 116, 119
St. Johns *see* Kain

St. Paul 19, 21, 32, 56, 131–133, *132*
Sandaas, Vivian 99
San Marco 13, 50, 58, 127–129, *128*, *129*
Saunders, Charles W. 10, *57*, 57–58, 101; *see also* Lawton, George W.; Russell (Apartments); San Marco; Saunders and Lawton
Saunders and Lawton *see* Lawton, George W.; Russell (Apartments); San Marco; Saunders, Charles W.
Schack, James 49; *see also* De la Mar
Schack and Huntington *see* De la Mar; Huntington, Daniel R.
Schack and Young 141
Schack, Young, and Myers 53
Schillestad 10, 51
Schuett, Henry 213–214
Sears, Roebuck 37–38, 43
Seattle: -centric building form 66–68, *68*; City Light 23; Electric Company 30, 189, 201, 231, 234; Home Builders Association 41; Housing Authority 121; Housing Resources Group 98, 103; Master Builders Association 41, 51; Rental Bureau 9; Street Railway 14; as walking city 14
Seattle and Walla Walla Railroad 6
Seattle Art Museum 207–208, 255*n*107
Senator 44, 96–98, *97*, 248*n*44
750 Belmont 42, 170
Sexton, F.A. 58; *see also* Bristol; Farragut; Gordon
Shay, Alban 58; *see also* Friedlander; Mount Baker (Apartments)
Sheffield 33, 51, 190–193, *191*
Sheridan 83, *83*
Sherwood 11, *66*, 105
single-family homes: apartment buildings' impact on 18–19; ordinances related to 17
Single Room Occupancy Hotels 103
Smith Tower 83, 86, *88*
Sovereign 31
Spalding, Albert Walter 58–59; *see also* Russell, Ambrose; St. Paul
Spring (Apartment Hotel) 46, *89*, 89–90
Spring Hill Water Company 20
Starbird (Apartments) *see* Starbird Court
Starbird Court 148
Stoddard, George Wellington 59; *see also* Park Court
stone 81
Straker Hardware and Auto Supply 232
Stratford *see* Nesika
streetcars *see* transportation
Stuart, Bertram Dudley 60; *see also* Biltmore; Claremont; Exeter; Ragley; Roundcliffe; Stuart and Wheatley; Wheatley, Arthur

Stuart and Wheatley 39; *see also* Berg, Stephen; Biltmore; Claremont; Exeter; Ragley; Roundcliffe; Stuart, Bertram Dudley; Wheatley, Arthur
stucco 83
Studio (Paramount Theater Apartments) 55, 98–99, 248*n*56
Summit Arms *see* Beaumont
Summit Elementary 29, 125, 152

Tacoma 6
tax credits (low-income and historic preservation) 89
telephones *32*, 32–33
1014 East Roy 208
Ten-O-Five East Roy 42, 208–211, *210*
1006 East Prospect 216, *216*
tenement houses 8, 9
Tenth Avenue East (eight apartments in 700 block) 211–212, *212*
terra cotta: decorative 84, *85*; exterior 78, 83, *83*, *85*
Terrell-Maverick Company 197
Territorial: Legislature 8; Library 37
Thomas *171*, 171–172
Thomas Park View *see* Thomas
Thompson, Charles L. 60, *60*
Thompson and Thompson *see* Bennett Charles; Laveta; Monmouth; Thompson, Charles L.
Thomson, Reginald H. 21
Tiffany finish 30–31, 141, 192
transcontinental railroad *see* Great Northern Railroad; Northern Pacific Railroad
transportation 14–15, *15*; downtown 86, 87, 99, *100*, 100, 109; East Capitol Hill 181–182, 189, 200, 201, 216; First Hill 115, 116, 126, 137; other neighborhoods 219, 221, 227, 229, 231, 232, 234, 234; West Capitol Hill 144, 156, 162, 164–165, 167, 177; *see also* cable cars
trolleys *see* transportation
Truro *231*, 231–232
Tudor (architectural style) 65; *see also* Harvard Crest; Roy Vue
1223 Spring 27, 31, 53, 129–131, *130*
Twenty-Seven Hundred Fourth Avenue *see* Hermosa

Umbrecht, Max 36
Union Arms–Union Manor 45, 133–135
United States Supreme Court 35
University District neighborhood 221, 255*n*5
University of Oregon 38, 63
University of Washington 15–16, 38, 49, 63, 57, 221
utilities 20–21

Valencia *see* Truro
Vancouver, British Columbia 10

Van House, Max A. 60–61; *see also* Bering
Van Siclen, William 83, 86
Vintage Park *see* Spring (Apartment Hotel)
Virginian 61, 109
Voorhees, Victor 37, *37*, 61, 139, 245*n*166; *see also* Virginian; Washington Arms

Waldorf 26, *27*, 56, 57, 82, 90–91, *92*, 248*n*19
Wallingford neighborhood 231
Washington Arms 61, 214–216, **215**
Washington Brick, Lime and Sewer Pipe Company 84
Washington State: Chapter of the AIA 39; Legislature 221; Society of Architects 39; Territory 17; Trade and Convention Center 87, 91
water 20–21; *see also* municipal water system; Spring Hill Water Company; Thomson, Reginald H.

Watermarke at the Regrade *see* Cedar
Welch v. Swasey 18, 240*n*90
West, Thomas L. 10
West Seattle neighborhood 227
Western Home Builder 37, *37*, 61
Westminster 51, 118, *118*
Westwood 56, 233–235
Wheatley, Arthur 61; *see also* Biltmore; Claremont; Exeter; Ragley; Roundcliffe; Stuart, Bertram Dudley; Stuart and Wheatley
White, William P. 20, 61–62, 78; *see also* Cyrus, Manhattan Flats; Olympian
Wiggins, Myra 208
Wilding, Al 29, 44, 116
Willcox, Walter Ross Baumes *62*, 62–63; *see also* Everett, Julian F.; Leamington
Wilson, Corinne 221, 223; *see also* women in apartment real estate
Wilsonian 45, 221–223, *222*
Winquist, Frank G. 146, 186

Winston *see* Lorraine Court
Woman's Century Club *see* clubs
women in apartment real estate 240*n*49; *see also* Brydsen, Jane; Clebanck, Anna; Dudley, Margaret; Innes, Margaret; Jones, Nellie; Monroe, Ellen; Plank, Marion; Wilson, Corinne; Young, Mae
wood 80, 82
Woodson *225*, 225–227
Woodson, Zacharias 225–226, 278, 279
Woodson Annex 226–227

Yesler, Henry 5, 225
Yesler neighborhood 235–236
Yoho, Jud 51
Young, Mae 214; *see also* women in apartment real estate

Zindorf 93–94
zoning 17–19, 241*n*96